D1131276

CRISSCROSSING
AMERICA
DISCOVERING AMERICA FROM THE ROAD

9.17.09

Mark - Hans,

It has been some time since we first talked about a book "concept." After an 18 month gestation period, I can now share Crisscrossing America with you. Hope you enjoy it.

I'm most grateful for the Harley-Davidson Museum's warm hospitality and for the opportunity to address its members and guests.

All the best,

CRISSCROSSING
AMERICA

DISCOVERING AMERICA FROM THE ROAD

JOHN GUSSENHOVEN

Aerial Photography by JIM WARK

RIZZOLI
NEW YORK

Published by Rizzoli International Publications, Inc.
300 Park Avenue South
New York, NY 10010
www.rizzoliusa.com

Text and photography © 2009 John W. Gussenhoven
Aerial photography © 2009 Jim Wark
"Crisscrossing America" ® is the registered trademark of John W. Gussenhoven
www.crisscrossingamerica.org

All rights reserved. No part of this publication may be reproduced, stored
in a retrieval system, or transmitted in any form or by any means, electronic,
mechanical, photocopying, recording, or otherwise, without prior
consent of the publishers.

Design: Aldo Sampieri
Text: John W. Gussenhoven
Editor: James O. Muschett

2009 2010 2011 2012 / 10 9 8 7 6 5 4 3 2 1

Printed in China

ISBN-13: 978-0-8478-3323-8

Library of Congress Catalog Control Number: 2009922209

CONTENTS

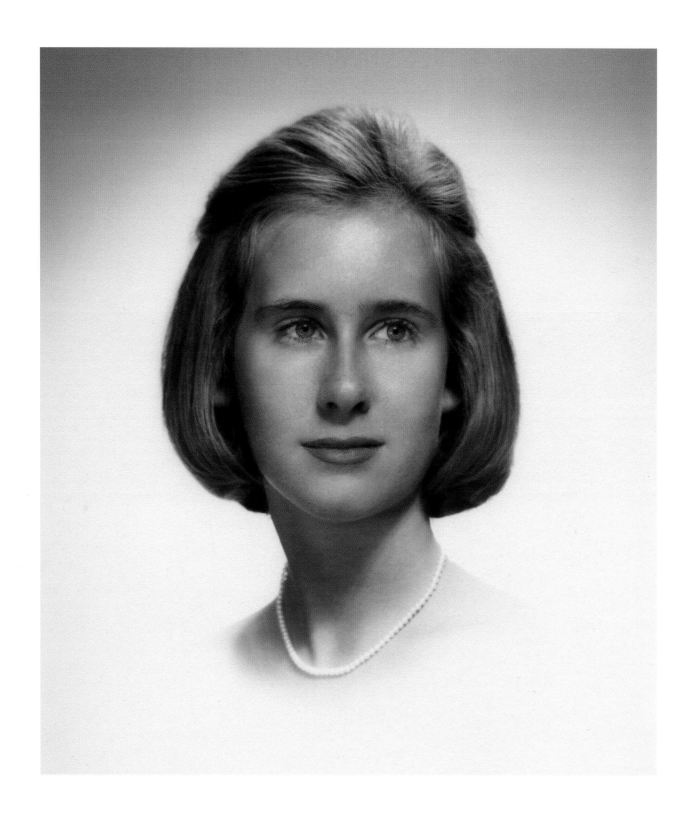

NINI GUSSENHOVEN

(1946–2006)

So to you, my dearest friend and angel,
I dedicate this book and the memories it evokes of a lifelong journey we took together.

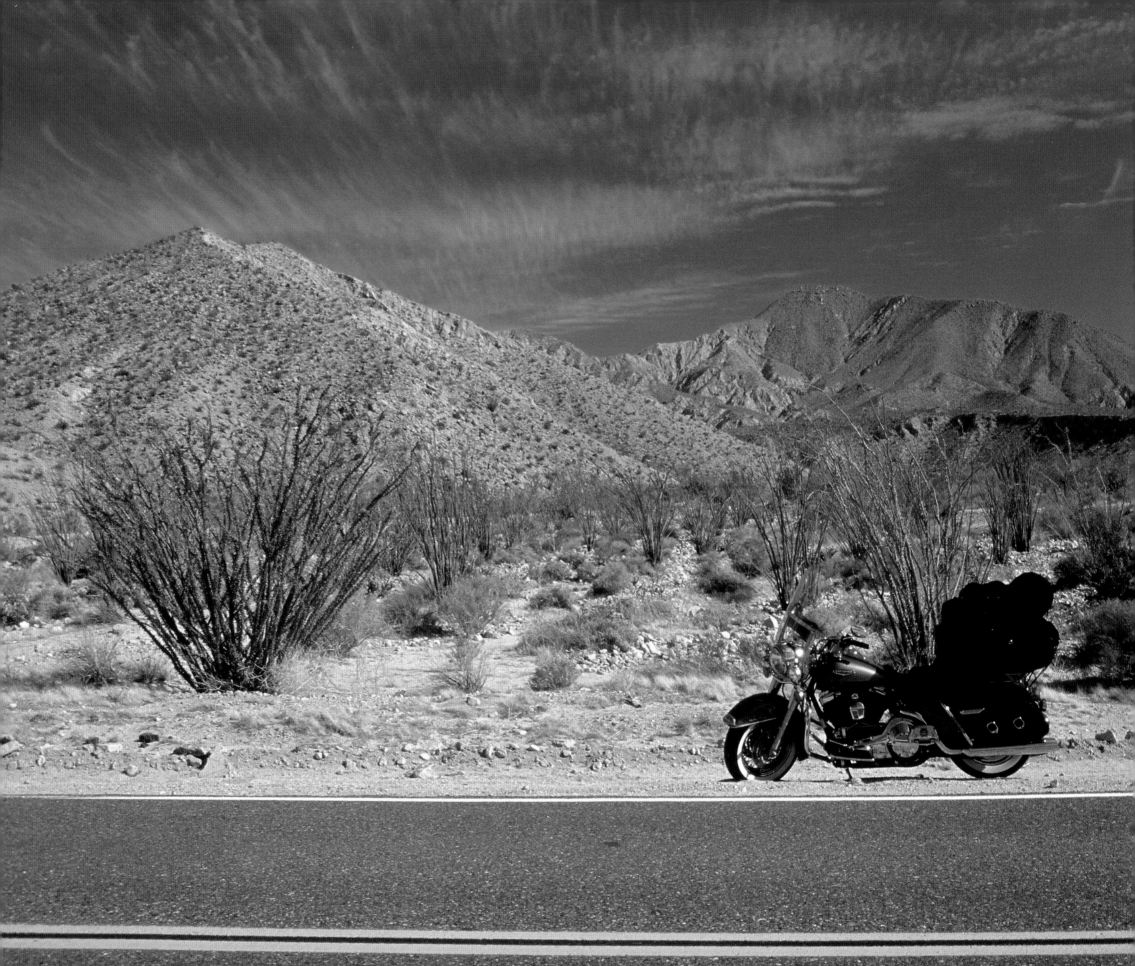

FOREWORD

Here I was facing 60, having had an invigorating, active business career, without the remotest idea of what my next step might be. I seemed to be craving new stimulations and challenges and was by no means ready to retreat from, or relinquish, the passing lane and resume the posted speed limit for my age. I wanted very much to redirect my time and seemingly boundless energy to new pursuits, some of which would require, as it turned out, the blessing of family and friends. One such pursuit led to this book project. It began with the purchase of a Harley-Davidson motorcycle on November 2, 2004.

Have you ever bought, or ridden, a Harley? I hadn't, so this would be a new experience for me, one that many people might find risky or puzzling for someone who had spent his entire corporate life dressed in a suit and tie, not in a T-shirt, leathers, and boots. But, yes, here I was buying a Harley—with the express purpose of exploring a country, the United States, which until 2005 was truly "foreign" to me. As an added benefit, I would discover along the way a much-publicized riding culture.

While I am an American citizen, as are my parents, I was born in Mexico City. Because of my father's work, I spent most of my youth living in South America. I attended schools in the United States starting at age 14 and began my business career living and working primarily in the Northeast, save for a seven-year stint in the Midwest and a few years abroad. It was not hard to see why, after all these years (almost a lifetime), I had an intense curiosity about the vast sections of America that I had never seen.

Facing my own personal crossroads back in the winter of 2004, I made the decision to travel across the United States. I created a two-legged "discover America" itinerary in which I would cross the country in west-to-east journeys that would occur in two separate two-week excursions. On the first leg of the journey (May 2005), I would travel from the Northwest to the Southeast, and on the second leg of my trip (May 2006), I would ride from the Southwest to the Northeast. Somewhere in the middle of the "X" that would be formed by these two trips, I would find myself in the

center of the country, and that's how I came upon the name for this book, *Crisscrossing America*. While it would have been more convenient, comfortable, and manageable to do the crisscross in a car, I was drawn by the urge to make the crossings by motorcycle. That, in my mind, would be the best vantage point from which to capture all that one could see from the road—unobstructed by roof posts, tinted windshields, head rests, and rearview mirrors. Because I intended to make this ride across my country an American experience on an American bike, I bought the Road King Classic instead of a foreign model.

I was looking forward to the great freedom of travel and the personal odyssey I was about to enjoy, but there was an additional motivation for this ambitious trip. Photography had always been one of my great passions and I wanted to use this opportunity to record my impressions of the country with the hope of publishing an illustrated book about the ride. I wanted to create a book with a visual perspective seldom seen in illustrated books. I decided that the best way to do that was to photograph the crisscross from both the ground and the air.

Now I needed to find a photographer who could capture the precise route of my ground crossings. As fate would have it, four years earlier I had connected with one of the world's great aerial photographers. As a type-rated pilot, I subscribe to numerous aviation magazines and one contained an article about Jim Wark, acclaimed by his peers as the best in his field. I called Jim out of the blue and asked if he had ever taken on an apprentice or student. His answer was, "No!" I asked, "Would you be willing to make me the first?" Without a pause, Jim replied, "Sure." I wanted to learn Jim's trade, not to compete, but to expand my world of photography and to use my flying experience toward a new hobby. Within days of my very presumptuous call, I was flying over Mexican Mountain in Utah in a fabric-covered plane, hanging out of the rear passenger seat at 12,000 feet, taking pictures of breathtaking western vistas. Thanks to that experience and the friendship that ensued, I had no hesitation calling Jim Wark to ask if he would take on the aerial portions of *Crisscrossing America* as an assignment. He enthusiastically agreed. Little did I know then that I had acquired an incomparable photography mentor, and now partner, whose wisdom and experience would go a long way in helping me create the work that you are now holding in your hands.

Fewer than six months from the date I had purchased the Harley and Jim Wark had signed on, I shipped the bike from my home in Naples, Florida, to Seattle, Washington, where I would fly to meet the bike and begin the first leg of the crisscross. I intentionally began each leg on May 15th so that I could capture what was left of the colorful new growth of spring and witness the rebirth and newness that this glorious season represents. It would also be the time of year when our roads and

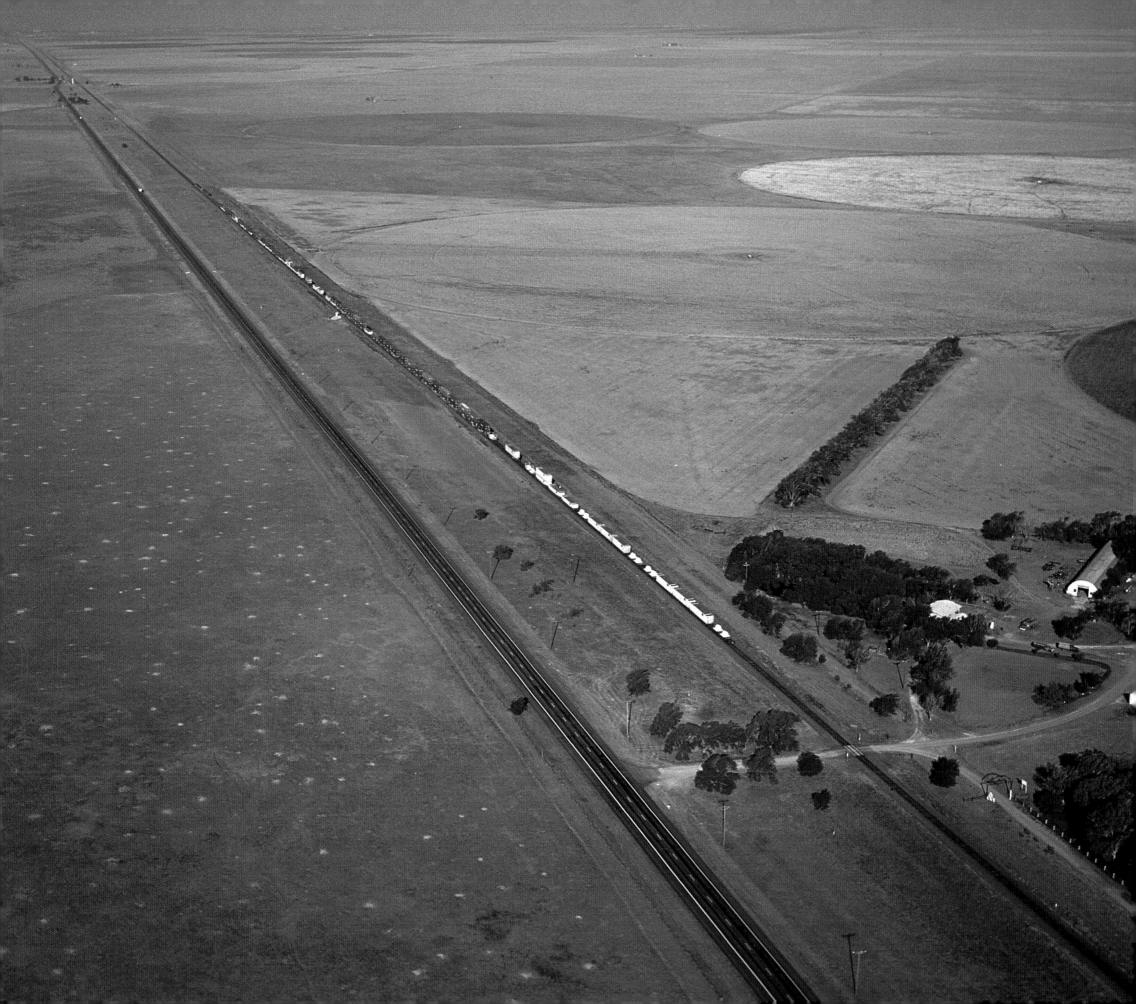

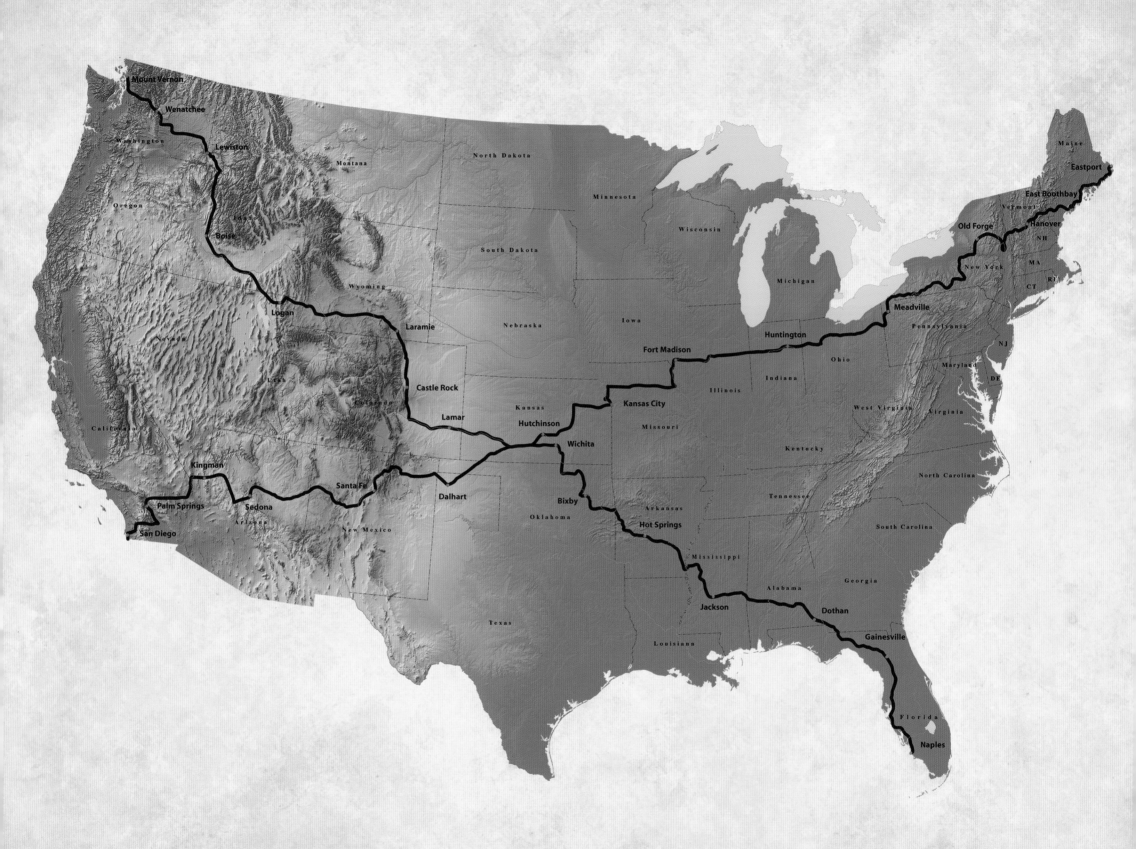

highways would be largely devoid of summer travelers. I oriented both legs of my trip from west to east so that I could keep the afternoon sun and evening sunset at my back—the times of day when fatigue would usually set in. I conceived the idea of conducting each portion of the trip over a two-week period to demonstrate that a similar trip could be undertaken by anyone who is able to carve out vacation time from work or get dispensation from family for a reasonable two-week "leave of absence."

Thanks to *Crisscrossing America*, I will now be able to revisit my America—which I was finally able to discover—just by opening the pages of this book. Though the experience was unforgettable and life altering, the book is not about me. It is about what I saw through the lens of my camera. The book's photos are representative of the 3,000-plus ground and close to 6,000 aerial photographs taken over this period. Ironically, the book is as much about what I did not see as it is about what I saw. If you could hover above the ground at 500 or 1,000 feet as you traveled across the country, you would see what Jim Wark captured from his airplane—vistas or sites that were only hundreds of yards from the main road, but that I was unable to see even from that close distance. As you make your way through the book, you'll notice that the ground shots are often complemented by aerial photographs. I achieved this by marking and recording every ground shot on a GPS device, and then logging the waypoints into a computer at the end of each day. Ultimately, Jim transposed them to aeronautical charts or entered them into a similar navigation device in Jim's airplane. My hope was that this juxtaposition of ground and aerial shots would make the book even more interesting and memorable for the reader.

Here's how I planned the trip. I placed a map on the table and drew an "X" across the country, like two traversing plumb lines that crossed in the middle, and this "crisscross" served as my guiding itinerary. This route expanded the scope of the geography and riding experience more than if I had traveled along a more horizontal route from, say, central California to Wilmington, North Carolina. I reached the "crisscross" point—Mullinville, Kansas—on May 21, 2006, on the leg headed northeast from San Diego, California, to Eastport, Maine. The Northwest-to-Southeast leg from Mount Vernon, Washington, to Naples, Florida, spanned 4,119.0 miles. The mileage from San Diego, California, to Eastport, Maine, covered 4,437.5 miles. The total mileage recorded on my Road King Classic for the two legs was 8,556.5 miles.

The aerial photography required more planning than the road trip and covered more miles. Aerial mileage for *Crisscrossing America* totaled 9,475 miles, at an average speed over the ground of 74 miles per hour. It took Jim Wark 128 hours of flying time in his Aviat Husky aircraft to capture 5,630 aerial photographs, each of which has been meticulously catalogued and archived for this project. Jim's Husky is a two-place, tandem, fabric-covered, single-engine aircraft (with no more room

inside than you'd find in a public telephone booth). Of the approximately 9,000 photographs taken, both from the ground and from the air, only 1,100 were taken with a digital camera. Most of the photographs in *Crisscrossing America* were shot with Leica cameras and lenses on Fuji Velvia professional transparency or slide film.

I crossed a total of 27 of the 49 continental states, passing through only two of them twice: Oklahoma and Kansas. I selected less-traveled federal and state highways for their photographic attributes, especially the proximity to unencumbered views of the surrounding terrain, towns, and villages. While the interstates were unavoidable (albeit safer, in my view, for motorcyclists), they offered generous opportunities for unique and memorable picture taking that differed from the images I could take on the smaller, back roads. The purpose of the trip was to travel the most direct route across America and not to deviate from the designated roads for the purpose of ancillary sightseeing excursions. I did not select in advance the precise route for each leg, but did so on a day-to-day basis, depending on weather and traffic conditions, road construction, and my personal stamina. Furthermore, I welcomed the idea of traveling on some of these lesser-traveled roads, since it would be in the spirit of my quest for discovery. For many who have wondered about the safety of such an expedition, I made the entire trip without accident, traffic violation, flat tire, spill, bruise, bump, or hangnail.

I completed the first leg of the trip on the Memorial Day weekend of 2005 and had the summer to reflect on the experience. As I read through the daily logs I had kept, I couldn't help but remember the extraordinary hospitality and generosity of the many people I had met on the road. Each encounter had its own story, but the common theme that linked them all was that of genuine kindness and courtesy. You might think of these complete strangers as Good Samaritans, especially since what struck me most about their memorable contributions to my trip (delicious, home-cooked meals; assistance with my Harley; evenings spent in local bistros and bars hearing about families and local folklore) was that most, but not all, of these generous people seemed to be just getting by, yet gave freely of what they had. All of them, however, were rich in character and spirit. Collectively, they helped me realize that this kind of goodwill and kindness is the essence of America's greatness.

In large part, thanks to these good people, I began to understand that this book could have a greater purpose than being merely a vehicle to share my passion for photography or to celebrate the talent and brilliance of other people, such as Jim Wark. I came to see that *Crisscrossing America* could acknowledge, if even in a modest way, people who quietly touch the lives of others without seeking anything in return. So in April of 2006, I funded a trust from which money or gifts could be directed to those who were in need, or who deserved some form of recognition or a lift. I was thinking less about the

money than about the joy that I, or a surrogate, could express in a personal note that would accompany a gift to these individuals. I have already dispensed gifts directly and through others from the trust, and intend to direct all the proceeds from the sale of *Crisscrossing America* into this fund as a way of helping to nourish it beyond my lifetime.

While it is difficult to adequately acknowledge everyone who has contributed to this publication, some individuals stand out for their early inspiration, guidance, and support. One such person, who has since died, is my beloved twin sister, Nini Gussenhoven, who passed away unexpectedly in October 2006. While Nini never saw the photographs in this book, she lived the journey with me vicariously from her New York City apartment through telephone conversations and e-mails during both legs of my trip. I had planned to surprise Nini with the first proofs of the book on our 60th birthday, but she left us just a month before this milestone celebration. While I have had a few willing riders on the back of my motorcycle, none was more enthusiastic than Nini on her first and only Harley experience. I will cherish that one ride with her forever. This book is dedicated to Nini and completes a promise I made to her at her graveside.

I share my experiences with each of you, as my new friends whom I have not yet met. Some of you may be curious about details of the locations photographed in this book, so in each photo's caption I am providing you with the GPS waypoint of that site. These numbers will enable you to go onto Google Earth and find all of these towns, villages, roads, streams, and railroad tracks that crisscross America in such an intricate, unique fashion.

The book is divided into two sections that chronicle the two legs of my journey: my excerpted journal entries from 2005 are followed by photographs from that portion of my trip, and those from 2006 are similarly followed by the images I shot during that time. As you progress through the journals, you will catch a glimpse of my daily routine, but more important, the highlights of the many visual and visceral experiences I was fortunate enough to have experienced along the way. I photographed images without people in them so that you could become the observer that I was and so that you could see America through your own eyes.

Please enjoy this book, since it celebrates you and your hometown as much as the ones profiled in these pages. I invite you to visit our website www.crisscrossingamerica.org where you will see photographs and journal entries in their entirety that are not included in the book. We would love for you to contact us with your own journeys of discovery.

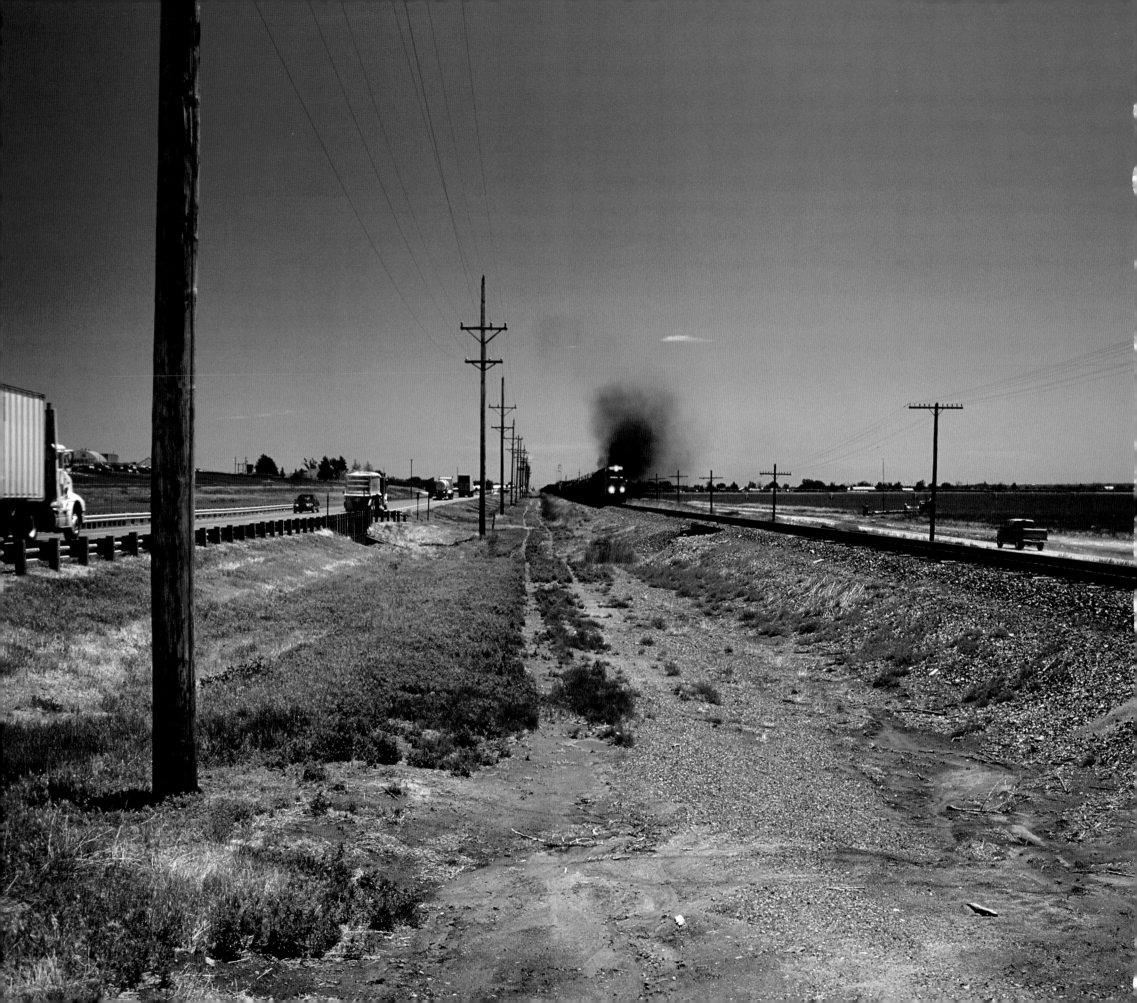

NORTHWEST *to* SOUTHEAST *journal*

May 15 to May 30, 2005

May 15, 2005

Tukwila, Washington

Was I crazy? Or was I on the verge of doing something that we should all try at least once in our lifetime? I was about to turn out the lights at the Double Tree Hotel across the street from Seattle International Airport. I had arrived on a quiet Sunday afternoon the day before I was to pick up my motorcycle at Downtown Harley-Davidson and begin my journey across the country from the northwest corner of Washington State to southern Florida.

Just hours before, I had been at the controls of a plane flying at an altitude of 41,000 feet toward Seattle, fighting a pesky crosswind yet making 300 knots (345 mph) across the ground. Due to cloud cover I was unable to catch a glimpse of what I envisioned to be a colorful, rich-green landscape that I planned to cover the following day, the first day of my journey. I couldn't help but feel secure in this aluminum cocoon, in a controlled, quiet, heated, dry, cockpit environment. To think that I had actually *chosen* to shed this familiar mode of transportation in exchange for climbing onto the saddle of an 800-pound, two-wheeled machine with nothing but a plastic windshield and leathers to protect me seemed ludicrous. To do so on a 4,000-plus-mile trip across America on a motorcycle for an uninitiated, inexperienced cross-country rider (which I was!) may seem asinine—or worse—to many people. I felt anxious, seated at the controls of the plane, knowing that I would have no choice but to begin this quest of discovery in fewer than 18 hours. Given the NW-to-SE direction of the crossing, with favorable winds at altitude, the plane could accomplish this feat in a day. I planned to do it on the motorcycle in two weeks, through unfamiliar territory, alone and in the hands (I would pray) of a higher authority.

For now, I was humbled and very much aware of how privileged I was to be able to embark on this first leg of *Crisscrossing America*. Fortunately, I had a comfortable bed in my hotel, since I was already exhausted and eager to begin my trip. I knew that in the morning I would want to escape the city's environs (congestion and traffic), jump on my Harley, and go. It was time to turn out the lights and imagine this great challenge as being less foreboding than it seemed at the moment. In my mind, I started to count backward from 4,000 miles—3,999…3,998…3,997…*zzzzz.*

May 16, 2005—Daily Mileage: 80.1

Tukwila, Washington, to Mt. Vernon, Washington

I woke up early, knowing that the daunting, seemingly reckless trip I'd been fantasizing about for so long was now upon me—and that there was no turning back, despite my pangs of uncertainty. The unknown was summoning me and today was my day of reckoning.

By 8:00 a.m., I arrived at the Downtown Harley-Davidson, in Tukwila, Washington—a suburb of Seattle. An amiable fellow named Steve greeted me and listened with interest as I told him about my impending trip across the country. He was quick to make suggestions about possible routes to take, which helped me get into the spirit of actually jumping on the bike and taking off. Alas, the shipping company had not yet delivered my Harley from Florida (it was supposed to have arrived three days earlier), but the delivery was scheduled for later in the afternoon. This delay was a slight setback for me, since I had wanted things to go smoothly from the beginning. But I figured it was a minor blessing in disguise, since it gave me a chance to orient myself and to take a small first step. Instead of plunging instantly into the 200-mile stretch that I had planned to do that day, I'd at least be somewhere north of Seattle and could start the trip in earnest the next morning.

When the bike arrived at 3:00 p.m., Steve checked it out and test-drove it. My long-time friend and co-pilot Garrett Snow helped clean and fuel the bike while I changed into my leathers and repacked bags. Then I jumped on the bike, bid farewell to all, and vroomed off into the distance—only to return immediately when I saw that the gear pedal needed to be adjusted. But I was back on the road by 4:00 p.m. and headed up Interstate 5, a major north-south artery that extends more than a thousand miles from the Canadian to the Mexican border. It was raining and I was in rush-hour traffic—two of the most undesirable features of my trip that I figured I might as well face head-on before being granted the luxury of sunshine, open roads, and pleasant sailing.

I couldn't wait to begin taking photographs and started doing so as I left downtown Seattle, stopping whenever I wanted to take a picture. I caught my first view of the valley and mountains on the north side of Everett, Washington. I pulled off the road in Mt. Vernon, Washington, gassed up, looked for lodging, and settled in at the Tulip Inn. As I tried to do each day during my trip, I dined at a local restaurant (this evening, the Cranberry Tree) and checked in with my family back home. Though I had intended to travel at least 200 miles today, my bike delays slowed me down and I achieved only 80 miles. But at least I was now in the saddle and had overcome my initial nerves about starting.

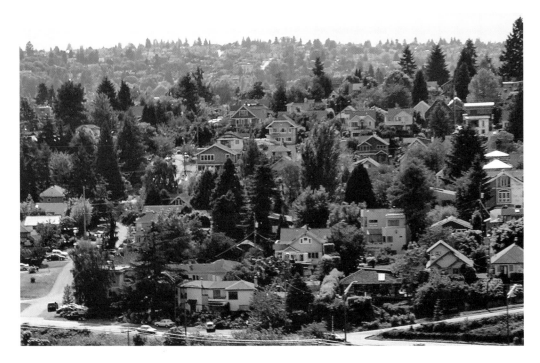

One of the nice things about settling into a comfortable hotel room at night was looking back on what I'd done during the day. While thinking about my impressions of Seattle, which I had never visited before, I found it to be a city nestled in bays, much like San Francisco-Oakland, but on a smaller, more intimate level. The houses appeared to sprout from the hillsides, thereby offering their inhabitants glorious views of the water and of the rising and setting sun. As with most cities at rush hour, commuters fanned out in navigable directions, but they seemed to be less in a hurry than in the congested cities of the Northeast—and they were polite toward other drivers. In the Seattle area the primary direction is north to south, and on the route I took, commuting traffic extended all the way to Everett.

The air in the lush countryside north of Everett was clean and free of industrial pollution. I noticed features like these especially when it rained, since riding heightened my senses. Had the weather been more cooperative, I would have taken pictures of this refreshing landscape. I saw few bikers on the road, and most of the ones I did see sported rain gear, a necessary evil to ward off the moisture and the chill. I once asked about the frequent rain and seemingly year-round gray sky, and was told, "If the sun decides to come out and it happens on a weekend, we go outside and have a picnic."

I remembered that it was just hours ago that I had arrived at the hotel hungry, cold, and uncertain about what lay ahead. Sure, I had curiosity, but it was a kind of intrepidness. All of this made me want to get a good night's sleep so that I could head out in the morning, well rested and eager to discover my new companions: strangers and nature.

May 17, 2005—Daily Mileage: 168.5 (Total Miles to Date: 248.6)
Mt. Vernon, Washington, to Wenatchee, Washington
I was up for breakfast by 8:00 a.m. and devoted a little more time and thought to packing my bike prior to departing. The day before, I had felt rushed. Today I wanted the discipline of performing this important task properly. I developed the habit of planning my day's trip either the morning of the trip or the night before. That gave me more spontaneity than if I had planned every detail of the two-week trip in advance. It also freed me from the pressure of having to meet certain mileage or itinerary goals if something came up during the day to change my plans.

Today I decided to take a less scenic route than Route 20, recommended by Steve at the Harley dealership in Tukwila. The mountainous, winding roads of Steve's route (versus the more direct Route 2) would have prolonged the day, not to mention adding a risk of snow and sleet. I reasoned that the weather on northern Route 20 looked threatening: it was raining there and at high altitudes the temperatures would be lower. By the time I reached the mountain pass on Route 20, the rain could have turned to snow—a treacherous condition for a car, much less a motorcycle. Since I was only on the second day of my trip, I was still wary enough to hear the little voice inside whispering.

Having made the decision to take the safer route and to head south on I-5 in order to meet up with Route 2, I was delighted to notice, on reaching the foot of the Cascades, that I had arrived in the small town of Startup. The town's name was such a coincidence, since it gave me the feeling that permission had been granted for me to continue. In my mind, Startup became the symbolic "start up" of my journey. In a way, this relieved some of the anxiety I was feeling about making all the correct decisions—about the heft of my bike, about the times and places where I should stop and start again, and so on. The sign prompted me to wonder if there was indeed divine intervention. I mean, what are the odds of arriving in a town called Startup so soon after you've just started up?

During my many years in the corporate world, I enjoyed the benefit of working with trusted advisers and a team of seasoned colleagues. But now I faced the unknown road alone, with no corporate infrastructure beneath me, no safety net, and no set of rules or patterns to follow. But one thing I did have was *myself*—and I realized, upon my arrival in Startup, that I could now set my own rules, determine my own routine, and make choices whenever necessary. The feelings of alienation or isolation that I may have been experiencing early on during this ride were the very reasons I had wanted to continue the trip, so it was time to discover what lay ahead and remain open to new challenges. Startup was my first photograph after leaving the Seattle area.

The landscape on the west side of the Cascades is dominated by rich farmlands. The view was breathtaking as the road gradually left the valley floor in its wake and wound up the side of the mountain. When I arrived at an elevation of 4,000 feet, my ears popped but I noticed no change in my breathing. Naturally the temperature was cooler and there were plenty of clouds, fog, and wet roads. The traffic was mostly commercial, not tourist. Railroad tracks parallel the roads and occasionally I could see a freight train jutting its red nose (white beacon) as it rounded a curve. Sadly, I never had enough warning to photograph the moving train as it arrived suddenly out of nowhere. Since I was still so new to my motorcycle, I didn't want to risk trying to capture images while steering the bike. Moreover, I was distracted by so many natural backdrops—streams, mountains, farms, towns, etc.—that I decided for the moment, at least, just to enjoy the charm of being in the midst of this important segment of our country's transportation and distribution network.

Stevens Pass, at 4,061 feet high, was a non-event at the base of a ski slope. But the east side of the pass was scenic, especially when a river joined the road. There I was able to capture an old bridge on film, with its weathered, rusted beams and wooden footpath. Shortly after this, as I approached Wenatchee, Washington, signs of civilization reappeared. It is a sizeable farming community, yet its city center and identity are lost to sprawling malls, familiar franchises, and single-story commercial structures.

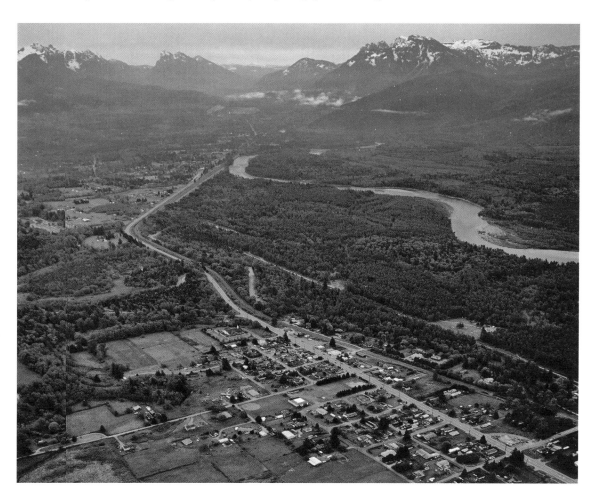

It had been a long day and I was tired, so I checked into the Red Lion Hotel, unpacked, took a shower and changed clothes, checked in with my family, then had dinner at Visconti's Italian Restaurant. I did laundry and prepared supplies for the trip—water, snacks, etc. I washed my bike and fueled it up for the next day, then sat down in my hotel room to record the waypoints from my *Garmin eTrex* handheld GPS device to a portable laptop. I wanted to record GPS waypoints for every image I took, not only so that I knew the exact location of each photograph, but also so that I could give that information to Jim Wark, who would then photograph the same locations from the plane.

Two hours later, I went to bed, too tired even to watch HBO or clean my cameras, load new film, and do other chores to prepare for tomorrow's trip.

May 18, 2005—Daily Mileage: 253.5 (Total Miles to Date: 502.1)
Wenatchee, Washington, to Lewiston, Idaho
I developed a routine that I went through each morning at breakfast whereby I took a napkin and jotted down the day's itinerary on it, using a small Michelin atlas for assistance. Prior to beginning this first leg of my journey, I had drawn a plumb line from Mt. Vernon, Washington, to my ultimate destination in Florida and each day I tried to plan my day's excursion as close to that line as possible, depending on road conditions, the weather, and my energy level. I used the napkin during the day as an easy reminder of the various road connections I needed to make, and it was a good way for me to make notes when I visited places of interest. Since one of my main goals was to take photographs, these shorthand notes helped me save time so that I could focus on the photography.

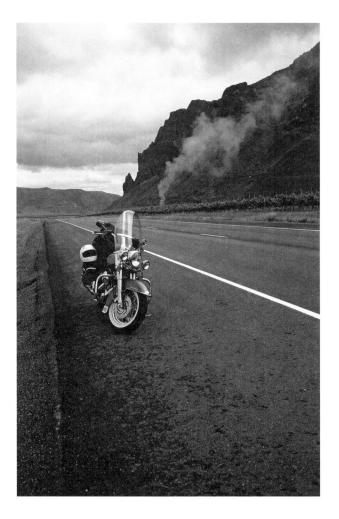

You may be interested to know what was involved each time I decided to photograph something. In most cases, I caught a glimpse out of the corner of my eye of a vista or subject, and by the time I'd seen it, I had to make a U-turn and retrace my path, then turn again to pull off the side of the road. I always hoped there'd be a safe, secure shoulder where I could park my bike. Then I'd shed my helmet and gloves, unpack my travel bag, pull out the camera, insert the lens, turn on the GPS, and take photos. After doing this, I needed to repeat all the steps in reverse, then start the bike and head back onto the road. I went through this process each time I decided to shoot an image. With a film camera, the process was more daunting than I had anticipated, though I'd already settled into a kind of rhythm that seemed to be working for me. And thanks to the few minutes spent each morning at breakfast planning my day's trip, I never lost my way.

The day's destination was Lewiston, Idaho, and during my eastward ride the skies above were overcast and threatening. I could see rain showers in the distance. The prevailing west-to-east weather kept the cold front on my nose, and even though the rain constantly moved away from me, I was still confronted with its aftermath: wet roads and an annoying film of moisture on my wind screen. I had a visceral desire to scream out to myself, "Do I really want to be doing this?"

The topography east of Wenatchee was unchanged from the descent the day before. It was still hilly, with a valley covered by groves all the way up to the highway's edge. I tried to photograph a scrub fire from the side of the road, and while trying to do this I noticed a man pulling up to inquire if I was all right. This was the first act of kindness that I'd felt thus far on my trip, but something told me I'd encounter many more such deeds. I told him that all was well and thanked him for his consideration. His thoughtfulness caught me off-guard. Maybe I had forgotten how considerate people could be. Oddly, I wasn't startled when I first saw him approach me, but I was somewhat suspicious of him until I heard the genuine concern in his voice. I was, after all, on a solitary journey, where there was no one to cover my back, so it was prudent to be aware of the people and events around me.

A few minutes after this scene, I set out again and climbed approximately 1,000 feet, where I reached the plateau east of Wenatchee known as the Columbia Basin. It extends eastward throughout most of the State of Washington. This area reminded me of northern Italy, where rows of cypress trees protect the groves from wind and cold.

Uncanny as it may seem, a couple of hours later I happened upon a peculiarly strange field, a so-called "crop circle," framed by meticulously planted stands of trees laid out in the shape of triangles. I wondered what was going on here and knew that Jim Wark could shed light on this mystery with his aerial photographs. Despite the massive appearance of these stands of trees, the individual trunks looked oddly fragile, like matchsticks. Perhaps their purpose was to protect the field within their parameters from the winter winds. Or maybe this was an efficient new use of land for a tree farm. But why this one field only? I saw no others like it as I progressed eastward.

Moving along from this almost surreal landscape, I couldn't help but admire the vistas along the Columbia Basin, where for miles and miles, in all directions, I could see fields of green winter wheat. I stood mesmerized by this view for what seemed like an hour, then realized that if I didn't get moving, I'd never reach Lewiston, Idaho, before dark. But I was curious: How does one cultivate such an irregular, yet soothing-to-the-eye-and-soul expanse of land? It was odd that there were no visible signs of people or machinery anywhere along this seven-hour leg. It would take thousands of manpower hours and as many hands to prepare the earth for this kind of cultivation and ultimate harvest—the magnitude of which seems impossible for us humans. This is one instance where one would have a hard time denying God's work. The word *breadbasket* means more to me now that I've witnessed the scale of this agrarian endeavor. And this is only one of many farming regions in this country. I wondered who owned this land.

I called it a day around 6:00 p.m. after a tiring ride in high winds and light rain, with only few exceptional opportunities for photos. A Comfort Inn beckoned me, high on a hill away from the major thoroughfare. Unfortunately, there was no elevator and my room was on the second floor, so it took four trips in order to unload my bike. I had fanny fatigue, so I chose a restaurant called the Pine Mandarin within walking distance of the hotel. The warm, bland food was at least a square meal and the Chinese beer was therapeutic.

May 19, 2005—Daily Mileage: 300.9 (Total Miles to Date: 803)
Lewiston, Idaho, to Boise, Idaho

I got up at 7:30 a.m. for a light breakfast and was greeted at the front desk by a man who had stopped to chat the night before as I was unpacking. He was a biker as well and after talking with him, ! was hopeful that this was the type of casual friendliness I would meet along my journey—intriguing people with insights and potential tidbits that I'd never find in my Michelin atlas. If I had asked him to, he probably would have helped me clean the chrome of my bike—the feature that most riding enthusiasts try to keep sparkling clean, almost to the point of obsession. Bikers use the expression "keep the shiny side up," to mean "don't fall." This man was genial and inquisitive—traits I often found in other biker fans. It's not unusual to pull up on a fully laden Harley and have other bikers ask questions like, "Where are you headed?" or "How many miles did you cover today?" Whenever I explained the nature of my trip, the inevitable response was, "Are you kidding? You're going across the whole country?" This was my first taste of the Harley culture.

It was a cool day with puffy clouds in the sky when I finally took off around 9:30 a.m. I now realized that I would need to hit the road earlier in order to complete my itinerary in two weeks. For this northern hemisphere segment of the journey, I'd packed heavy leathers, waterproof gloves and boots, and a rain suit. As the temperature rose and fell this particular day, I had to make numerous stops in order to change in and out of all this gear. I hadn't realized that riding a motorcycle is a classic example of multitasking: While I was watching the sky for bad weather, I was at the same time sensing a change in both the winds and the temperature. And I knew that, in a moment's notice, I might quickly need to find a safe spot to pull over, not only to protect myself from the weather, but also to continue changing another layer of clothing. Try doing all this *and* taking pictures at the same time. It was a good thing I didn't take up any of my friends' kind offers to accompany me on what turned out to be a veritable boot camp. For reasons such as the above—and many more—this truly needed to be a solitary endeavor.

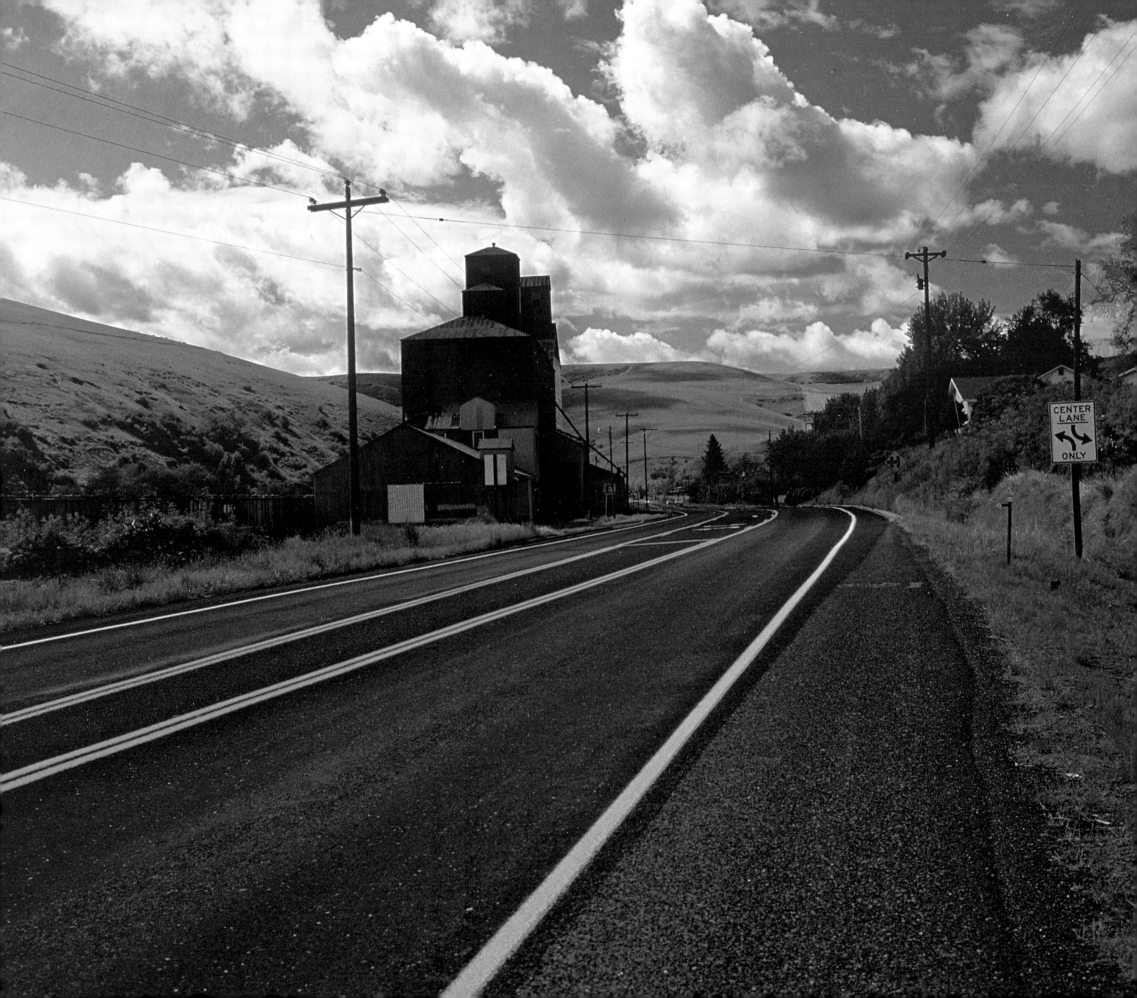

I headed toward Boise on Highway 95/55 South, a narrow road dotted with farms and communities very close to the highway. I realized how much more intimate a bike trip could feel than a trip made in a car or by train. I had chosen Boise, since it was a natural linkage between the back roads and the urban hubs. Maybe this was the reason I saw so little human traffic except for the usual UPS truck making its morning deliveries. It was the first major city on my trip, and I felt my pulse start to race at the idea of navigating this 800-pound monster through full-blown traffic.

There was annoying construction in the towns of Culdesac and Winchester, Idaho, not far from my departure point in Lewiston. Winter must really take its toll on these roads, since most of them were being resurfaced. The roads' narrowness made it risky to take pictures of the mesmerizing streams that flow alongside the highway. I would have missed a train trestle had I not casually glanced over my left shoulder on the long, wide turn south of Culdesac. This thrilling vista of a railroad trestle built into the side of a steep mountain would, I was sure, look magnificent from the air. The pilot within me yearned to experience these stirring sites from above, but I knew that Jim Wark would cover them. For the moment, I was an earthbound biker and happily returned to my two-wheeled journey.

Few people are lucky enough to witness the flowing water that ascends and descends the mountains, foothills, and valleys of our country. Rivers flow north on the climb and south on the descent. In every case, roads snake treacherously through the canyons and, because of the high cliffs, these sinewy roads sit dangerously high above the water below. One false move and I would have been zooming off the edge of the road, airborne into a cold, swift stream.

After taking in a breathtaking view of a yellow rapeseed field, I suddenly found myself famished, so I pulled into a neat little Subway restaurant—one of many Subways where I would eat during my trip—in the whistle-stop village of Grangeville, Idaho. As I jumped on my bike after lunch, I could see that farming dominates the region. The landscape was dotted with farms and fields of wheat and vegetables, the rapeseed fields being the most striking in color. Most towns I saw that day were small, with gas stations and general stores as the hubs of activity. My trip down the Salmon River and the Little Salmon Forest valley was thrilling. It is almost impossible for bikers to stop for pictures or even to rest, because of the narrow width of the roads and the shifting gravel that covers the shoulders. However, there are state-posted signs that designate safe places to enjoy scenic views. This highly hazardous portion of the trip heightened my senses and forced me to focus intently on the challenges of the road. There were runaway truck ramps everywhere, which only underscored the need to pay attention.

Even though the day had started cool, it warmed up on my approach to Boise, where the transition from country to city was not nearly as intimidating or daunting as I had anticipated it might be. The mountains to the north of the city were bathed in the soft light of the setting sun. I saw how fortunate the people who live here are to be nestled in the midst of these near-mystical mountains.

I seemed to be falling into the comforting routine of stopping by the local Harley shop and today was no exception. The people were wonderfully courteous and curious about my trip. Even though I arrived after store hours, the staff welcomed me. I was eager to take with me memories of my experience, so I picked up some bike accessories and a T-shirt—and in fact, I decided I was going to hunt down as many Harley shops as I could throughout my trip, and maybe even build my own little collection of Harley shop T-shirts. The people in the shop felt like a home away from home, and when you are away from loved ones and dear friends it's amazing how total strangers can almost instinctively become your family. These folks were truly Good Samaritans, and I felt I would meet more just like them. A few hours earlier I rode through the small town of Riggins, Idaho, and laughed when I saw a sign hanging outside a bar that boasted, "Harley Spoken Here."

Just my luck—in Boise the high school track regionals had tied up all the hotels. The only available room in town was the most whimsical of the "theme" rooms at the Anniversary Inn. My room was the Carriage Suite but the inn also had a Romeo & Juliet Suite, a Treasure Island Suite, and many more. I showered quickly and checked in with my sister Nini, who was living every hour of this journey with me from her apartment in New York. She had asked me so many questions about my trip, and I dutifully responded to each with joy. She wished me, "Buena Suerte."

Before heading out for a quick Italian dinner across the street, I put the dust cover on my bike, since the nasty weather had left it a grimy mess. Ordinarily I would clean and polish it, as *all* die-hard Harley owners would do before tucking in for the night. But happily my Harley compatriots would forgive this one indiscretion, knowing that I would wash and care for it in the morning.

May 20, 2005—Daily Mileage: 310.3 (Total Miles to Date: 1,113.3)
Boise, Idaho, to Logan, Utah
I was up at 7:00 a.m., yawning and stiff from the ride the day before. I had breakfast at Elmer's, a neat little family diner that was more comforting than a five-star restaurant. While having breakfast, I scribbled down the day's plan on a paper napkin. After breakfast, armed with this tattered itinerary, I "detailed" my bike (Harley-speak for thoroughly "cleaning and polishing") at a local dollar car wash.

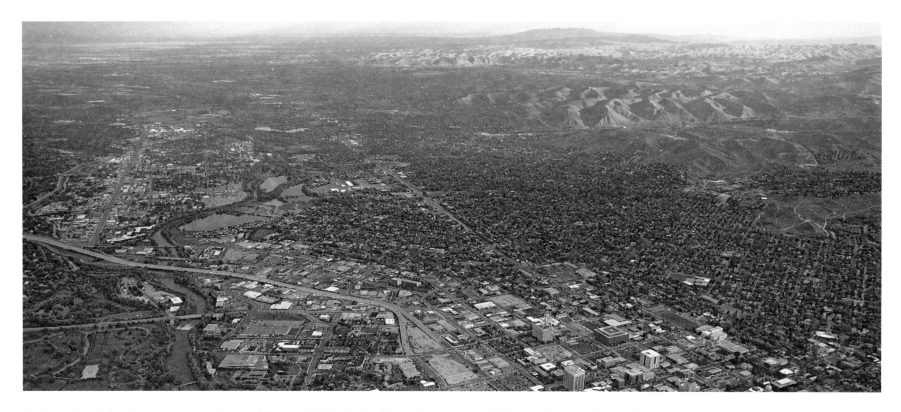

Having a clean Harley brings you one step closer to following H.O.G. (Harley Owners Group) protocol. After checking out of my grandiose Carriage Suite, I packed up my bike and thought I'd hit the road after some lunch in order to make up for time lost from having washed the bike. It was nearly noon as I returned to Elmer's and devoured a BLT and a vanilla shake. As I left the diner, I glanced at the headlines of a newspaper left by the register; it offered little good news about the world.

Off I went onto 84 East, then headed south on Highway 93 for a short visit to Twin Falls, Idaho, and the Harley dealer, Snake Harley-Davidson, named for the seemingly endless Snake River that flows from Yellowstone Park north of Jackson, Wyoming, all the way across Idaho and up to Washington State near Walla Walla, Washington. As I headed south to Logan, Utah, I felt the first signs of true freedom and progress since having set out on my quest four days earlier. It bothered me that I had left so late in the day and from then on I planned to get up at 6:30 a.m. and be on my bike as soon as I could, fully fueled and ready to roll. Already I had learned that filling my gas tank was as important as filling my stomach.

Most of southern Idaho along Interstate 84 is on an elevated plain. As I had expected, the area was largely farmland. Roads, even the interstates, were patchy and bumpy. I missed several photo opportunities from the edge of the road, not because of hazardous shoulders or narrow roads but because I neglected to stop and turn around—a decision I now regret. All photographers will understand these missed opportunities. As a city boy, I was amazed that there were almost no signs of human activity. I'm not sure how these vast fields get watered. Most are on a rolling sprinkler system that I had never seen before. I failed to understand how these caterpillar-like contraptions work, connected as they are to some kind of water source.

As the day progressed, it became warmer and more springlike. The rays of the late afternoon highlighted many features of the landscape, magnifying the green vein of young aspen trees against the barren mountainsides heading into Utah. The Twin Falls Gorge and the bridge over the Snake River were thrilling, even if their proximity to the town detracted from the beauty of their natural surroundings. For some reason I had thought Utah would be more barren, so it was a happy surprise to see such a rich landscape. The sky, clouds, rain showers, and rainbow along the western mountains made for a hypnotic kaleidoscope of colors. The views were so compelling that I stopped more than once to shoot them.

The one element that I became quickly aware of is that, at dusk, the roads and air are plagued with bugs, most of which inevitably meet their fate on the Harley. Trust me, you do not want a bumble bee inadvertently flying up inside your helmet while you are cruising at 60 mph. Aside from the safety reasons for wearing a full-face helmet with a visor, I wore it to prevent this very kind of unpleasant and avoidable setback with insects. Nevertheless, my ride into Logan with all the spires and snow-capped mountains lit up by the setting sun was magical, bugs and all. I checked into a Best Western, dined at the Copper Mill restaurant, and went to bed.

May 21, 2005—Daily Mileage: 408 (Total Miles to Date: 1,521.3)
Logan, Utah, to Laramie, Wyoming
After an early breakfast at Angie's, the local hot spot, I took a nice, long walk. At 10:00 a.m. I began my trek east toward Laramie, Wyoming, but not before swinging by the Logan Harley dealer, where I purchased my obligatory T-shirt. Then I headed up Highway 89 to Beaver Lake, which ultimately led me across the Continental Divide at 6,930 feet. This route was similar to most mountain traverses, with rushing streams paralleling twisting roads. The temperature dropped as I climbed toward the Beaver Lake lookout, where snow covered the ground in spots.

The scenery around Beaver Lake was almost surreally spectacular. I happened to notice that the shoreline had receded 200 to 300 feet from past years. East of the lake the land was arid and covered with tumbleweeds and I could see what looked like the Tetons far to the north. Southern Wyoming had less farmland along the highways than Washington and Idaho, probably because the soil and climate are not as conducive to agriculture. Evidence of this harsh environment showed on signs posted at frequent intervals along the highway which, when flashing, warned winter riders to turn back. Apparently, highways in this area often close due to snowdrifts. Numerous snow fences were visible along the roads for miles, presumably to keep the snow off the highways. I was puzzled to see that in even the most barren spots, the land was fenced along the roads for the entire length of the highway. Could this be to keep the cattle in and/or the trespassers out? In a moment of nostalgia, I caught a glance of the proverbial deer and the antelope playing as I approached Laramie.

The railroad tracks paralleled the highway and this was the first time I noticed so much east-west railroad traffic (tankers, box cars, containers, etc.)—to the point where I actually became distracted by train encounters on most turns, overpasses, and straightaways. The trains' lengths and speeds were impressive. For a Saturday, there were more trucks on the road than I had encountered in the previous days. The drivers courteously gave me a wide berth, especially when I pulled onto the emergency apron to take pictures. One highway patrolman stopped behind me on an overpass while I was taking a picture of a passing train simply to protect me from traffic. He escorted me until I was safely back on the highway.

The high, warm winds from the west made the trip more comfortable. I now understood the biker expression, "May the wind be at your back!" In an effort to make it to Laramie before sundown, I stretched the tank of gas. Fortunately, Harley gauges are accurate and I made it to Laramie with the needle flickering on low reserve. From the road, Laramie is undistinguished, which is probably why I almost passed it.

As I checked into my good ole Comfort Inn, I met a group of riders—Tree Rountree, Gil Gilbert, and Bennie Kirtman—from the Sacramento Iron Souls Motorcycle Club who were en route to the Rolling Thunder Motorcycle Rally in Washington, D.C. Here I was, bushed from having ridden more than 400 miles today, only to learn that these guys averaged 600–700 miles per day on their two-week trip. Tree, the pack's leader, noticed that I was about to go to my room with a valet cart filled with gear and asked if I'd like to join them for dinner. I was thrilled to accept his offer. Off we went to the closest restaurant, Winger's, a few hundred feet up the hill from the inn. Soon after our first beer, we fell into a wonderfully animated discussion about our respective pasts and Harley experiences, in particular those moments when, as African Americans, they had experienced inexcusable discrimination. Thanks to our "Harley" common denominator and the good spirit and soul of these riders, our impromptu gathering was one of the highlights of my trip thus far. After dinner we bid farewell with the embrace of newly found friends.

May 22, 2005—Daily Mileage: 194.2 (Total Miles to Date: 1,715.5)
Laramie, Wyoming, to Castle Rock, Colorado
The Harley-Davidson in Laramie had not yet opened for business as I headed down Highway 287 to Denver early in the morning. It was a warm, sunny day as I set out through the hills south of Laramie. While they are not dramatic, the hills are pastoral until you reach higher altitudes. I noticed a peculiar wooden structure that I quickly identified as a snow fence. I could see patches of snow on the higher altitudes, but no doubt they would melt during this warm May weather. I ate lunch in Fort Collins at the Always Open Café. I was intrigued by a grandfather who was treating his teenage grandson to lunch. The young man, sporting a shaved head, was polite, but clearly from a different generation than his grandfather who wore overalls. Although they appeared to be two very different people, I was glad to see the bond they shared.

After lunch, I approached Denver on a six-lane highway where traffic was moving at 80 mph. The mountain vistas were phenomenal. After Seattle and Boise this was the first real metropolis that I had encountered and I was already at the midpoint of my trip. I had become spoiled by the more rural settings and less-congested, more accessible communities, which by now had become my preference. I looked forward to getting back to smaller towns and back roads. Just a mile north of downtown Denver, I felt the bike slow down, despite having not moved the throttle. Not knowing how to interpret this symptom, I eased over to the slower traffic lane and limped to my destination, Castle Rock, Colorado, where I spent the evening with a good friend, Don Holmes, and his son, Kyle.

May 23, 2005—Daily Mileage: 227.6 (Total Miles to Date: 1,943.1)
Castle Rock, Colorado, to Lamar, Colorado
I got up and headed south, slowly, from Castle Rock toward Pueblo on I-25. I was impressed by the mountain ranges to the west of the interstate. Along the way, I passed the highly congested Colorado Springs area, where every square inch of land south of the Air Force Academy is crammed with commercial and residential properties. I reached Pueblo at noon and met with Jim Wark at his home there. Knowing that one of my bike's cylinders had protested, I asked him to direct me to a repair shop. We went there together and they helped me replace a faulty spark plug. After grabbing a quick lunch, we enthusiastically compared notes on the journey to date. Jim was as interested in the ground trip as I would be in his subsequent air trip. With renewed spirit and a full stomach, I headed east on Highway 50 toward Lamar, Colorado, my final stop for this day.

All along the highway small towns popped up every 20 to 30 miles and I was intrigued that the roads between each of them parallel the rail and power lines. I pulled off at Fowler, one of the whistle-stop towns that formed part of a string of small communities where each town developed as a kind of "service center" for the surrounding farmers and ranchers. All of them contained a bank, flower shop, police station, old-time movie theater, and so forth. An old man in overalls and a farmer's hat stared at me in my "spacesuit," and had it not been for his disapproving scowl, I would have taken his picture. Within miles of downtown Fowler, I saw old, abandoned trucks in a field, a dilapidated plane hangar with the painted nose of an old Cessna sticking out of the door, and other old-fashioned artifacts. I would have enjoyed seeing more of this part of Colorado, but I was running on empty and a storm threatened.

When tornado hunters pulled in at the Sinclair gas station where I was filling my tank, I gathered that there might be a big system nearby and thought I had better find a hotel room soon. I reached Lamar ten minutes later and was fortunate to get checked into my room at the Cow Palace Best Western before the storm unloaded sheets of rain and hail.

May 24, 2005—Daily Mileage: 341.9 (Total Miles to Date: 2,285)
Lamar, Colorado, to Wichita, Kansas
It was a clear, cool day with superb early-morning light when I set out for Wichita, Kansas. I made a quick tour through downtown Lamar and caught some great shots of Art Deco buildings. The refreshing weather and a good night's sleep made for the best ride I'd had since Seattle. People in other vehicles must have wondered why I was screaming "Yes!" at the top of my lungs and pumping my fist into the air. Is this why they call it a Colorado High? My invigoration was tempered only by the slightly empty feeling that I was unable to share the experience with anyone. Riding through the countryside unchallenged by any traffic or distractions and listening to the chatter of twin cylinders was a penetrating/deep massage of the soul. I had finally gotten comfortable with the bike. The extra saddlebag for my rain suit and camera, which I had purchased in Loveland, Colorado, also made it easier to stop and take pictures.

Within a few hours I reached Dodge City and found it disappointingly commercialized. Even the Boot Hill cemetery—an important part of Western folklore—seemed strangely bland. As I high-tailed it out of town, I saw very few Harleys and bikes, but the trainmen were pleasant and blew their whistles to say hello. I couldn't help but notice the beautiful, amber-colored wheat fields as I approached Wichita. The fields blanketed the scenery in all directions and I could grasp the scents and sights of stockyards hither and yon.

I experienced the same rural-to-suburban-to-urban transition on my approach to Wichita as I had with other cities. There were signs everywhere for motels, fast-food restaurants, car dealerships, insurance agencies, and everything else we associate with urban blight. The road expanded from two to four lanes; housing became more dense and predictable—changing from mobile homes to track houses to commercial and industrial structures to clusters of tall office buildings. As a society largely consumed by television, we Americans are programmed to respond to visual cues, so it stands to reason that the major arteries leading into and out of our cities are littered with familiar (albeit annoying) reminders of the hourly bombardment of television and radio advertising. I can see why many people want to escape city life and flee to quieter environments.

May 25, 2005—Daily Mileage: 224.1 (Total Miles to Date: 2,509.1)
Wichita, Kansas, to Bixby, Oklahoma

After breakfast at 8:00 a.m. at the Hilton, I headed to the Harley dealer for my bike's 5,000-mile service. Both Kevin and Tony, the mechanics who serviced my bike, were puzzled by the fouled plug, but concluded that a dirty air filter was the likeliest culprit. After finishing at the Harley shop, I called Garrett Snow and his father, Carl, my flying friends, who were departing from Tulsa, Oklahoma, to meet me on their Harleys at Ponca City, Oklahoma. They would escort me back to their home in Bixby, Oklahoma, my destination today.

The region east of Wichita is a continuum of suburbs and strip malls all the way to Highway 15 South, where a number of bedroom communities serve McConnell Air Force Base. I passed through Winfield, Kansas, a typical all-American town, and to the south I noticed the landscape changing back to a wide canvas of brightly colored wheat fields, rail crossings, silos, and cattle ranches.

I met up with the Snows on their Harleys outside of Ponca City and headed toward Tulsa, with Carl leading the way. I see why a bike "pack" is such fun, albeit noisy if you're at the tail end of it. I felt more secure riding with a group, even though I had never felt intimidated as a solo rider. Harleys have a magical, throaty sound that distinguishes their arrival and leaves heads turning. I noticed, from riding behind Carl, that there is a rhythm one maintains in the turns that almost seems choreographed. Being in the middle of the formation allowed me to experience this smooth execution of subtle turns, which was repeated flawlessly for the remainder of the ride on the twisting roads south.

We stopped outside of Pawhuska, Oklahoma, to photograph a "welcome" sign with all the old Rotary, Lion's Club, and other business-society emblems dangling from it. This is a familiar sight as you approach these rural towns and it helps, I would guess, to promote or boast about civic activity. I noticed on our ride into Tulsa that the city appears to rise out of a forest of trees. It was a welcome relief that there was no 10-mile apron of malls and commercial edifices flanking the city.

I wish I'd videotaped the three of us riding together, knowing how much we share a passion for flying and riding. Oddly, the safety-conscious Carl was wearing a do-rag instead of a helmet. That bears explaining, Carl.

As we pulled into the Snows' driveway, we were greeted by Carl's wife, Marcia, with her familiar camera in hand. Before long, Garrett was grilling steaks, and Marcia was cooking locally grown organic vegetables and making strawberry shortcake. We dined informally in the kitchen and then sat together in the living room as a family, recounting the day's events. I'll cherish this slice of Americana with the Snows for a lifetime.

May 26, 2005—Daily Mileage: 284.1 (Total Miles to Date: 2,793.1)

Bixby, Oklahoma, to Hot Springs, Arkansas

After rising for breakfast at 7:00 a.m., Carl, Garrett, and I all packed, suited up, and took one last round of photos. We rode to the Snows' Haskell ranch, where Garret is a third-generation steward, keeping 150 head of cattle—from calves, to yearlings, heifers, and bulls. They bale hay, do all the maintenance on their fleet tractors and vehicles, and have built all the fences, sheds, and special wells for getting water to the cattle in the winter. Prior to this day, I had never understood all that goes into raising cattle.

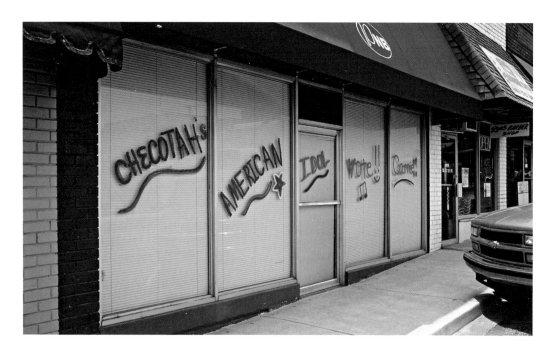

After a tour of the ranch, the three of us headed off to Checotah, Oklahoma, to have lunch at Katy Cafe, Carl's favorite haunt. Everywhere we looked, storefront windows were covered with grease pencil congratulations for a hometown hero—Carrie Underwood—who had just won the *American Idol* competition the night before on national television. The packed restaurant was buzzing and served great home-cooked food. After lunch, the Snows rode with me to the Arkansas border, where I reluctantly bid farewell to them.

Though the weather was improving, the views were not as breathtaking on this portion of trip. But south of Fort Smith, Arkansas, I rode through the Ouachita National Forest, where lush, leafy trees brushed up against the highway. Several hours later, having eagerly anticipated a stay and treatment at one of the celebrated spas, I arrived in Hot Springs, my destination for the day. I was exhausted, and when confronted with dozens of spas—large and small—I couldn't make up my mind. Despite the number of spas, the center of town felt abandoned, with no signs of life save for a patron or two entering one of the bars. In my weariness, I retraced my steps and retreated to a motel on the outskirts of the city. The bike seemed to know where to go.

May 27, 2005—Daily Mileage: 353 (Total Miles to Date: 3,146.1)

Hot Springs, Arkansas, to Jackson, Mississippi

When I woke up the next day, I had an uplifting telephone conversation with Jim Wark, who urged me to revisit downtown Hot Springs with fresher eyes and in daylight. To get there, I passed through rundown neighborhoods. A number of buildings at the heart of the city were architecturally nostalgic, with fanciful storefront windows and unexpected parapets. My hour-long side trip back into Hot Springs was definitely worth the time.

Past Pine Bluff on Route 65 South, I rode through a number of outposts and small farming communities that exist only because they are nourished by this north-south corridor. The land was flat and agricultural, covered with rice fields and acres of young corn.

I caught my first glimpse of the mighty Mississippi—also known as the "Big Muddy"—as I approached Greenville, Mississippi. I stopped to shoot some pictures as I crossed the narrow bridge that traversed the river. Signs to downtown Greenville and the port were misleading. I never saw anything that resembled a quaint, old river town, despite my attempts to find one. Highway 82 East

through Greenville was littered with fast-food restaurants and convenience shops, block after block. The early-evening light from the setting sun exposed an unattractive side of the city, so I pressed on to Jackson, even though I was longing to get off the bike, hit the shower, and catch a good, home-cooked meal.

Yazoo City! I'd never heard of it, but leave it to me to happen upon this extraordinary little town as I made my way toward Jackson. What struck me most was the wildly creative, artistic use of color that embellished some of the town's most dignified commercial buildings, located on South Main Street. If I hadn't known better, I would have thought that this long, meandering street was lifted directly out of a Hollywood studio back lot.

This was my second-longest day on the bike, and though I was comfortable on the bike *per se,* I was irritated by the heat and humidity. I arrived in Jackson after sunset, located a Days Inn after an hour's search, and zeroed in on Crechale's Cafe, which served the best fried flounder on the planet. A couple who walked in after I did were anxiously returning to Crechale's after they'd moved away from Jackson five years before. They were back for the food, which made me wonder how many "institutions" like this are still in business. Not many, I would venture to guess.

May 28, 2005—Daily Mileage: 365.6 (Total Miles to Date: 3,511.7)
Jackson, Mississippi, to Dothan, Alabama
I got up at 7:30 a.m., ate a light breakfast, and was soon back on the road. I saw more evidence of the big lumber industry in Meridian, Mississippi, and again in

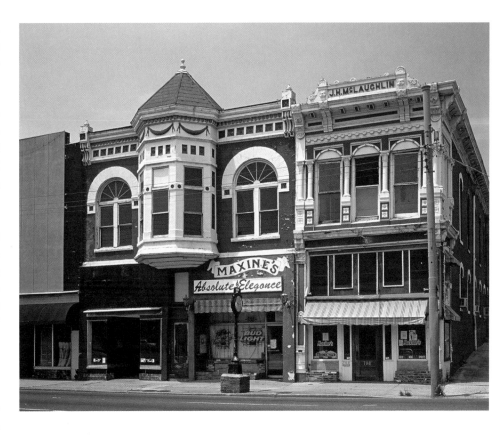

Camden, Alabama, the latter being a Weyerhaeuser mill. My drive through the Bienville National Forest on I-20 was spectacular. Large deciduous trees would have formed a canopy over the highway had they been left to grow. The full trees bore young, bright-green leaves. It was extremely hot, and, unexpectedly, I had symptoms of heat stroke—a dry forehead, a headache, and chills. I changed helmets from full- to half-shell, consumed a full bottle of Gatorade, and ate salty peanuts. That did the trick.

Highway 10 took me through interesting towns—the type I had always heard referred to as "sleepy Southern towns" and about which I had always been curious. I was delighted to arrive in Pine Apple, Alabama, and to discover the "Town Hall," which was no bigger than a walk-in closet.

A few miles past Sweet Water, Alabama, I came upon a run-down gas station converted into a "home." It sat only a few feet from the road and was nearly suffocated by old furniture and junk strewn everywhere. I was intrigued by this puzzling homestead, so I parked my bike and began taking pictures. Moments later a toothless old woman charged out from behind the house and yelled at me as she raised a large baseball bat. Clearly she wasn't able to have a rational conversation and I was getting nowhere trying to justify my alleged intrusion. She charged down the path toward me, at which point I told her that I had stopped taking pictures and would leave. She summoned her dogs, but the sweaty old pit bull lying on the porch didn't budge. The only brave, suicidal soul was her Chihuahua. I wasn't going to try my diplomatic skills on this woman, so I made a run for the bike, tucked my gloves into my jacket, and skedaddled.

I was careful from that point on to pick safer subjects to photograph and made sure to stay below the speed limit. It is funny how your mind works. After this scare I was worried that I would get caught speeding by the local sheriff, who, with my luck, would turn out to be the son of the angry woman with the bat. He'd eventually learn about my transgression against his mother and would lock me up for the duration of the Memorial Day weekend, waiting for the judge (her brother) to adjudicate *impartially* a series of so-called infractions: trespassing, snooping, public nuisance, and speeding.

Notwithstanding this little drama, today was the first time I had seen red clay soil thus far. On arriving in Dothan, Alabama, I was greeted yet again by a concrete and neon cordon around the city. Not only was this a constant visual intrusion in these southern towns, but also it prevented an easy, inviting access into the city. Bypasses are probably the largest contributors to inner-city blight, since they force people to avoid the city itself. I checked into the Holiday Inn Express and dined at PoFolks.

May 29, 2005—Daily Mileage: 268 (Total Miles to Date: 3,779.7)
Dothan, Alabama, to Gainesville, Florida

I ate breakfast at 8:00 a.m. and headed to downtown Dothan against my better instincts. I had seen no signs pointing to a historic district and so I assumed this would be a repeat of my initial reaction to Hot Springs. However, it turned out to be a pleasant surprise as I found myself in the midst of an ongoing restoration project. Murals adorned various buildings in commemoration of black Tuskegee airmen,

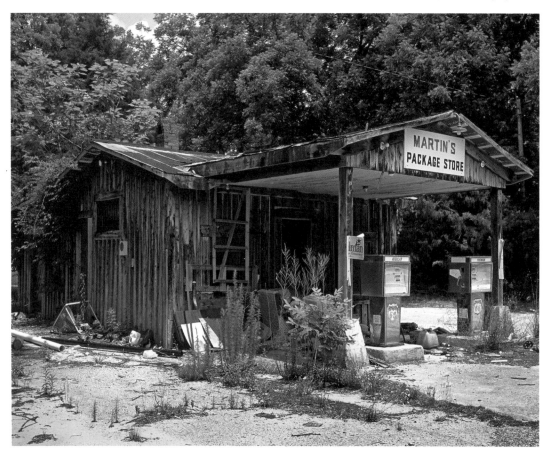

the decorated World War II squadron. Even though inner-city decay was still visible, banners festooned the street lamps. I left Dothan, pleased to see these wonderful civic efforts, and before long I reached the Georgia state line, even though there was no sign to indicate as such. After passing the small lumber-mill town of Jakin, I continued past a number of pine forests and tree farms that extended all the way through to northwestern Florida. I was caught off-guard by all the signs in Florida that advertised "Christmas Trees."

I made my way to the state capital of Tallahassee, a memorable experience that reminded me, strangely, of New Orleans with its wrought-iron balconies and outdoor bistros. The city is clean, with good signage. In fact, many of Florida's cities brim with civic pride and each has its own distinct character—such as the towns of Havana and Mayo. Both are "Main Street" towns, which are miles apart but share the same common road, Highway 27. The streets are spotless, the merchants are friendly and the stores are easily accessible with ample and convenient street parking. One would travel here for the intimate, low-key shopping and dining experience, hearkening back to those familiar "Sunday Drive" excursions.

I made Gainesville my destination, since I wanted to see the University of Florida campus. The college town is tucked east of Interstate 75 on Route 26. It reminded me a little bit of Chapel Hill, North Carolina, although Gainesville is a larger city. The usual watering holes and ethnic restaurants of a campus town line the street alongside the university and extend east for many blocks. The Holiday Inn was the only sanctuary of its kind in the heart of the campus, so I checked in for my last night on the road.

I was suddenly nostalgic for my family, friends, Harley friends (Bob and Sara), for sleeping in my own bed, and for getting back to a normal diet, especially at breakfast. I wouldn't miss dragging cycle bags and lugging paraphernalia to and from motel rooms and my bike twice a day. But kudos to Harley for producing a reliable and suitable bike for this undertaking. My Harley bags accommodated virtually all of my needs. I probably overpacked on the clothing end, but don't we all?

Throughout my trip, I experimented with different combinations of glasses, contacts, and earplugs—and the verdict is still out. The half-shell helmet was the most comfortable in warm weather yet not as safe as the full-face helmet. The full-face helmet was comfortable and warm in the colder climates; in warm climates I got by with a half-shell and a red handkerchief around my neck. Carrying

two helmets was a smart decision, as I learned when I suffered the heat-stroke symptoms during the first hot spell of my trip. Moreover, the pouch behind the windshield was indispensable, as it housed the back-up camera, GPS, and both my pen and the napkins scrawled with directions. The taller windshield kept the rain and wind from buffeting my helmet.

While I tried to maintain the bike in pristine condition, I found it difficult and tiresome to tackle the road grime and bug spatter every evening. But I did my best to hit the road every morning with a polished and fully fueled bike. I'm glad I stopped at the Harley shops for mementos; the T-shirts extended my inventory of clean clothes and spared me an afternoon or two at a coin laundry.

May 30, 2005—Daily Mileage: 339.3 (Total Miles to Date: 4,119)
Memorial Day—Gainesville, Florida, to Naples, Florida

On my last day, I woke up with a bang at 6:30 a.m. I went back through the Florida campus again on my way back to I-75. The northbound highway was crowded, but light going south, since people were heading north after the three-day Memorial Day weekend. I passed a number of horse farms in Ocala, one of the state's more important industries, that may even rival those of Kentucky.

I stopped in Bradenton to catch up with an old college friend and fellow soccer player, Jaime Canfield. We had brunch at a Palmetto, Florida, restaurant and stopped by a boatyard where Jaime was restoring an old, wooden sailboat by hand. What a labor of love! I rejoined I-75, where the traffic was heavy. I must confess, the road signs for my hometown of Naples were most welcome, especially as the distance to Naples decreased from 90 miles to 80 to 70 to 10. Upon reaching Naples I stopped by to see Bob Milliken, who had gotten me started on the Harley after graduating from Rider's Edge (Harley's motorcycle safety class) the previous fall. I presented him with a T-shirt (what else?) and he was delighted but relieved to see me back safely and in good spirits. As I pulled closer to my home, I saw more clearly than ever the beauty of the transition from Highway 41 to downtown Naples. I put my Harley to bed in its own garage, having graduated from a storage unit—a just reward for having transported this rider safely across the country. Piles of dirty clothes went into the washer and I put my gear away until the next ride. Tomorrow, perhaps?

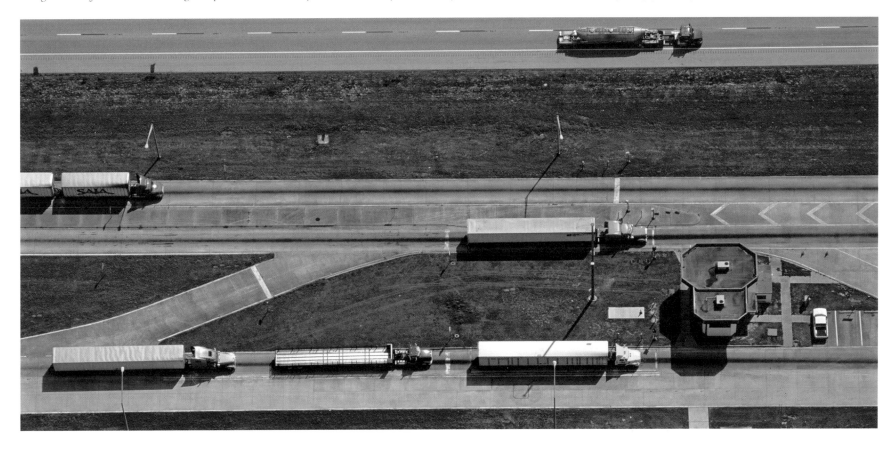

NORTHWEST *to* SOUTHEAST

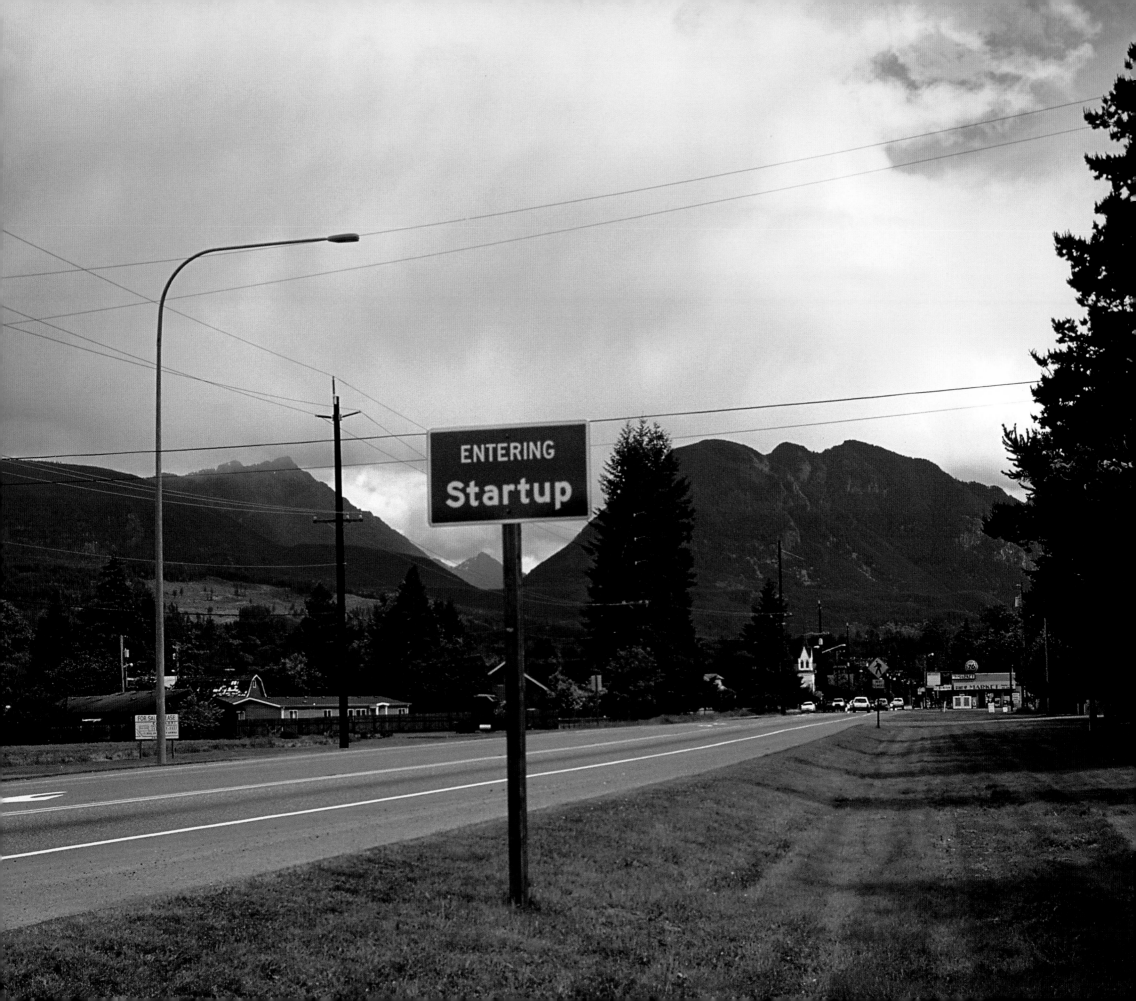

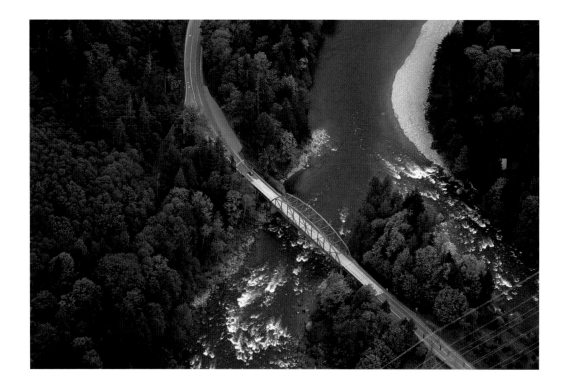

On Page 33: Google Earth Waypoint # 47°52'01.52"N, 121°44'54.85"W
Startup, Washington, an appropriate starting point for the first leg of my journey.

Preceding Page: 47°51'28.61"N, 121°42'05.47"W Gold Bar, Washington. This
stationary train at the western foothills of the Cascade Mountain Range
was a welcome taste of what was to come: a daily encounter with east- and
westbound freight trains conducting commerce across America. Here, only
the familiar rhythm of steel wheels rolling over the track seams was missing.

Above and Right: 47°48'45.11"N, 121°34'41.51"W Aerial and ground views of
Mount Index Bridge, Washington. This is the first of many bridges I encountered
during my two-year trip. You would be astonished by the number of bridges
that actually exist in our country. Note the concrete wall wrapped in moss
and the old-world latticework of the bridge. Can you hear the rushing stream?

Overleaf: 47°37'49.38"N, 120°43'40.32"W Northwest of Leavenworth, Washington.
An aerial and ground view of the Wenatchee River snaking its way southbound
down the Cascade Range through a lush, floral riverbed, paralleling Highway 2.

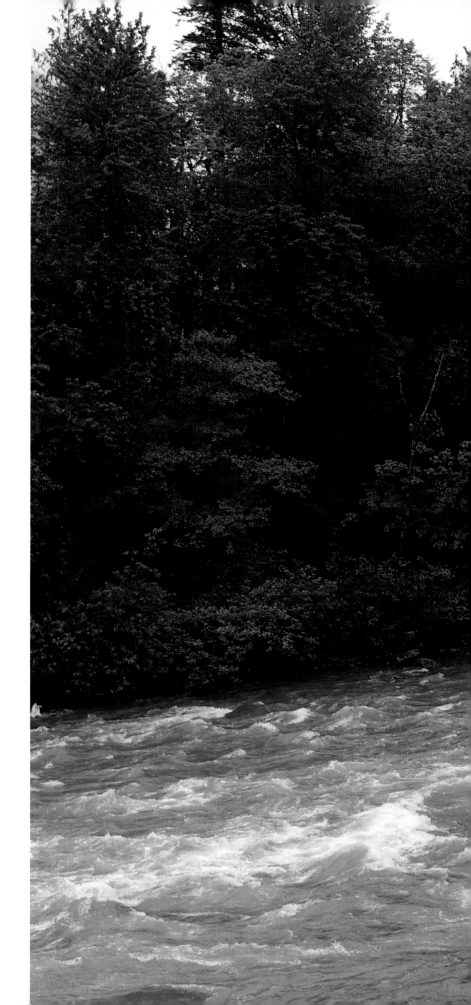

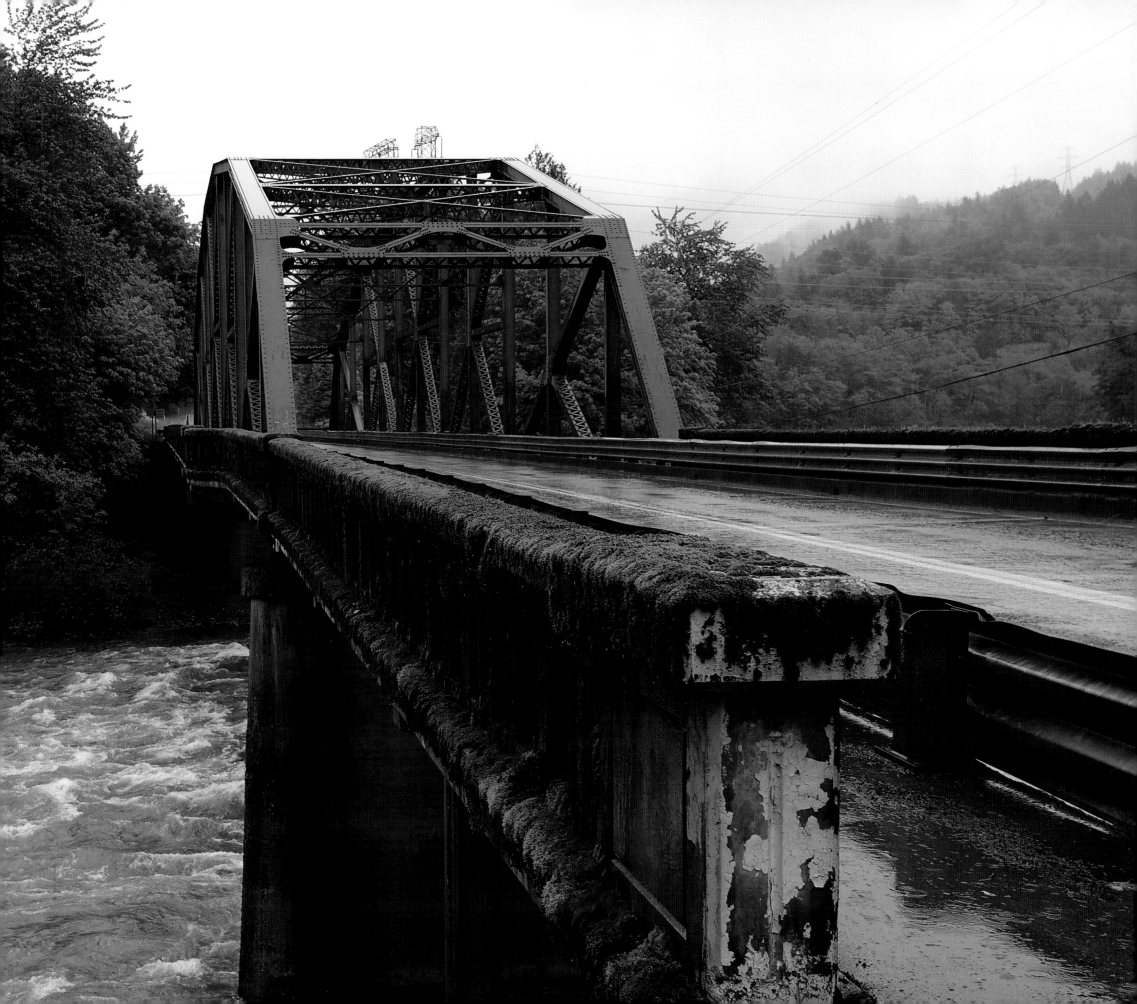

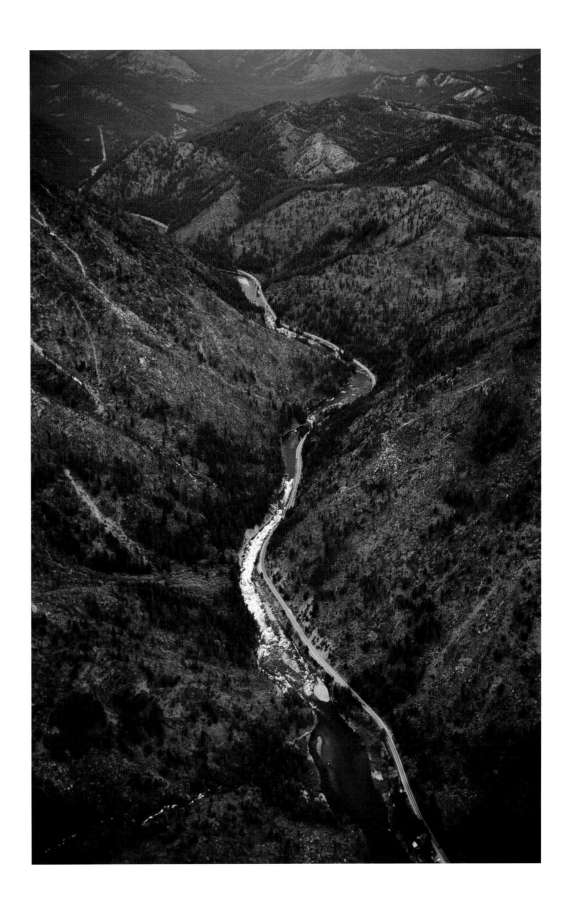

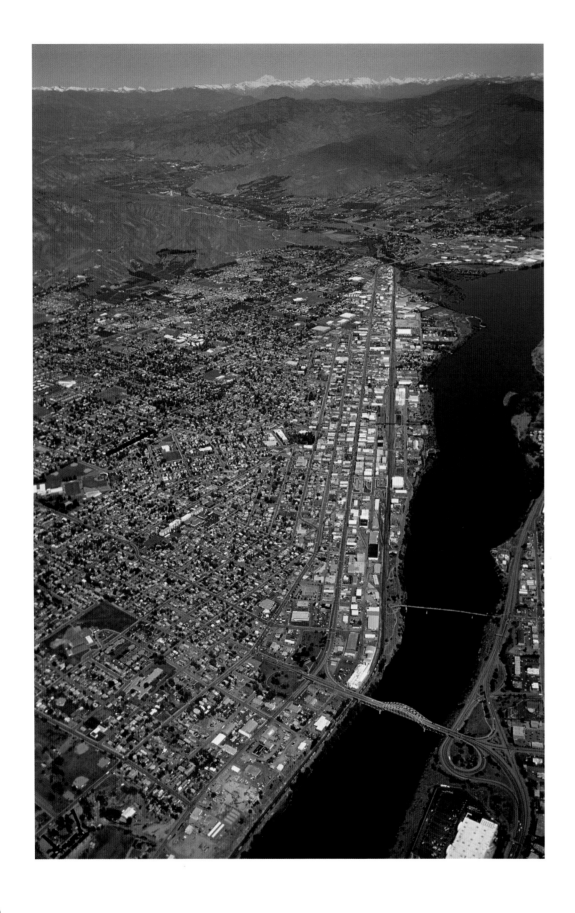

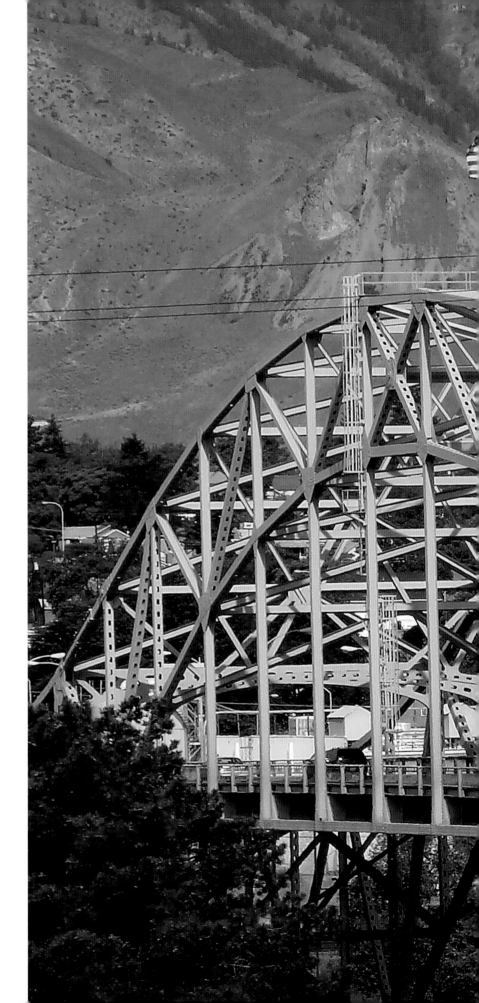

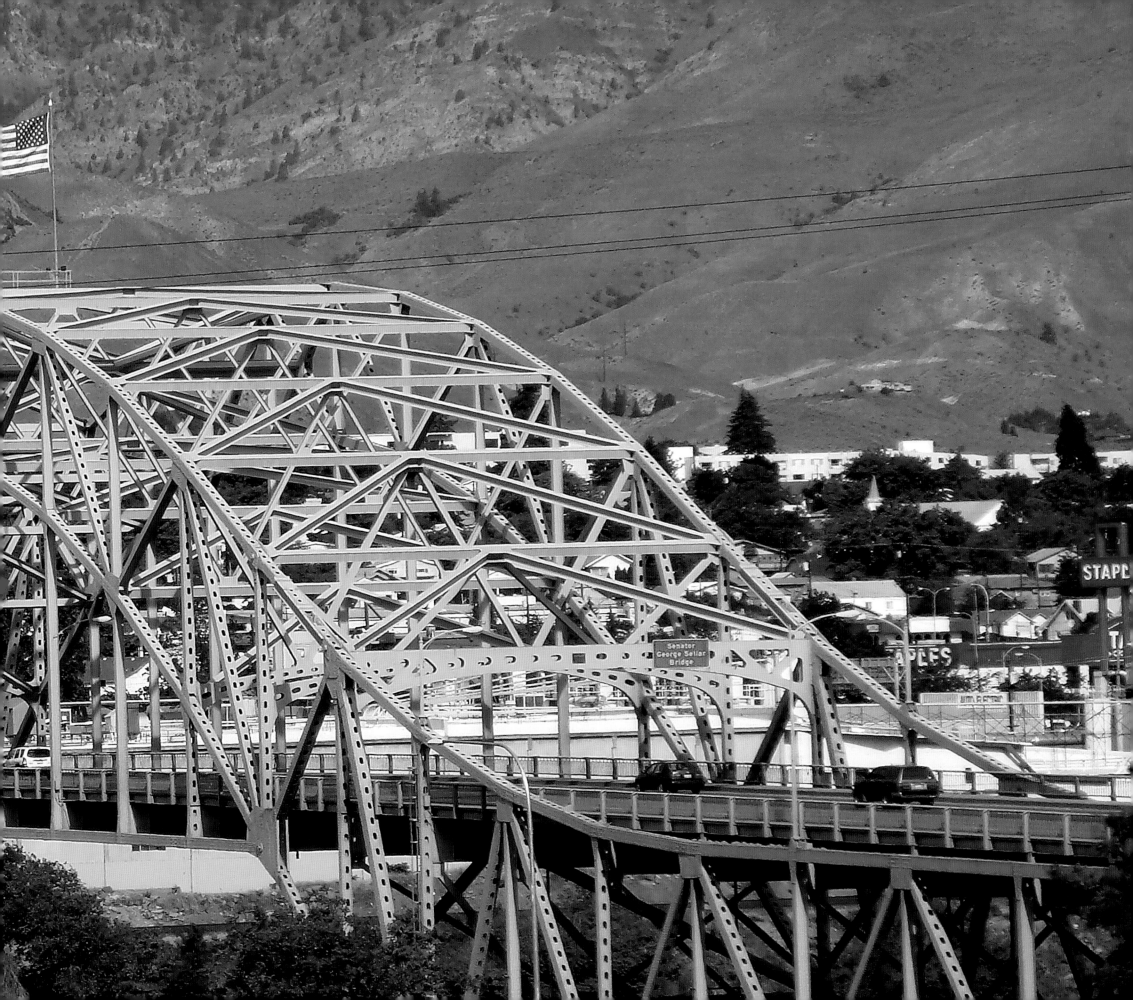

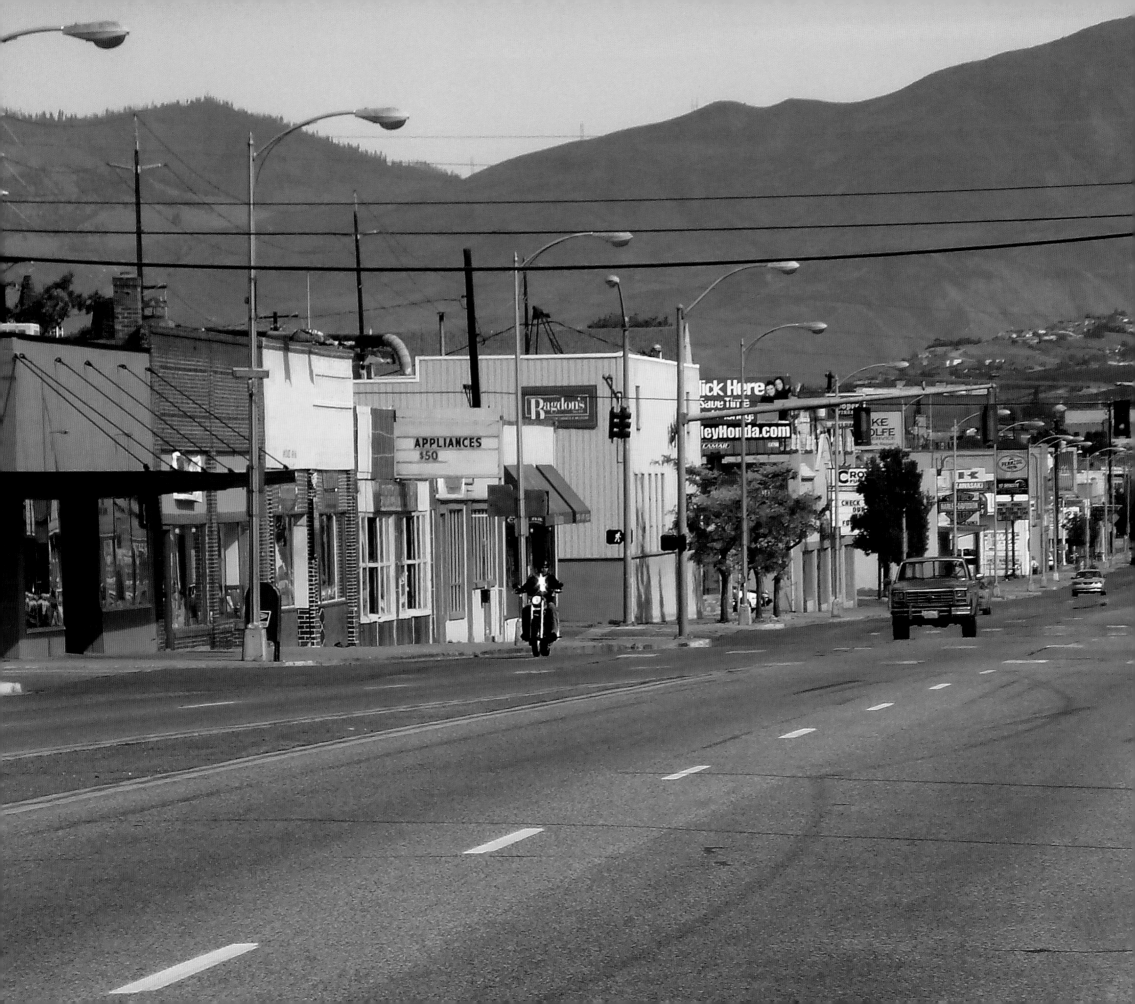

On Pages 40–41: 47°24'31.43"N, 120°17'24.55"W Wenatchee, Washington. The romping, roller-coasterlike bridge traverses the Columbia River to Wenatchee. The intricate webbing of the sturdy wrought iron, set against the rock-hard majesty of the mountains behind it, evokes an earlier age of bridge design. The American flag symbolizes the strength of both. At left, the aerial view of the Senator George Sellar Bridge shows East Wenatchee on the right and the larger town of Wenatchee on the left.

Left: 47°24'49.34"N, 120°18'11.80"W South Mission Street, Wenatchee, Washington. The charming main drag of this farming community, known as the apple capital of the world, is lined with simple, yet comfortable, one-story buildings. It's the long-term result of years of gradual sprawl.

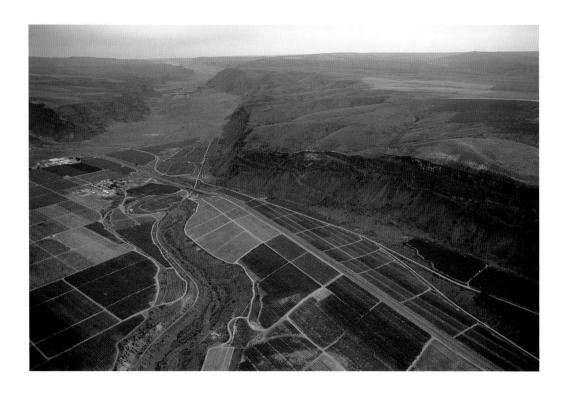

Above and Right: 47°16'51.43"N, 120°03'56.59"W Southeast of Wenatchee, Washington, where this peaceful, sweeping strip of Highway 28 leads out of the farming town. Notice the fresh-fruit orchards spanning both sides of the road, occupying every square foot of arable land in this part of the Columbia Basin, made even more compelling when viewed from the air.

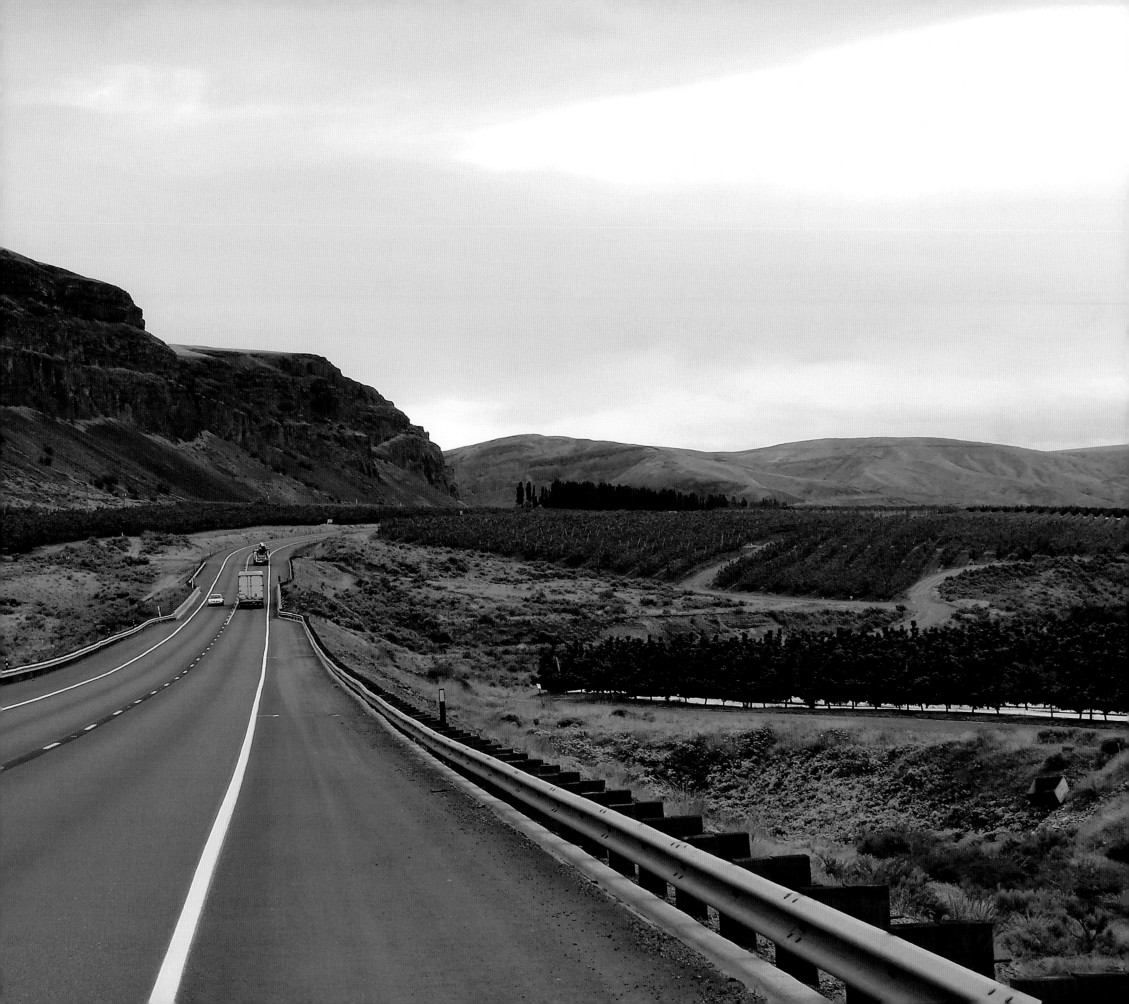

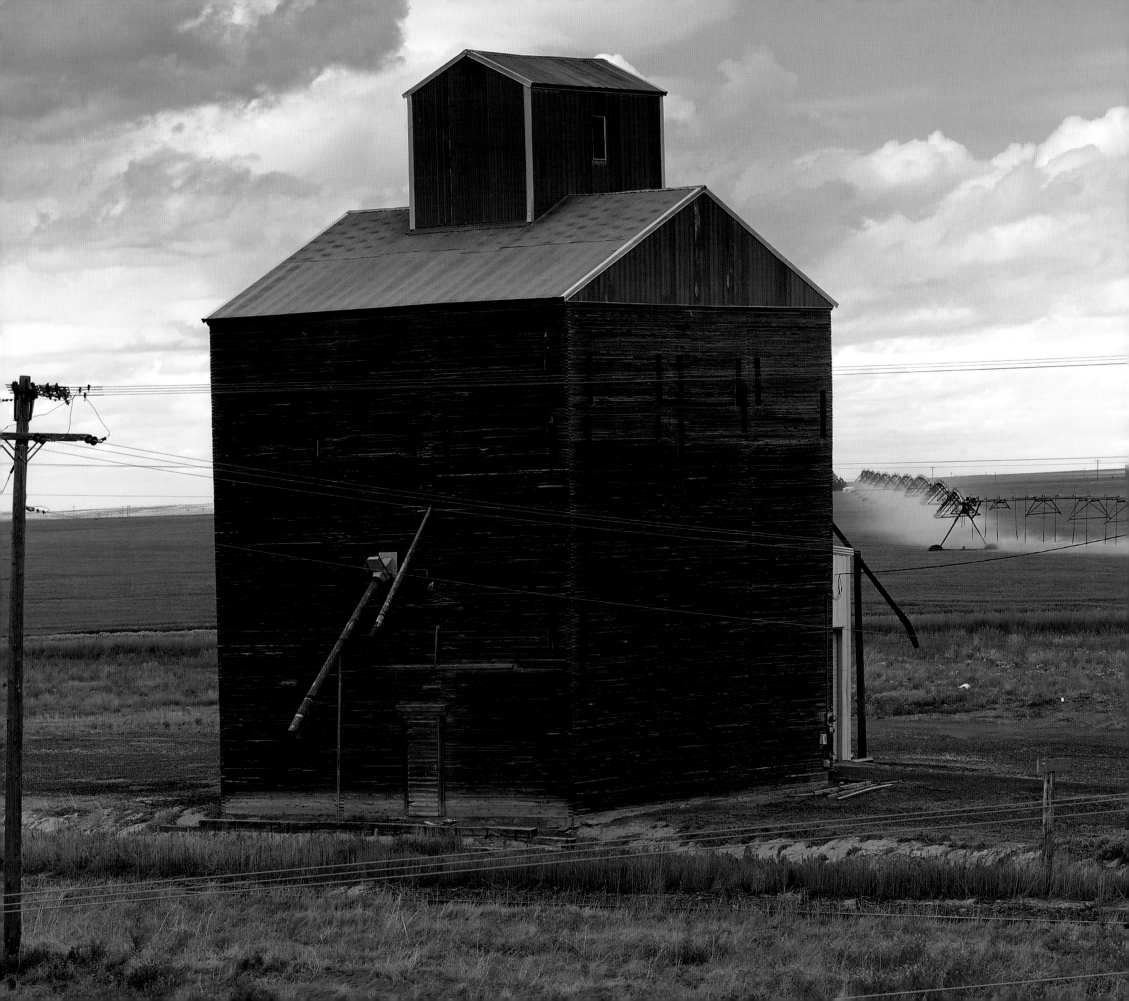

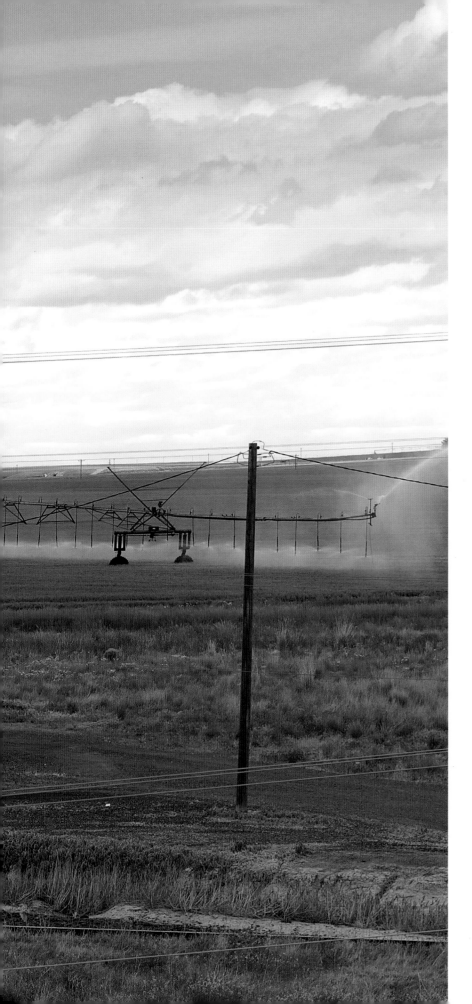

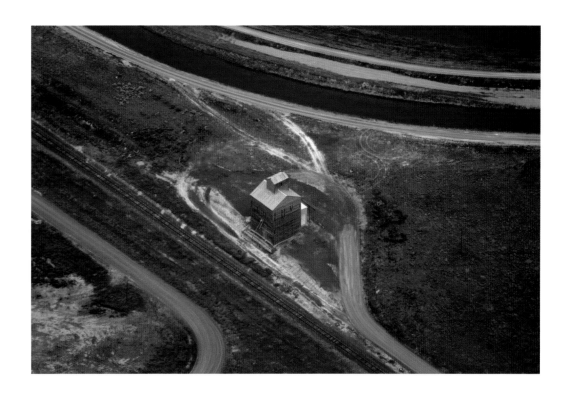

Left and Above: 46°47'42.55"N, 119°01'03.56"W East of Othello, Washington.
This wooden grain elevator off Highway 26 looks like a small, two-story barn.
It receives the harvested grain and dispenses it to passing freight trains via the
tubes protruding from the building. The vibrant sprinkler system in the background
is irrigating a so-called crop circle—a corner of which can be seen in the aerial photo.

47

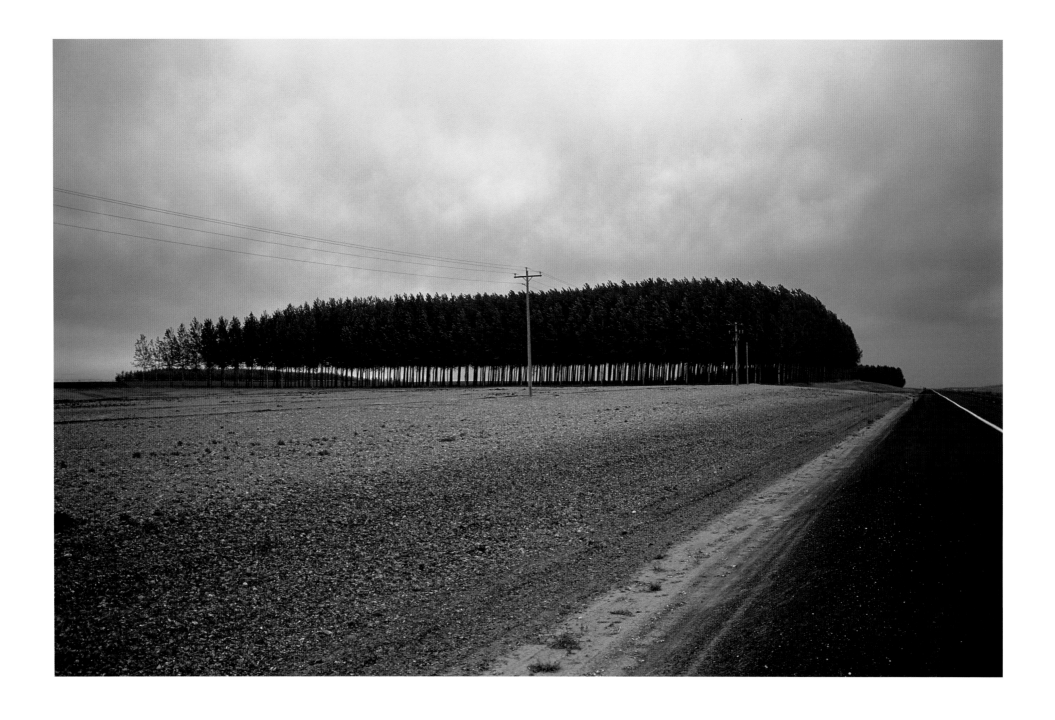

Above and Right: 46°47'40.94"N, 118°59'52.12"W East of Othello, Washington. In the ground view above, a stand of trees alongside Highway 26 hovers like a spaceship over fragile, spindly trunks. In the aerial shot at right, these trees surround and protect a crop circle of green wheat. This perspective reveals a unique layout of trees that forms an overall design in the shape of bowed triangles.

Overleaf: 46°47'46.73"N, 118°59'36.07"W A closer aerial view of this stand of trees shows the near-perfect symmetry of this verdant landscape and its apparent fragile nature. Notice the highway running behind the triangle of trees in this overleaf image.

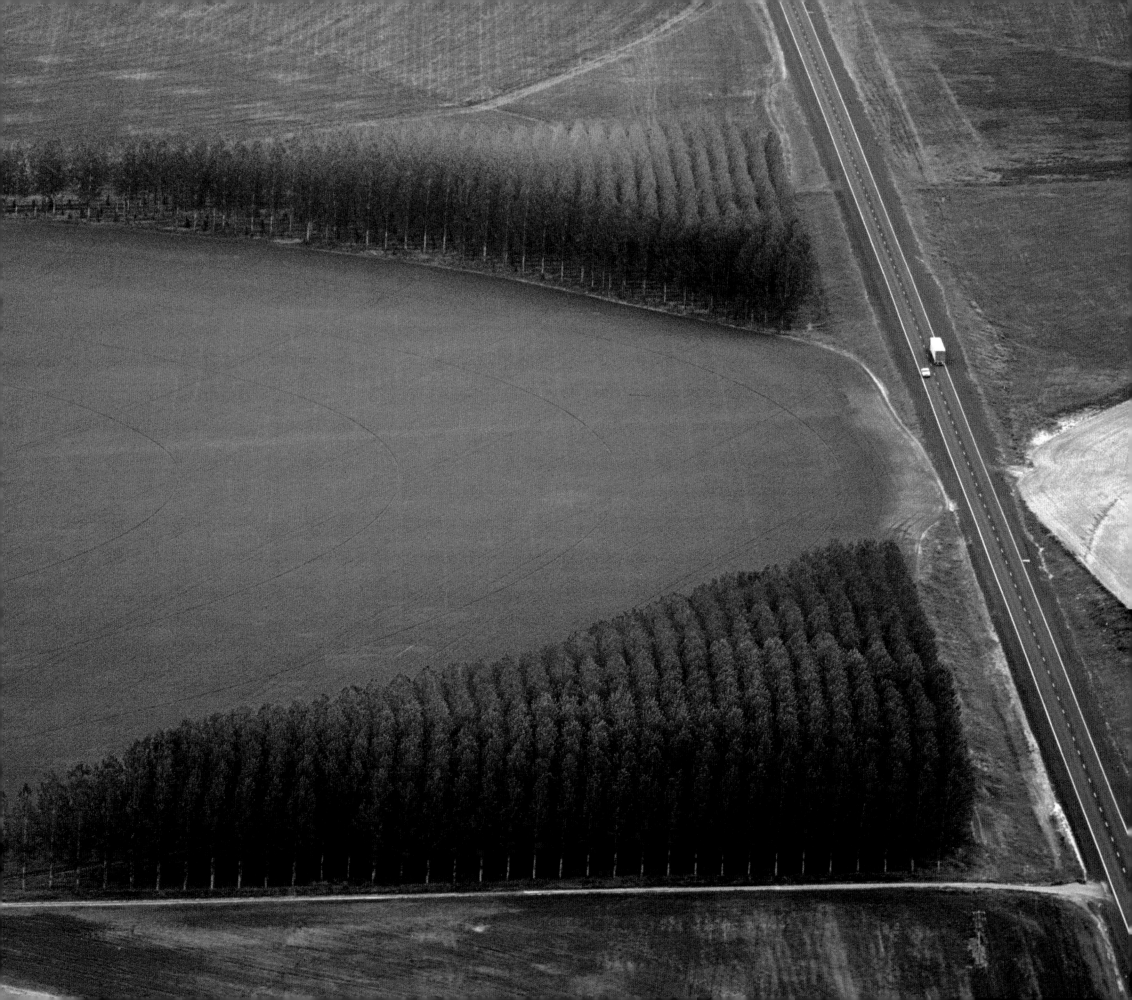

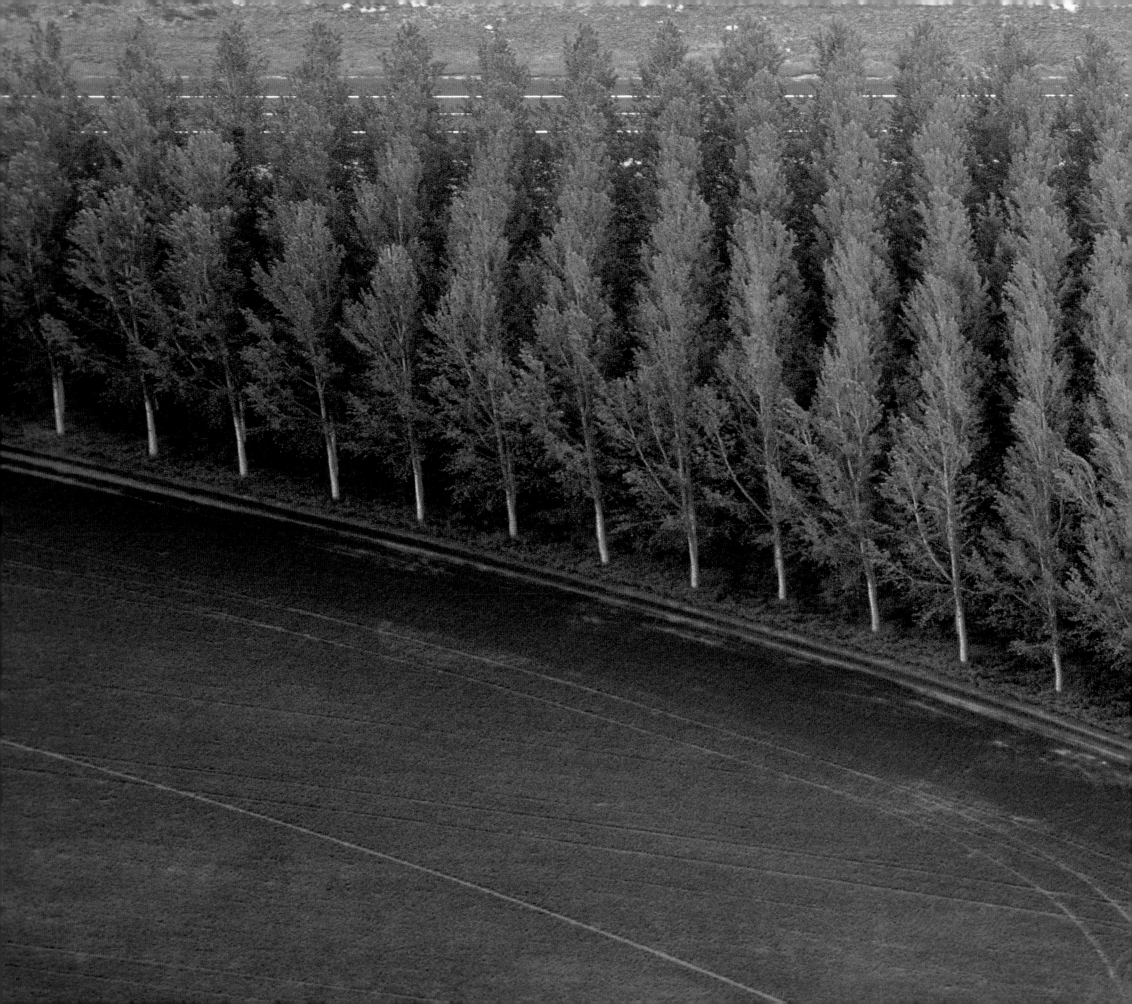

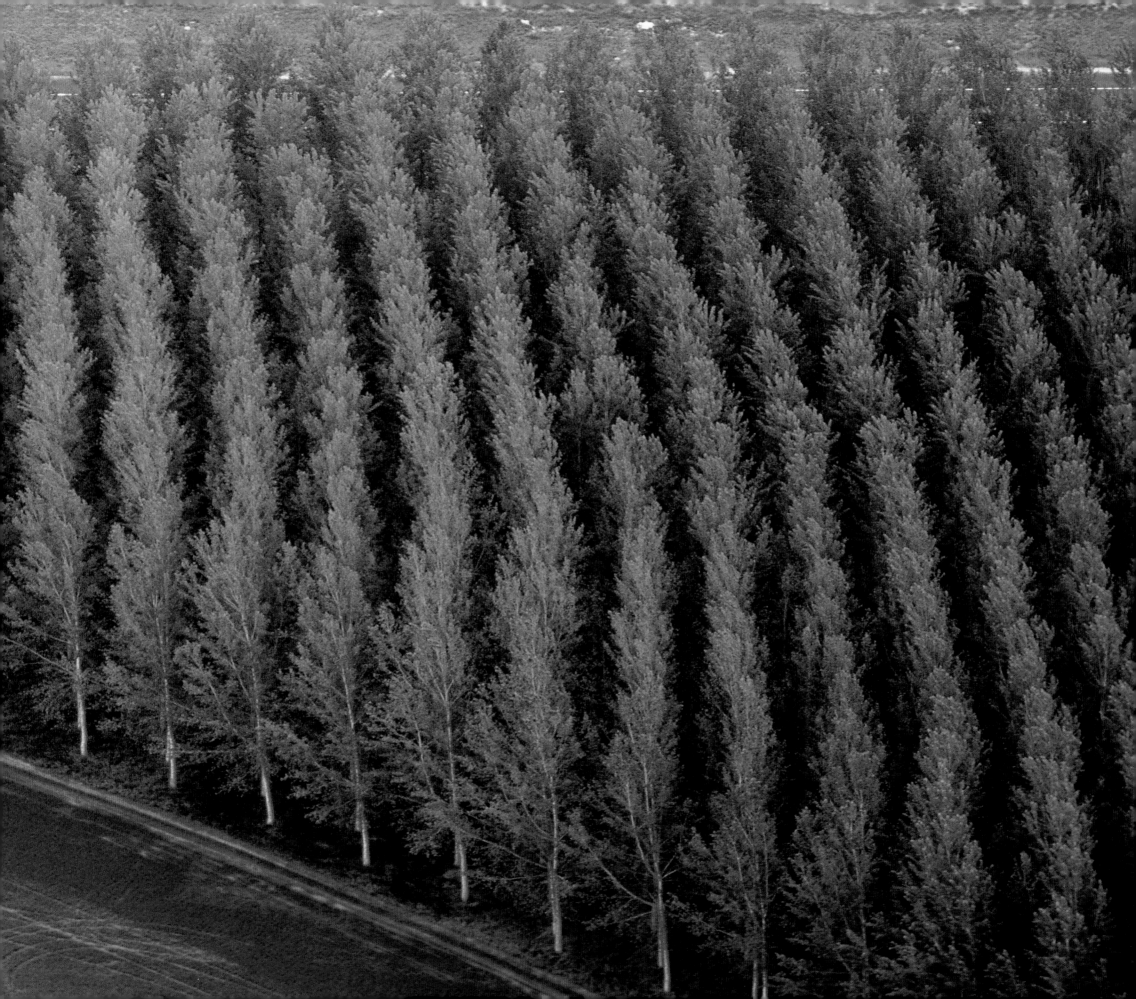

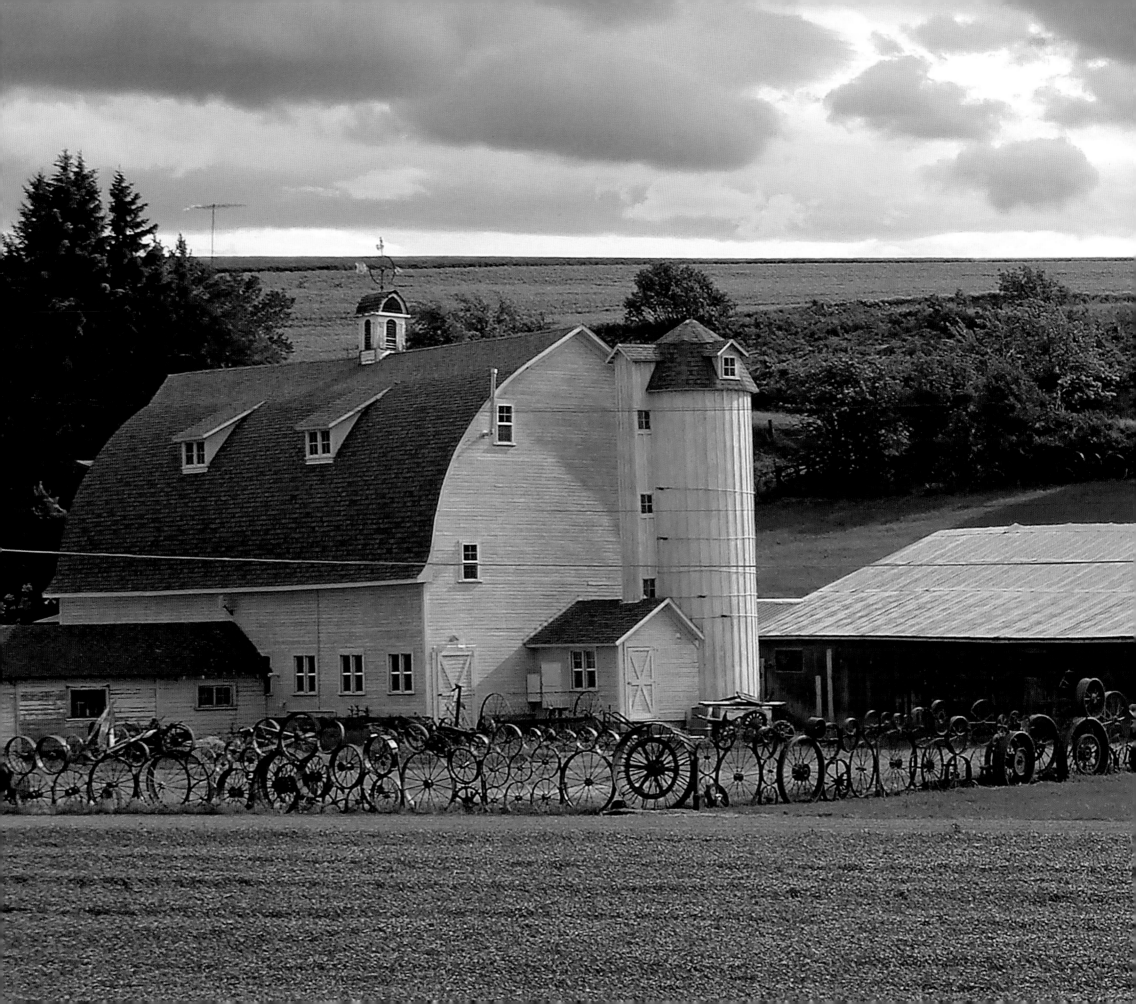

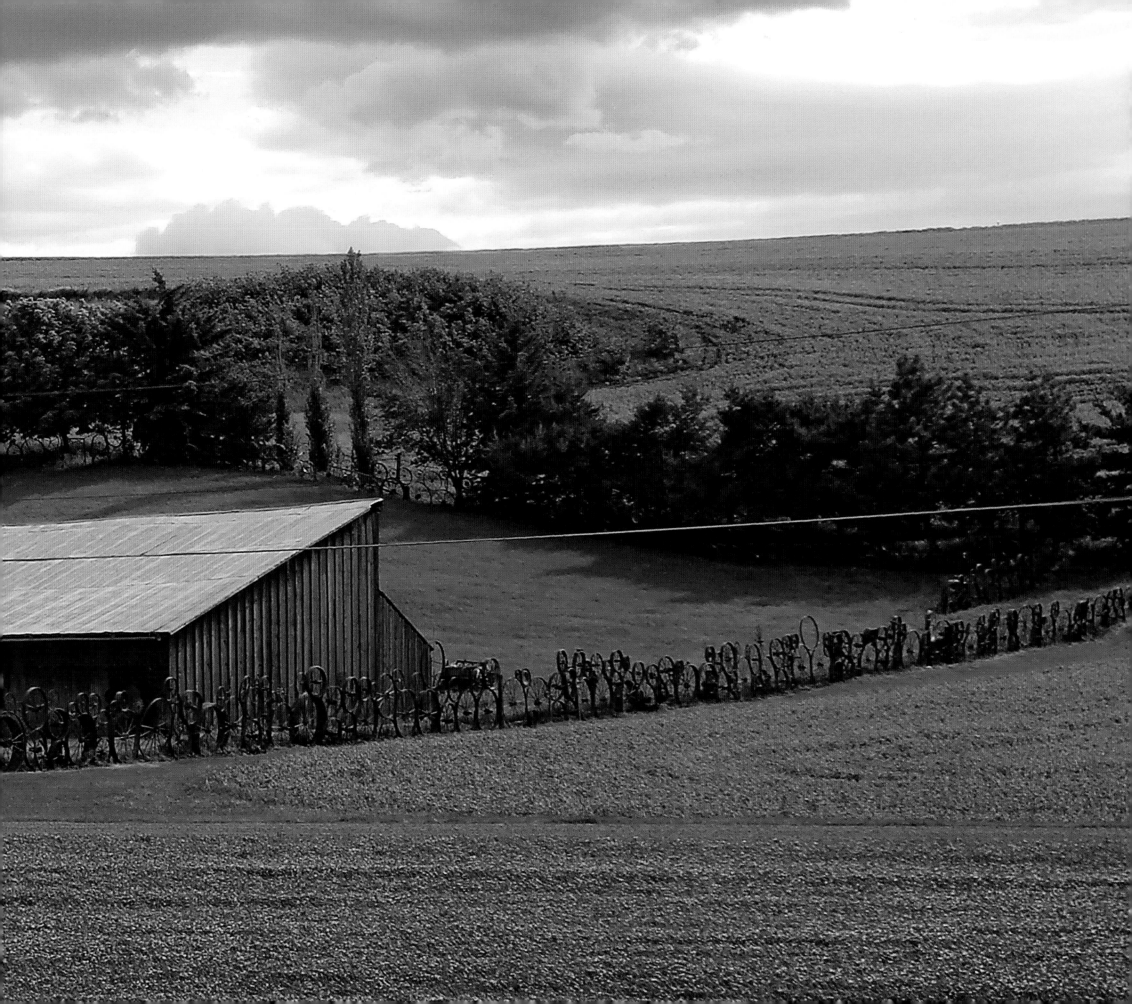

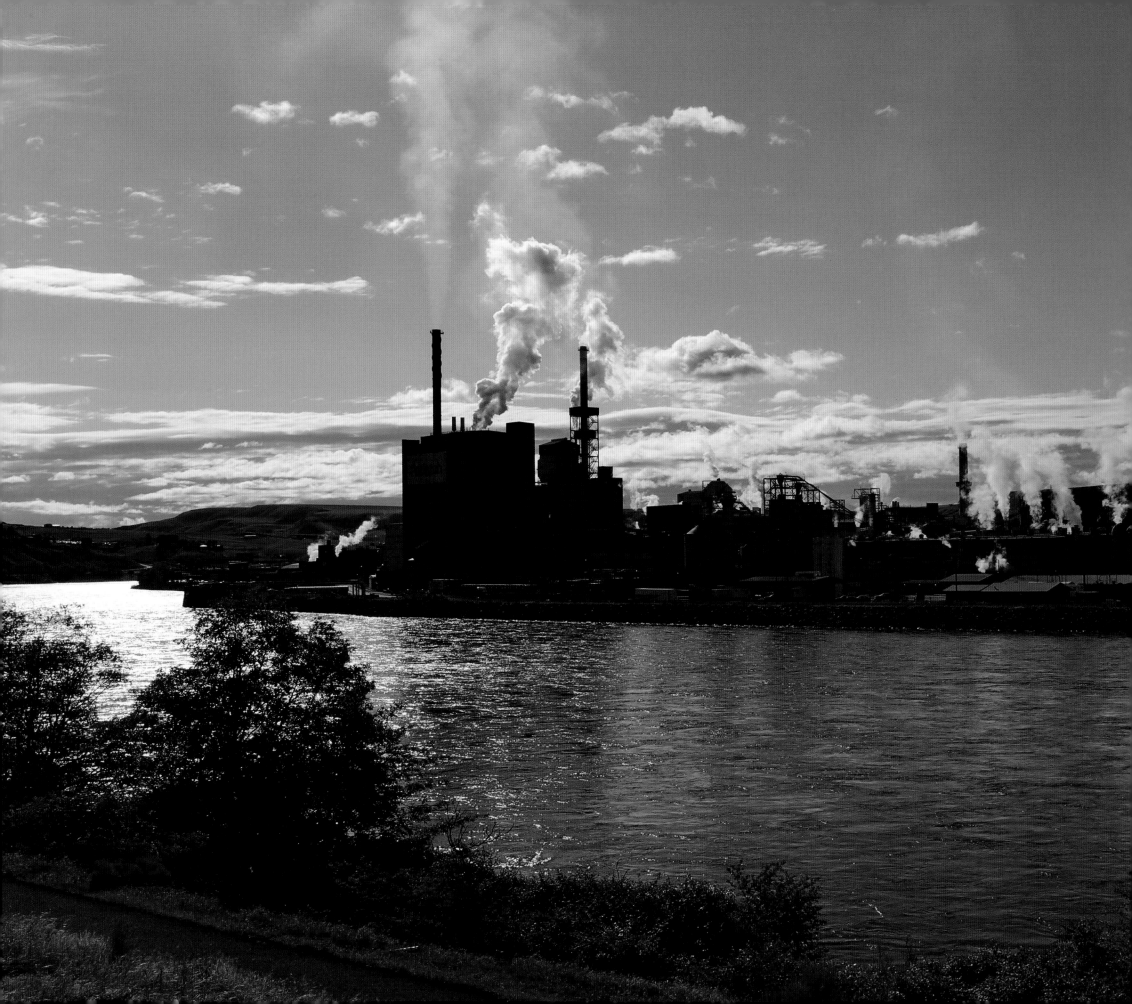

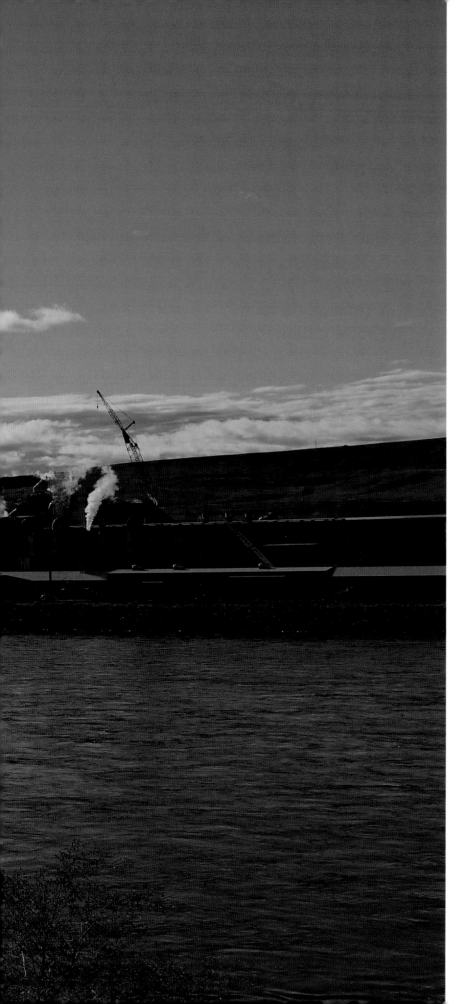

Preceding Page: 46°32'41.54"N, 117°05'29.12"W Union Town, Washington, taken on Highway 195 en route to Lewiston, Idaho. This wonderfully eccentric fence, constructed of abandoned farm-machine wheels, runs alongside a barn that is currently being used by artisans.

Left: 46°25'51.35"N, 116°59'07.54"W Lewiston, Idaho, on the old North and South Highway. If you are wondering why all of the steam and smoke is rising from these structures early in the morning, it's because this plant makes bathroom tissues, napkins, and paper towels—all of which require a lot of water. This is one of the reasons why industrial complexes such as this one sit along the banks of a river—here, the Clearwater River—and along transportation arteries.

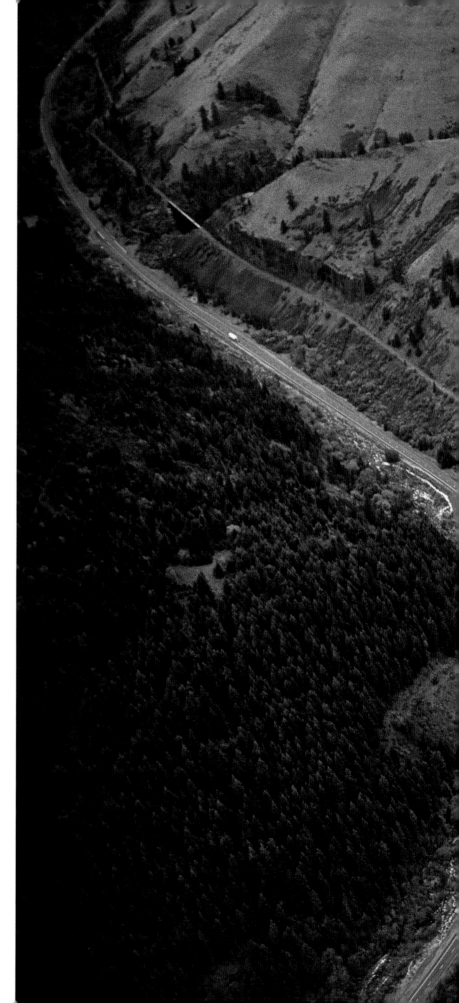

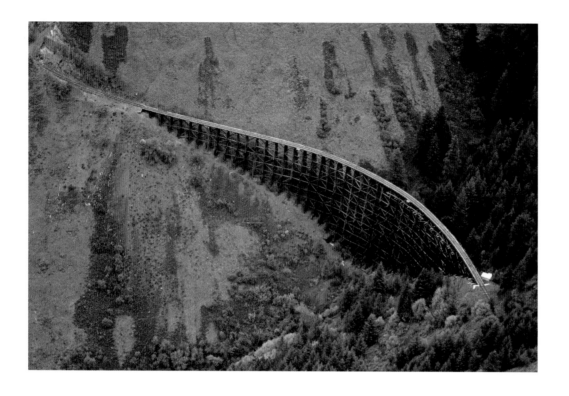

Above and Right: 46°19'28.62"N, 116°34'39.24"W; 46°19'28.68"N, 116°34'32.73"W
Southeast of Culdesac, Idaho, on Highway 95. In the photograph on the right, I rode along
the winding road and nearly missed seeing the spectacular railroad trestles with their
treacherous hairpin curves. The image above shows the trestles' intricate wooden bracing.

Overleaf: 45°57'56.92"N, 116°15'50.66"W Southeast of Cottonwood, Idaho. A breathtaking
vista from afar of pure color and texture. I love the peekaboo tip of the roof in the distance.

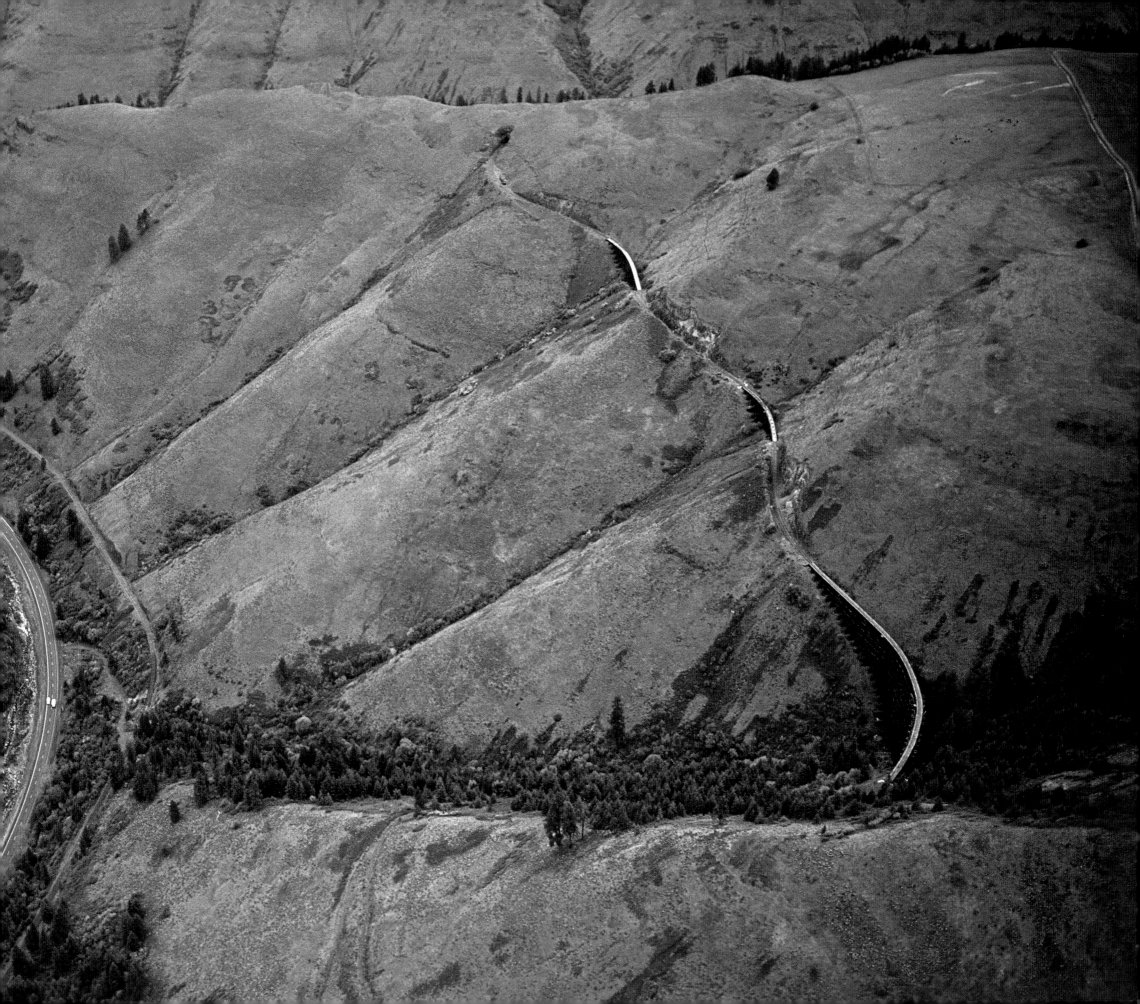

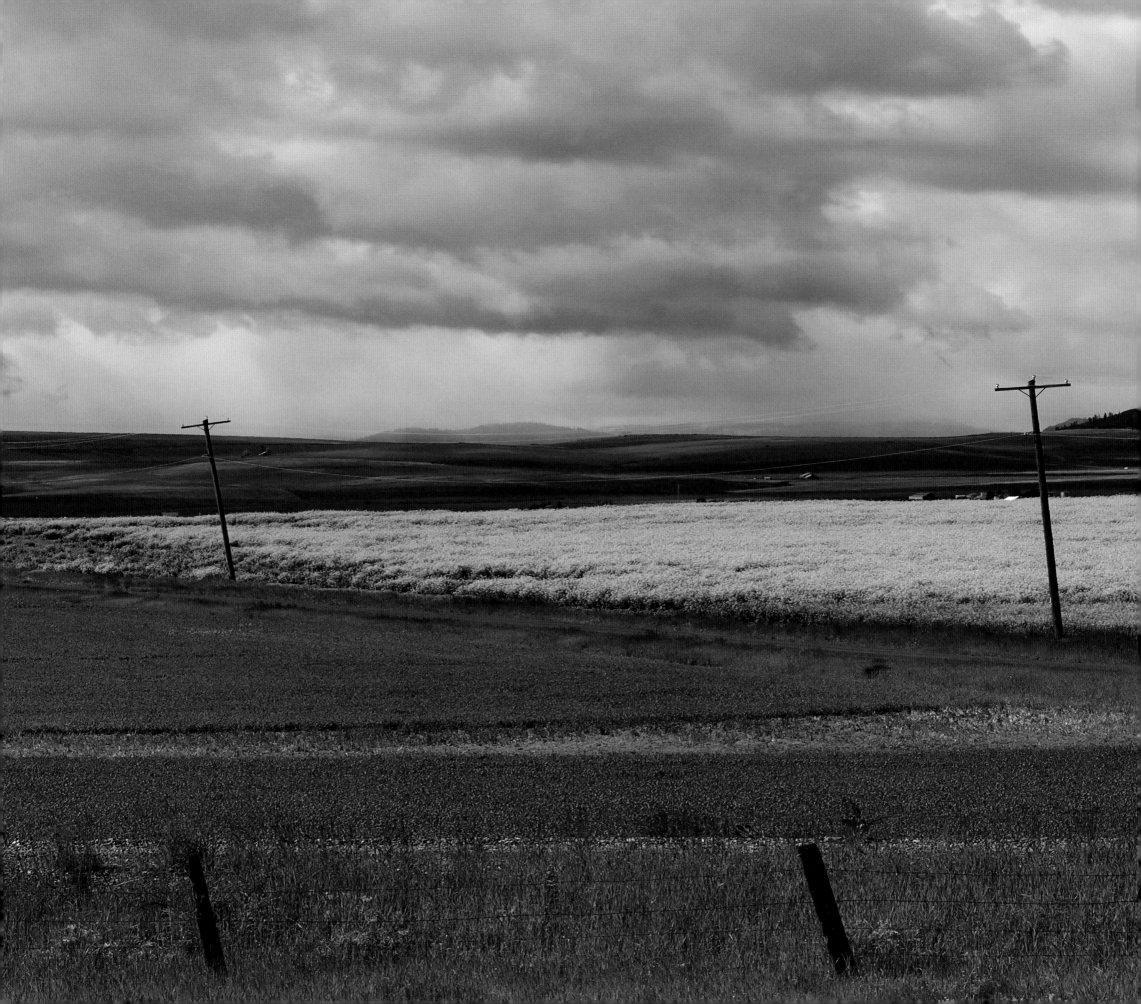

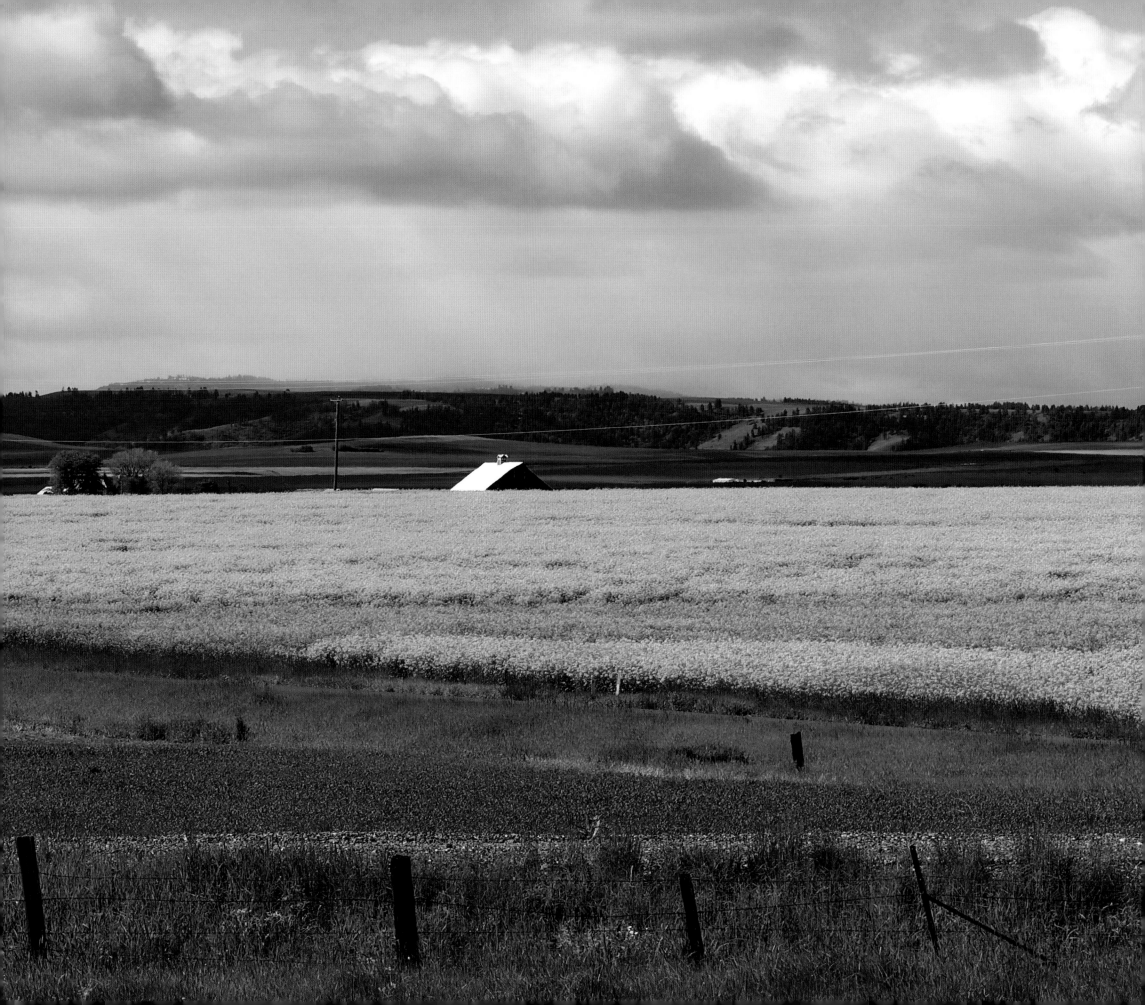

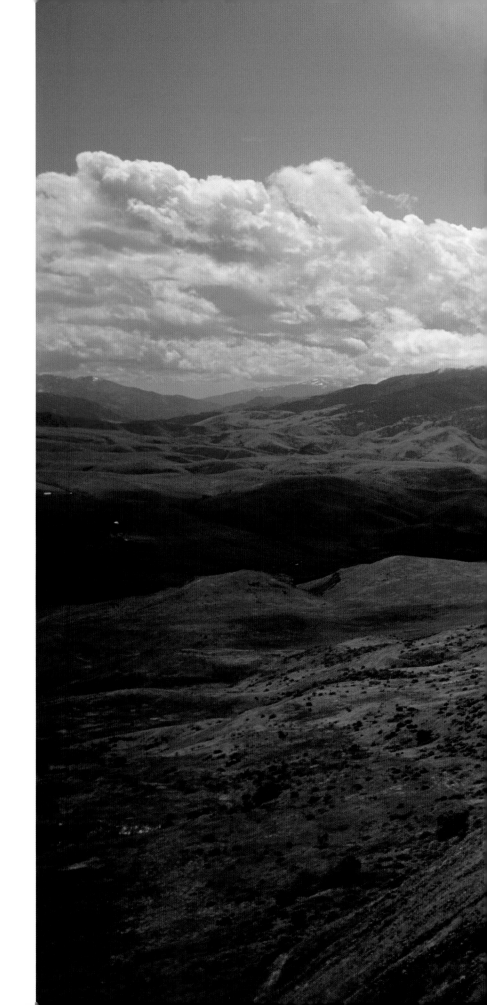

45°49'22.78"N, 116°15'40.90"W White Bird Canyon, Idaho, on Highway 95 south of the Nez Perce Indian Reservation. From this point on the road, I had the feeling of flowing downhill all the way to Florida, as if someone had picked up the corner of the country like a blanket.

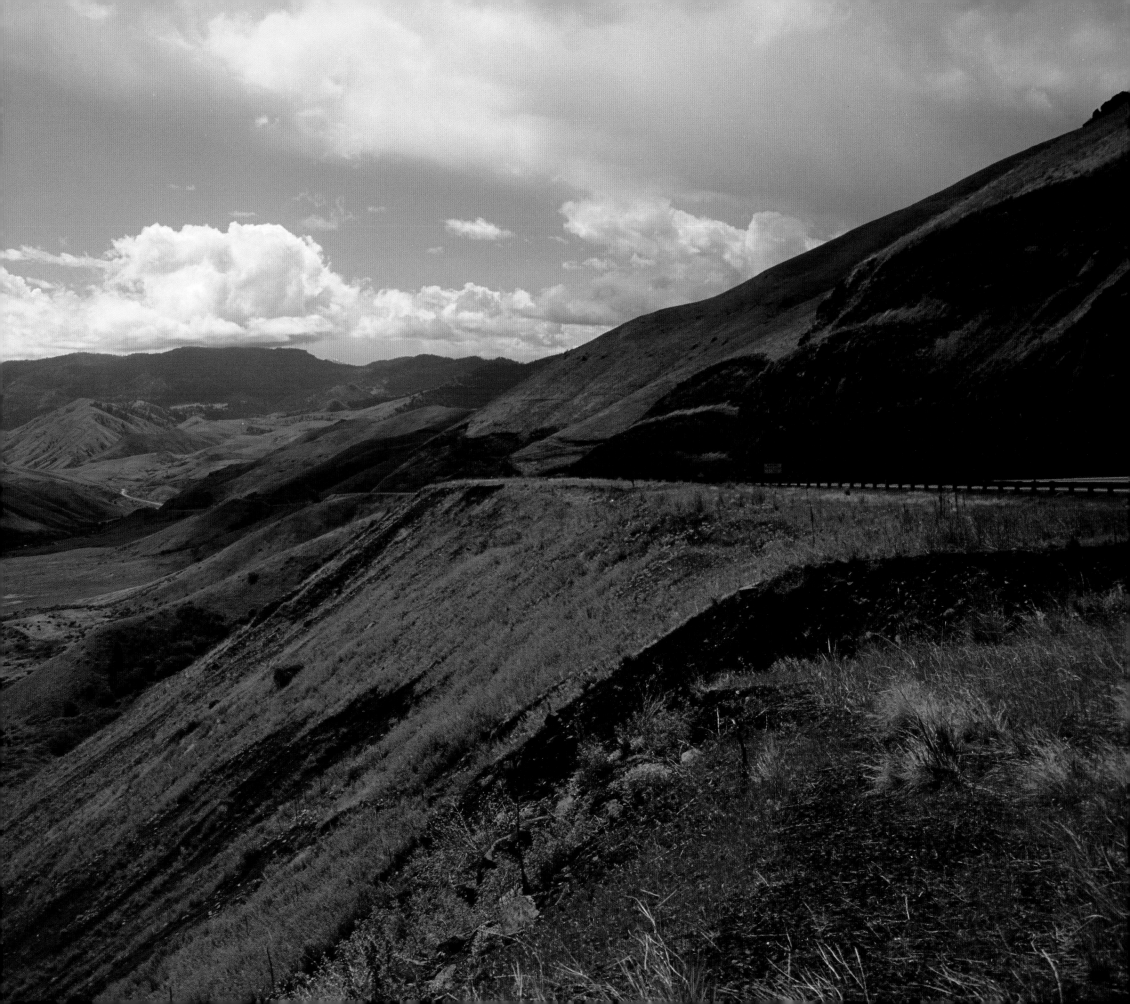

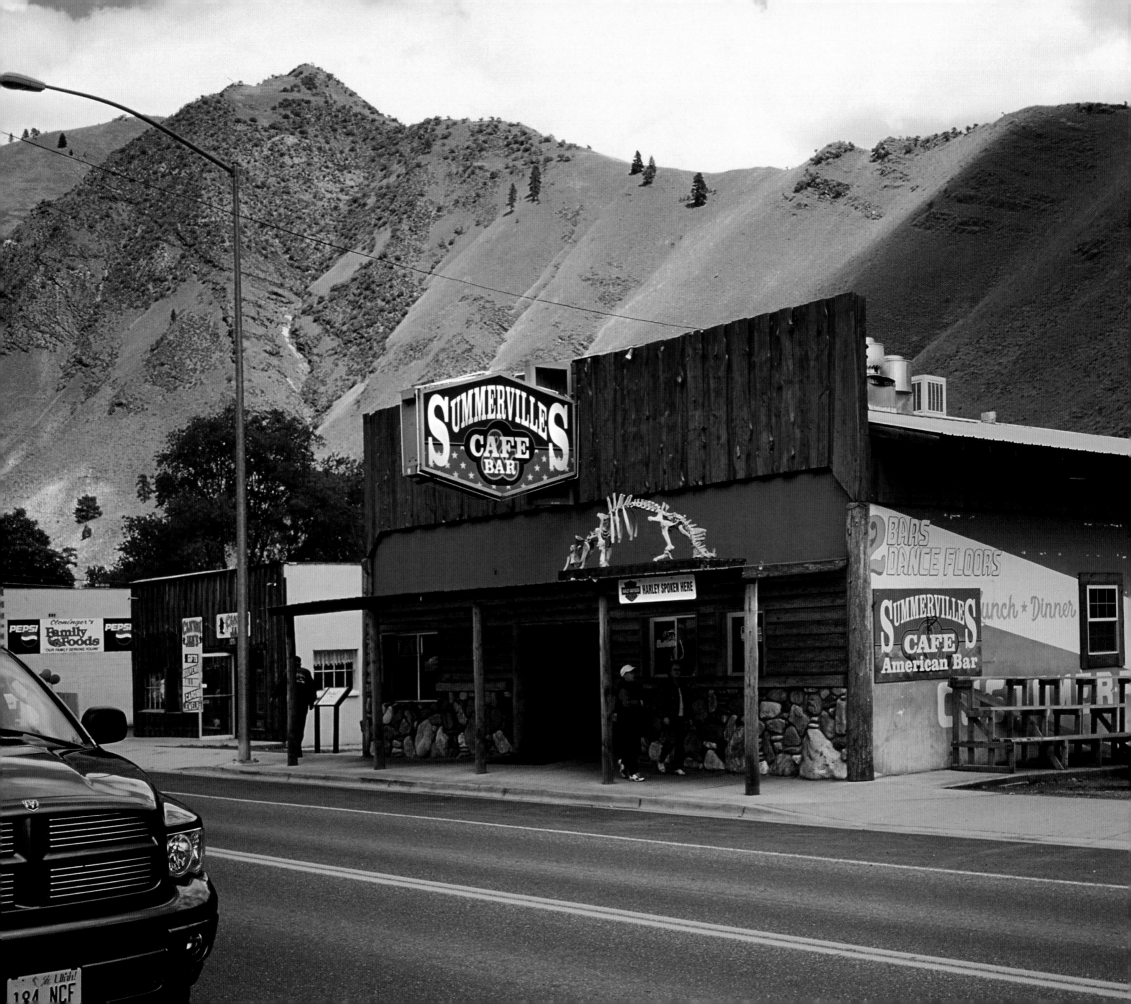

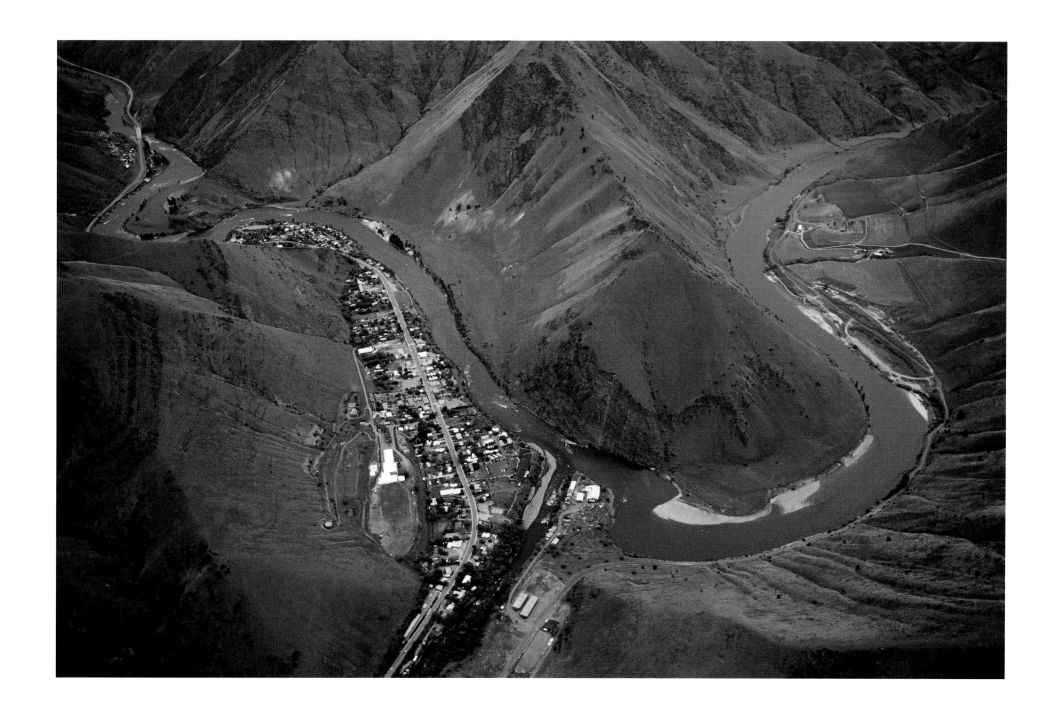

Left and Above: 45°25'17.29"N, 116°18'55.48"W Riggins, Idaho, at the Summervilles Cafe American Bar, a watering hole on Marx Street. As seen in the picture above, the town hugs the edge of the Salmon River, which flows around the base of the mountain.

Left and Above: 44°36'29.98"N, 116°02'54.71"W North of Cascade, Idaho.
An archetypal American farm, with its beautiful homesite and decorative
surroundings. It's all the more alluring from the air with its multicolored canvas.

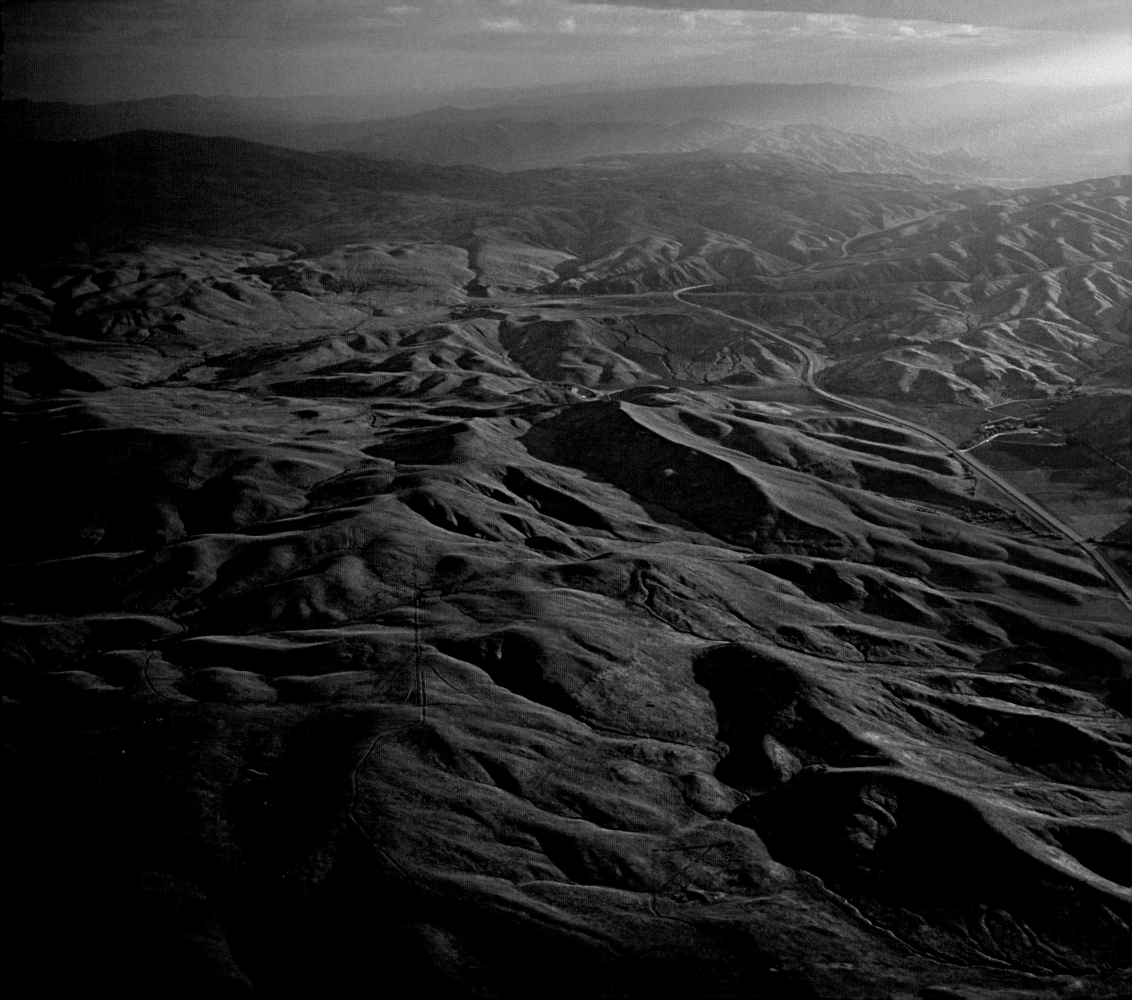

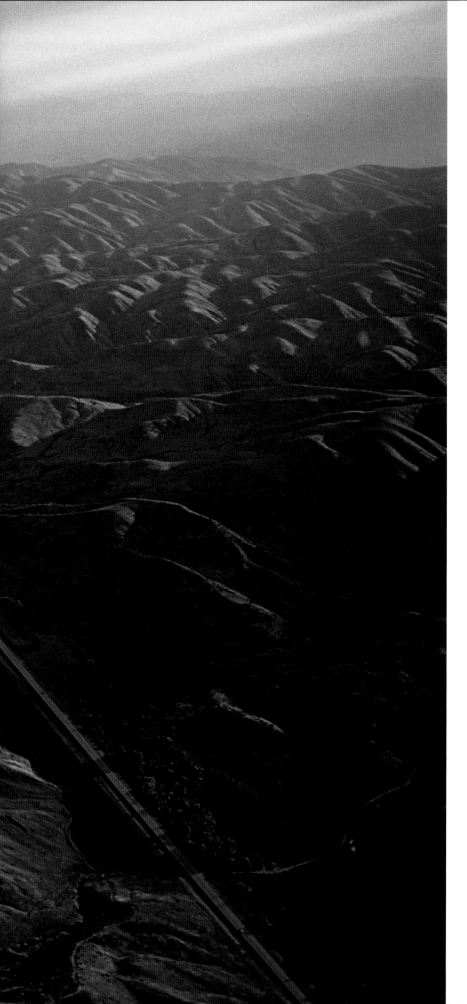

Left: 43°44'58.42"N, 116°17'24.57"W Boise National Forest, Idaho.
The flood of light sweeping across this mogul-like terrain left me breathless.

Overleaf: 42°36'08.56"N, 114°27'12.14"W Twin Falls, Idaho. The magnificent, harrowing Perrine Memorial Bridge, spanning the Snake River Canyon, was the highest bridge in the world when it was constructed in 1927.

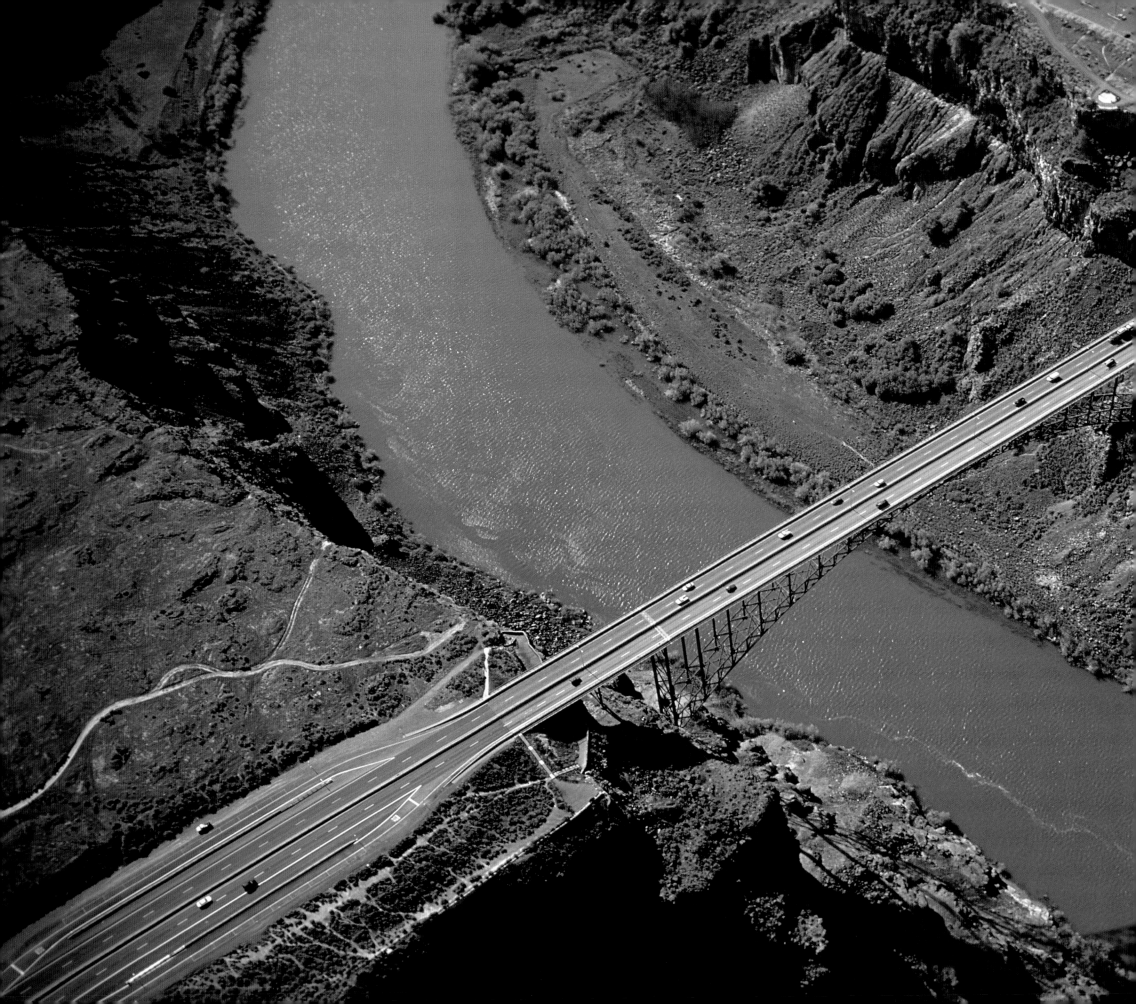

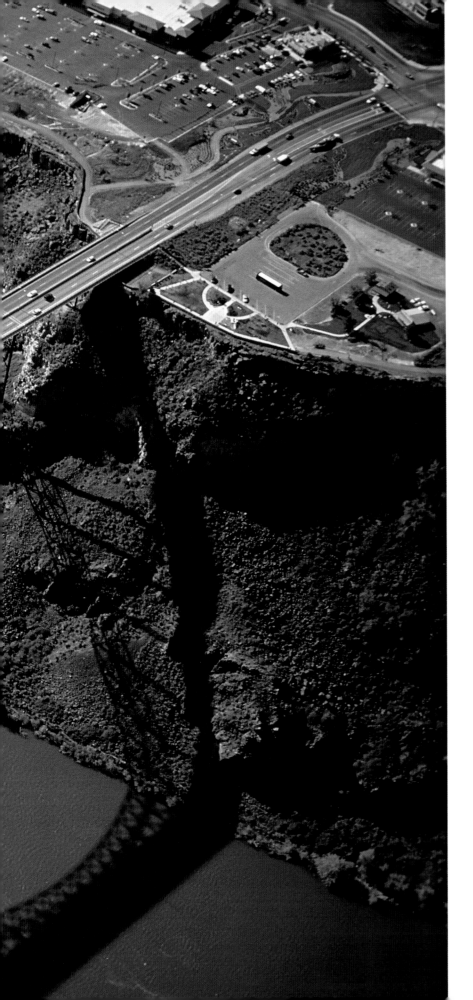
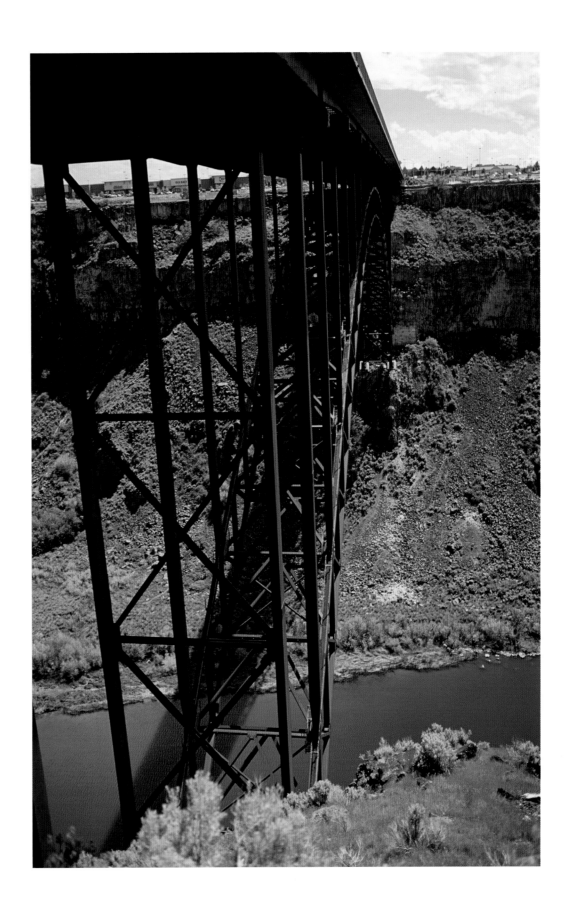

41°47'54.01"N, 112°18'02.56"W Northwest of Tremonton, Utah. Highways, trains, rivers, and bridges form the basis of our country's transportation network, which I could see on this gradual descent from Idaho to Utah on Interstate 84. Note the loneliness of the setting and chill of the sky, reminiscent of an Edward Hopper painting.

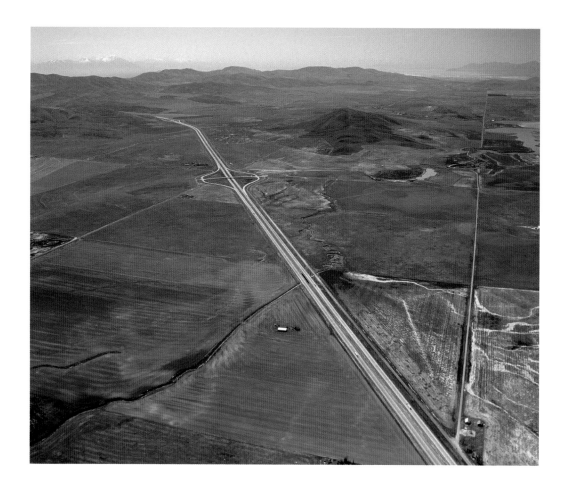

Above and Right: 41°51'44.86"N, 112°27'26.56"W Northwest of Tremonton, Utah. From the ground (at right) you can see the power substation structures, but from the air (above) you're more aware of the bigger picture—a vast highway system that sprawls miles into the distance, leaving in its wake the smaller county road that veers off into the horizon. This is an example of being able to see something from the air that I couldn't see from my bike.

Overleaf: 41°43'35.63"N, 107°43'41.83"W Twenty-six miles west of Rawlins, Wyoming, on Interstate 80. This blast from the past is a disappearing sight from the landscape of American pop culture and historical celebration. Note the shrewd marketing skills of these firecracker vendors: brilliant colors, patriotic flags, and the unabashed positioning of the port-a-john. Notice the "No Smoking!" sign on the building's façade. Not a good place for cigarettes.

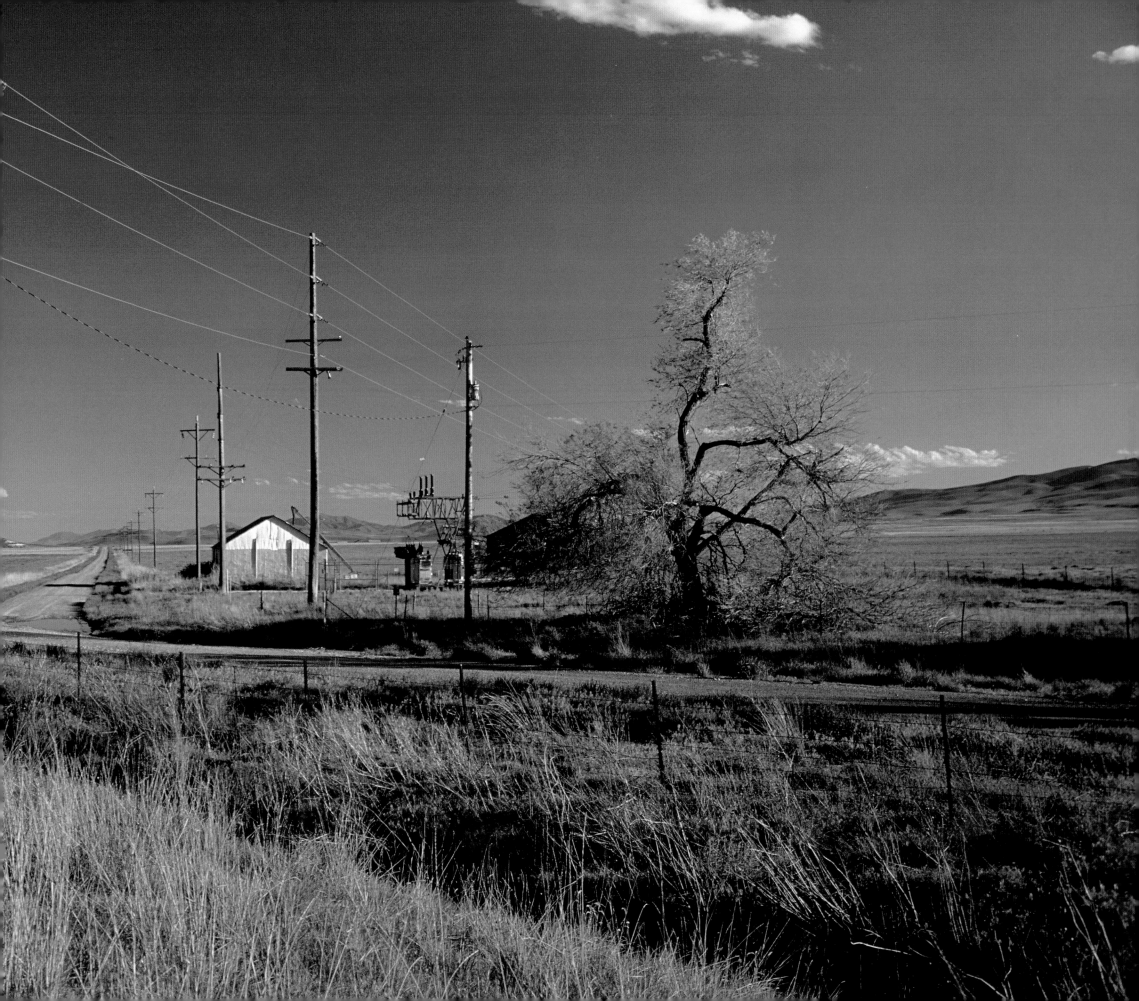

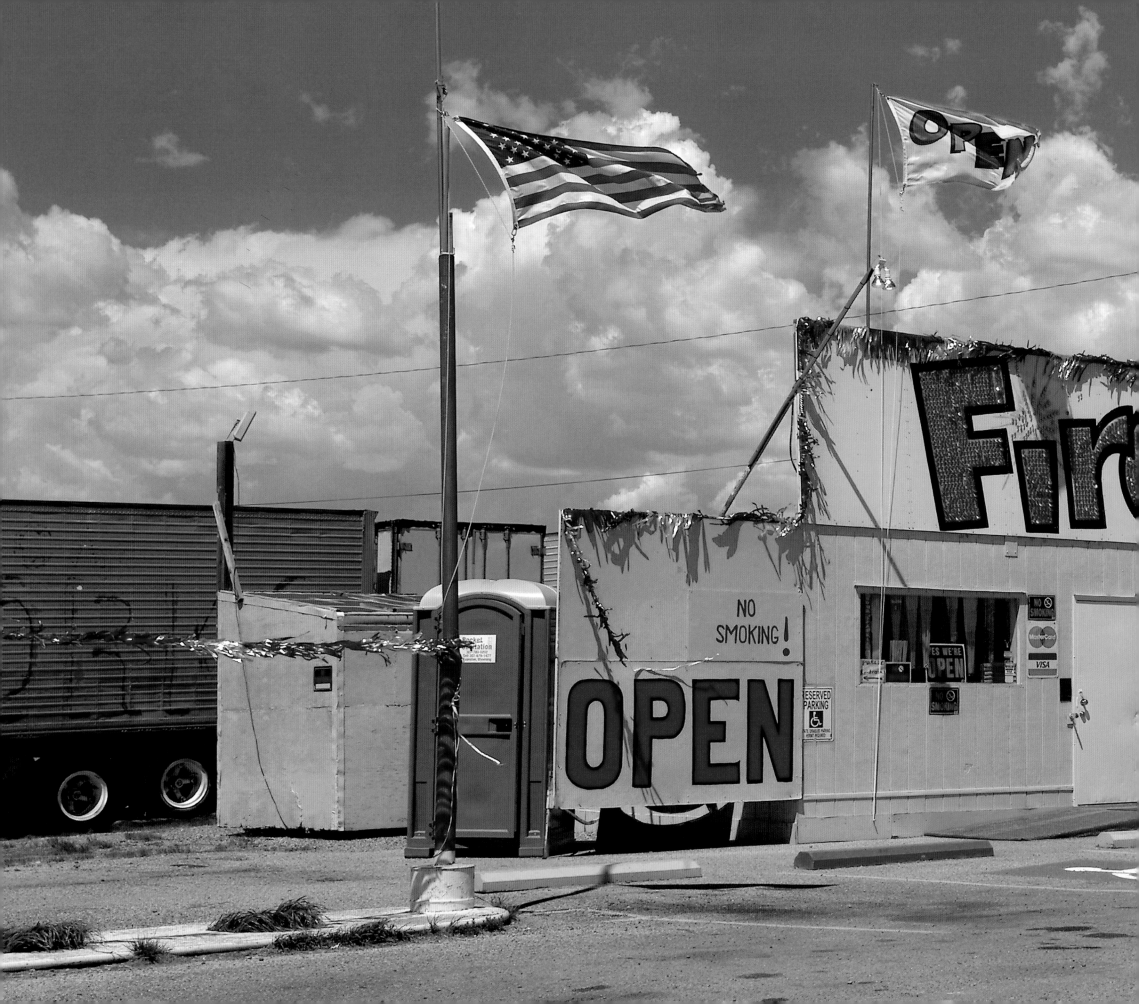

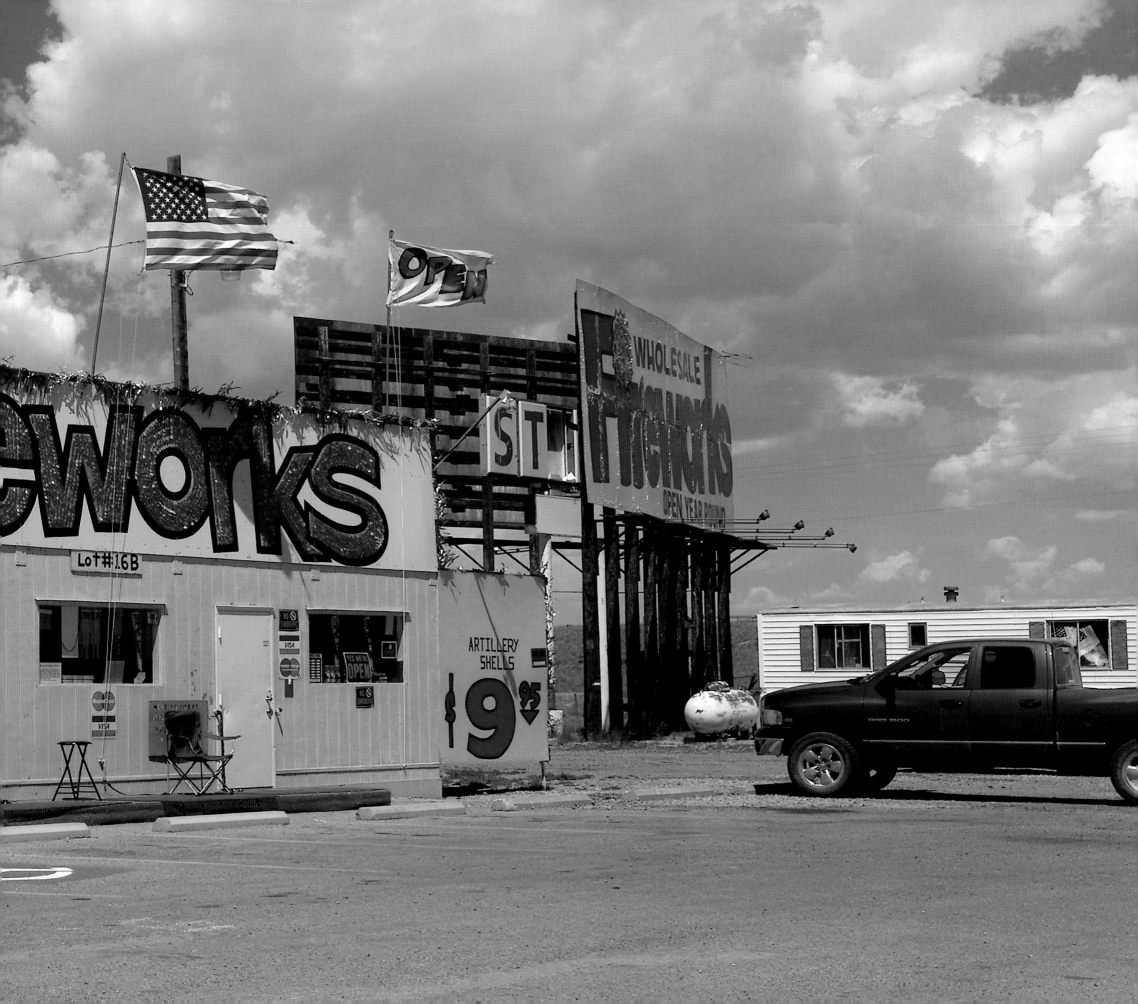

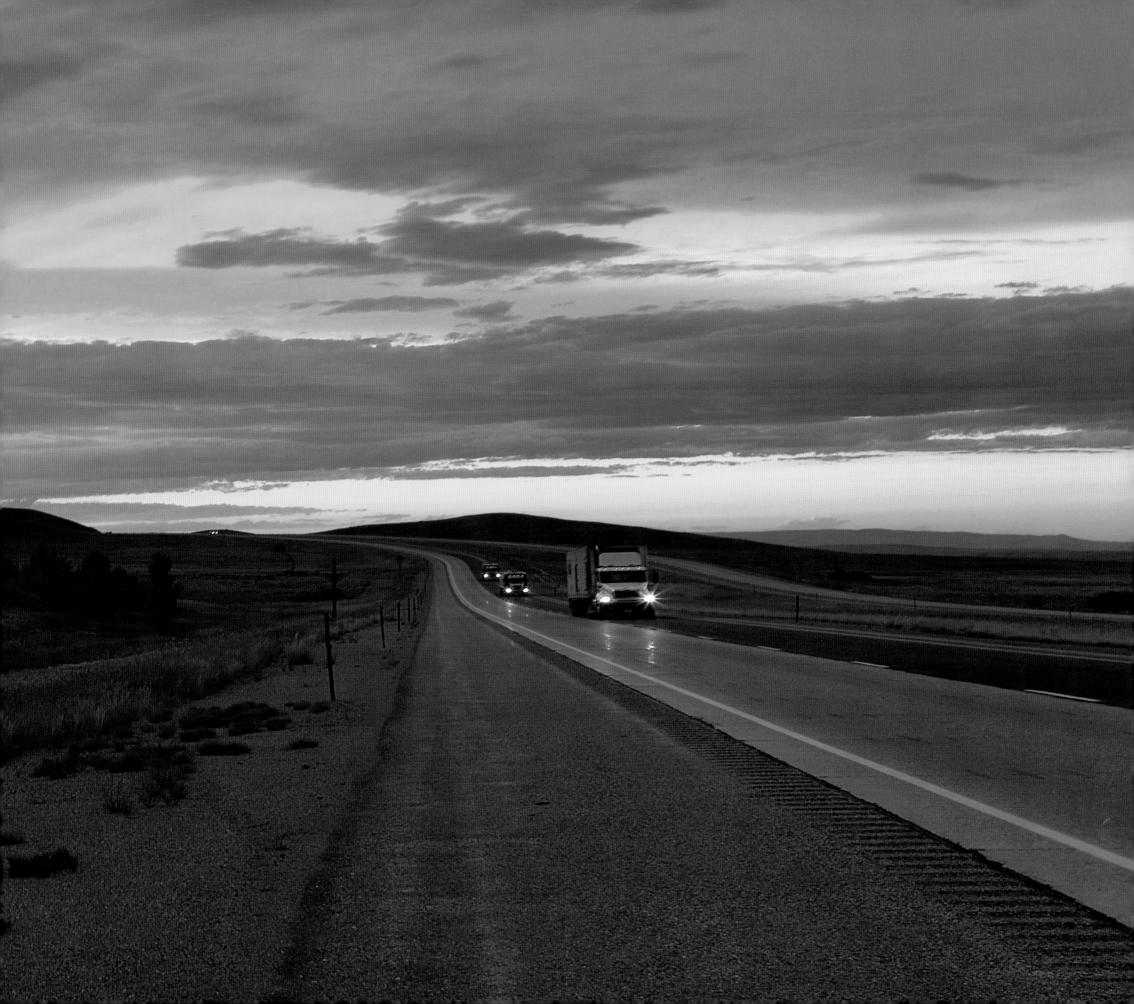

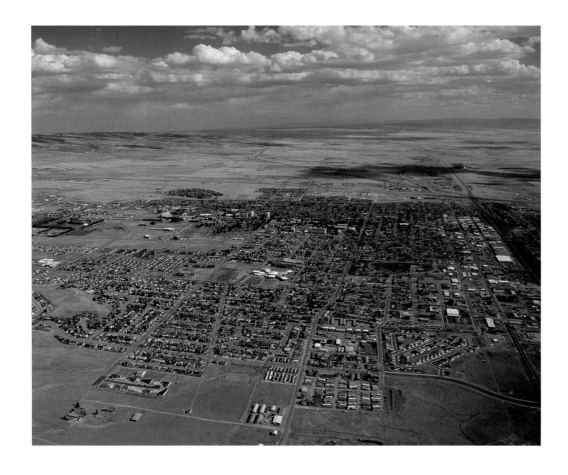

Preceding Page: 41°36'42.34"N, 106°13'58.30"W Near Arlington, Wyoming, looking west on Interstate 80. This day's ride was the longest of my Washington-to-Florida trip, ending with the onset of nightfall—a time of day I preferred not to travel. But, fortunately, I made it to Laramie, just 40 miles away, before dark.

Above and Right: 41°18'43.77"N, 105°35'41.43"W Laramie, Wyoming. An aerial view (above) of this town of 28,000 people located in southeastern Wyoming, 49 miles west of the state capital of Cheyenne. Home of the University of Wyoming Cowboys with their mascot, Pistol Pete, Laramie sits 7,200 feet above sea level on the eastern edge of a large plateau called the Laramie Plains. Note the quiet elegance of the American–Victorian architecture with its majestic storefronts (at right) along South 2nd Street—a fine example of intelligent urban planning.

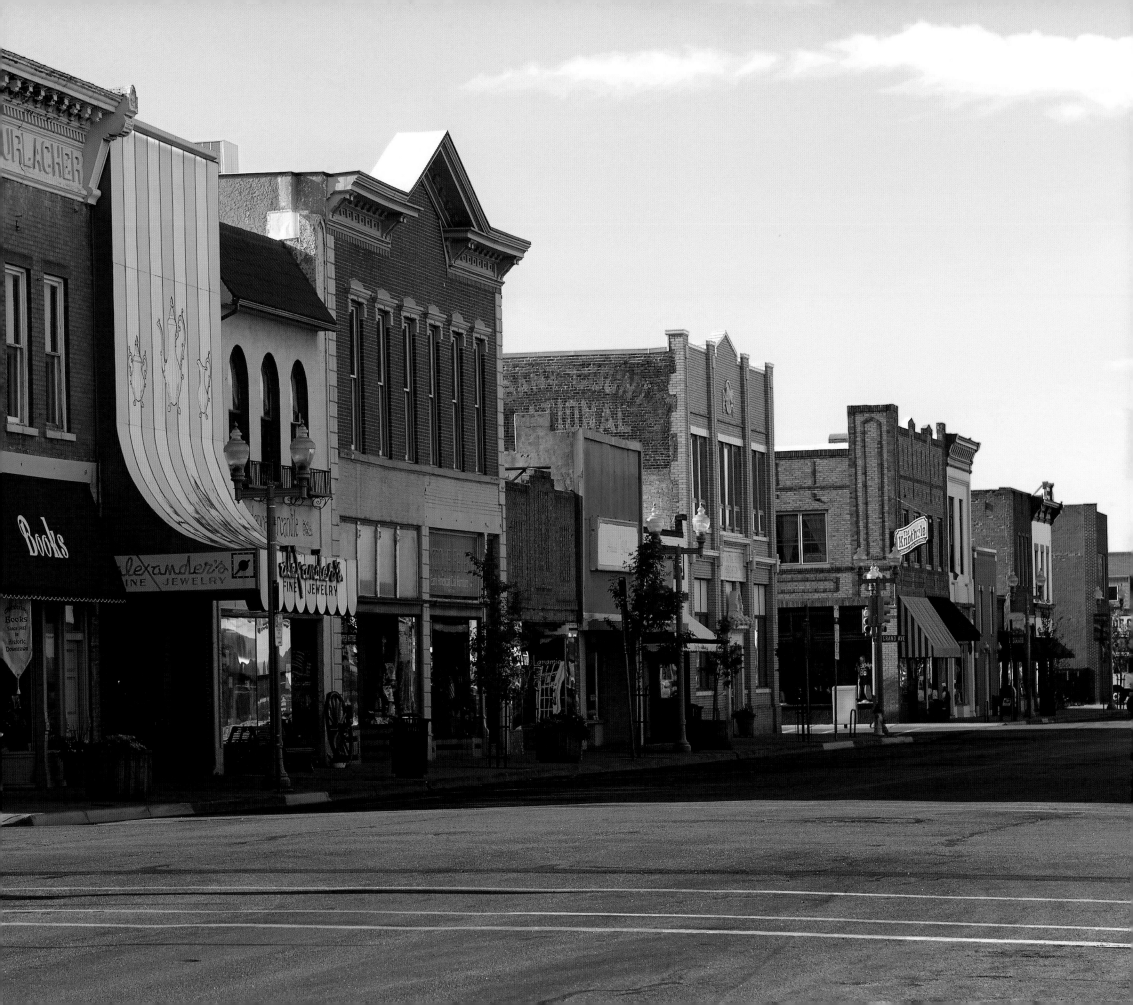

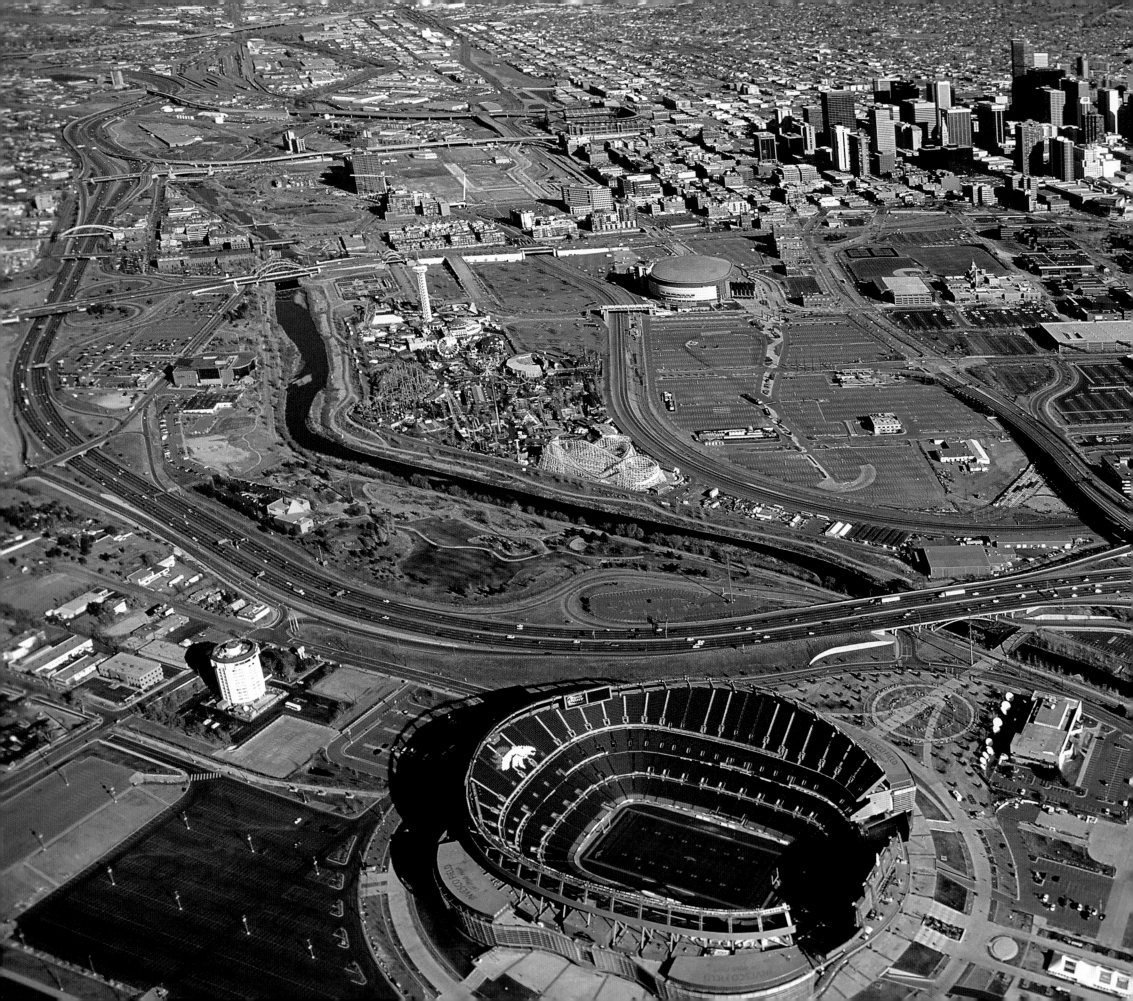

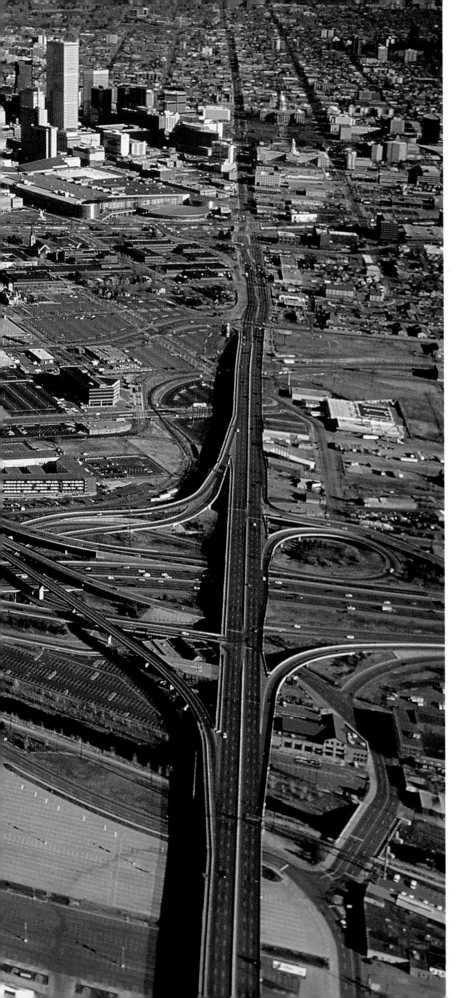

Left: 39°44'29.16"N, 105°01'28.69"W Denver, Colorado. Looking east along Colfax Avenue and across Interstate 25. As it turned out, Denver was the most heavily populated city on my crisscross route after leaving Seattle. Driving with a fouled plug at rush hour, I didn't take any pictures of this metropolis from the side of the road, since it was safer to leave this to my aerial photographer.

Overleaf: 38°07'50.26"N, 104°01'25.78"W Fowler, Colorado. This is archetypal, small-town America at its finest: peaceful, quaint, clean Main Street. To many, this may seem like a time-warp experience, with its pickup truck, lampposts, and old-fashioned clock on the Art Deco bank sign. I knew this town in my heart without ever having seen it before.

81

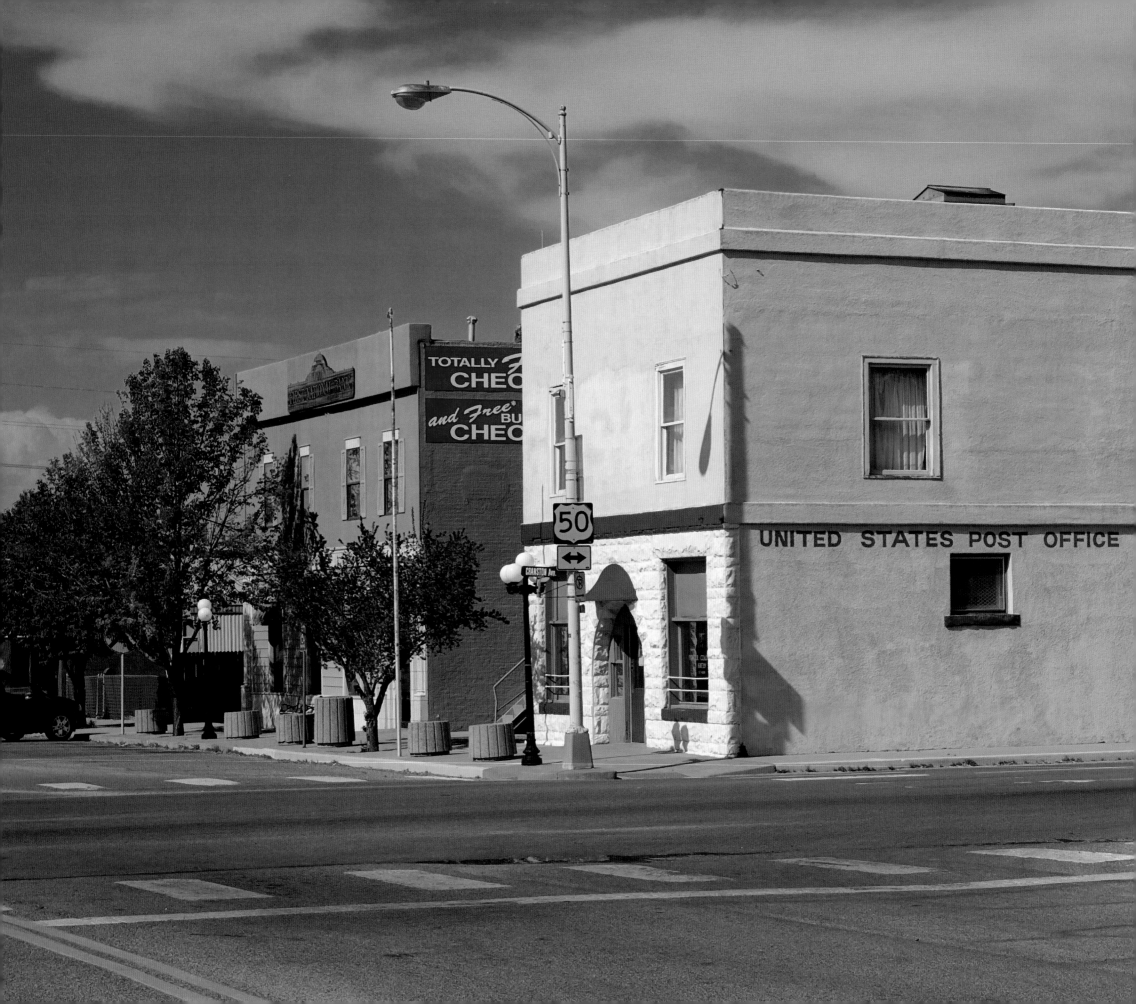

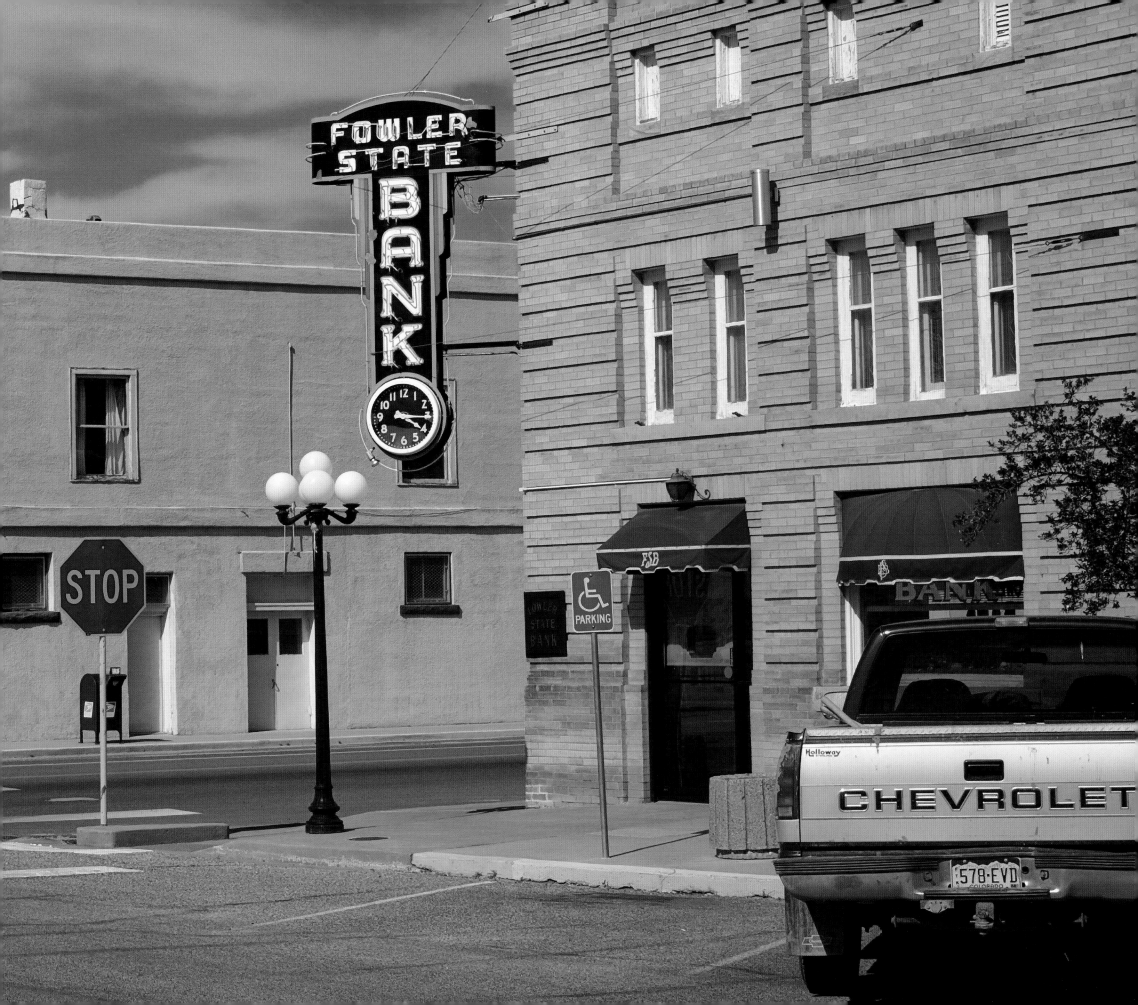

Left and Above: 38°05'17.14"N, 103°12'07.88"W North of Las Animas, Colorado. A modest but charming airplane hangar that one rarely sees anymore. The orange windsock indicates the direction of the wind, as do the sweeping cirrus clouds in the sky. As a solitary rider on my motorcycle, I felt a kinship with this solitary plane, both of us with the wind in our nose, barely protected from the elements.

Overleaf: 37°57'37.59"N, 100°49'11.01"W A mobile-home park on Highway 50/400 in Garden City, Kansas. The types of homes throughout my travels changed from street to street and the diversity never ceased to amaze me.

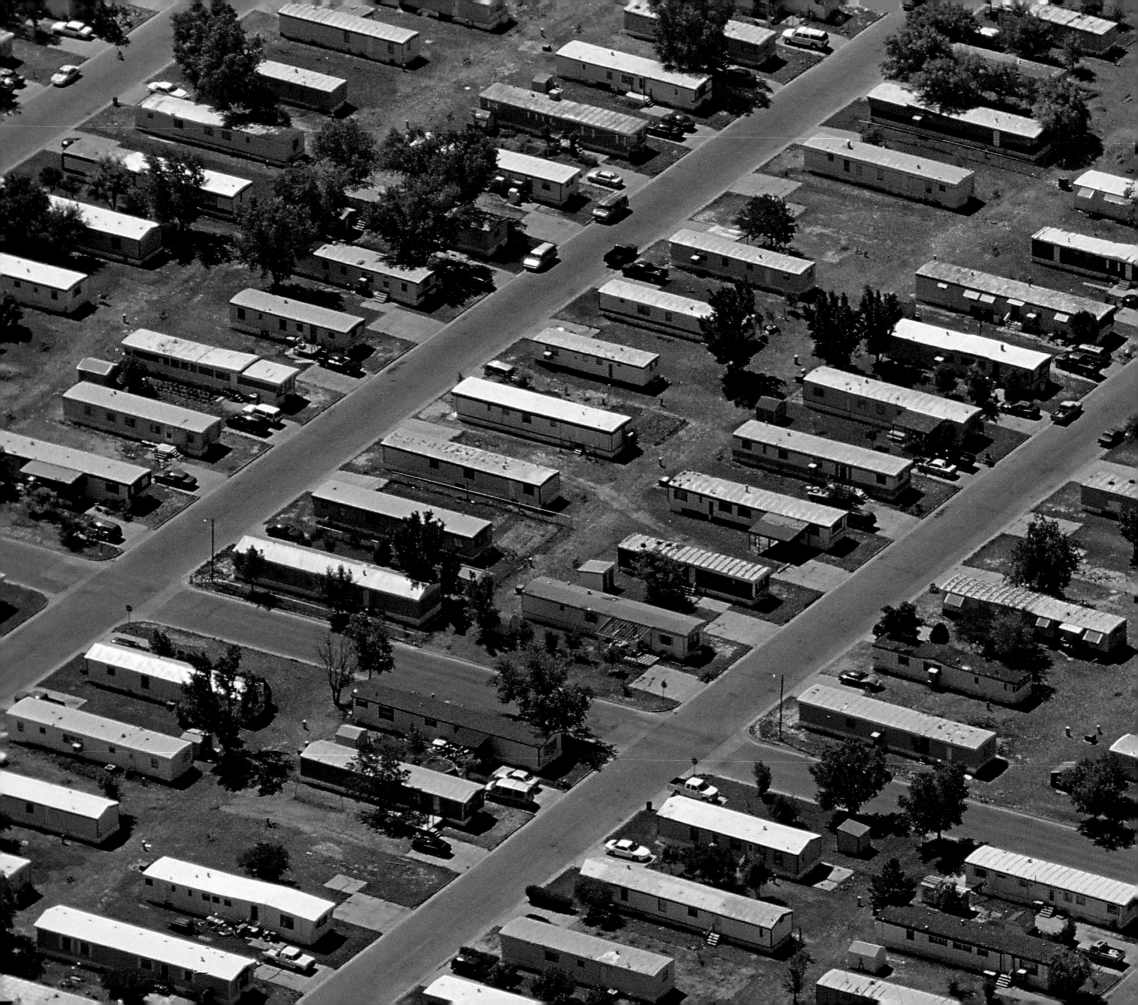

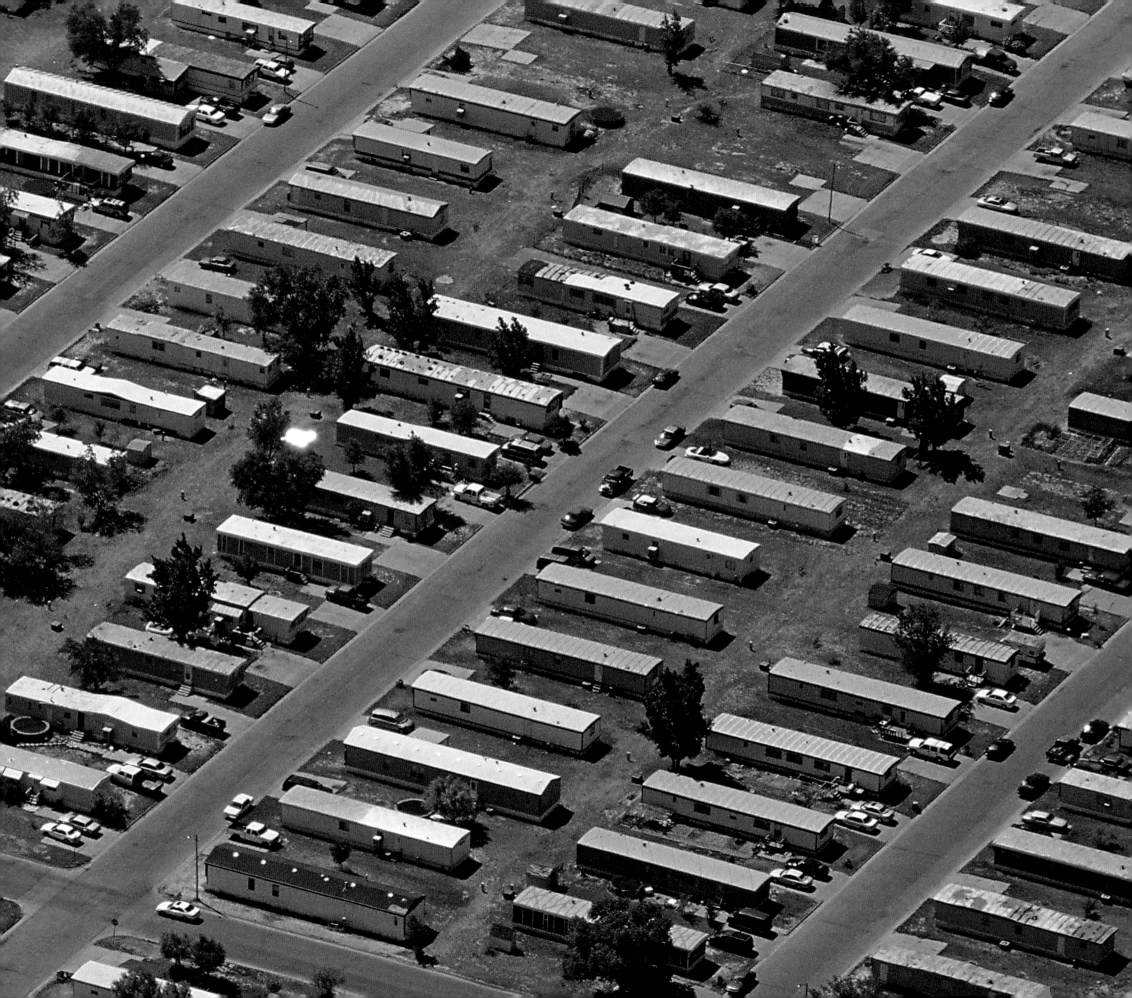

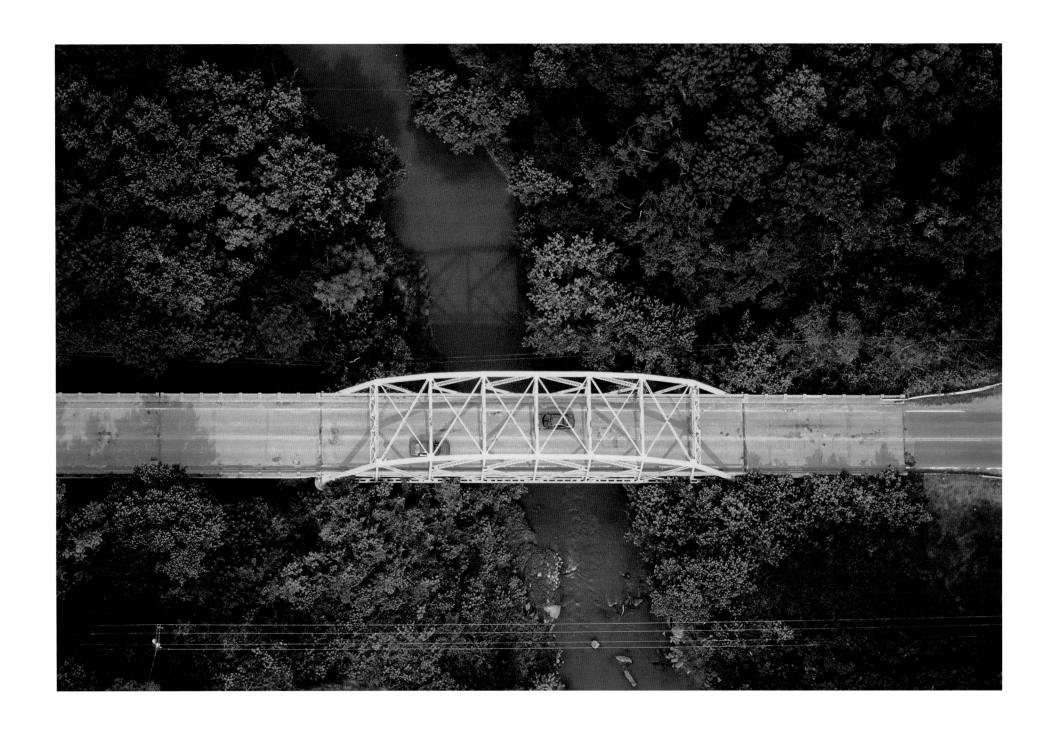

Above and Right: 36°19'00.57"N, 95°59'29.47"W North of Sperry, Oklahoma, on Highway 11. The Hominy Creek Bridge basks in the rays of a setting sun. It's hard to believe this was only minutes away from the bustling, urban center of Tulsa, Oklahoma.

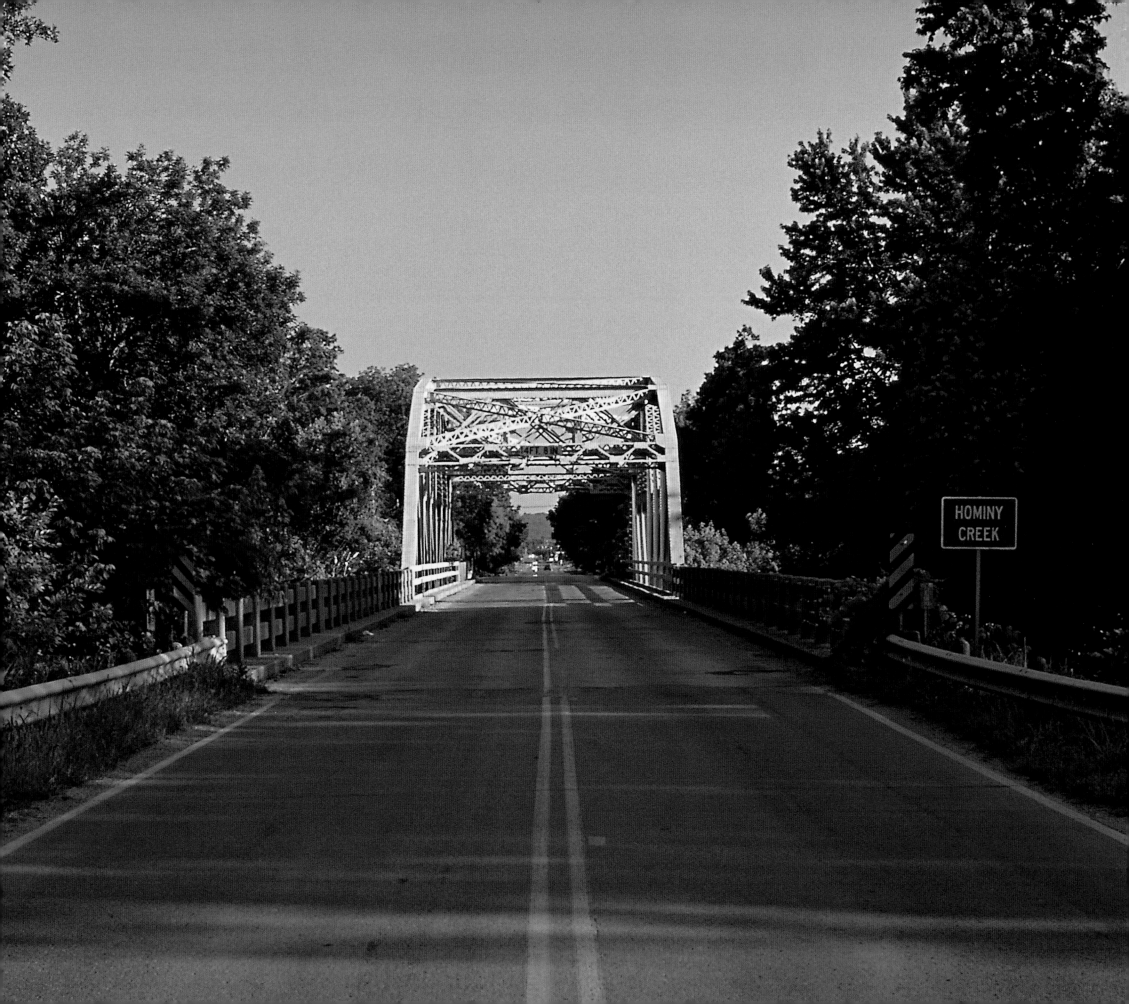

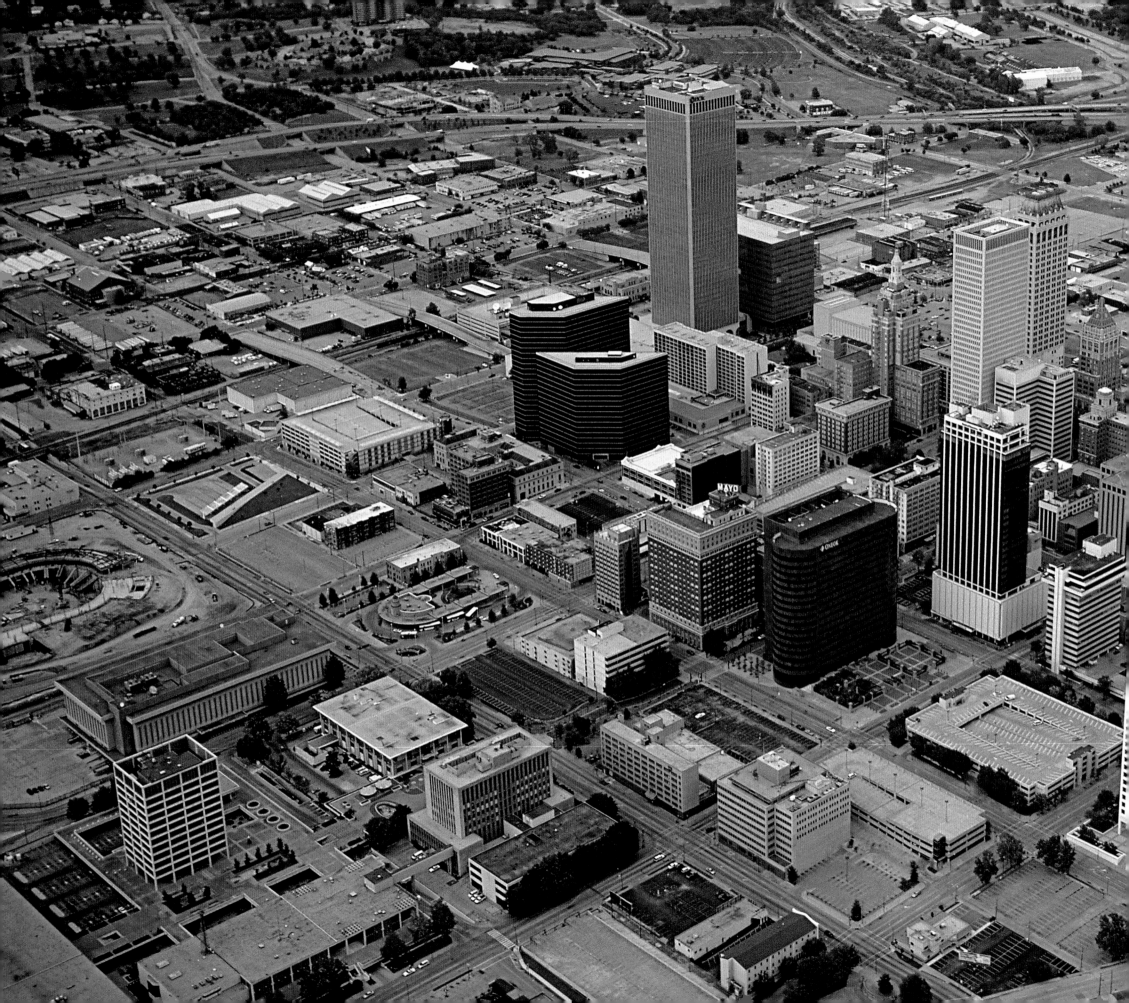

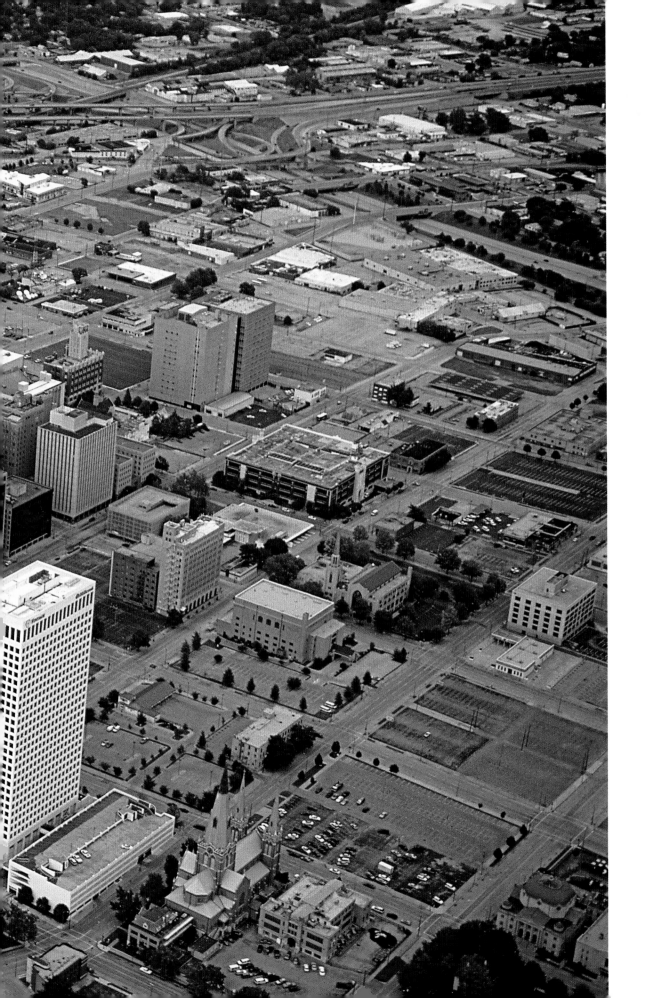

Left: 36°08'40.07"N, 95°59'32.05"W Tulsa, Oklahoma. Remarkably, this was one of the few cities I encountered on this journey that, from the road, appeared as if it were a bouquet of tall, spring flowers placed in a simple, stylish vase. From the air, you can see that the city has been thoughtfully developed within its forested setting.

Overleaf: 34°49'04.21"N, 94°02'15.30"W Needmore, Arkansas, on Highway 71. From the roadside, I got a glimpse of the Ouachita National Forest, the South's oldest and largest national forest at 1.8 million acres. The aerial photograph, looking west down Highway 270 at the same forest, expands the experience of the earthbound journey.

91

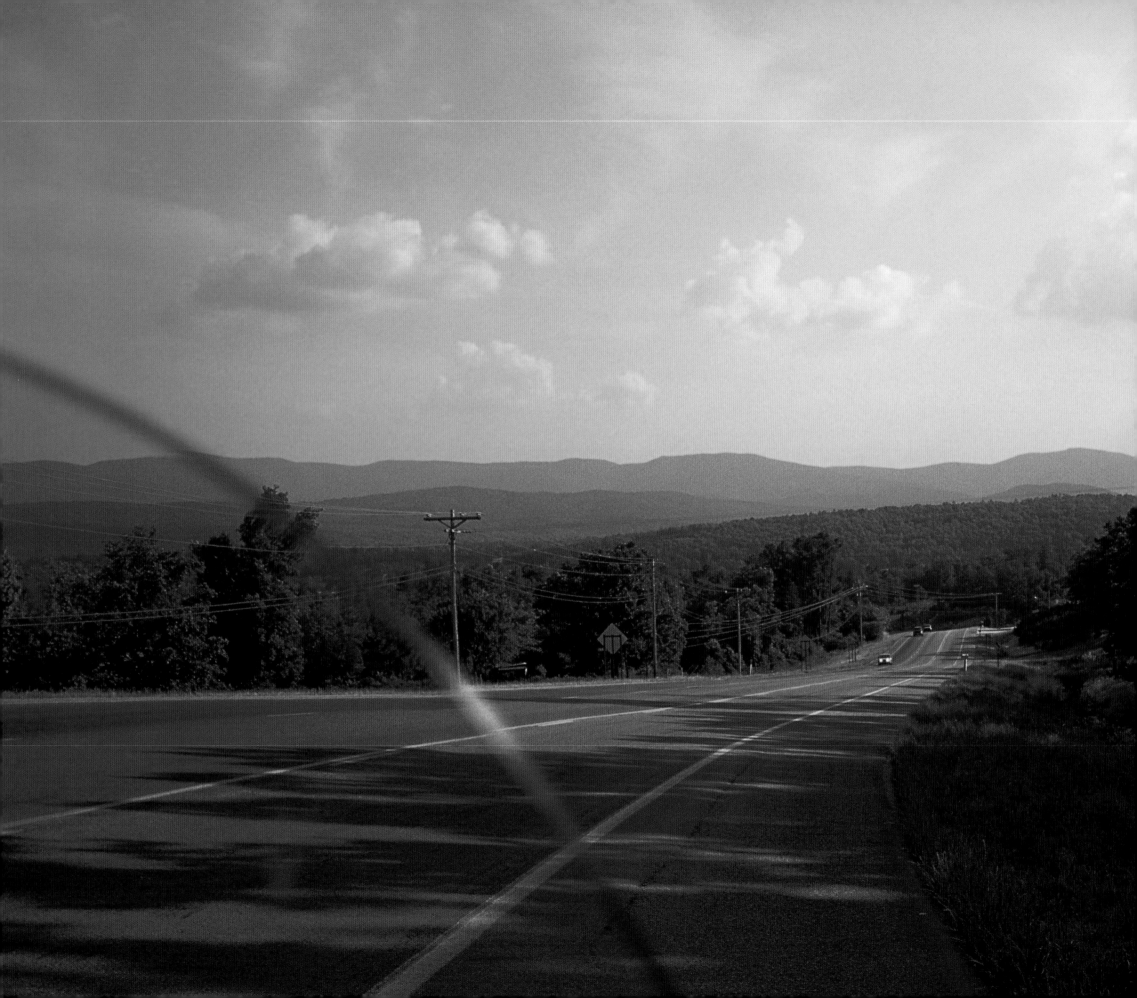

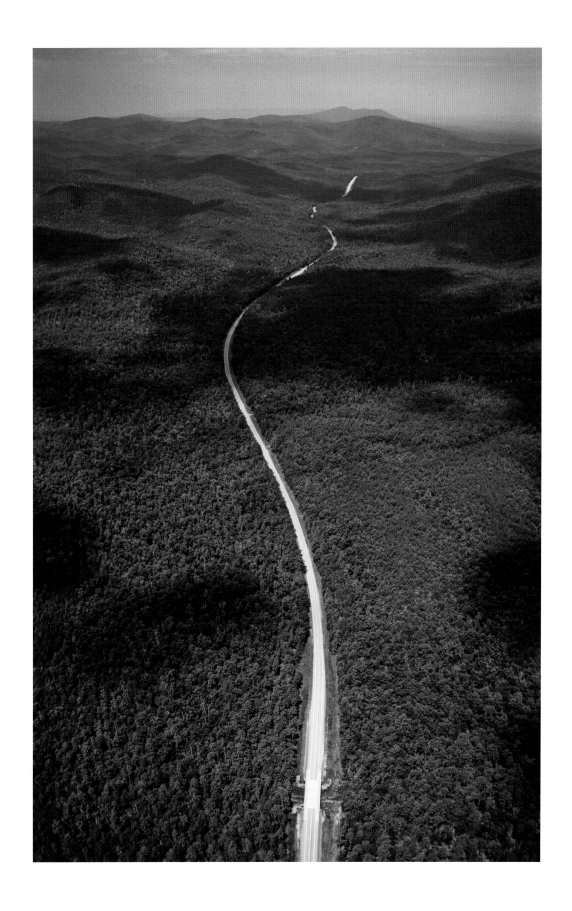

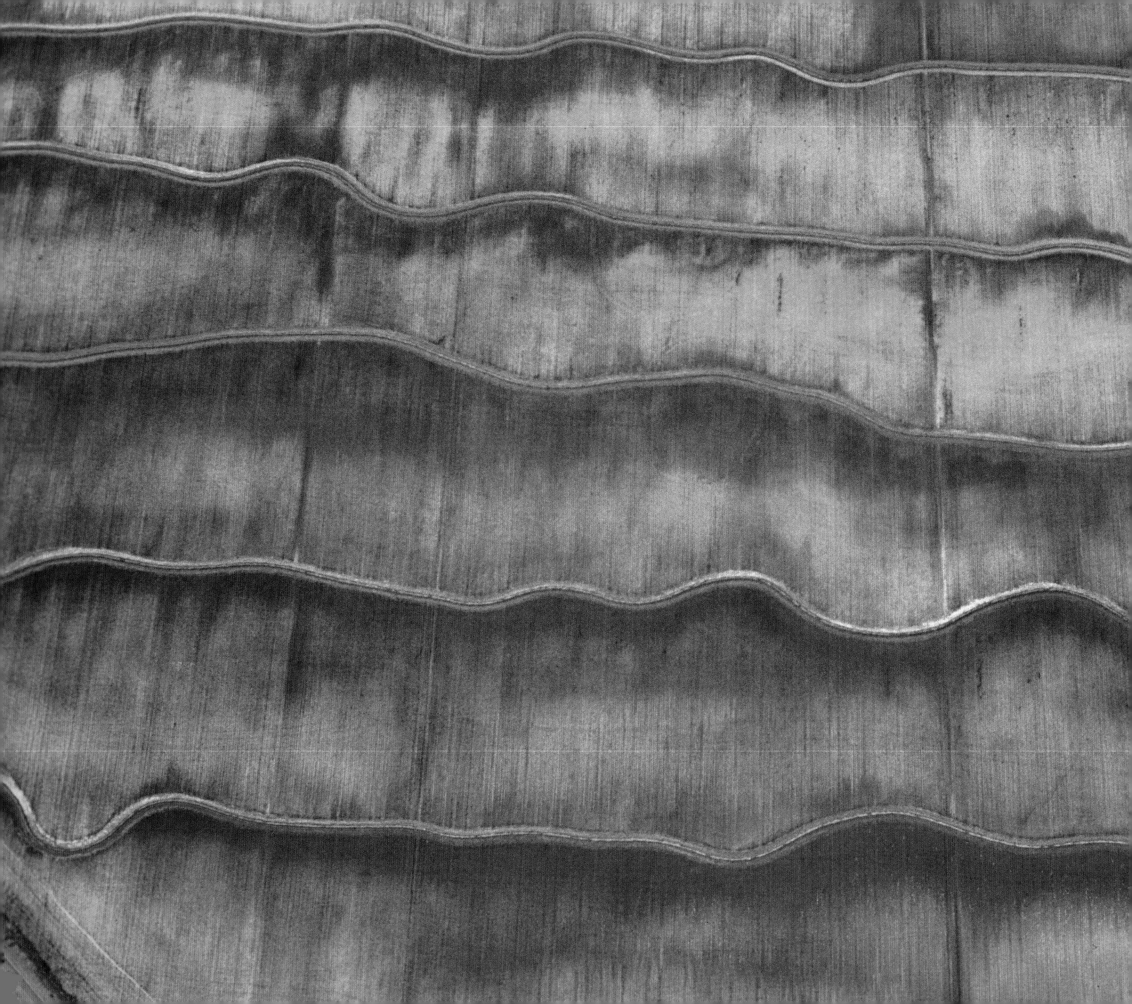

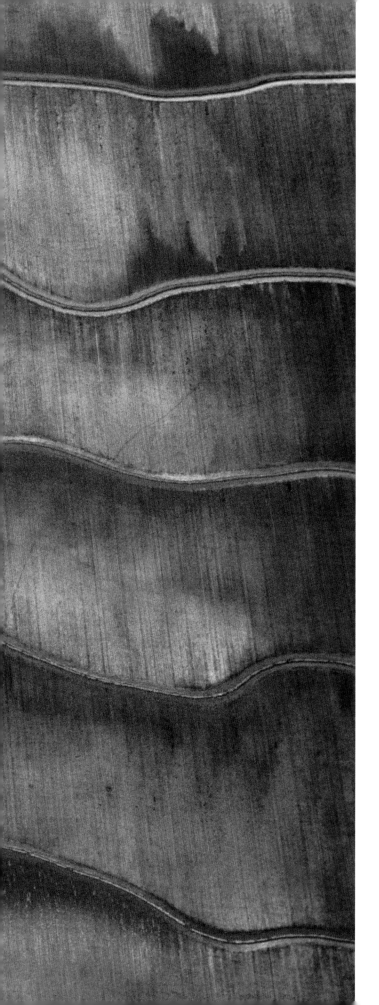

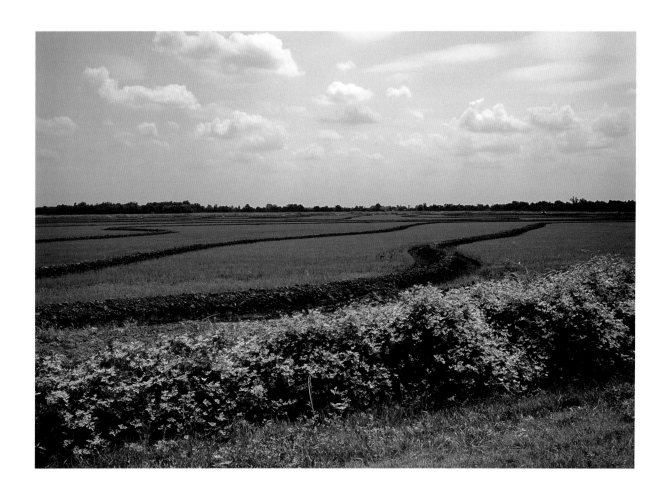

Left and Above: 34°11'41.01"N, 91°54'31.97"W Southeast of Pine Bluff, Arkansas. In the image above, the mounds of dirt in the rice fields seem to be constructed in random fashion, as if by groundhogs. In fact, they are made to contain the water used to flood these fields. In the aerial view at left, the green is paler because the light reflects from the shallow water covering the ground. This mesmerizing image looks like a delicate, Italian-designed silk fabric.

Overleaf: 33°17'36.79"N, 91°09'32.34"W Benjamin G. Humphreys Bridge, Greenville, Mississippi. I first crossed the legendary Mississippi River, also known as the "Big Muddy," at dusk. The road's narrowness and the bridge's webbed design indicate its age, yet despite its simple elegance and sturdiness, it is being replaced by a modern suspension bridge. The latter is under construction half a mile down the river.

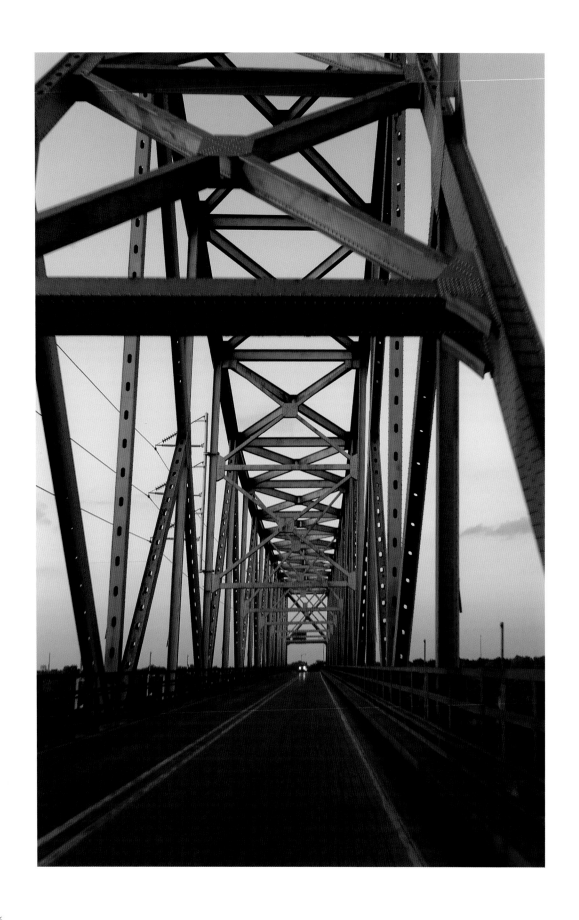

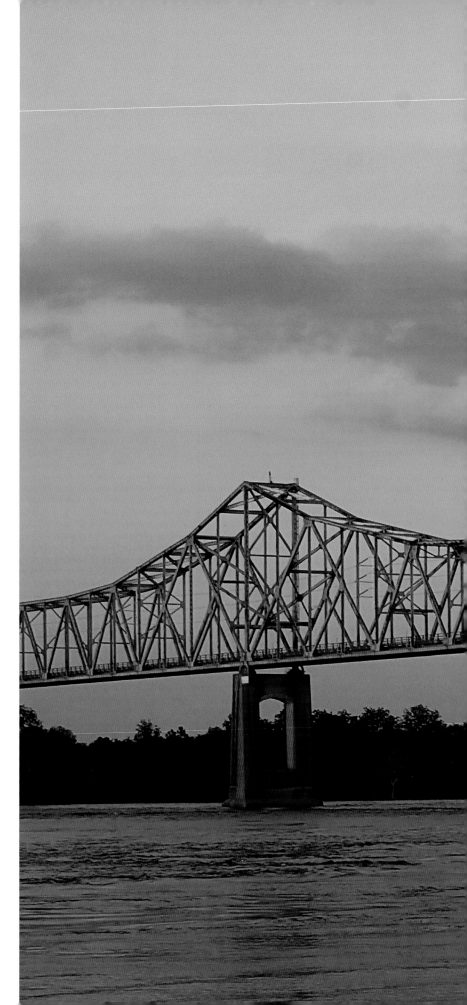

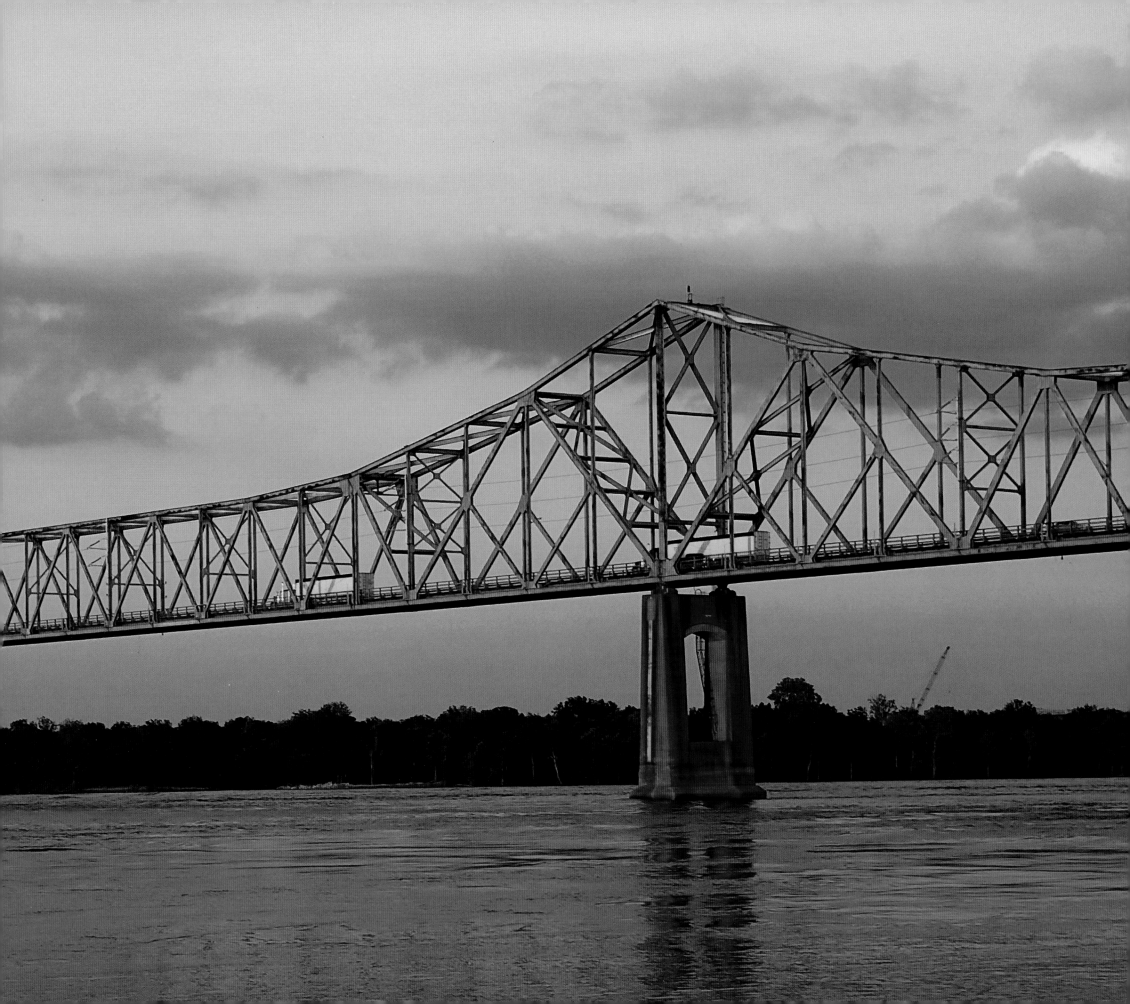

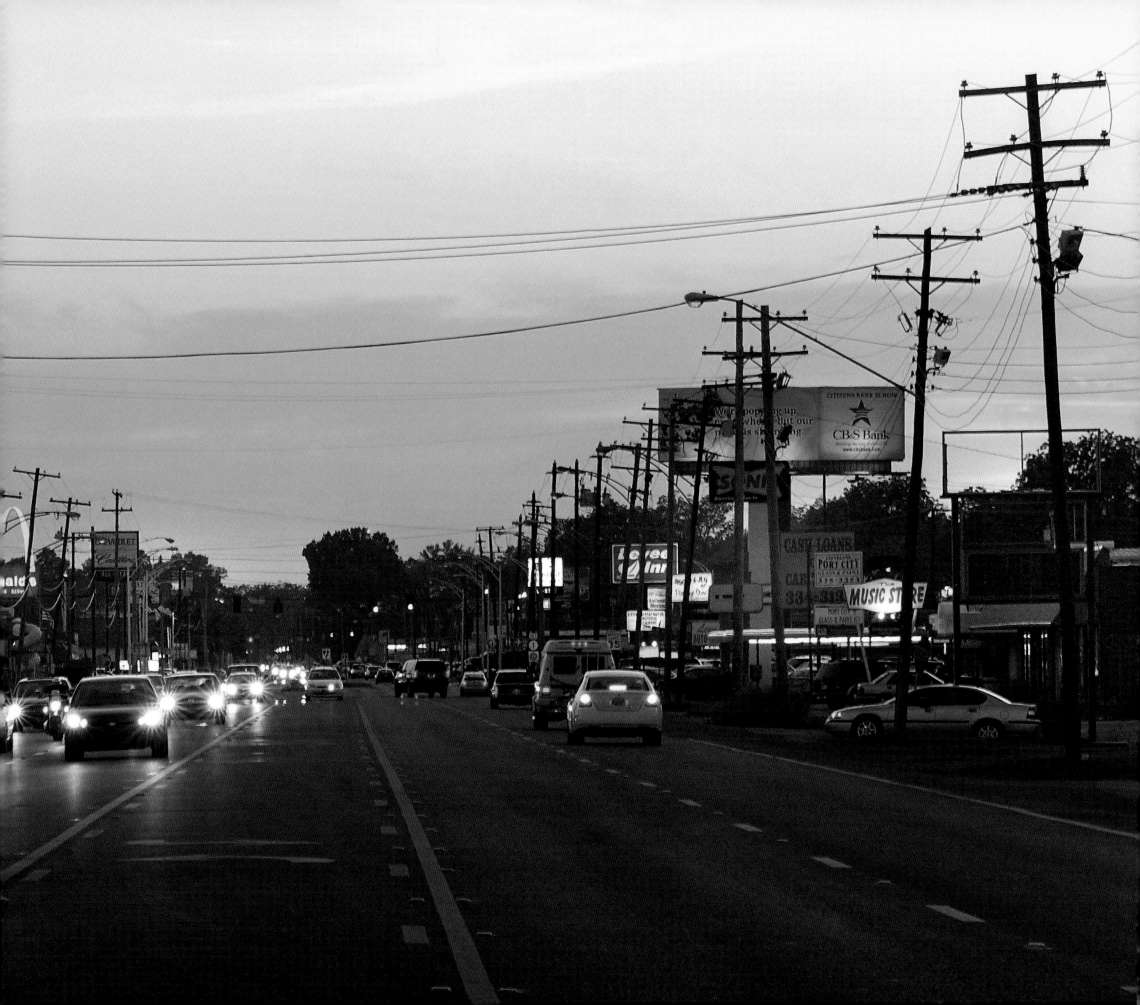

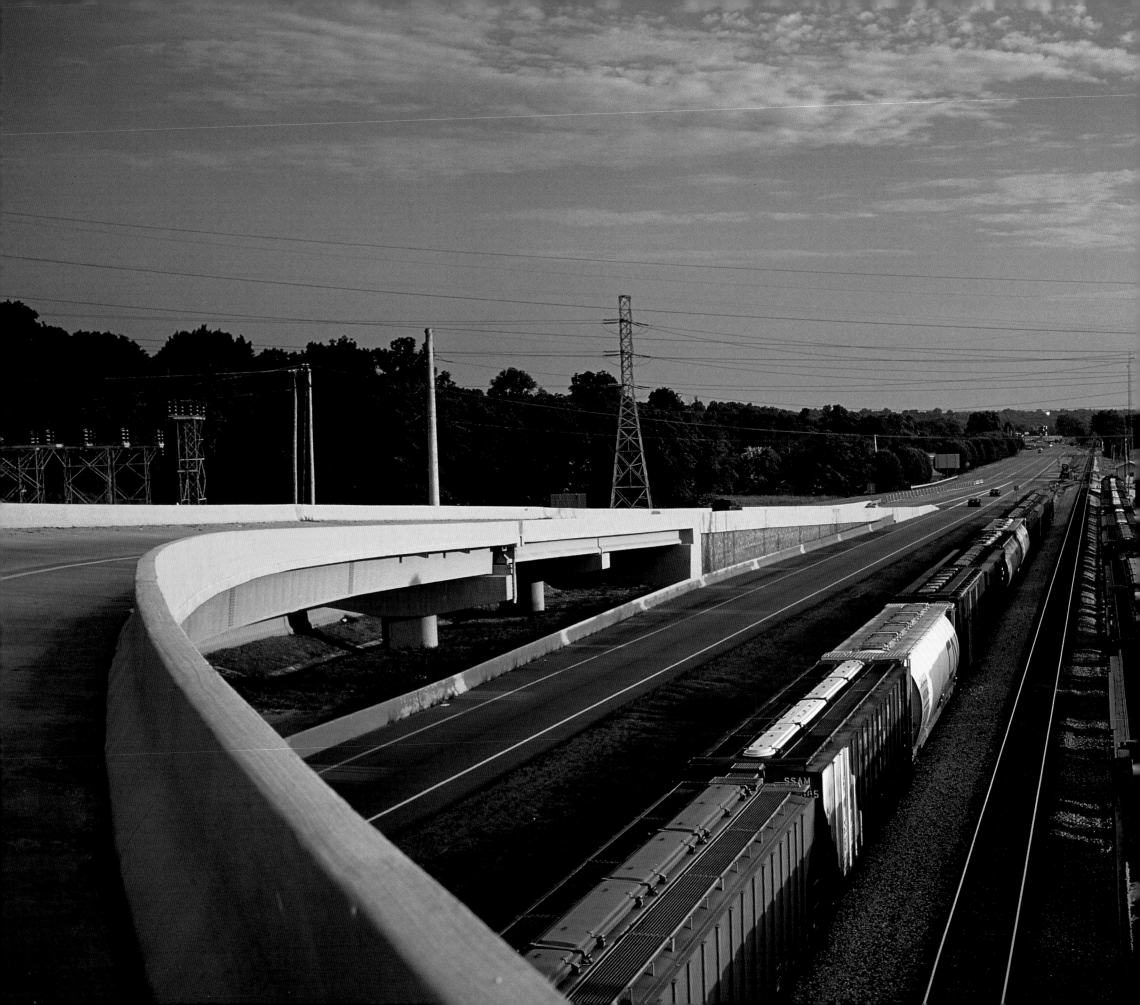

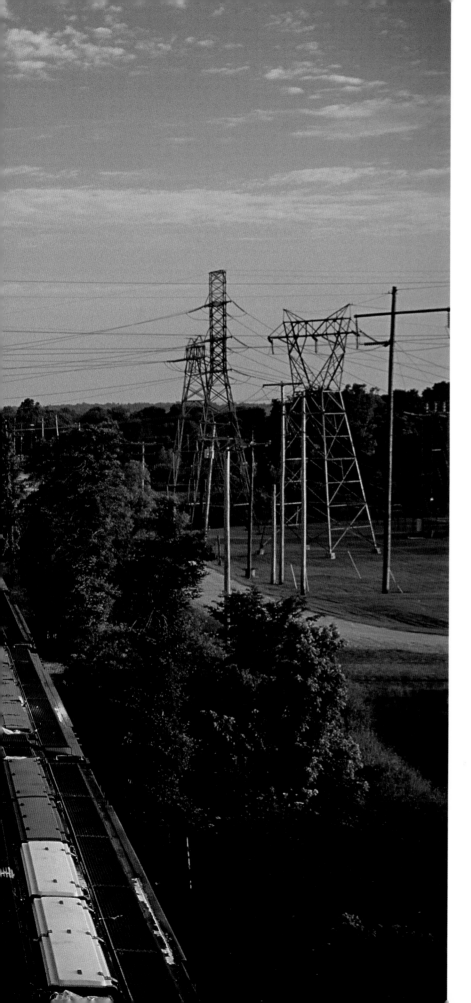

Preceding Page: 33°23'58.42"N, 91°01'55.06"W Greenville, Mississippi. This major east-west artery of Highway 82 is lined with the usual strip malls and fast-food outlets skirting Greenville's historic downtown. The replacement of the old-time Main Street by this suburban sprawl doesn't always seem to be a sign of "progress and growth."

Left: 32°53'07.52"N, 90°23'20.02"W The entrance ramp to Highway 49, north of Yazoo City, Mississippi. I was astounded by the extraordinary interplay of the highway, railroad, and electric-power grid—our country's infrastructure. I enjoyed this irresistible late afternoon scene as I progressed down the state of Mississippi to the capital of Jackson.

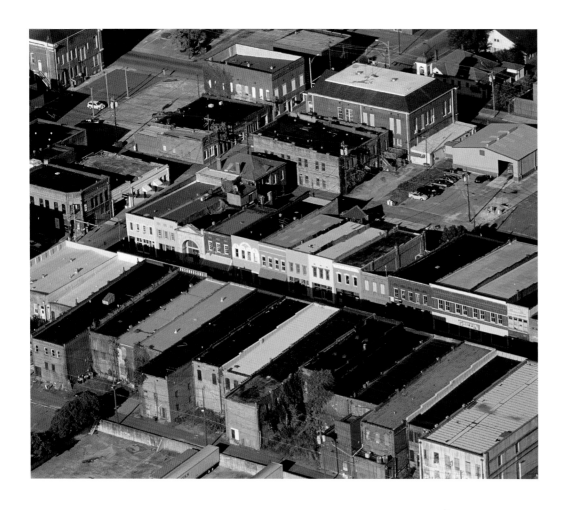

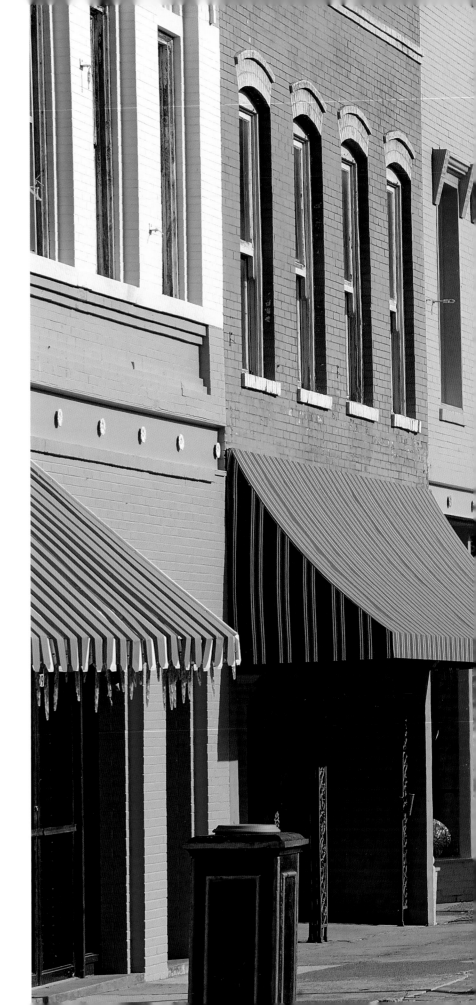

Above and Right: 32°50'46.71"N, 90°24'50.87"W North Main Street, Yazoo City, Mississippi. This is a fine example of America's quintessential Main Street—memories of yesteryear that we long for and strive to recreate in our urban renewals. Yazoo City has restored its historic district with dazzling color that preserves the charm of its architecture. If you've never visited a Hollywood movie lot, this is a dead ringer. The linear, functional layout of the buildings can be especially appreciated in the aerial photograph above.

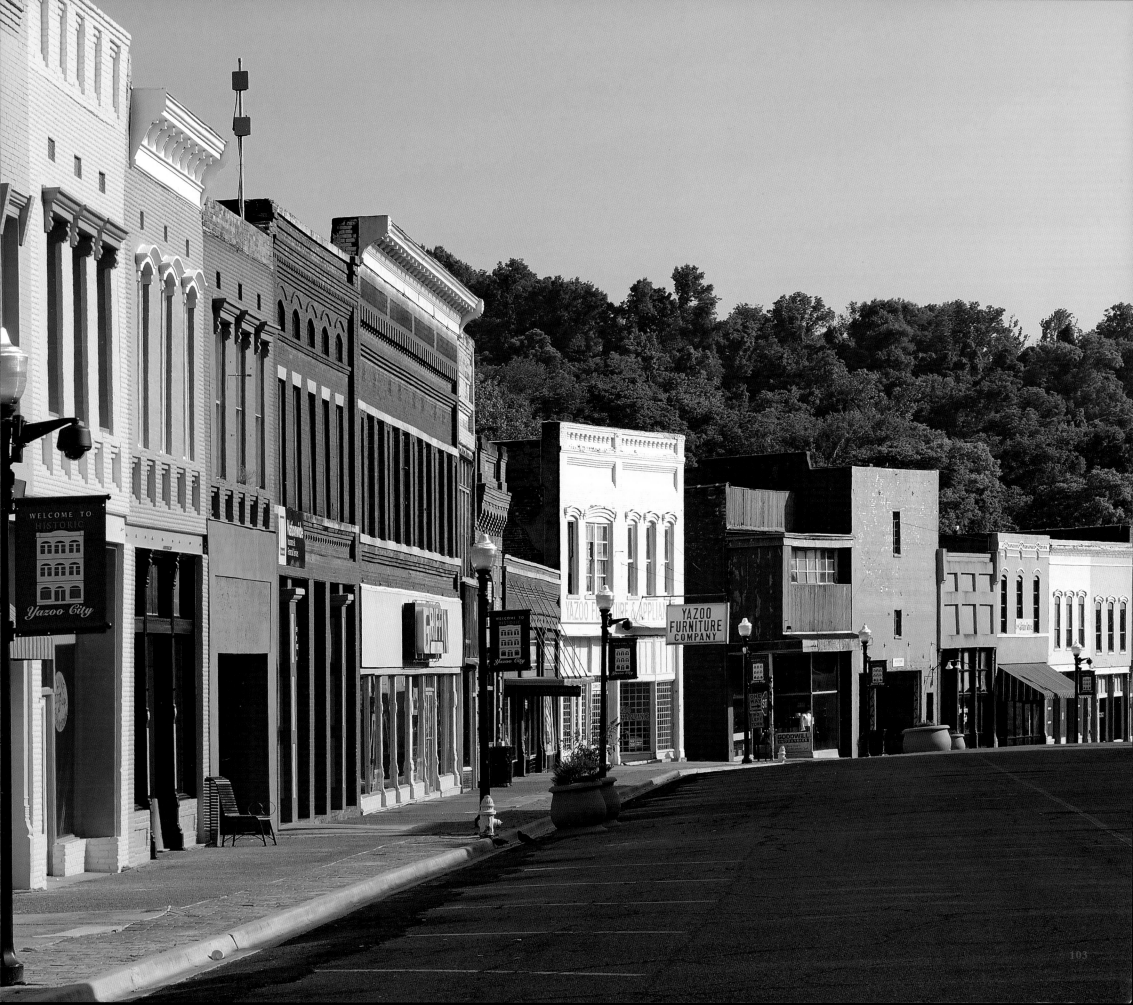

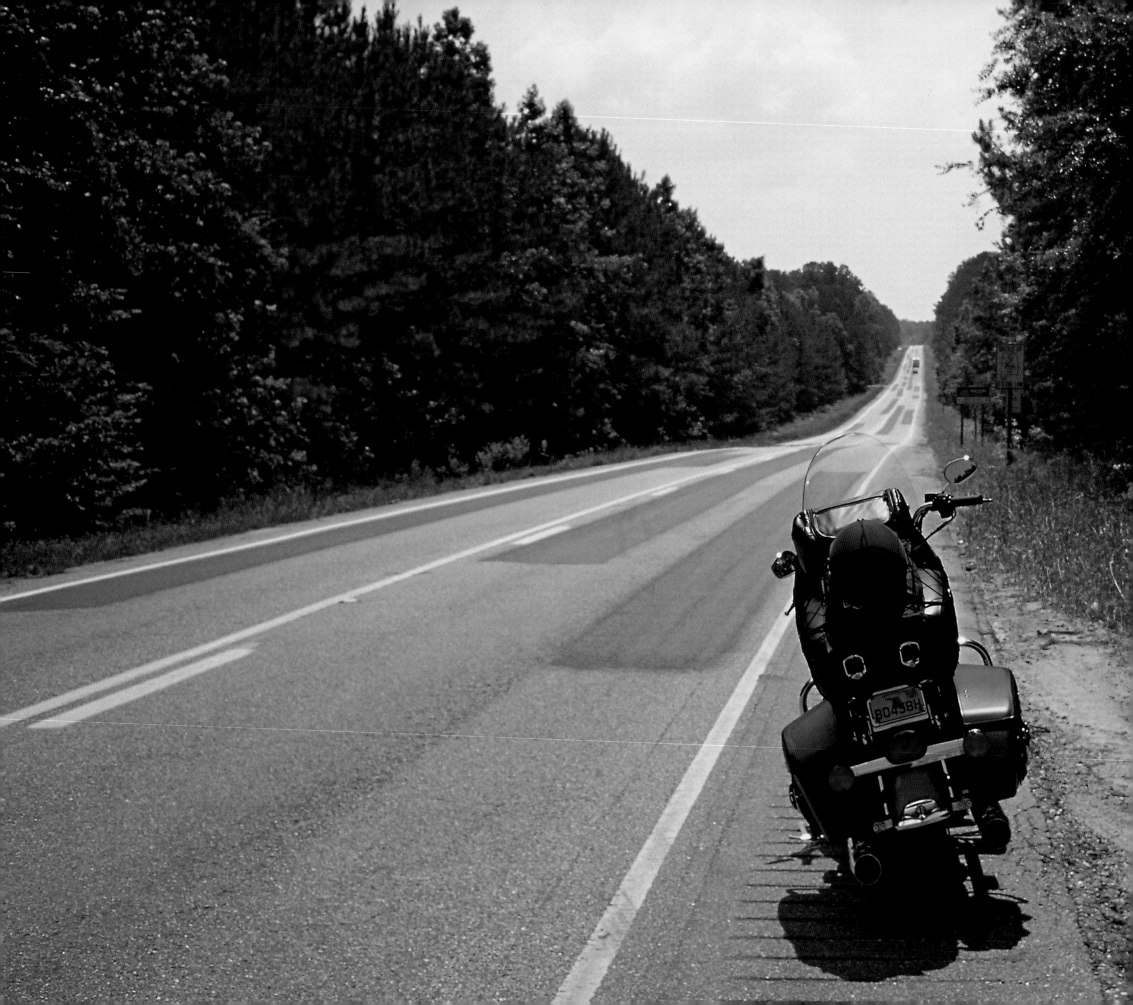

32°15'10.71"N, 88°25'40.99"W Southeast of Meridian, Mississippi, at the Alabama State Line.
It was Memorial Day weekend when I took a leisurely ride down this hot, sultry, backcountry
road in Alabama. I felt fortunate that we're able to travel unencumbered by borders or checkpoints.
Apart from the welcome sign, there is no evidence that my bike is parked at the state line.

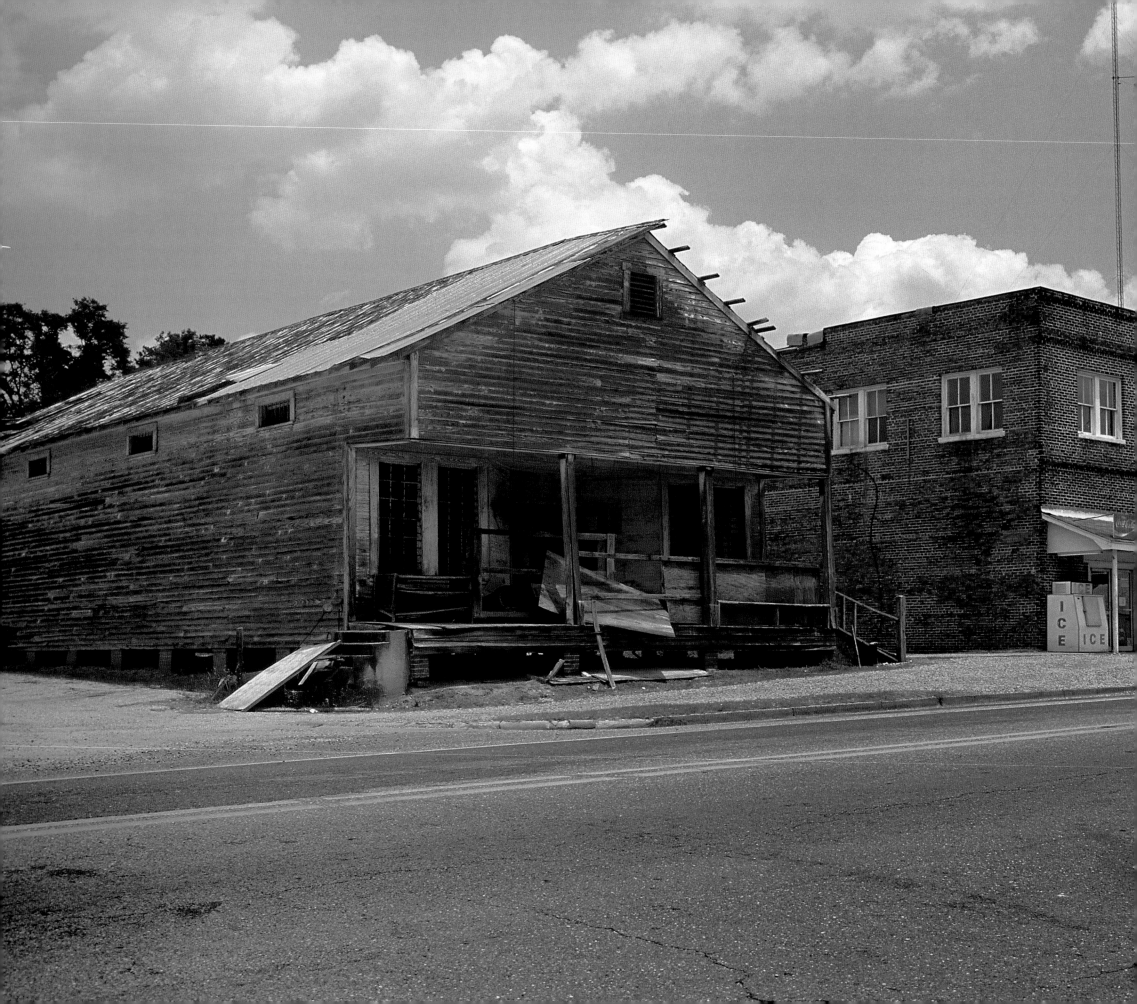

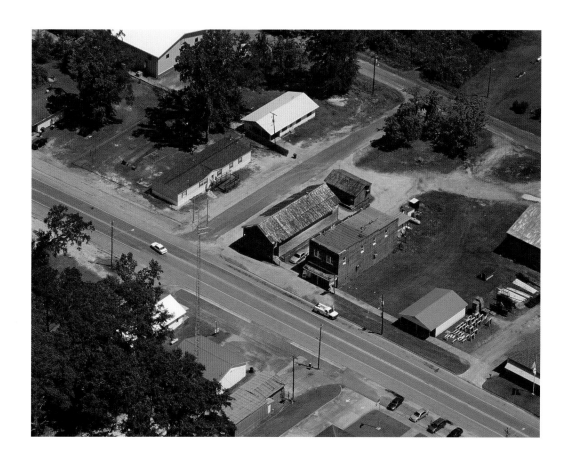

Left and Above: 32°05'37.33"N, 87°52'13.33"W Sweet Water, Alabama. A glimpse of architectural history and progression in this small, three-block, southwestern Alabama town. One wonders if the Lewis Self Service store had once occupied the old wooden building and moved into the newer, red-brick structure next to it.

Overleaf: 31°58'20.14"N, 87°29'10.86"W A Weyerhaeuser lumber mill on Highway 10, in Yellow Bluff, Alabama. From my limited roadside viewpoint, I imagined that behind the security fence there would likely be a traditional manufacturing plant. But this aerial image reveals something far more intriguing: the uncanny symmetry of neatly circled piles of uncut tree trunks waiting to be stripped of their bark and cut into floorboards. Had I not known better, I might have thought this was the underside of an industrial floor polisher, with its twin-bristle brushes.

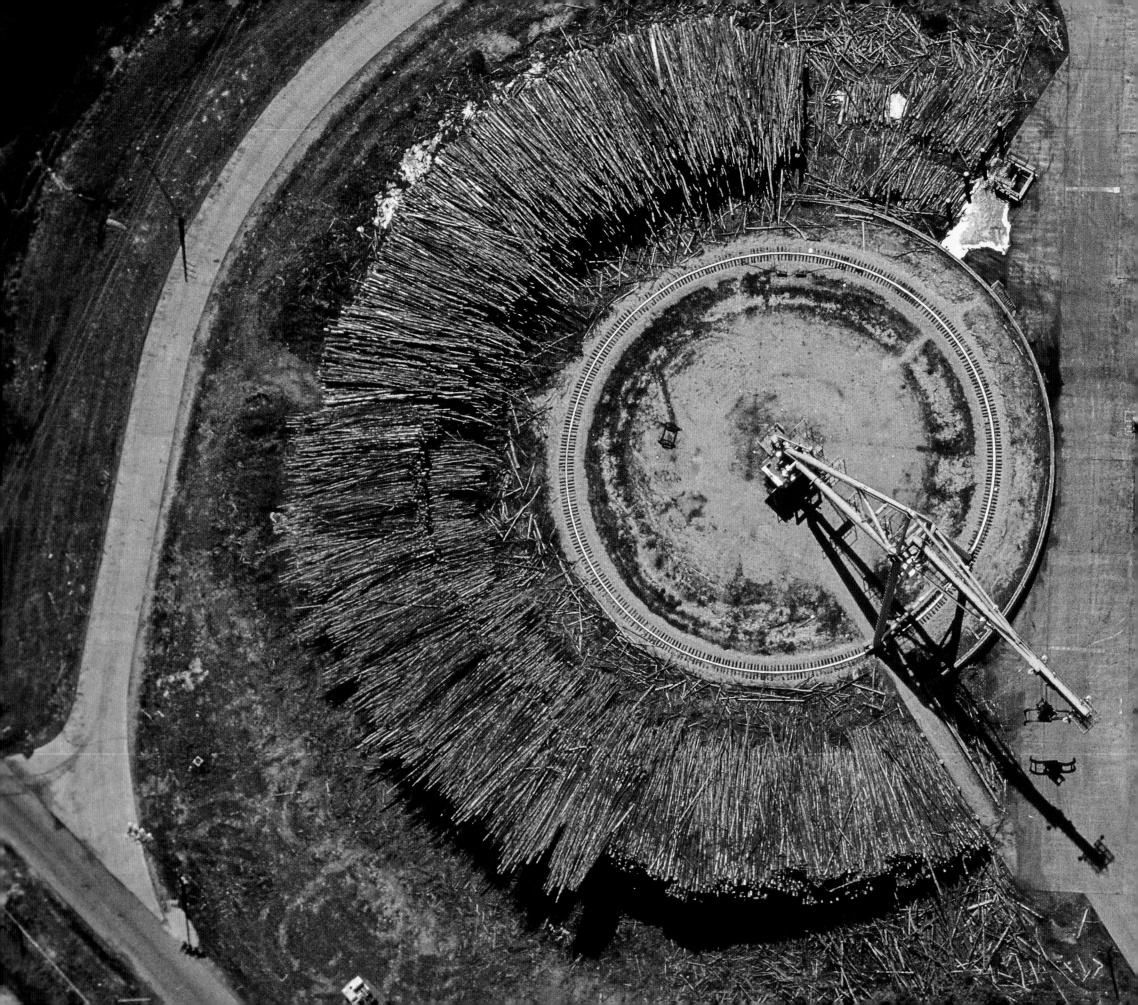

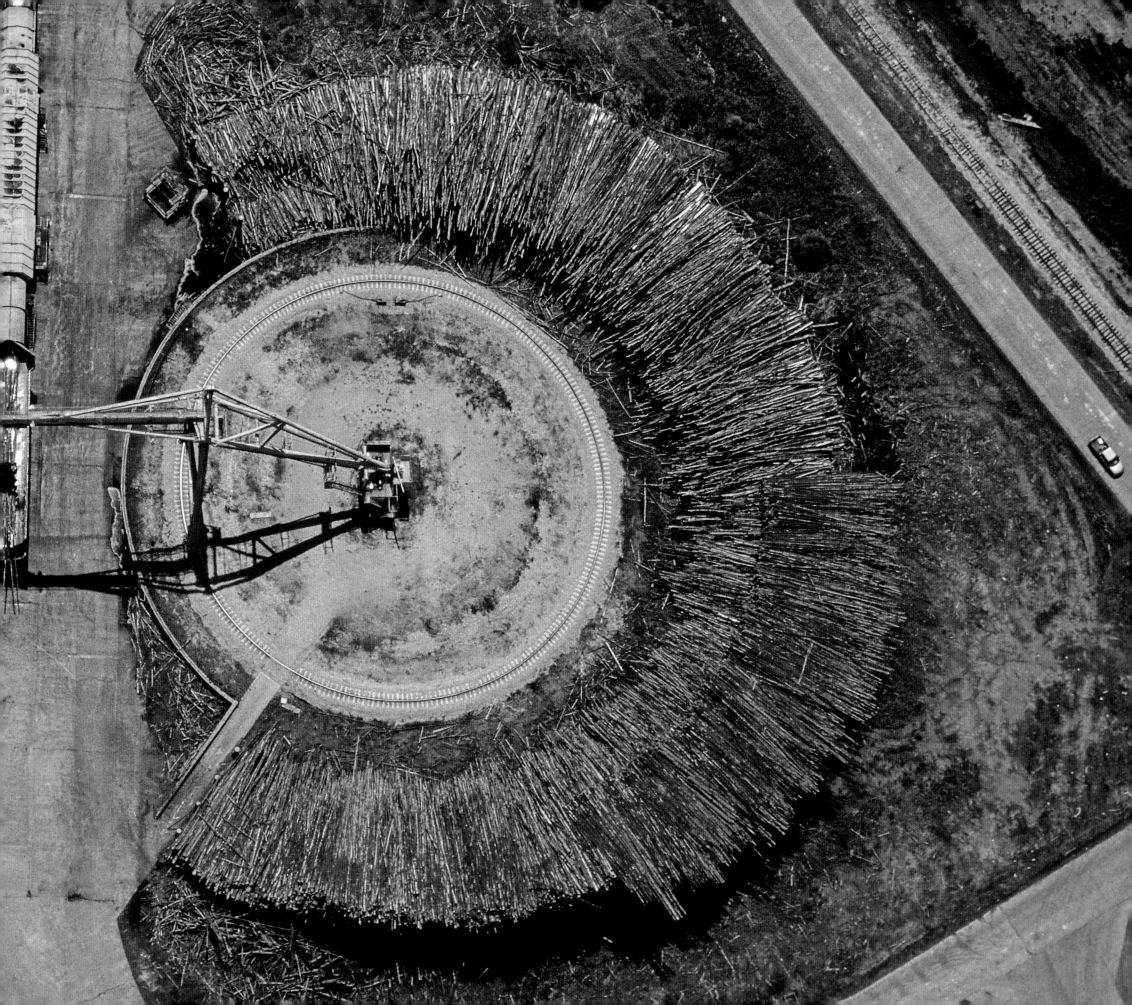

Left and Above: 31°52'26.42"N, 86°59'20.04"W Broad Street, Pine Apple, Alabama, one of many memorable, peaceful Southern towns. As I strolled through this community on foot, I enjoyed such small touches as the colorful flower planters and inviting benches in front of the Post Office at left, adjacent to the elegant family practice building with its green awning. The aerial view above shows the quaint layout of this one-block town.

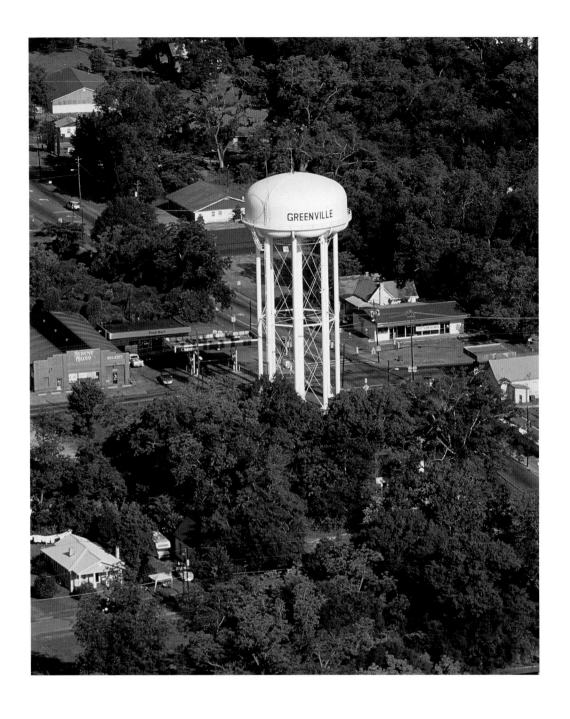

Above and Right: 31°49'46.62"N, 86°37'26.68"W West Commerce Street, Greenville, Alabama. This sweeping view shows the mostly forgotten era of America's Main Street past, celebrated by its Art Deco theater (charmingly spelled "Theatre"), with its weathered marquis, and the town's prominent water tower, easily identified from both the ground and the air.

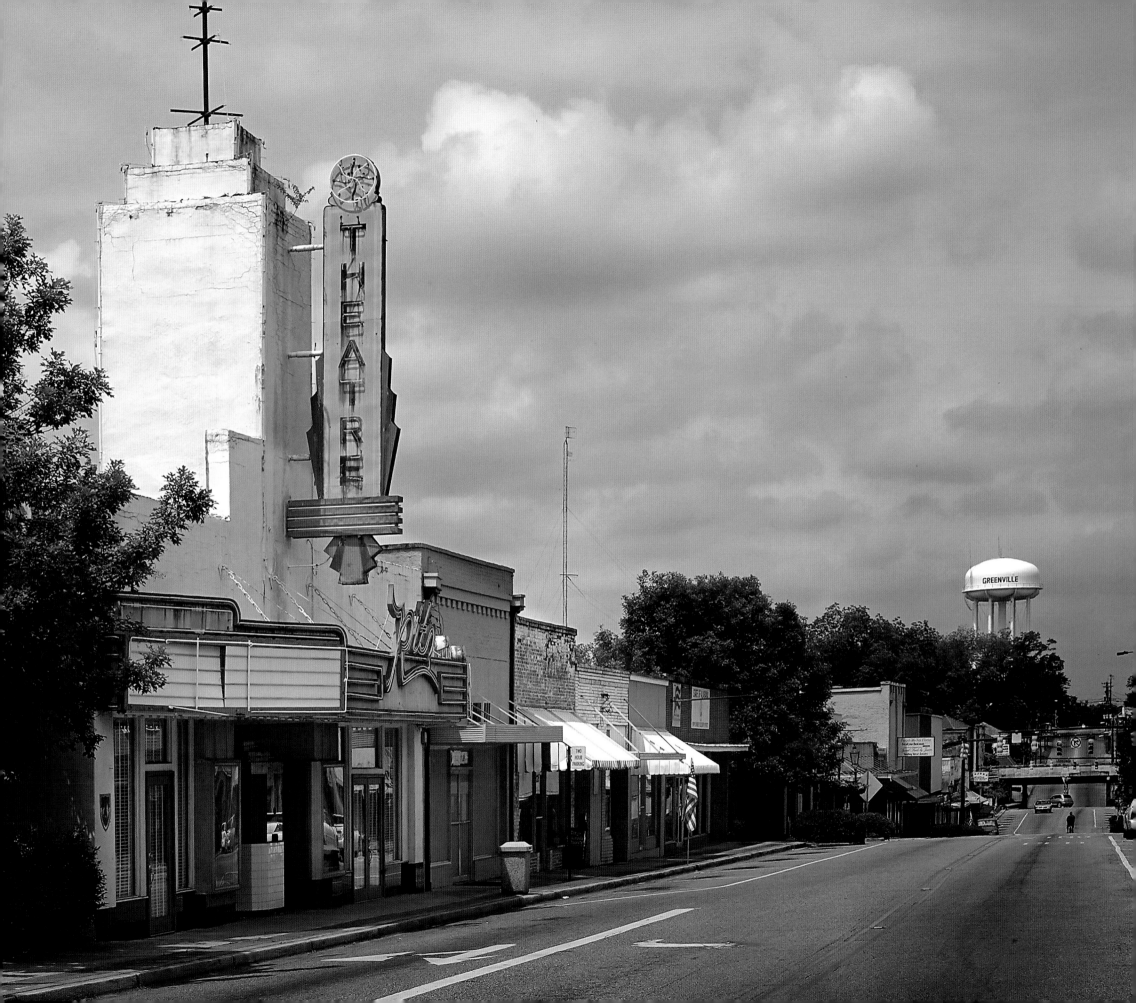

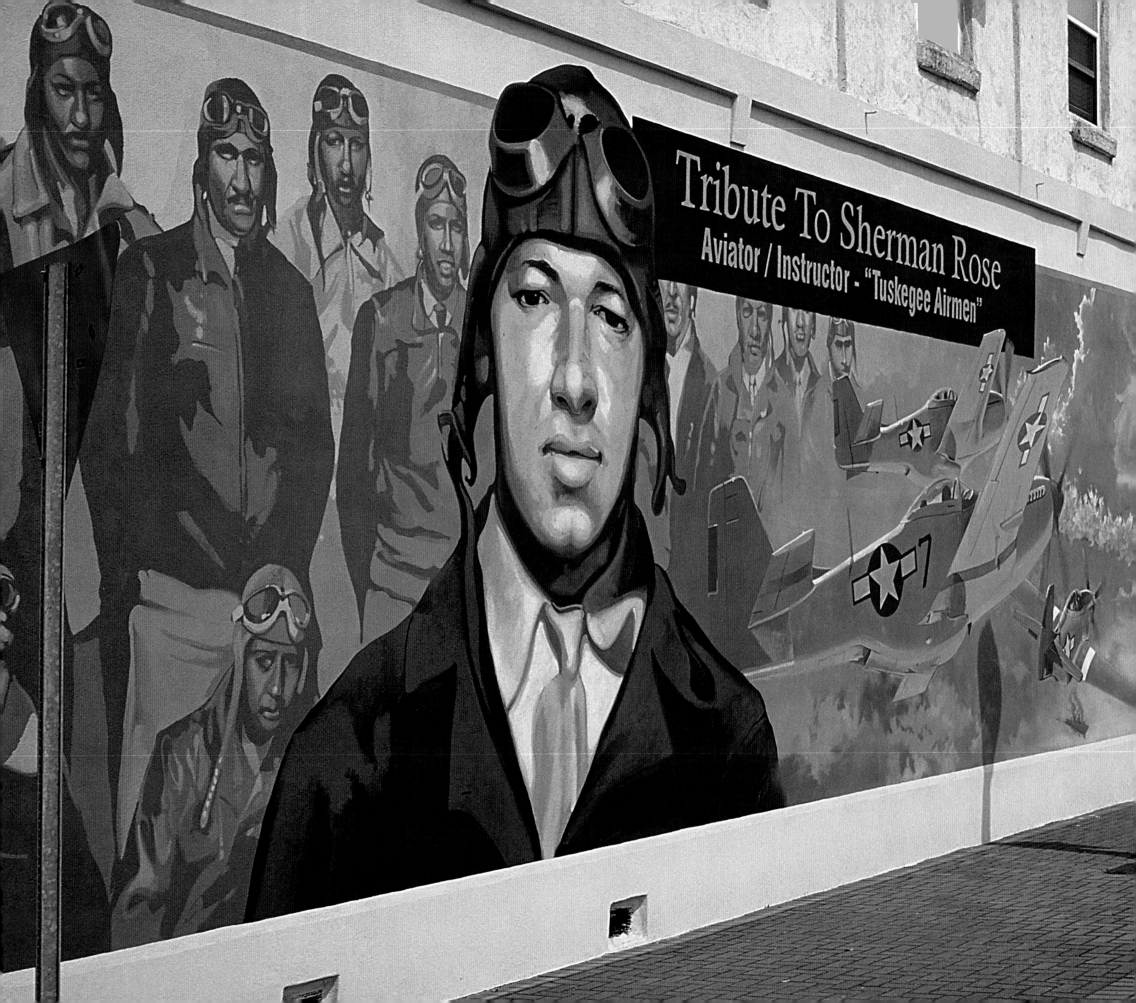

Left and Above: 31°13'24.82"N, 85°23'27.40"W Dothan, Alabama, at the junction of North, Andrews, and East Main Streets. While few signs lead you to this historic downtown district, it is well worth pursuing. Dothan's civic leaders and residents have funded a series of commemorative murals painted on numerous buildings in this district. One of them is a testament to those brave heroes, the Tuskegee Airmen, a World War II squadron of P-51 Mustang aviators that became one of the most decorated and successful fighter groups of the war.

Overleaf: 30°07'04.57"N, 83°24'28.67"W West of Townsend, Florida, off Highway 27. This was one of many blink-of-an-eye photographs that I nearly missed and captured only after making a U-turn. I was dazed by the bright white sand and the mystery of the horizon. Swindle Road was perhaps named after a family.

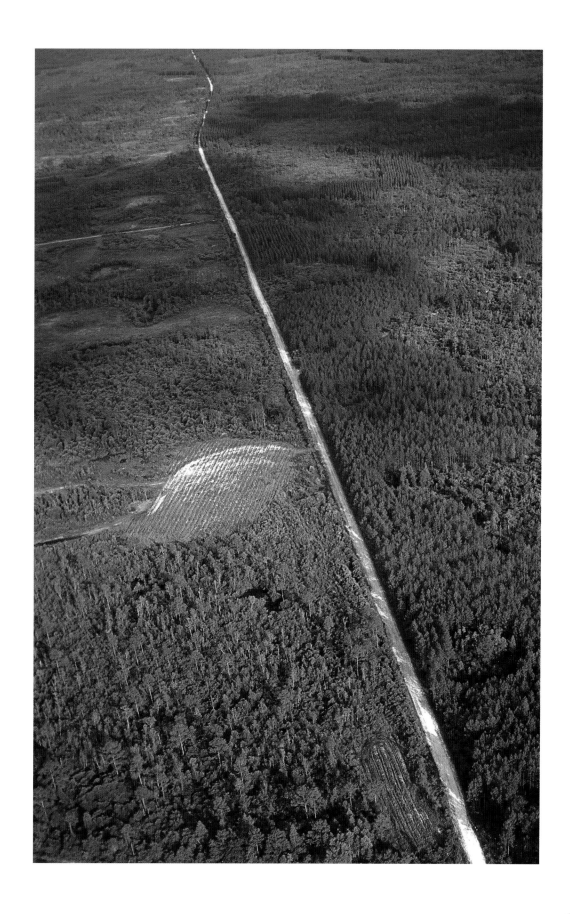

Preceding Page: 29°47'55.54"N, 82°30'52.27"W Alachua, Florida, off Interstate 75. Florida's horse farms rival those of Kentucky: this southern state has a warmer climate during the winter and ample, lush farmlands—all of which are an attraction to "snowbird" breeders and racing enthusiasts. These farms and their miles of delicately crafted fences dot the landscape in this part of the state.

Left and Above: 29°39'07.48"N, 82°20'44.80"W Gainesville, Florida, home of the University of Florida Gators. It is an example of the many educational institutions—from universities, colleges, vocational, primary, and secondary schools—that form the backbone of so many of our communities. Notice that the stadium and playing fields at left dominate the campus—an indication of the university's commitment to sports and an acknowledgment of its teams' impressive records of national championships. This campus would not be complete without its array of bars, pubs, and food emporiums, as seen flanking University Avenue above.

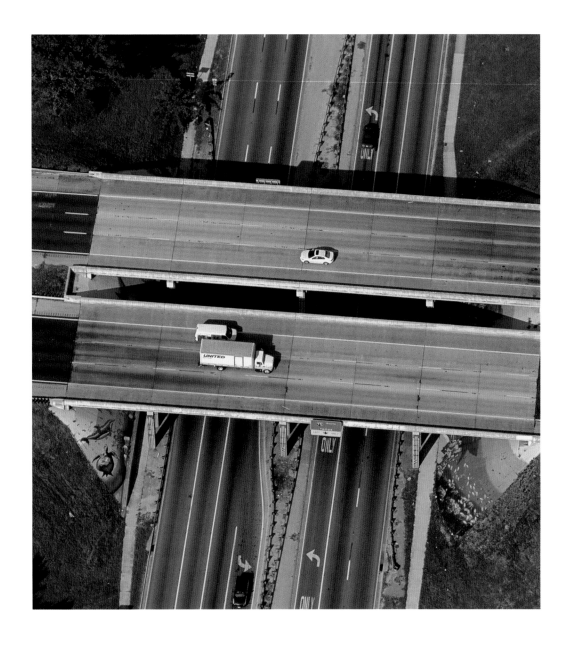

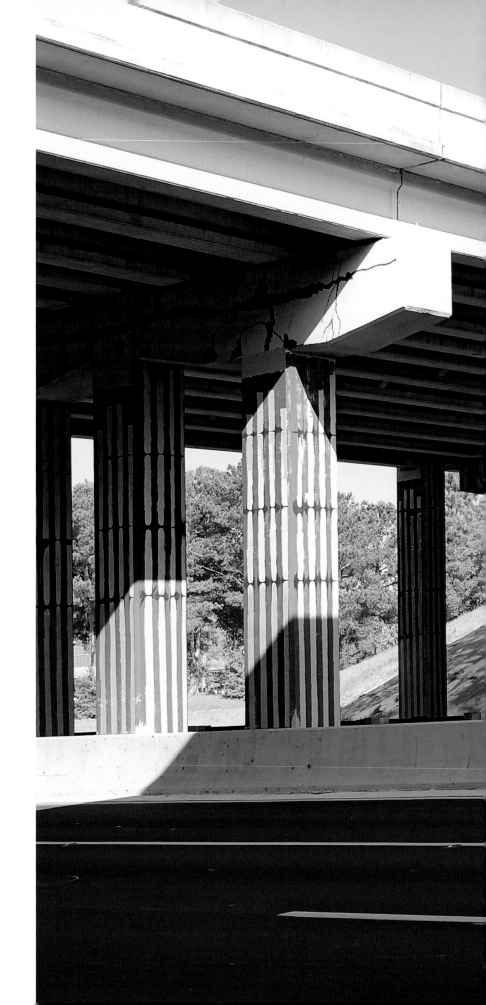

Above and Right: 29°37'02.39"N, 82°23'09.24"W Gainesville, Florida, Highway 24 exit off Interstate 75. On the embankment running upward behind the pillars of the freeway at right, one suddenly sees thrilling murals that celebrate Florida sea life. Only people driving past them can enjoy these murals, since the overhead traffic on the interstate is oblivious to them.

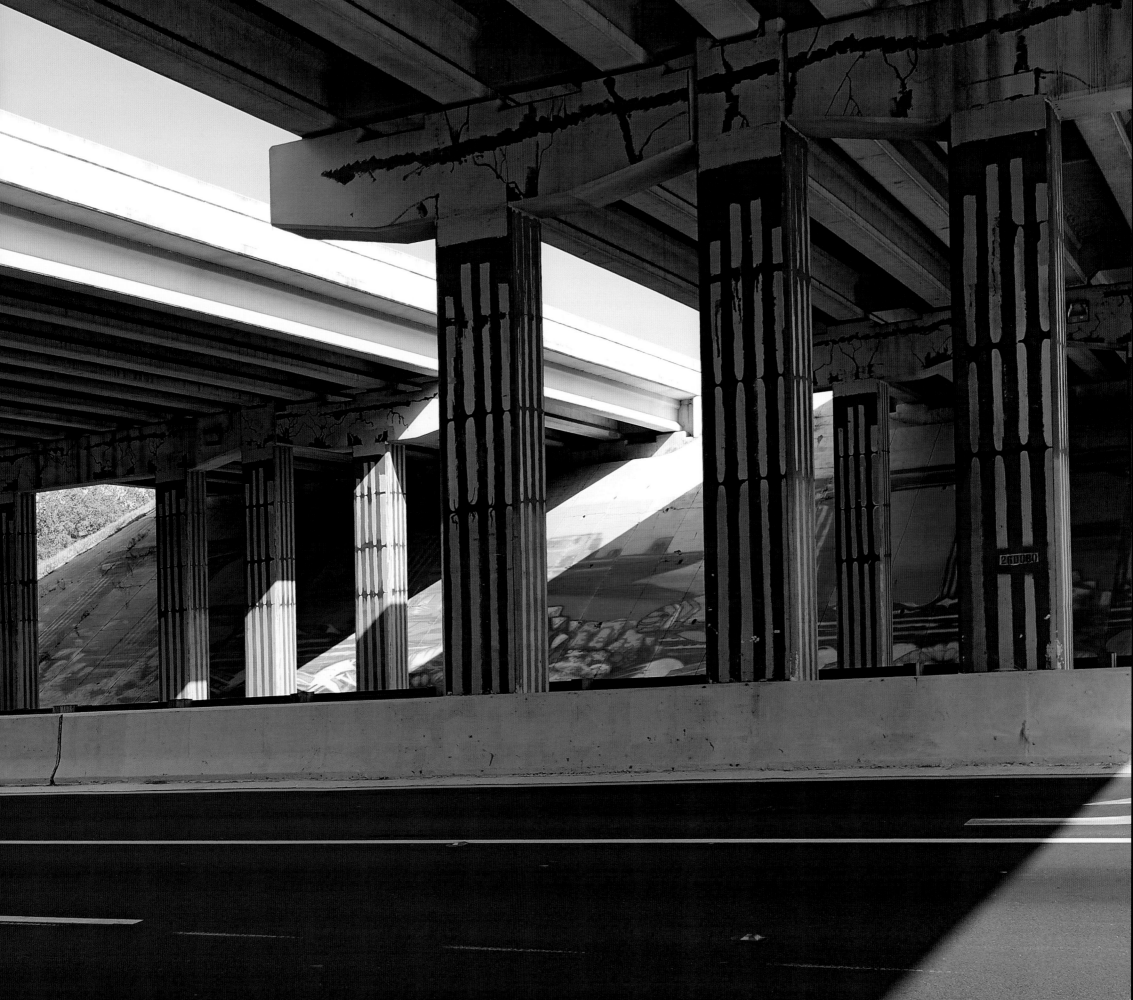

Right: 26°34'43.95"N, 81°59'40.68"W Cape Coral, Florida. This is yet another vivid example of how we Americans live and of the diversity of choices we enjoy. It would be hard to capture this perspective of a typical Florida development from the ground—something I could not do when I was miles away on the major north-south artery of western Florida on Interstate 75.

Overleaf: 26°07'20.25"N, 81°48'17.52"W Naples Pier, Naples, Florida. This Gulf Coast setting at dusk was a fitting conclusion to my weary but immensely satisfied eyes. The tranquil yet stirring locale begs for pause and reflection: its calm seas, the silhouettes of peaceful beachcombers, and the inviting pleasures offered by an equally "lone" pier—waiting to welcome me home.

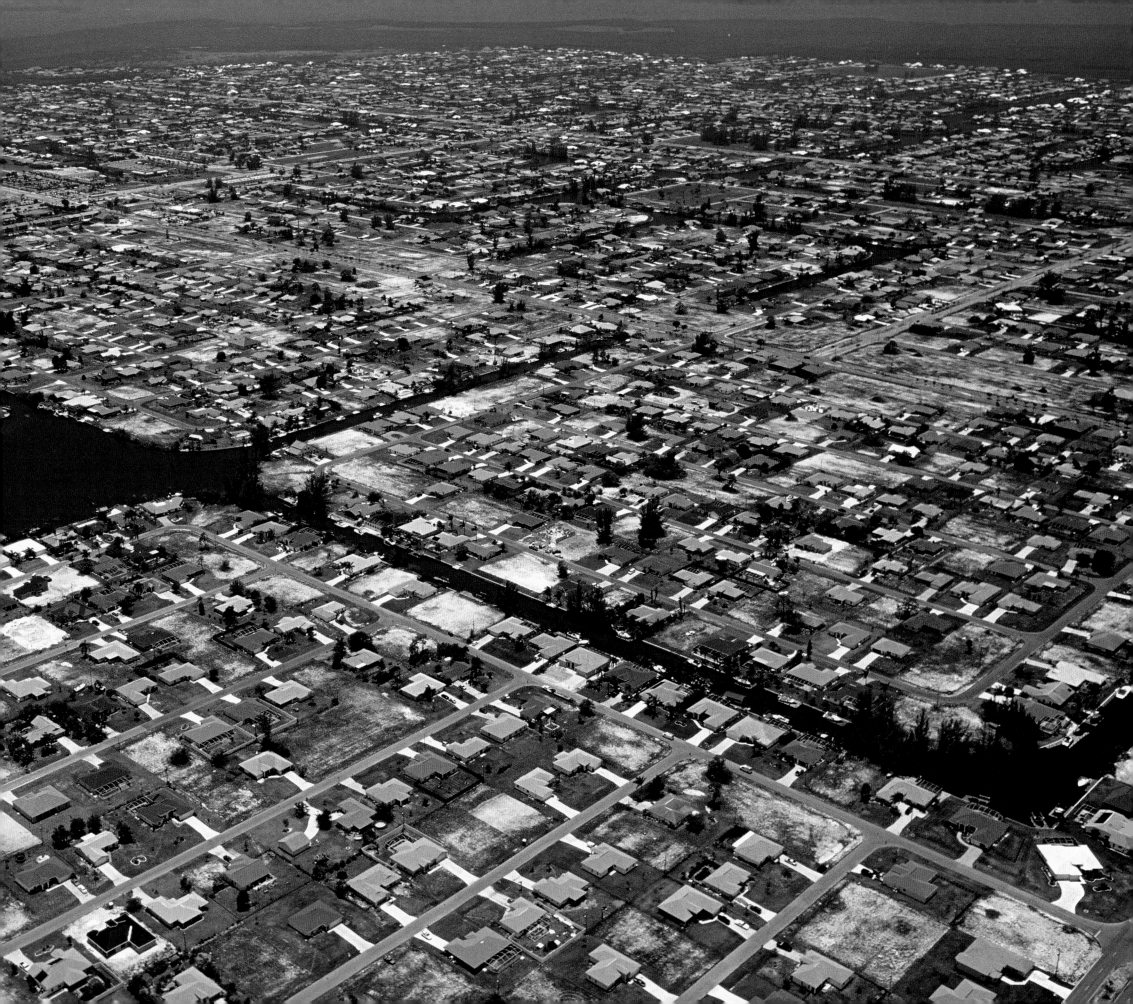

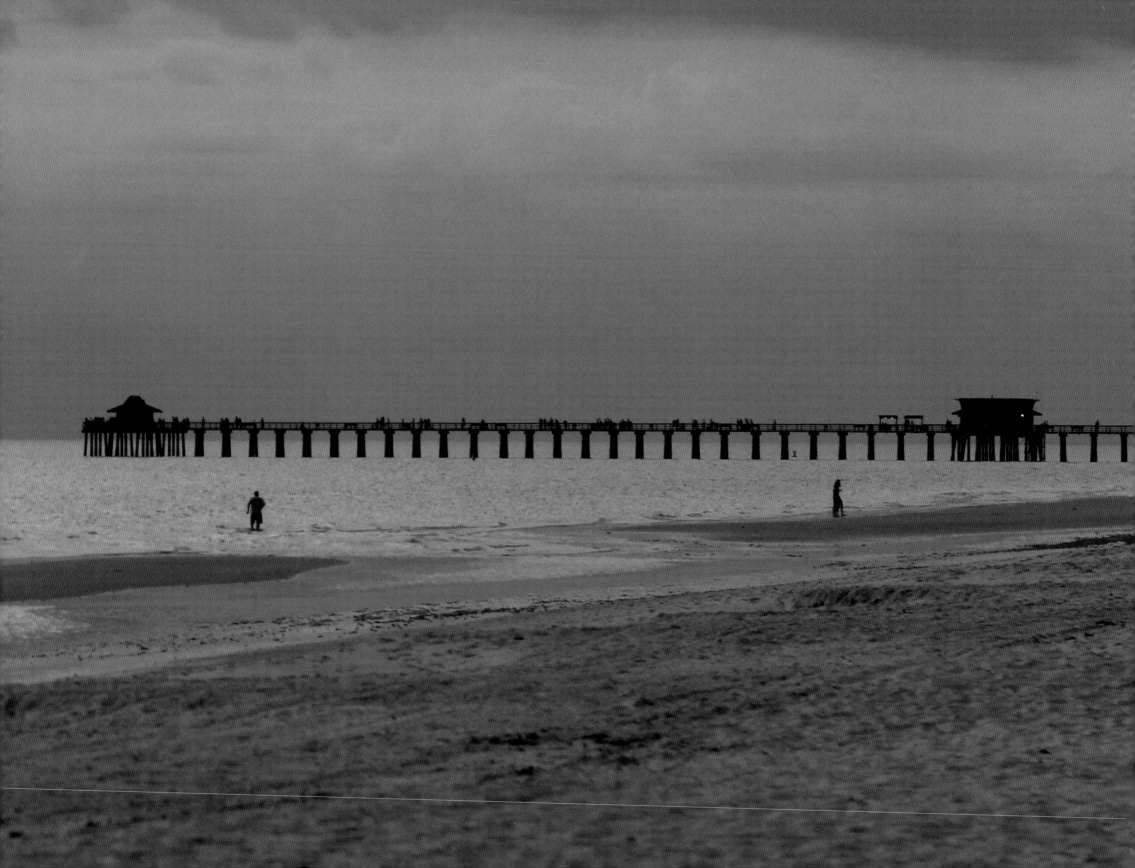

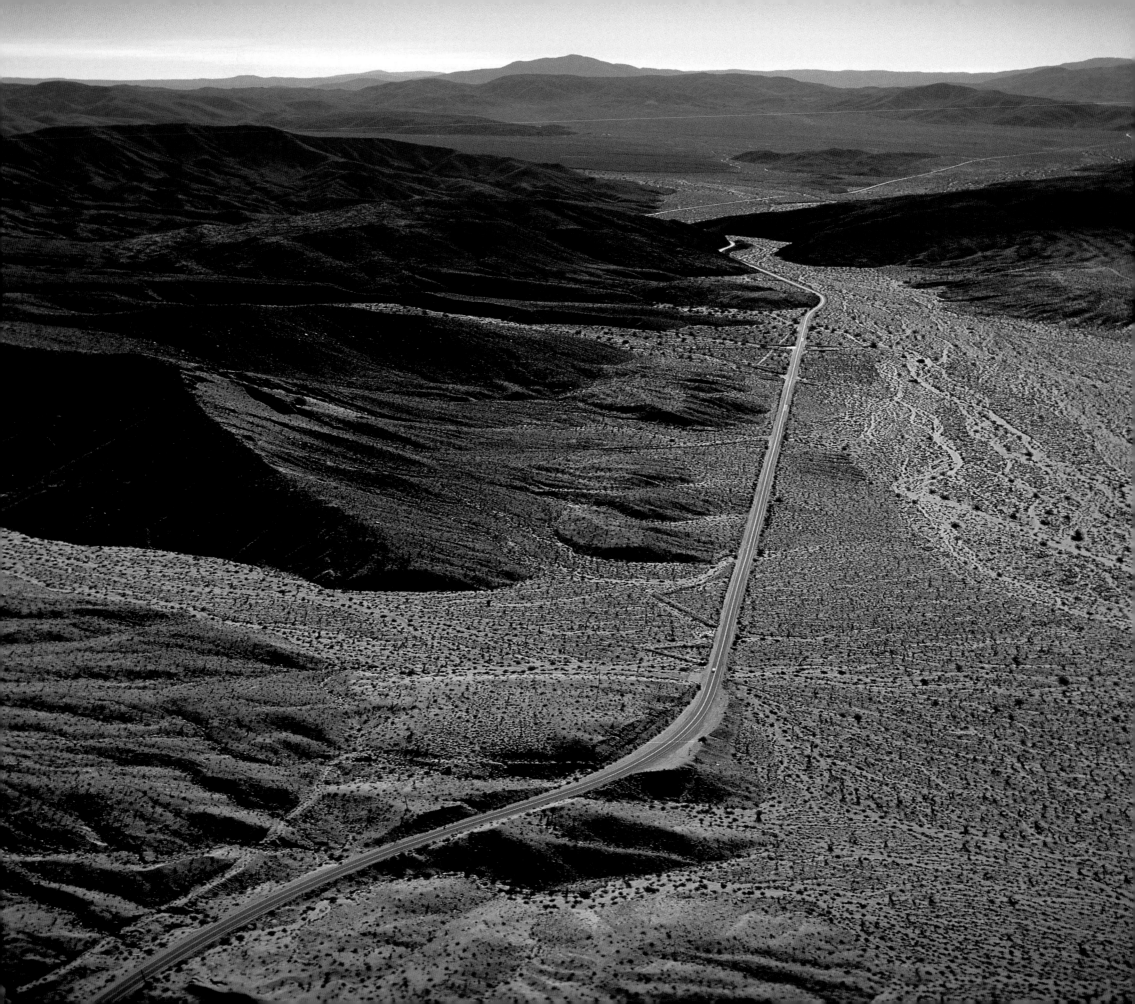

SOUTHWEST *to* NORTHEAST *journal*

May 14 to May 30, 2006

May 14, 2006
San Diego, California

A year had passed since my northwest-to-southeast journey in 2005. And here I was, again seated at the controls of a plane, flying from my home in Florida to San Diego, California, instead of to Seattle, Washington. The following day I was to begin the southwest-to-northeast leg of my Harley trip with the same purpose of getting to know my own country. So if the 2005 trip was the "criss" portion of *Crisscrossing America*, the 2006 leg would be the "cross."

As the plane descended through 18,000 feet above the Anza-Borrego Desert—60 miles northeast of San Diego—I spotted from the cockpit a stretch of road down below that seemed to spring out of the base of the mountain foothills and trail off for hundreds of miles into the distance. It was a sobering thought that tomorrow I'd be biking along that desolate highway, with no assurances of a safe, trouble-free journey.

I wasn't as uncertain about my journey as I had been the previous year. I was lucky enough to have one half of the crisscross under my belt and I'd already developed a familiar, daily routine during last year's ride. Riding the Harley was no longer strange to me, and with more than 4,000 miles of cruising experience, I felt more confident now in the saddle. I'd made many new friends during the 2005 trip and would carry their blessings and those of my family with me.

As we encountered fog and low clouds during the descent into San Diego, the view from the cockpit was limited to a few feet. My co-pilot, Garrett Snow, was seated beside me, just as he had been in 2005 when we approached Seattle. Garrett was not only my good friend and valuable traveling companion, but he was also vital to me as a second pair of hands and eyes during the flight.

Once we landed in San Diego, Garrett and I checked into the Hilton Gas Lantern Hotel, then jumped into a rental car and made the 15-minute trip south to National City, California, where the Harley-Davidson Sweetwater dealership is located. There we met up with Harley's service manager, who had taken possession of my motorcycle a week earlier and had serviced and detailed it for the trip. Everything looked good for my start the next day, so we returned to San Diego and had dinner at the Greystone Steak House.

I took a short walk around downtown San Diego after dinner. To my dismay, this city by the bay was not as idyllic as I had imagined it from the pictures I'd seen, with all its naval activity and sailing traditions. Even though it was Sunday, the city felt eerily empty and cheerless, lodged in a backdrop of smog and cool weather. With endless construction taking place everywhere, it looked—as do many American cities today—as if it were undergoing some kind of massive renovation. Obviously San Diego was making an effort to restore its historic legacy and one-time vibrancy, but the city's attempts to make improvements seemed radically different from its purported goals. I was sure I'd witness similar attempts to "rescue" our inner cities as I traveled northeast through America.

Come midnight I was beat from my long flight. I went to bed knowing that first thing in the morning I was likely to see my first concrete example of our country's so-called "immigration problem" along the Mexican border—an issue so vast that already I knew I would have to see it before being able to grasp its complexity.

May 15, 2006—Daily Mileage: 214.4
National City, California, to Palm Springs, California
I got up early and dressed in "civilian" clothes in order to meet Garrett for breakfast in the hotel. Afterward, I returned to my room to finish packing and change into my bike gear. This would be my last chance to enjoy the luxury of sorting through drawers of clean clothes and of enjoying a casual morning routine for at least two weeks. From now on, I would have only three days' worth of clothes to choose from; that's all I could fit into my one-top box insert and waterproof saddlebag.

Sara—a Harley parts manager back in Florida—had given me her own holy cross to wear for the ride. It comforted me to put this cross around my neck. I felt that I would now have the good Lord's protection on this journey.

With gear in tow, Garrett and I set out in a rental car during morning rush hour, heading back to the Harley dealership. The service manager, who commutes from Mexico every day, had done a great job of detailing the bike. He even topped off the gas tank for free and warned me about the potential hazards of taking pictures at the border. Customs agents can be strict and will often prohibit you from taking photographs of certain checkpoints.

At 11:00 a.m., with my bike neatly packed, I left the Harley-Davidson dealership and set out for the Mexican border, with Garrett following me in our rental car. Fifteen minutes later, we pulled into a parking lot a block away from the border, and while Garrett kept an eye on my Harley, I set out on foot to take some pictures. I was astonished by what I saw as I peered through the chain-link fence separating Mexico from the United States. Never in my life had I observed such masses of bumper-to-bumper cars, lined up for miles, preparing to enter America. People without cars and those who could only afford the public transportation that dropped them off on the Mexican side of the border entered the country on foot, walking along the sides of the roads, sometimes carrying suitcases or plastic bags filled with personal belongings.

At first it seemed odd that there were so few cars or pedestrians heading into Mexico. But it was only noon and by day's end traffic would be flowing in the opposite direction. The border crossing was peppered with bodegas and train depots, bus stations, and taxi stands, all awaiting their daily migration of workers or job seekers. The area was arid and dirty. The people I saw who were walking across the street to meet the bus seemed resigned to their fate. No one looked happy, but who could blame them, given their plight of yearning to improve their lives yet feeling trapped within such a hopeless, seemingly unsolvable predicament. While I was discreetly photographing people, an old, unshaven man politely warned me that he had witnessed many provocative encounters with immigrants who had taken offense at this perceived intrusion of their privacy. I thanked him for his advice and returned to my motorcycle.

Having now touched the southwest corner of the country, I bid farewell to my dear friend Garrett. He wished me Godspeed and assured me that he would be waiting for me in Maine as I pulled into the final stretch of my ride, two weeks hence. It was already 12:30 p.m. and I had seven or eight hours of solid riding ahead of me. I felt exhausted emotionally from the border crossing, so I was glad to have a reason to escape the San Diego area. As I got back on the road and drove away from the border, I couldn't help but feel the poignancy of the immigration problem, realizing all the while that there are two sides to every story. Yet human suffering, regardless of its cause, makes me sad—and seeing firsthand the frustrations and horrendous bureaucracy that these hopeful immigrants must deal with every day of their lives left me drained. Government rhetoric notwithstanding, I was left wondering how on earth our nation will deal with this urgent, growing problem.

I set out for Palm Springs, California—a place remarkably different from the stretch of prisonlike fences I had just left behind. I felt distracted during this drive north, since I was focused more on getting out of the big-city congestion than I was on the joy and exuberance of the trip that lay ahead. But once I got comfortable in the saddle again and began recalling the life-saving tips I had learned in "Rider's Edge," I settled into a rhythm. Within 30 minutes, I found myself enjoying the sights and shooting pictures.

After leaving San Diego, the topography changes abruptly from that of rolling hills to a canvas of dramatic mountains, with miles of exposed rock. The vistas are breathtaking and reminded me of the gorgeous scenes from the Northwest—particularly those of Wyoming and the Dakotas. Yet I was a thousand miles south of those places and would soon discover the striking differences between the landscape of the Southwest and its sister quadrant in the Northwest. The cool, 60-degree temperatures on the coast quickly climbed to the 80s as I approached the desert and national parks south of the Santa Rosa Mountains.

My first official stop after leaving San Diego was the town of Descanso, California, the one-block town that reminded me of Startup, Washington, the symbolic beginning of my trip a year ago. Since my stomach was still operating on Eastern Time (where it would now be 5:00 p.m.), I was famished, so I ducked into the Descanso Junction Restaurant and devoured a hearty lunch. To my good fortune, a Harley rider and (presumably) his wife were seated next to me and he outlined the most scenic route I could take while circling around the massive Salton Sea, an unmistakable landmark in southeastern California. Ultimately I would take a shorter, less picturesque route in order to save time on the road, but I was moved by his generosity and warmth. What a nice introduction this was to California-country dining.

Leaving Descanso, I proceeded north to Julian, California, along a road flanked by farms and ranches. Unfortunately the shoulder of the road was too narrow and dangerous for me to stop and take pictures, but that didn't prevent me from enjoying its beauty. I was, however, still troubled by my visit to the Mexican border. Even though I am an American citizen, I was born in Mexico, so clearly this experience was causing a shiver within me that many other Americans might not feel. I rode through the Cuyamaca Rancho State Park—as spectacular a setting as any I have ever seen—miles and miles of twists and turns and lush forests, open fields, streams, and horse ranches. I found it strange, however, that the barks of the trees were as black as charcoal, even though the trees themselves had leaves. How could this be? Obviously, they had been scorched by devastating forest fires and the new growth was a sign of nature's ability to survive against all odds. As I had seen in other parts of southern California, the terrain is vulnerable to forest fires because of the extremely dry weather, high temperatures, and windy

conditions. Yet in the midst of this stark landscape, I spotted a beautiful flowering yucca plant that looked like a giant floor lamp studded with clusters of light bulbs. It was a moment of poetry in a landscape of prose, and I couldn't resist stopping to photograph it.

The descent down the mountain to the floor of the Anza-Borrego Desert State Park (just above sea level) was breathtaking. Not only was there a sudden change in flora and topography, but also a swift increase in temperatures from the 80s to more than 100 degrees—which, a few months later, would reach 120 degrees by midday. Thankfully, the mountain roads were deserted, but this leg of the trip took longer because of all the hairpin turns, which kept speeds between 25 to 30 mph. I found the air so burning-hot that I had to shed layers of clothes, hydrate, and switch helmets.

The ride in this heat lasted four hours and made me feel as if I had stuck my head into a hot oven. Thank goodness for the four bottles of chilled water that I had purchased in Descanso. Even though most of the bottles had become 105-degree waters in my saddlebag, I had kept one inside my jacket where it could stay more "chilled" at 98.6 degrees. One would be hard-pressed to survive much longer than an hour in this heat without water, which was nowhere to be found. I worried constantly that my heavily laden bike would break down at any time or that I would get stuck in the sand. Imagine a straight line that spanned a distance of one hundred miles through the sandy desert. That is what I rode along for hours—no visual relief, no hills, no signs of life except for an occasional mobile home—not even a gas station or a rest stop. The landscape was monochromatic—desert-brown, dull, and endless.

It was so hot that the asphalt had melted in spots, especially where truck traffic had carved ruts into the road. In fact, I almost lost control of my bike once or twice due to a lack of traction on these marshmallow-like sections of the road. Even at 65 mph, with the winds blowing past my body, there was no relief from the heat. I did, however, make an occasional (but cautious) stop on a few soft shoulders—a challenge each time—to capture the beauty of the desert flowers. It mystified me that these plants could produce such colorful blossoms and remain happily alive without any visible signs of water.

Just shy of the Salton Sea I turned toward Palm Springs. The ride on 86 was a welcome relief, since finally I began to see people. I even had the good fortune of locating a gas station, where I drank bottles (plural) of water and fueled my bike. I felt newly energized from that brief respite (or was it from the Hershey bar?) and I began to enjoy the sights again. I kept looking over my right shoulder at what appeared to be a mirage, but when I stopped to take a picture of it, I saw that it was actually the reflection in the Salton Sea of the mountains alongside its eastern shore. For some reason I had imagined the sea to be more picturesque than it was, but perhaps I was too far away from it to fully appreciate its beauty. I'm told that this vast inland body of water contains more salt than the Pacific Ocean, only 80 miles to the west. This may explain the arid monotony of the landscape around its shores.

As the sun set, I rode through the towns of Indio and Coachella. The sprawl of low-income housing and trailer parks indicated that they are probably bedroom communities for the valley's migrant workers. It is a startlingly quick transition from this migrant area to the more upscale communities I began to approach just north of Coachella—Indian Wells, Rancho Mirage, and Palm Springs, to name but a few. This part of California looked as if God had brushed the base of the mountains with a broad stroke of green against the endlessly brown, sandy-colored canvas of the desert floor along which I had been traveling almost in a trance. I found it remarkable that such an oasis of high-end communities could exist in this otherwise stifling, desert context. I couldn't help wondering where the fresh water comes from and how it continues to support a growing population.

With these questions on my mind I coasted along Highway 111, known locally as Palm Canyon Drive. But with the change in light, I saw that when I was surrounded by the dull desert, framed by such stark mountains, the greens look greener (especially at sunrise

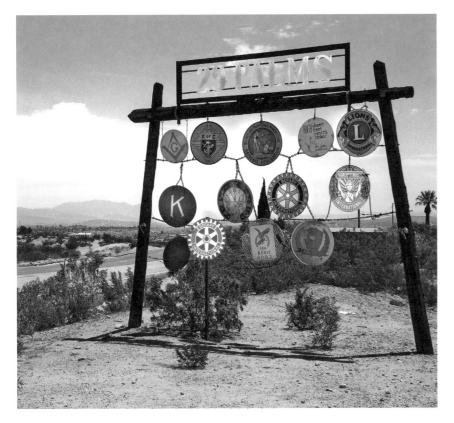

and sunset) and the contrast of colors is truly spectacular. The physical beauty of this quirky location must be one of the reasons people choose to live here. The necklace of communities dotting this stretch of the desert makes for a modern-day wonderland, removed from the smog and congestion of Los Angeles and San Diego. As long as there is ample water and electricity to provide air conditioning, Palm Springs seems to survive just fine.

Having been on the bike for more than eight hours, I was drenched in sweat and felt joy at seeing the Las Brisas Best Western, where I pulled in for the night. The hotel manager saw that I was bedraggled and gave me permission to park my bike in a handicap spot. It had been a long day, with many rugged, draining miles between the Mexican border and Palm Springs. I unloaded, showered, and—feeling in need of a much-deserved treat—headed off to the posh area of Palm Canyon Drive for dinner. I stumbled upon Kalura Trattoria and had a good Italian meal there, with many courses and, of course, a Peroni beer, not to mention gallons of water. The sole disappointment of my evening was the people: In Palm Springs, everyone seemed to have a "strictly business" attitude and, perhaps because it was a Monday night, there were few people around. Although I was too tired to engage in conversation, I had at least hoped for a smile and a warmer reception at the restaurant. Not so on this night. Given my exhaustion, I put off my sightseeing until the morning and headed back to my hotel.

May 16, 2006—Daily Mileage: 271.2 (Total Miles to Date: 485.6)
Palm Springs, California, to Kingman, Arizona
I didn't want to admit it, but the day had taken its toll on me. The first day of a long trip is always the most taxing, but I had the added emotional struggle of trying to reconcile in my mind the juxtaposition of the downtrodden Mexican immigrants with the inhabitants of luxurious Palm Springs. It's a lot of information to process, much less in one day, and this strange turmoil prevented me from settling into my usual routine. My body was protesting a bit as well from saddle fatigue and I had sore wrists caused by the shifting of the clutch and the throttling of the bike. After checking out of the hotel I headed to Palm Canyon Road to sightsee and capture the "Main Street" activity of Palm Springs. As part of my routine, I rode to Harley-Davidson Palm Springs to pick up some gifts and my mandatory T-shirt. While there, I had the service staff check out my bike's kickstand, since it was binding and needed lubrication.

On the north side of Palm Springs, I passed some impressive windmill farms that probably provide supplemental energy to the community. This was the largest concentration of wind turbines I'd seen from the bike to date. Local environmentalists would not tolerate coal, since pollution in the valley would soon rival that of the Los Angeles basin. As I looked up at these giant machines, my eye followed each of the hypnotic propeller tips through an entire revolution (unlike the propellers of an airplane). I admired the commitment and creative forces that had been invested in this use of alternative, clean energy. While the jury may still be out on their cost-efficiency and visual impact on the surrounding landscape, they are nonetheless fascinating to watch.

As I progressed eastward beyond Palm Springs, I entered the Mojave Desert and soon realized that there was little to inspire a photographer in the miles that followed. The desert was less sandy and scrubbier than that of the Anza-Borrego Desert. Apart from a few insignificant towns, the highway seemed abandoned, yet it was the lifeline to a number of communities in the heart of the desert. Twentynine Palms, which I soon reached, was the largest. I came across an unusual "welcome" sign on the outskirts of town—a wooden frame from which large, colorful medallions dangled on chains. I remember seeing a similar signpost in Pawhuska, Oklahoma, on last year's trip. The medallions are the symbols of the many service clubs that flourish in our communities—the Lions, Kiwanis, and Rotary Clubs to name a few. One sign read, "Soroptimist International." I had no clue what that was and I'm ashamed to say I had to look it up. It turns out that it's a women-executives service club.

The streets that I could see from the road at Twentynine Palms seemed to be losing their battle with the sand, as if they were living on the edge of a lava flow and succumbing to its slow but relentless creep. Evidently temperatures here run as high as 120 degrees, and though it was only now May, the heat was still oppressive. As I scanned the city with my eyes, I saw few, if any, shade trees. Only a handful of business establishments (with the exception of gas stations) had awnings for protection from the sun. I filled up on gas and purchased all of the water I could

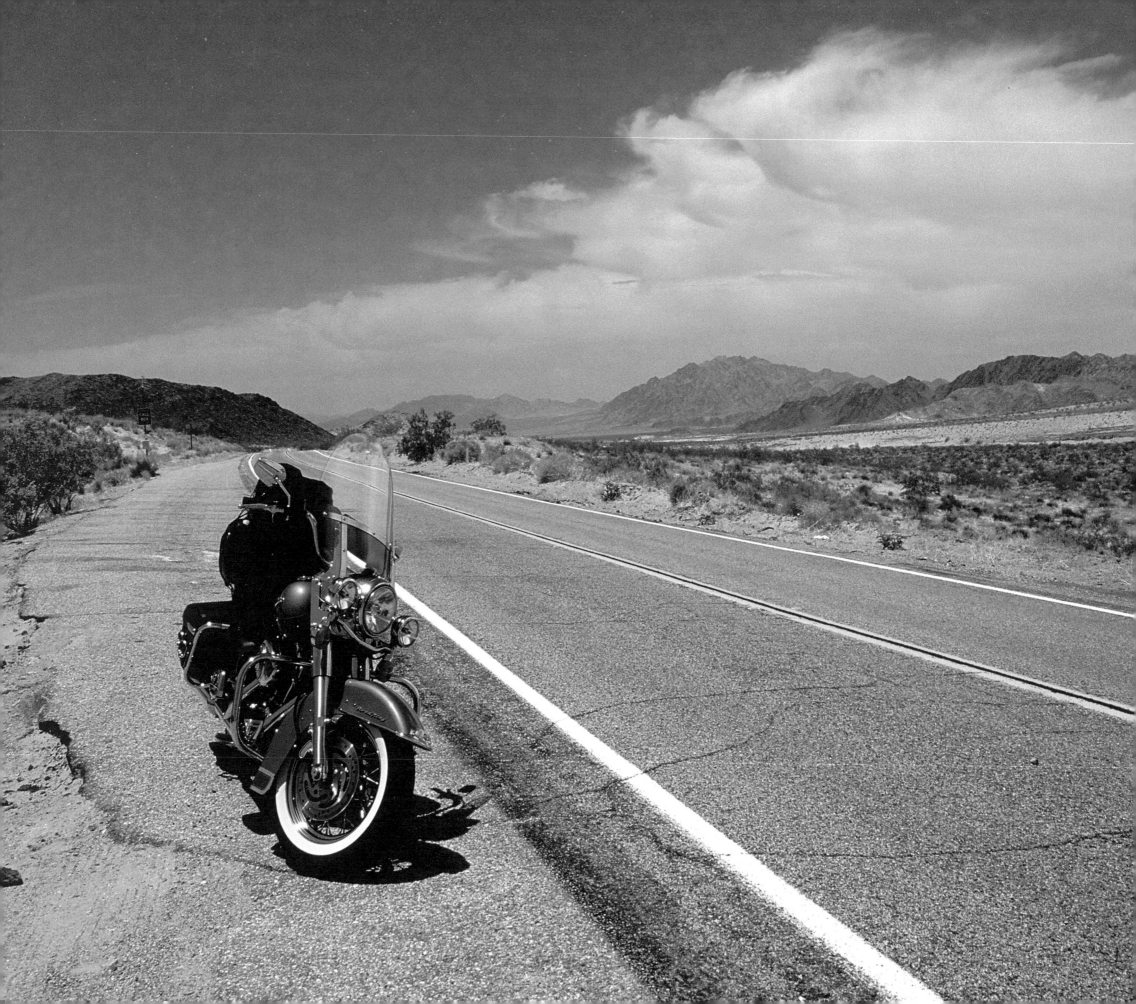

stash away on the bike. I wanted to eat lunch before tackling the long trek across the Mojave Desert up to Laughlin, Nevada. Imagine ordering a pizza in 110-degree weather! But that's exactly what I did at Rocky's New York Pizzeria in the heart of town. I think people congregate at Rocky's as much for the freezing-cold air conditioning as for the piping-hot pies. After lunch I began my march, yet again, across miles and miles of desert. What impressed me most about this vast tract of land was its monotony: there were no signs of life, just a moonscape. As an example of the paucity of gas stations, there's a highway sign just as you exit from Twentynine Palms that warns, NEXT SERVICE 100 MILES. And it was true. Even at the remote village of Vidal, the 20 x 20' store and gas station had only two pumps—one for diesel and one for regular gas—with no posted prices. En route to Laughlin, Nevada, I was relieved once again to see traffic and life. I didn't want to be buzzard bait on my second day out. Riding up 95 was somewhat dizzying—up and down, up and down for as far as the eye could see. Maybe I was tired, but I was mesmerized by the fleet of trucks in front of me that followed each other's movements like a school of porpoises as they maneuvered tribelike along the wavy asphalt highway. This stretch of highway looked like pure-licorice ribbon candy.

Sadly, nothing caught this shutterbug's eye. There were mountains everywhere but the high western sun made for lousy picture taking. I had just read a book on biker outlaw gangs who participated in the town's yearly "River Run" to Laughlin. As I approached the town I was surprised to see high-rise buildings, not the small outpost on a winding river's edge that I had imagined. Laughlin turned out to be a sprawl of large casinos and parking lots that accommodated its patrons and the Las Vegas wannabes. Harrah's, the Golden Nugget, and the Flamingo were recognizable casino names. Predictably, no one seemed happy as they entered and exited the casinos. No doubt the winners were still inside, losing their temporary gains.

In the same way that I had zoomed out of San Diego in order to escape the congestion and crowds, so too did I flee Laughlin, even though I was tired enough to call it a day. I couldn't bear the idea of fighting my way through the slot machines and craps tables, bike gear in tow. In addition to being sleepy, I was also hungry, but saw nothing but fast-food restaurants—which, at the outset of my two-year trip, I had vowed to avoid. So, like any cowboy, I "saddled up" and rode out of town, hoping that the next town, Kingman, Arizona, would be better.

Within 45 minutes, I hit Kingman's main street, the famous Route 66, and was shocked to see that it consisted mostly of old, run-down motels. I persevered to the eastern edge of town, where I came upon familiar hotels. Once again I settled on a Best Western, even though the only available room was a triple-queen suite. I couldn't figure out how the town was booked. What business travelers come here? I couldn't get any answers from the front desk clerk. After a long shower and a quick change of clothes, I walked across 66 to dine at JB's, a family restaurant. Their clientele was mixed but was likely driven to the restaurant by its prices, the highest of which was $12.99 for a steak dinner.

Prior to my trip, I had known little about Route 66, short of the James Dean stories and the penchant of cyclists and car enthusiasts to flock to Route 66 to relive the golden years of automobile travel. Clearly the remaining communities that sprinkle what's left of an ever-shrinking stretch of this historic highway depend on tourism for their survival and perhaps even on nostalgia for the old TV show, Route 66, that ran on CBS from 1960 to 1964. Sadly, there are not enough tourists to keep the older, more historic hotels and the Main Street shops open. All have been replaced by the usual culprits: T-shirt emporiums, discount stores, and fast-food restaurants. Their touristy signs visually pollute the highly fantasized Route 66 of yesteryear, but at least I had seen for myself this one-time strip of American history.

My impressions of the day, apart from remembering the heat and perspiration, were mixed. I had never seen such an expanse of desert before and certainly had not ridden at high noon across such terrain on two wheels, with no shade or cloud cover. I would find desert living stressful, since there is no respite from the heat and no relief to the eyes from the numbingly cheerless color of sand. The lack of greenery and of other visual contrasts would likely take a toll on my psyche, but obviously others see life differently. The irony is that the visual and spatial monotony leaves you feeling claustrophobic, even though you are in wide-open spaces. I was hoping to have a different reaction as I progressed farther east into Arizona and New Mexico. Thankfully, I seemed to be dodging bad weather, even though toward the end of the day clouds had begun to gather and I could see rain to the north of my route. By midnight, it was time to turn out the lights at the Best Western, having freshly recorded the day's waypoints and my diary entry.

May 17, 2006—Daily Mileage: 230.7 (Total Miles to Date: 716.3)

Kingman, Arizona, to Sedona, Arizona

I was up at 6:30 a.m. to a bright and sunny day. I hit the road at 9:00 a.m. and worked my way through the back streets of Kingman to get to the Harley-Davidson Mother Road store. En route, I passed a small elementary school, where some young children were stepping off a school bus and assembling outside the secure front entrance. I wanted to take a picture but, with times being what they are, most teachers would have reacted with disdain to the sight of an unshaven biker in black leather gear taking photos of little kids. I didn't want to take the time to explain my purpose, so I proceeded directly to the Harley-Davidson store for my usual shopping.

There I met the marvelously intuitive and embracing Lyn Moss, a pilot (Cessna 195), a bike rider, and a poet at age 66. She immediately understood me and wanted to talk all day about my trip. Lyn told me about Peach Springs, the rafting mecca on the Colorado River. In season, the town teems with tourists and rafting aficionados and boasts a number of

bustling stores and tourist centers. While she agreed with my reasons for including the town of Seligman on my itinerary, she noted that there would be little of interest to photograph during that portion of the trip.

Since I had missed downtown Kingman the night before, I retraced my steps back to it via Route 66 in order to photograph, what I had heard was, the original Harley-Davidson store. The old, wooden Mother Road structure sits by the railroad tracks, and just as I was making my way over to it a freight train passed through town. I had my camera in hand and quickly caught this on film, since in today's cosmopolitan life it's not often that we get to see trains chugging their way through towns and villages. The Harley store has murals of considerable historic merit painted on the outside of its wooden walls. According to Lyn, they were created many years earlier by local artists in a style that falls somewhere between Thomas Hart Benton's regionalism and the down-home Americana of Norman Rockwell. For good or for bad, Kingman's downtown historic district has emphasized its heritage by plastering Route 66 emblems all over the many fixed objects that one sees everywhere: road signs, light poles, water towers, and so on. The Harley-Davidson store was, for me, the architectural masterpiece in town.

After shooting a few rolls, I headed back onto Route 66 toward Seligman, as the road parallels I-40 to the north. Arizona seemed less arid than eastern California. Maybe the altitude makes a difference, as the air was drier and much cooler in the early morning than on prior days, thank God. The red-stone mountain backdrops were sensational, along with the grass-covered tundra, and this vista made things easier on the eyes. The dark-blue sky was dotted with small, well-defined clouds that make great lighting for a photographer. There was still not much human activity in the towns or on the roads—or even on the ranches. Everything was serene, as if frozen in time. Not even a sign of farming or cultivation. I didn't know if this could be the result of poor soil, high temperatures, or the lack of rain, but it was certainly a good time to clear my mind and focus on the stops ahead.

I detected signs of rain just west of Seligman, so I lunched quickly at West Side Lilo's Café and suited up in my rain gear for the ride to Sedona. Though the rain was light, it arrived in sudden bursts and was accompanied by high winds, to the point where I had to stop for shelter next to a highway berm. I didn't want to have to dodge the wind-driven tumbleweeds, which the cars and trucks seemed to be doing. On a bike, getting hit by one of these hazards would be tantamount to being slammed by a bowling ball and I needed to avoid a strike (or spare) at all costs.

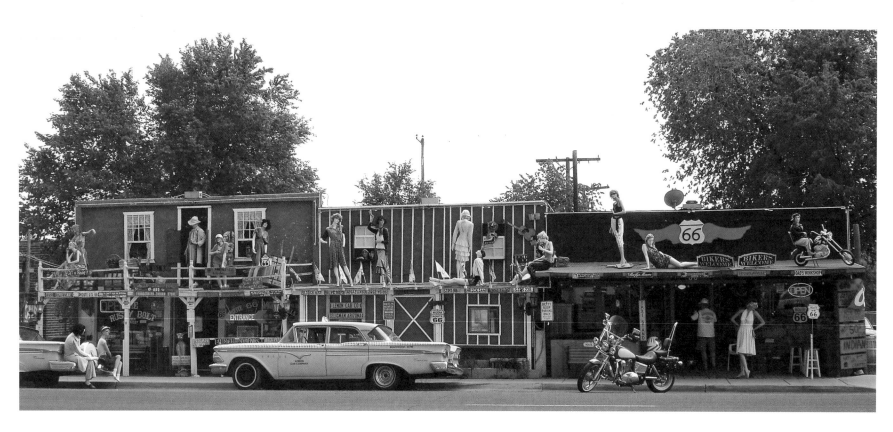

Finally, the weather cleared up and I exited on 89 south, driving through scenic parkland and an occasional farm town. The housing was mostly prefabricated and modest, and it was hard to determine who lived here and what kind of commerce supported the area. It appeared more Hispanic than white. Money seemed tight here, since there was no logical overpass out of Prescott, which may mean that it had been planned for but never constructed. This caused annoying detours and delays, and the alternate 89 was under repair, so traffic was forced into one lane. I note this because sitting on a bike in stalled traffic makes you feel somewhat more vulnerable than one feels in an idling car under the same conditions.

I continued up the mountains to an altitude of 6,000-plus feet, where I felt as if I were back in the Black Hills of South Dakota. The curves and switchbacks were treacherous, and there were few barriers, so I made sure to stay even more alert than usual. On one such curve, I was almost struck by a teenager in a gray pickup who was careening way too fast for the tight curve. I swerved to avoid him, and as I completed the turn—a bit shaken—I saw a cross on the opposite side of the road that probably marked the spot where someone not so fortunate had lost his (or her) life. Close calls like this are humbling and made me feel grateful to be alive. And it was comforting to see a few other bikers with their mates or comrades, dealing with this same challenge of risky roads and crazed drivers.

At the top of the mountain, I stumbled upon the quaint town of Jerome, Arizona, a community built uniquely into the mountainside. Streets, houses, the fire station, and the post office were all lined along winding plateaus that had been carved out of the hillside. This town's layout reminded me of the Amalfi Coast in Italy. I was struck by its ambiance, architecture, and colorful homes, and wanted to stay until dusk in order to savor the experience at one of the local bars, but I had to press on. I left quietly—in Harley-speak, that would mean third gear—out of consideration for a man reading peacefully on one of the town's upper plazas.

After a relatively short ride up Alternate Highway 89, I could see the mountains surrounding Sedona in the distance. Magnificent red-rock canyons formed a backdrop to the city on three of its sides. The setting sun made the mountains shine as if they possessed their own lights. Despite some road construction on Main Street, I soon checked into the Best Western Arroyo Robles and went through my post-ride ritual of unloading, unpacking, showering, and changing, and then set off on a long walk for some much-needed exercise and stretching. I spotted the Cowboy Bar and decided to have dinner there, but after waiting for an hour I gave up my spot in the crowd and strolled over to the Redstone Cabin, only to discover what a small world it is—my waitress there had lived in Pueblo, Colorado, and knew the Warks and their film studio. After a pleasant dinner I returned to my hotel to write my log and record the day's waypoints. My beard is coming in but the jury is still out.

May 18, 2006—Daily Mileage: 438 (Total Miles to Date: 1,154.4)
Sedona, Arizona, to Santa Fe, New Mexico

I woke up at 6:30 a.m. and ate a light breakfast. Before saddling up for my long ride to Albuquerque, New Mexico, I made a swing through downtown Sedona for a few early-morning shots. Not far out of town I caught the Sedona Fire Station on film with its gleaming red truck and American flag all nestled on a curve at the foot of the mountains. The ride up the Kaibab National Forest was stunning. The crisp morning air, sunny skies, and lush forests (and no tourist traffic to speak of) made the riding experience complete. I was going to skip my first stop, Flagstaff, because of the lengthy ride ahead to Albuquerque/Santa Fe (400-plus miles), but my instincts got the better of me, which turned out to be a good call.

I rode into Flagstaff and stopped at the University of Arizona campus, absent its student body. I took a quick tour through the college town, which straddles active railroad tracks. It must have been fun living here in the early 1930s and 1940s, when most peoples' daily activities likely revolved around a passenger or freight train schedule. As I was standing by the railroad station, miraculously a train came through, which of course held up crossing traffic. As luck would have it, I caught a group of young school kids being escorted across the tracks by their teacher, like a mother duck leading her little ones in single file across a busy road—a poignant scene.

I got back on the bike to start my longest ride of the trip, up to now, to Albuquerque (which is hard to type fast; I need an abbreviation!). Light rain, cooler temperatures, and blustery winds lay ahead, as I cast an eye to the east. I donned my rain suit for the second time, which was short-lived as the front passed through quickly, exposing the sun once again and bringing the temperatures up by another 15 degrees. The ride on this major east-west artery (which starts in Barstow, California, and ends in Wilmington, North Carolina) was uneventful. The scenery captured on film was high desert scrub brush and grasses covering the plains between two mountain ranges. I encountered lots of train traffic going both ways and was moved by the sight of a troop train carrying tanks and vehicles, which looked new, heading to a western port. I wondered if these vehicles would eventually go to support our troops in Iraq. The thought of the war in Iraq hit home for some reason and I realized that these trains must have been a familiar sight during World War II. I thank God that my son, Jordan, has never been called to fight in the war. At the same time, I know that, if called, he would serve. I'm grateful for all those who serve in harm's way.

Interstate 40 was populated, unfortunately, with bright-yellow signs promoting Indian wares and casino gambling. Too bad the state allows this kind of advertising as it detracts from the beauty of the land. Sedona seemed to have it under control, as there were no visible signs around town except for those above the stores that were set back from the main roads. What a relief

to the eyes. I grabbed lunch in Winslow, Arizona, at the Flying J truck stop and diner. I happened to sit next to a portly man whose life I was so pleased to learn about. It makes me feel more connected to the places I visit when I hear other people's life stories.

As I continued east, I encountered a sand storm that engulfed the highway. I pulled under an overpass and waited it out, although other bikers and vehicles pressed on without fear. I guess they were not as concerned as I was about having the sand scratch their paint finish. The approach to Albuquerque from the ground was different than the one I had experienced from the air earlier that week en route to San Diego. Albuquerque is fairly compressed around tall office buildings with major highways leading to and from all directions. From the look of the ribbons of highway that are intertwined on its northern edge, this is a major crossroads for Interstates 40 and 25.

Being so tired and ready for my day to end, I set my sights on a night's stay in Albuquerque. As I rode into the heart of the city, I found lots of activity around a theater, whose marquis read "Rock & Soul Revue." Now that was up my alley, but not in sweaty clothes. But I couldn't find a hotel that was close to the center of town. While resigned to call it a day, I just tightened my helmet's chinstrap and decided to press on to Santa Fe, New Mexico, even though it was getting close to dark.

After buying gas, I got back onto I-40 and took I-25 to Santa Fe, pushing the bike faster than I had previously done, but keeping up with traffic. I took some interesting shots of my shadow cast by the setting sun on the roadside as I was moving. I arrived in Santa Fe in the dark and after riding in ever decreasing concentric circles, I found my way to the Hilton Hotel near the Plaza. Unfortunately, the hotel was booked, but the receptionist, Heather, made a dozen calls and found a suite for me at La Fonda, which was on the Plaza and only a few blocks away.

I checked in at 8:46 p.m., my latest arrival so far, and parked the bike, thanks to Gustavo, by the valet station. My room, which was one of two suites at the top of the hotel, was very luxurious. After a quick change I made it to the hotel restaurant before closing. I ate a sumptuous meal (my first Mexican dinner), which turned out to be a bit spicy for my taste. I walked the famous Santa Fe Plaza, and, on hearing some good dance music, went up to a second-floor restaurant called the Ore House. I ordered a beer, sat at a table on the balcony,

and listened to an outstanding trio, the Hoo Doos. I was seated next to a table where a very tall American Indian (who reminded me of Jack Nicholson's co-star in *One Flew Over The Cuckoo's Nest*) sat with a very pretty woman, her hair in a bun. When the two of them got up to dance, they did so with great zest and rhythm. He weighed 280-plus pounds but was light on his feet. She was more diminutive and was graceful and spirited.

When they sat down, they asked me to join them at their table. His name was Zeb and he had arrived in Santa Fe from California seven years earlier and was proud to claim Santa Fe as his sanctuary. Zeb's friend, Lisa, invited me to dance and that's when I saw how gifted a dancer she was. What struck me most was that she possessed unusual inner beauty; unlike so many beautiful people, she was considerate and friendly, not at all "better" than anyone else. I was charmed and felt welcomed by her. After dancing, I met the bandleader, Billy, and the manager, Nancy, and picked up a Hoo Doos CD.

The wonderfully warm and happy atmosphere with these enjoyable people—coupled with a beer or two—made for a special ending to a long day. This evening was clearly the highlight of the trip so far—an evening on a balcony of the Plaza in Santa Fe with a clear sky, stars, adobe rooftops in view, good dancing and music, and sharing the joy of interesting, friendly people. Exhausted, I finally thanked Lisa and Zeb and knew that we'd stay in touch by e-mail. Lights out at 12:30 a.m., New Mexico time.

May 19, 2006—No Miles Logged Today
Santa Fe, New Mexico

I stayed in Santa Fe all day to rest and get laundry done, so there were no miles logged. I rose at 6:30 a.m. and took some early-morning photos of rooftops and nearby churches as I heard the bells ringing. What a nice wake-up call. For the moment, at least, I felt lifted by this brief spiritual interlude. By noon I left the hotel in order to take pictures of a lively square, with its Mercado (market) in full swing. The merchants were seated along the market's wall, selling their wares—silver, turquoise jewelry, etc.—neatly and colorfully displayed on felt or blankets. There must have been 40 to 50 "stations" with active buyers, mostly tourists parading up and down the covered walkway. Most merchants spoke English fluently, and the presence of so many young merchants seemed to suggest that the silversmith trade was being passed down successfully from one generation to the next. There seemed to be a pecking order or squatters' rights that determined who got the best location with the best exposure to pedestrians.

I left the Plaza and decided to walk to Canyon Road, the location of Santa Fe's world-famous art galleries. It's about a 20-minute walk from the Plaza and is a real treat for any art aficionado or sightseer. Canyon Road must be the only one of its kind in the country. The street winds up the canyon and is flanked by one art gallery after the other, filled with paintings, sculptures, and every kind of artwork. While enjoying lunch at an outdoor restaurant, I unwound by watching the tourists and locals move up and down the street. I think I was going through rider's withdrawal, being silently drawn back to a world that seemed to be moving in relaxed slow motion. After a long walk back down Canyon Road, I returned to La Fonda to pack up for the next day's departure north. I noticed, while walking through the lobby, that the hotel was hosting an international conference on "Making Cities Livable." I was glad to see that people are dedicating themselves to this cause, as many cities are suffering from neglect and are losing residents and business traffic daily due to blight and crime. I had witnessed this phenomenon all too often on last year's crisscrossing of America leg from Mount Vernon to Naples.

The owner of Julian's, an Italian restaurant, was kind enough to accommodate my last-minute reservation on a busy weekend night. Isn't it odd how the simple pleasures in life can lift us beyond our daily stresses into a realm of greater peace and clarity? I returned to Canyon Road to reconnect with my newly found friends at a bar, El Farol, and to listen to the Hoo Doos again. Unfortunately, my friends were not there, but nonetheless I enjoyed listening to the band again and getting a glimpse of the local color. My stop in Santa Fe was therapeutic and I met some wonderful friends. I'm glad the mind won over the body, as I would have likely continued my ride without this much-needed interlude. Thank you, Santa Fe.

May 20, 2006—Daily Mileage: 310 (Total Miles to Date: 1,464.4)
Santa Fe, New Mexico, to Dalhart, Texas

After a full breakfast at La Fonda at 7:00 a.m., I headed north toward Taos, with my gas tank and spirit on "full." The ride northward is dramatic because of the sudden change in topography and architecture. You see less adobe and more wood construction as you climb to higher elevations (above 8,000 feet). The best part was following the Rio Grande River. As I climbed through the Santa Fe National Forest, I no longer felt as if I was in the West. The mountains were so impressive that I felt like I was in Switzerland or in the Alps, though here the mountains are lower and less severe. Pine and deciduous trees brightened the landscape with their new, light-green spring growth. As I reached the upper plains, the panorama became even more spectacular.

To my shock, however, Taos was a visual disappointment, even though it too is an artists' community. It is not quaintly nestled into a hill, as is Santa Fe, and the plaza is commercial, mostly crammed with low-priced stores selling Indian jewelry and pottery. The finer galleries and shops are located off the square, as they are in Santa Fe, yet the atmosphere in Taos

was oddly different. Despite these differences, I wondered why artists settled in these two communities over the years. Perhaps because of the magnificent landscapes and vivid colors, which would inspire their arts and crafts. On the way to lunch, I passed some young street musicians trying to make a few bucks—a sign of the town's youthfulness.

After lunch, I took a quick bike tour of Taos. I stuck my leftover lunch—a peanut butter and jelly sandwich—in my inside jacket pocket for a later snack only to discover down the road that peanut butter melts in the heat. I rode east on Highway 64 to Eagle Nest, New Mexico. Climbing the Sangre de Cristo Mountains was a scenic ride and offered a sharp contrast to the lower plains of Arizona and New Mexico. It got progressively cooler as the sun slipped behind the growing rain clouds. Once I reached the higher plains, the topography changed yet again. This part of New Mexico is devoid of any life, yet I still saw a few ranches and homes. I felt as if I were riding in a large bowl surrounded by mountain peaks. Eagle Nest sits by a large lake, with breathtaking views. The ride down to Cimarron, New Mexico—slightly more than 20 miles to the east—was rainy and the sky to the north was peppered with lightning.

Just south of Cimarron, I came across a Boy Scout camp that was set up in an almost military style, with its OD-green (Olive Drab) tents. The camp must have been getting ready for summer activities and jamborees. The scene reminded me of my days as a cub scout in Peru. Looking back, I can see that I learned, if nothing else, how to fill my spare moments with basic activities, which more than likely and thankfully kept me out of trouble.

My turn south onto Highway 21 to skirt the wet weather was a good choice and ended up being the highlight of the day. I felt like I was back in the southwest of England or Ireland, on a typical moist, overcast day. It is remarkable what a fresh rain does to the senses. I saw more of nature's creatures on this day than on most others since beginning my trip in San Diego—such as an antelope grazing 20 yards from the road. I couldn't help but hum to myself the age-old song, "Home on the Range" ("…where the deer and the antelope play").

I had Highway 21 all to myself, with an occasional interruption by a lone vehicle. I actually began singing aloud the hymn "America the Beautiful," which describes what I felt at this wonderfully free moment. I think I must have sung the anthem 20 times at high speed and at the top of my lungs. The beauty and serenity of these surroundings could easily have been the kind of inspiration felt by the composer. I pulled out my camera and took two pictures, one of which became the jacket of this book.

It was hard for me to get on the bike to continue my journey after this interlude. I crossed I-25 at Springer, New Mexico, where I intended to stop for fuel. After devouring a banana, I debated buying gas, but the octane level was not high enough for my Harley. I came close to regretting this decision because I later found myself nearly out of fuel. I headed across Highway 56/412 to Clayton, New Mexico, since there were no fuel services between Springer and Clayton and I had less than half a tank of gas for a lot of riding ahead.

The road belonged to me and my Harley. I was 55 miles from Clayton, New Mexico, when my low fuel light came on, with nothing—no gas stations—anywhere in sight. I kept riding, trying not to think about the dreaded possibility of running out of gas, and I was cursing myself for being foolish enough to have passed up that fuel hours earlier. I feared that at any moment I would have to park my bike on the shoulder of this narrow country road and hitch a ride into Clayton, several miles away. I drew on my flying experience and got rid of the drag by leaning my upper body on top of the tank and tucking my legs as close to the engine as I could. Then I dropped my speed from 70 to 60 mph to improve gas consumption.

Finally, I coasted into the Sinclair Station in Clayton. I was stunned but amused to see the pump register 5.25 gallons for a five-gallon tank. This was a chilling miscalculation for me and I swore never to do this again. The day was getting long and my body and mind were feeling the stress of a worrisome ride. Yet I was dead-set on getting to Dalhart, Texas, which was less than an hour away.

When I hit the road after fueling, I thought I was home free. But the weather gods thought differently as they rolled in a major front directly in my path. While I raced ahead of the storm, which was moving to the northeast on my easterly run, I was overtaken by a microburst precisely as I encountered highway construction. While there was only light rain, the winds peaked at 50–60 mph, which created a huge dust storm that quickly enveloped me and the bike. There was no place to seek shelter and the dust and gooey clay bombarded the bike and its nervous passenger without relief for 15 minutes. Tumbleweeds flew past me at terrific speeds, but somehow I avoided being hit. Several gusts were so strong that they nearly pealed my vice-like grip from the handlebars.

The storm took a sharp turn to the north just as the road suddenly veered south. I was finally free of the threat but was coated in mud and had problems breathing. This reminded me of a similar experience on last year's leg as I was approaching Lamar, Colorado. Ironically, I had pushed the bike to its fuel limit, and while I was fortunate to find a gas station outside of Lamar, I had nonetheless encountered a serious storm, with storm trackers descending on the same station to fuel their trucks for the chase. In my case, I was lucky enough that night to come upon a Best Western, where I cried uncle and settled in for the night.

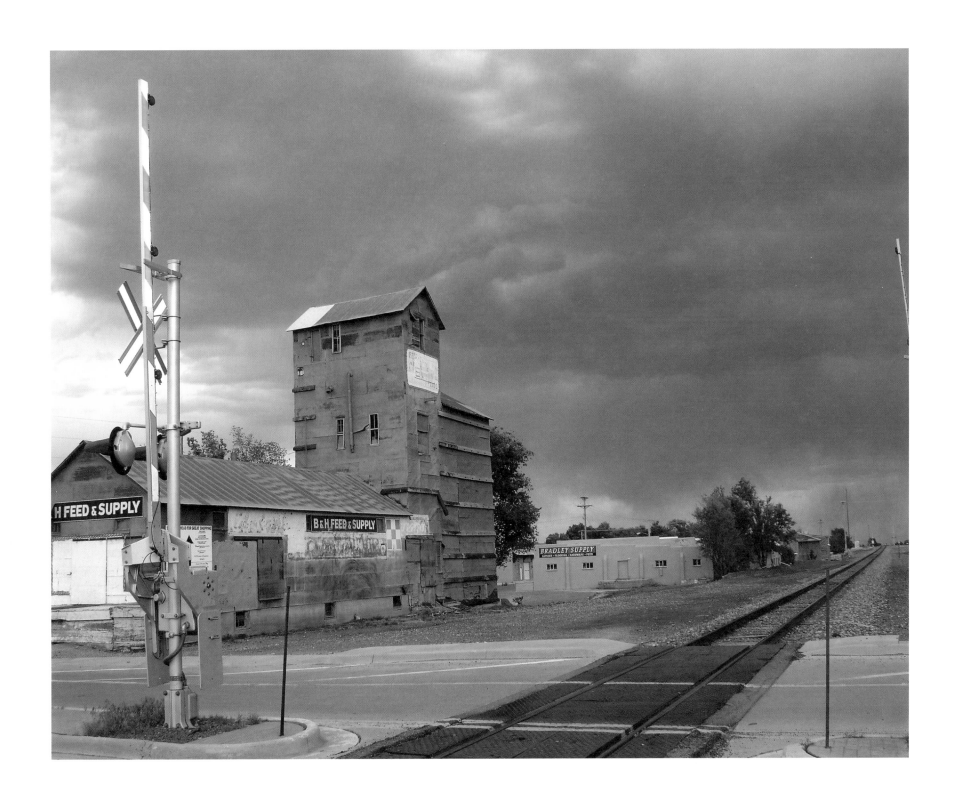

Today, however, I still had 20 miles to go before reaching Dalhart, Texas. I finally pulled in to the Holiday Inn Express in Dalhart at 7:30 p.m. Not only did I have to unload the bike, but I also had to wash it, since I couldn't leave a dirty Harley at the front of the hotel for the night. By 8:00 p.m., I was at the car wash, dutifully cleaning my bike. I returned to the hotel and made the 9:30 p.m. closing at the Bar H Steakhouse. That Coors Light (make it plural) tasted better than any beer I had tasted in memory. That's how ready I was for some libation. I sauntered back to the motel to complete my log and record the waypoints. All I could think of was that I still had another week of this to go. Lights out at 1:00 a.m.

May 21, 2006—Daily Mileage: 327.7 (Total Miles to Date: 1,792.1)
Dalhart, Texas, to Hutchinson, Kansas

Again I was up early to get a head start but was sidetracked by doing my log and answering e-mails. I rode through downtown Dalhart, which was no different from most farm towns, dominated by grain elevators and train tracks. In fact, most rural towns I'd passed were situated on some form of railroad line and truck route. Like their urban counterparts, the downtown areas of these small towns showed signs of neglect from years of weakening economies and dwindling work forces. Dalhart was no different, although there was some effort to beautify the town's center with cobbled streets. It was remarkably clean, although desolate, on this Sunday morning.

I traveled over flat, mostly farm country on my route north to Kansas. I saw wheat fields for miles on end and felt no respite from the heat and monotony of telephone poles, fields, and railroad tracks—the latter, busy with trains hauling produce, cattle, and retail merchandise. As I approached Stratford, Texas, I noticed roadside signs boasting the town's status as "the pheasant capital of Texas." A young kid in an old Ford automobile stopped and admired my bike as he was pulling out of Subway and wished me good luck on my journey. A middle-aged woman said the same thing, adding that she had never seen a bike with a champagne color before. She wished me luck and rode off with a smile.

Once I crossed into the panhandle of Oklahoma, I noticed the economy change from farming to cattle ranching. The odor in the air confirmed it. This part of the country seemed hillier than Texas, but anything more than a few feet high seemed hilly to me at this point. I soon crossed the state line into Kansas—my second time there, since Kansas was the site I crossed on my way from Mount Vernon to Naples last year.

As I progressed along the highway, from town to town, the speed limit of 65 mph dropped to 35 mph inside the town limits—a gold mine for local sheriff departments, who probably pull over many unsuspecting drivers for not slowing down. When I entered Mineola, Kansas, I was moved by the sight of a small park and monument, with flags flying high to commemorate all those who had fallen in defense of America and our freedom.

I experienced a case of mistaken identity when I stopped at Kismet, the next big town on Highway 54 after Mineola. A man in a truck with his family came over and asked if I had been in Liberal, Kansas, which was back south on 54. I said, "Yes." Apparently a large group of Harley riders had gathered en masse for a Memorial Run to Liberal, and he assumed that I had been a part of that group. He thanked me for paying tribute to the fallen American soldier who had been killed in Iraq, not knowing that I had indeed honored the fallen but had not been part of the Harley group. He said that he had a boy over there and that my gesture meant a lot to him. God bless them and the family who had lost their boy. It sure hits home.

I finally approached Bucklin, Kansas, the closest city to the Highway 54/400 intersection. My adrenaline was high in anticipation of arriving at the site of the "X" location of *Crisscrossing America* down the road. The actual spot turned out to be exactly eight miles west of Greensburg, Kansas (or a stone's throw from Mullinville, Kansas, to the west). With a sigh of relief and many arm pumps in the air, I got off the bike and set up the tripod for this momentous (for me) occasion. I'm sure many onlookers wondered why I appeared to be so happy on the shoulder of a busy highway. I couldn't wait to check in with my twin sister, Nini, to share this milestone event. She had asked that I keep her posted often, as she was tracing my progress on her own map in New York.

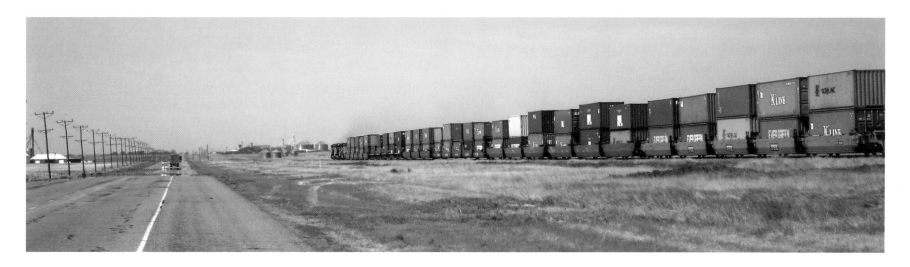

The intersection, as it turned out, was not a perfect "X," since there was no northeast-bound route from this point. At Pratt, a few miles east of this "X" intersection, I turned north on Highway 61, which the H.O.G. Touring Handbook notes as a scenic ride. It met all of these expectations, but unfortunately the alfalfa fields or some other pollen in the air triggered my allergies and I sneezed uncontrollably all the way to Hutchinson, Kansas, my destination for the day. I checked into the Holiday Inn Express in Hutchinson at 7:00 p.m. and immediately headed to Houlihan's, where I savored their famous "California Bangers" (baked cauliflower). After returning to the hotel after dinner, I updated my travel log. The next day I was off to Leavenworth, Kansas, weather and body permitting.

May 22, 2006—Daily Mileage: 320.6 (Total Miles to Date: 2,112.7)
Hutchinson, Kansas, to Kansas City, Missouri

Thunder woke me up several times during the night. It looked like this day would be the first on this leg where I might be facing some serious rain. As I peeked out the front door of the motel, I could see that the cold front had passed through Hutchinson and had moved 20 miles east. I headed to downtown Hutchinson, which I had been told was attractive—and this turned out to be true. It is a Middle-American town with a wide Main Street and multiple railroad crossings. The tree-lined streets boasted some well-maintained homes that indicated lots of civic and national pride, with flags flying to commemorate the upcoming Memorial Day weekend. Main Street had its share of familiar stores, many unique to the town, some having been established 50 years earlier.

After traveling on Highway 50 for a few minutes, I caught up with the rain and finally stopped to change into my rain suit. The weather got progressively worse as I headed directly into the eye of the thunderstorm. The harder the rain fell, the worse the visibility became, which, irritatingly, did not stop truckers from passing me at high speeds. The rain finally let up and I made my way to Strong City, Kansas, to catch Highway 177 North, where I had the pleasure of glimpsing the Flint Hills Rodeo.

When the lunch bell rang, I had conveniently already pulled into Council Grove, Kansas. As it turned out, it was the most photogenic town to this point and looked like those portrayed in the movies of the 1950s and 1960s. A very pleasant man, whose swagger suggested that he might have been the mayor, guided me to his favorite restaurant in Council Grove, the Hays House. The hand-squeezed lemonade was the best I'd ever tasted. My waitress reminded me that refills were not free, a lesson learned by a patron days earlier when he had unknowingly asked for seven refills.

I continued on to Junction City, Kansas, and then east to Kansas City, Missouri. I came upon a radio tower next to old telephone poles just prior to joining I-70. It was yet another poignant reminder of the new replacing the old. As I got back on the interstate, I was dismayed that the bike began stalling again. This reminded me of the fowled plug experience just north of Denver last year. Needless to say, that took my mind off photography and from getting to Leavenworth, my destination on this day. I passed by Topeka, with its beautiful State Capitol building. The approach to the city is much like the one leading into Tulsa, Oklahoma, which had impressed me last year. The highway wraps around the north and eastern edge of the city like a tight necklace.

I headed to Kansas City to find a hotel for the night and got directions to The Plaza section of Kansas City, world famous for its shops, restaurants, and parks. I checked into a Best Western (it had secure parking for my bike, an important criterion for picking a hotel) and contacted my friend Garrett Snow to ask for his advice in diagnosing the bike's problem. We concluded that it was best to change plugs, and after doing so, I was pleased that the Road King Classic purred yet again, like Harleys are supposed to.

My hay fever was proving to become a major annoyance. I loathe taking an antihistamine as it always keeps me up. I, for one, couldn't live in Dorothy's (*The Wizard of Oz*) part of the country for this reason alone. Kansas City is a large, sprawling metropolis with some lovely neighborhoods, but it's not without its share of decaying, inner-city ghettos. The Plaza section is like an oasis, with lovely parks, stores, and restaurants.

I crossed my fingers that the bike would be in good shape and ready to continue the journey ahead. I still had much ground to cover and needed to have a healthy horse under the saddle.

May 23, 2006—Daily Mileage: 365.6 (Total Miles to Date: 2,478.3)
Kansas City, Missouri, to Ft. Madison, Iowa

I was up at 6:30 a.m. and headed to the Harley-Davidson dealership in Gladstone, Missouri, where the bike was fine-tuned. When one of Harley-Davidson's customers heard I was headed for Leavenworth, Kansas, he kindly offered to escort me out of town—yet another example of friendliness that I find so wonderful yet lacking these days. During the 45-minute drive to Leavenworth I had the good fortune to drive across a spectacular web of a bridge that traversed the Platte River. I feel like you almost never see these kinds of intricately built wrought-iron structures anymore.

Leavenworth is an Army town and is the site of Fort Leavenworth, the oldest active Army base west of the Mississippi River. Established in the late 1820s, Fort Leavenworth also houses the Defense Department's only maximum-security prison. While I didn't visit the base, I did ride a few blocks farther west to the federal penitentiary, a splendidly impressive and imposing granite structure situated 200 yards from the road and surrounded by concrete barricades. It sent shivers down my spine to see an active prison with inmates parading the grounds, officers at the ready in their guard towers. One off-duty guard warned me that a prison official may ask me to leave, so I stopped taking pictures. I rode through the U-shaped parking lot and noticed the blue signs marking reserved spaces for the "Guard of the Month," the warden—being closest to the main entrance—and the usual pecking order, as in corporate America. Cars exited the lot, filled with young and old members of the inmates' families. Sadly, this must be a daily or weekly ritual for some.

I set out for Hannibal, Missouri, the boyhood home of author Mark Twain. The weather was cool and overcast but the mist quickly burned off. It's amazing how sharp one's senses become while on a bike. I was miles away from rain but could smell a sweetness in the air and felt a change in temperature, cooler by a few degrees. Within minutes I saw signs of a looming shower. Ragweed covered the sides of the highway, as if the road had been laid down over a field of weeds. It made life unbearable for me until I gave in and took some more allergy medication.

I got as far as Cameron, Missouri, where I stopped for a quick bowl of pinto beans at Ma & Pa's Kettle, a restaurant serving home-cooked food. At the table next to mine, an African-American gentleman, a Caucasian man, and an Indian (from India) were engaged in a conversation about Christ. To my surprise, all three individuals delighted in reinforcing each other harmoniously with, in their parlance, the "Word of Christ."

After getting back on the highway, I reached Hannibal by 3:00 p.m. There was not much to see but the Mississippi River—the "Great Muddy"—which was flowing strong and mighty. Hannibal's economy hangs on the lore of Mark Twain. Clearly, the Mark Twain Boyhood Home and Museum and other Twain-related attractions keep the merchants in business, at least through the holiday and vacation periods.

Instead of going east to Illinois as I had intended, I decided to ride north into Iowa in order to add another state to my journey. I headed to Fort Madison, Iowa (the fort itself was erected in 1808). While the town had seen better days, the surrounding neighborhoods were nonetheless maintained proudly, with a strong sense of community. There was a re-created fort in a park located along the Mississippi. I made a loop of the downtown district and when I saw the Kingsley Inn, I decided to check in. The proprietors, Fayek and Rebeca Andrawes, were lovely people and had obviously invested much effort in renovating their old Victorian hotel.

They showed me several rooms and I picked the largest one because of all my gear. Rebeca was nervous that I was leaving my bike outside. They lived in the hotel and invited me to park my bike in their private garage. Very thoughtful. Fayek and I shared stories of our both having lived in London and in other cities abroad. I could tell that he derived great pleasure from interacting with his guests. He even showed me his collection of Roman pottery and African art. Tough as it was to terminate the conversation, I had to say good night and retire to bed by 11:00 p.m. The next day, I needed to make good progress in order to reach the Adirondacks before the busy Memorial Day weekend.

May 24, 2006—Daily Mileage: 353.7 (Total Miles to Date: 2,832.0)
Ft. Madison, Iowa, to Huntington, Indiana

I set out at 8:00 a.m., after having eaten a delicious breakfast in the Kingsley Inn's elegant dining room. Rebeca greeted her five guests with great warmth and Fayek came by to wish me Godspeed. I got onto the toll bridge and crossed the Mississippi River into Illinois and the first town I encountered was Dallas City. I photographed a quaint house and scenes around the railroad tracks. I don't know what it is about me, but every time I stop to take a picture, a train shows up, almost as if by command. And this was no exception. Flags were flying in most of the towns along Highways 9 and 24, celebrating the upcoming Memorial Day weekend. Middle America is firmly patriotic, especially in rural communities, where I have spent most of my time on the bike.

It intrigues me that in the Far West, the topography, flora, and dramatic vistas caught my attention, but as I headed east into the heartland—Texas, Oklahoma, Kansas, Missouri, Iowa, and Illinois—it's mostly flat farmland and pastures. That said, I tended to be more acutely aware of patterns, such as crops planted in neat rows, roads running in tangents off the main highway, and miles of telephone poles that resemble musical bars and notes from sheet music. Having little to distract my eye, I tended to focus on structures such as farm houses, outbuildings, silos, and fences.

In Bushnell, Illinois, I photographed a sign that read "Global War on Terrorism." It listed the town's people who were serving or had served in Iraq or Afghanistan. How lucky we are that there are those who volunteer to serve this country. It made me appreciate the need to celebrate Memorial Day and remember those who have shown such bravery and who will continue to do so in the future.

I continued on to Peoria, Illinois, the first urban center I had encountered since leaving Kansas City. Peoria seemed to mark the change from a purely agrarian landscape to an industrial region. Farmhouses and silos gave way to multistoried brick structures, steel mills, and the familiarly intrusive smoke stacks that belch pollution into our air on an hourly basis. On the outskirts of town, I saw a dilapidated, decaying textile mill that had been converted into a storage facility for truck trailers. Nearby, there was a junkyard with cranes piling wrecked cars and steel waste onto big piles. While I had expected Peoria's inner city to be run-down, I was surprised to see a clean, vibrant complex of tall office buildings and lots of pedestrian activity on the sidewalks and streets.

Crossing into Indiana, I was welcomed by a sign that heralded "Indiana: The Crossroads of America." I thought that was apropos. Taking Highway 24 instead of a major interstate across the Midwest enabled me to see America's small towns connected as if they were beads on a string. On the interstate, I would have seen the major cities but would not have glimpsed people going about their regular routines. The backroads approach was more colorful and broke the monotony of an interstate ride.

I loved Monticello, the first major town I encountered in Indiana—one with lots of character. One such example was an old gas station that had been converted into a flower shop, now called the Flower Station. I laughed out loud when I saw the price per gallon of seven and 9/10 cents on the old gas pump. How times have changed.

As I headed toward my destination of Fort Wayne, Indiana, I noticed the clouds turning darker in the vicinity of Huntington, so I decided, for safety reasons, to settle in for the night at the Holiday Inn Express. I cleaned the bike before thunderstorms broke, caught dinner, and then returned to the room.

May 25, 2006—Daily Mileage: 377.2 (Total Miles to Date: 3,209.2)
Huntington, Indiana, to Meadville, Pennsylvania
I was off by 9:00 a.m. with a trip through Huntington, Indiana. It was a pleasant, interesting spot with winding streets and a combination of old and tastefully designed new buildings. As I stopped to take pictures, the obligatory train pulled into town. I then continued on to Findlay, Ohio, a town spread out with blocks and blocks of malls and shops. I rode east until I came upon the Soni Junction Restaurant, a makeshift diner from which I called my hosts in the Adirondacks to let them know that I would be at Old Forge, New York, within one or two days.

I pressed on to Akron and its western suburbs, and as I approached the southern end of the city I noticed several big tire companies, Akron's heritage. Two Goodyear plants straddled Highway 76 on both sides. I continued on to Warren and Youngstown, Ohio. Youngstown and steel are synonymous to me. I exited the highway onto a side road and made it to the heights above this old city, from which I saw scores of row houses and people seated on their front porches—each house was carefully lined up for the entire block and was only a few feet apart from its neighbor. I headed downtown for a quick tour and then resumed my trip east. On leaving Youngstown, I passed a massive but abandoned steel mill—a symbol of once-great American industrialism that has been killed off by foreign competition.

After crossing the state line into Pennsylvania, I stopped for a breather in Greenville, where I was lucky enough to see some Amish people, dressed in their instantly recognizable attire. There were at least a dozen Amish in the convenience store stocking up on worldly goods, which they piled into a large red van. Obviously they had hired a non-Amish driver, since they do not believe in modern conveniences. Had they not needed the space offered by a van, they would have no doubt driven their own horses and buggies into town. I reached my final destination of Meadville, Pennsylvania, at 7:30 p.m. and checked into a Holiday Inn Express. I raced off to Chovy's Italian Restaurant for a square meal.

On returning to my hotel room, I found myself thinking about the start of this journey more than a week ago. I am glad I took backcountry roads, since, taken individually, each of them would have constituted a great Sunday bike ride anywhere in America. I had the roads mostly to myself. Traffic was minimal and the stops through towns broke the rhythm. Each town had its own character. Some were sleepy while others were busier and more alive. I kept thinking about "America the Beautiful," which really tells the tale of my trip: spacious skies, amber waves of grain, purple mountain majesties, from sea to shining sea. My voyage has been not only therapeutic, but also enlightening and energizing. I seem to have been touched more deeply by what is small and quaint than by what is large and less personal. Thanks to my trip across the Midwest, I've had a glimpse of what American life was like in the early 20th century. Perhaps it is just nostalgia for a simpler, less complicated life. Lights out by midnight. I expected the next day would be a long, tiring day, as it appeared the rain would persist, at least for 24 hours or so.

May 26, 2006—Daily Mileage: 507 (Total Miles to Date: 3,716.2)
Meadville, Pennsylvania, to Old Forge, New York
I got up early after tossing and turning between thunderclaps and heavy, windy downpours throughout the night. I knew it would be a slog of a day trying to get to Old Forge, New York, at the start of a busy Memorial

Day weekend. The traffic would be heavy, and adding to that the inclement weather, the picture looked bad altogether. After a quick breakfast, I went out to check the bike. The dust cover was soaked. I returned with lots of towels and after moving the bike out of the rain to a sheltered spot under the portico, I dried it off and loaded it up, this time with each of the luggage inserts covered in trash bags.

I gassed up across the street, bought water and granola bars, and by 9:00 a.m. was proceeding cautiously to I-79 North headed toward Erie, Pennsylvania. As I didn't want to miss seeing Lake Erie, I took the downtown exit to the bay front and one of its marinas. It was locked but the service folks had left a side entrance open, so I invited myself in to take a quick picture of the lake from the gazebo.

I headed back toward I-86 East to Horseheads, New York, this time with more confidence and greater speed. As I got onto the interstate, I pulled over at a rest stop to regroup and plan the long ride to the Adirondacks. I spotted a man behind the "Welcome Desk" offering advice and weather information. His name was Ron Cotton and he showed me the north-to-south low that was bringing moist bands up from the south and dumping heavy rains on this part of New York State.

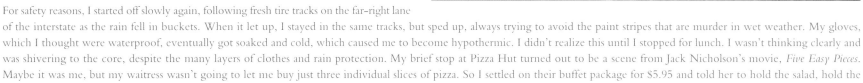

For safety reasons, I started off slowly again, following fresh tire tracks on the far-right lane of the interstate as the rain fell in buckets. When it let up, I stayed in the same tracks, but sped up, always trying to avoid the paint stripes that are murder in wet weather. My gloves, which I thought were waterproof, eventually got soaked and cold, which caused me to become hypothermic. I didn't realize this until I stopped for lunch. I wasn't thinking clearly and was shivering to the core, despite the many layers of clothes and rain protection. My brief stop at Pizza Hut turned out to be a scene from Jack Nicholson's movie, *Five Easy Pieces*. Maybe it was me, but my waitress wasn't going to let me buy just three individual slices of pizza. So I settled on their buffet package for $5.95 and told her to hold the salad, hold the drink, and hold two of the five slices of pepperoni pizza. Before I left she warmed up, as did I, and wished me a safe trip.

I got back onto the interstate and finally reached the Ithaca exit at Route 13 just east of Horseheads. Now that highway construction was behind me and the rain was subsiding, I was hoping that the rest of the trip would be quicker. As I approached Ithaca, the Cornell and Ithaca College traffic at 3:00 p.m. in the afternoon of this Memorial Day weekend was predictably heavy. I wanted to tour Cornell, which is up in the heights, but it was too close to rush hour and I was still a long way away from Old Forge. After a few twists and turns through beautiful farm country (Route 221 being one of the prettiest stretches so far), I reached Marathon, New York, birthplace of my mother.

The town of Marathon sits on a hill by the river and railroad tracks, surrounded by dairy farms. My approach from the west left quite an impression: Marathon simply appeared before my eyes. I never realized Mother had been raised in the countryside. The pastoral setting was such a juxtaposition to the urban living experience that she had enjoyed during her adult life. I could picture her running up and down the hills, going to the general store on Main Street, and catching a glimpse of the train, which she hoped, I imagine, would take her to New York City one day to pursue a career.

I asked a local resident for directions to the town cemetery, so that I might find Mother's parents and the rest of her kin. The cemetery, on the eastern side of town, was located on a hill across the river. I tried to find her family's gravesite, but the grass-covered paths were too narrow and slippery for my Harley. In fact, I almost lost control of the bike as I approached an inner circle of graves. I called my brother James later in the day and he informed me that, ironically, my grandparents were buried in the inner circle. I'm not superstitious, but it is likely that I slipped just at the very spot of their gravesites—I was just too preoccupied to stop and look. It was starting to rain again and the grass was getting slippery, so I left the cemetery and got back onto the I-81 ramp.

Syracuse was 42 miles away and Utica was the same distance east of Syracuse. So 80-plus miles seemed like a piece of cake at 6:00 p.m. As I approached Utica, I saw no signs pointing to Old Forge. This turned out to be my second mistake of the trip. I realized, when I saw the next sign leading to Albany, that I had missed my exit. There were no exits to turn around until Albany and that was the straw that almost broke this camel's back. After a long wet day, I was about to cry uncle. I called my hosts, who were very understanding. They told me to reverse course and take my time and press on to Old Forge—and they would hold dinner for me. That's all the encouragement I needed.

I was so relieved to be on the right road. I stuck to the middle of the narrow roads leading to Old Forge and avoided getting a ticket, seeing state troopers out in numbers. On approaching the town, I saw numerous "Deer Crossing" signs. That was like a red alert of potential danger. So I goosed the throttle and cozied up to the car in front of me, using it as a shield.

I made it to Old Forge by 8:30 p.m., almost a 12-hour day in the saddle. I called my friends from town to get instructions to their home, and 10 minutes later, was greeted by them. Fred and I went to high school and college together and were thrilled to see each other. After a long shower, I joined Fred, his wife Dinny, and their family for a delicious dinner. Before long I was off to their guesthouse by the lake and was soon fast asleep. This was the longest, most challenging ride so far. But it did not diminish the experience of riding along some of the most scenic interstate highways in the country. The trees were bright green, with new spring growth. The farmland was richly colorful and was made more dramatic by the gray, granite outcroppings and bright-red barns and white clapboard homes interspersed throughout the countryside. While the highway had been treacherous in parts (painted dividers offer no traction when wet), I was glad I had a new set of tires. They made for more confident, less risky riding. The ride up the Adirondacks was not as dramatic as I had expected, but perhaps this was because of the weather and the time of day.

May 27, 2006—No Miles Logged Today
Old Forge, New York

No miles today, as I remained in Old Forge for an extra day, much like in Santa Fe. My hosts persuaded me to stay at the guesthouse and catch up on much-needed rest. I called my brother to let him know that I was postponing our get-together in Saratoga Springs until Sunday. So the rest of the day was spent resting. I slept in until 7:30 a.m. but wished it had been noon instead. Fred and I took a tour of the lakeshore by car and met the property manager at the Bisby General Store, a throwback to the 1940s. I returned to my cottage to rest and shower before dinner. A stray fox came up to my screen door but my host chased it away so I could leave the cabin in time for dinner. The best part of the evening was rowing in an old lake boat with Fred to and from dinner at a restaurant farther down the shore. The Adirondacks were mesmerizing—almost surreally so. In this refreshed state of mind, it didn't take me long to pack and fall asleep in this serene, comfortable setting—foxes and all.

May 28, 2006—Daily Mileage: 261.1 (Total Miles to Date: 3,977.3)
Old Forge, New York, to Hanover, New Hampshire

I bid farewell to Fred at 8:00 a.m. after he made absolutely sure that I was fit and ready to continue my journey. This dear friend joined my list of Good Samaritans. A few miles outside of Old Forge I came across Inlet, New York, one of the prettiest of the Adirondack towns. My ride couldn't have been more soothing, especially on this dry and cool sunny morning. People were jogging, strolling, and riding bicycles. Most of the lakes visible from the road were still covered with low clouds, which were slowly lifting as the sun rose higher in the sky. I was caught by surprise to see a sign pointing to the Hudson River, not realizing that the Hudson's headwaters were in the Adirondacks. Many New Yorkers and tourists had descended here to catch the rushing spring waters and enjoy rafting down the river. My ride to Saratoga Springs, known for its spas and horse racing, was equally as scenic as all of New York State's thruways. I reached Saratoga Springs just in time to meet my older brother at the Amtrak station. He traveled all the way up from New York City to catch a glimpse of me on this strange odyssey. His was only the second commuter train that I had seen during my entire trip, both this year and last. We had a great time catching up over lunch, after which I set off to New Hampshire.

My ride north on the New York side took me past the Champlain Locks and through some towns, some of which, like Whitehall, were preparing to celebrate Memorial Day (the U.S. Navy has its origins in Whitehall). I couldn't help but marvel at the church spires that seemed to appear on every corner as I headed east. Woodstock, Vermont—not to be confused with the site of the famous New York State music festival—had a mixture of quaint stores and high-end restaurants. If I'd lingered there, I might have discovered the character of this New England village that attracts so many visitors and full-time residents. I ended the day at 5:30 p.m. by checking into the Hanover Inn, located in Hanover, New Hampshire, the home of Dartmouth College, the quintessential college campus, and one of the prettiest in the country. Dartmouth is known for its big "quad," surrounded by some of the finest architecture on any college campus—brick and clapboard, with tall spires and brass clocks. My father attended Dartmouth from 1930 to 1934, so I was eager to tour the campus and locate his fraternity house, which I did. All the doors were locked except for one, so I let myself in. The first floor was empty, although I heard voices coming from the basement, no doubt from students who lived there. I stayed only a few seconds, long enough to satisfy my curiosity. I headed back down to Main Street to catch a bite at the Canoe Club. I made a few phone calls from my hotel room and was in bed by 10:30 p.m.

May 29, 2006—Daily Mileage: 266.7 (Total Miles to Date: 4,204)
Memorial Day—Hanover, New Hampshire, to East Boothbay, Maine

Happy Memorial Day! I left Hanover at 9:00 a.m. and headed north on Highway 10. I noticed more bicyclists in New Hampshire than anywhere else. There were some lovely New England villages along the route, with well-defined squares and typical New England white clapboard colonial buildings. The roads in New Hampshire seemed to be more treacherous than in the preceding

states because of the frost and snow plowing every winter. I had to be extra vigilant, on curves especially, so as not to lose traction on what riders call "snakes," the seams, cracks, and plow scars were repaired with a smooth coat of asphalt that looked like a shiny, flat snake from a distance.

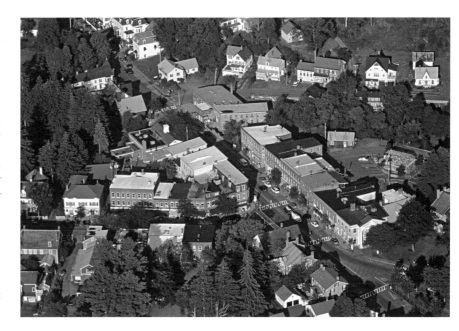

Route 112, also known as Kancamagus Highway, leads across the White Mountains of New Hampshire. It was a great ride, crowded with bikers on this sunny Memorial Day. From the time I'd left San Diego, nearly two weeks earlier, the bikers I'd encountered had been courteous, acknowledging me with the friendly biker's greeting— a drooped left hand. Oddly, very few towns in New Hampshire had flags flying on this Memorial Day. What's more, the flag etiquette—half-staff on Memorial Day—was not practiced in every case. And even stranger, I saw no Memorial Day parades in any of these towns, a disappointment since I was looking forward to catching a glimpse of Americana on one of our country's most important days.

I soon reached the Maine border, where the welcome sign said it all: "The Way Life Should Be." I took this to mean a life that is laid-back and relaxed. I stopped at an outdoor drive-in theater in Bridgton, only the second one I'd seen between San Diego and Maine. I used to love going to the drive-in in our old car and parking on the mounds, with the speakers hanging on the roll-down windows. I would always order a root beer float and popcorn. Part of the fun came from having so many kids jammed in the car. I'm sure we distracted others who were on serious dates, oblivious to what was on the big screen. I rolled the Harley onto the mound, next to a speaker stand, and took a picture of the bike facing the screen. To my surprise, the drive-in was still in business and was showing current movies. Admission was $7 for adults and $4 for children.

In Naples, Maine, I ran into lots of traffic. As I approached the center of town, which sat on the shores of a large lake, I saw restaurants, boat-rental facilities, and a seaplane operation. The unseasonably warm and sunny weather brought everyone out, including Harley riders. As I approached Lewiston, Maine, I saw no signs pointing to the Maine coast, which is where I needed to go to catch the famous U.S. Highway 1 drive. In Bath, I marveled at the imposing City Hall at the top of the hill of this renowned shipbuilding town.

I moved on to Wiscasset, which I liked the most because of its cleanliness, pristine lawns, and familiar white New England colonial homes. It was one of many picturesque towns in Maine. I had made good time on this day and realized I was a bit early to check in at my hosts' home, so I headed directly to Boothbay Harbor, a scenic town on one of Maine's many peninsulas. While the old buildings in the harbor are attractive and colorful, most of the stores cater to tourists and many of the fine-dining restaurants and upscale stores were located away from the prime locations on the wharf. There were numerous signs for boat rides, whale-watching trips, and other marine activities.

The little town of East Boothbay is more typical of a Down East town—in this case, nestled in the hills overlooking a harbor, a seafood restaurant, and a marina. I arrived at my hosts' house at 6:00 p.m., where my friend Chet was waiting by the door. After a long shower, I joined Chet and his wife Kathy for a cocktail on their porch, and took in the spectacular views of Linekin Bay and the bays to its south. Their house was peaceful, the air was moist, and the smell of seaweed and the ocean was unforgettable. After dinner I retired to write my log and pack for an early departure in the morning. I knew tomorrow would be long, with Eastport and unfamiliar Maine territory ahead.

FINAL DAY OF MY TRIP: May 30, 2006—Daily Mileage: 233.5 (Total Miles to Date: 4,437.5)
East Boothbay, Maine, to Eastport, Maine
Hard as it was to believe, this was the final day of my two-year journey—and already I missed my beloved new friends and newly discovered homeland. I was up here in Maine, about to pack my bike and set out for our country's easternmost point. Once I was back home in Florida, it would take time for me to contemplate the myriad experiences of the past two years and to start seeing the progress I'd made as a human being, not to mention all the feelings that had been new to me as I'd broken out of my mostly East Coast frame of mind.

At the moment, I had a full day ahead of me, and I could honestly say that I was both relieved—and not relieved. On the one hand, I would take pride and joy in having followed my heart and achieved my goals. But on the other hand, I would dearly miss the exploration and sense of derring-do that this kind of a trip involved. It was as if each day I learned something new on

the road or saw something I'd never witnessed before. I had encountered many new faces and shook more hands than a politician. My feelings toward these new acquaintances, however, had been genuine. I was (and remain) extremely grateful to them for their endless courtesies and kindnesses. The American spirit runs deep throughout the land and it is one of great faith in humanity. I love being an American and am proud of my roots, even if I spent much of my youth abroad.

I was up at 6:30 a.m., full of energy. I said goodbye to my friends and reconnected with U.S. Highway 1. I was struck by the paucity of advertising billboards, which had been an eyesore for most of this trip across America. In Maine, even the largest advertisers such as McDonald's have been relegated to a few square inches (not yards) on modest and uniform signposts along the highway. Kudos to Maine for not giving in to Big Business. One of the small towns along the way, Thomasville, was typical of the coastal towns in Maine, with ample green lawns, freshly painted white houses with colorful window boxes, and a historic park with its Civil War monument. Rockland, the next town to the east, is a ferryboat town on the Maine coast that provides services to the offshore islands. There was only one ferry on this day at the city docks. It was loaded and about to leave.

Perhaps the most picturesque town in Maine is Camden. The approach into town takes you down a relatively steep hill, which provides an ideal vantage point from which to scan Camden's harbor, rooftops, church steeples, and ships' masts. The inns along the hilly entrance to town were skirted with flowers and were freshly painted for the season. Camden was bustling, probably as a result of vacationers taking advantage of the long Memorial Day weekend to start their "summer" vacation. The warm, sunny weather was a big bonus for this time of the year, and everyone was out and about. The scene reminded me of my travels through northern Europe where the townspeople would come out of the woodwork on those rare sunny days to sit on the public lawns, craning their necks to capture the sun. Unfortunately, road crews were out repairing Camden's streets, as the winters here are harsh, with the roads taking the most punishment.

I headed to the wharf and city docks past rows of stores, restaurants, and bars. Young, enterprising college kids lined the docks trying to drum up kayak trips, boat tours, and a day sail on an old schooner. They said things were slow today, although the weekend was fast and furious. Boats, old and new, covered the waterfront. Old schooners were moored or docked, by design, at the head of the harbor for the greatest exposure. Water and boats soothe my mind and I lingered there, soaking up the maritime scene. The smell of seaweed gets stronger as you head farther east on the coast. It makes you want to take a deep breath, which I did. The tides here are very dramatic. It was low tide when I arrived and the floating docks and their respective ramps extended well below street level (maybe 15 to 20 feet). Camden's square boasted a Civil War memorial, located at the head of the harbor. It was populated today by sun seekers, young and old.

Most of U.S. Highway 1 takes you along the Maine coast, so water views are plentiful and breathtaking. However, the farther north and east I traveled past Camden, the further inland Coastal Route 1 took me. So any glimpse of the ocean was transfixing and my tendency was to stop, thinking that it might be my last view of the water (and what a view it was). Just north of Searsport, I traversed the Penobscot River Crossing. As with most highway and bridge modernization programs across the country, the old bridge was being replaced by a new one. The new bridge was almost complete. This made for a good shot of the old and the new.

Maine is dotted with inland lakes and estuaries that run north and south along the Maine coast. There are lots of lobster eateries along Route 1. I stumbled upon the "Museum of Natural History" (Maine's humorous version). From the road it looked like it had archives of license plates and automobile history and junk dating back to the 1930s. And the entry fee is more reasonable than that of any other natural history museum—FREE.

At precisely 5:00 p.m., I reached Eastport, Maine, the easternmost city in the United States and the end point of my crisscrossing of America. Just like the ritual in Kansas at the crisscross, I was not going to miss a photo opportunity, especially on this unusually bright day with the sun at my back. I set up the mini tripod to record the Harley and me at the wharf in Eastport on this milestone day. It felt good to be here. While enjoying a private moment, I said a prayer of thanks and let out a guarded but pleasing "YEAH!" accompanied by a few fist pumps.

While my journey officially ended in Eastport, Maine, I couldn't seem to close this day's entry without saying, "Good Night," or "Lights Out," or some closing remark. But I have to record that the trip on this day did not end as planned. I thought I'd check into an Eastport motel, unpack, shower, and head out to a local fish restaurant (lobster, do you think?) and raise a glass to those who got me across the country safely (my Guardian Angel, for one). Then I would crash in bed with a great smile and sense of accomplishment and humility and get up the next morning and start to head to the nearest airport for the flight home. But having left the wharf, I searched and searched for an accommodation in Eastport and couldn't find one. So I raced up Route 1 to Calais, at the border crossing with Canada. As the sun was setting, I fueled at an Irving gas station in Calais and rode south and west toward Bangor, where I had planned to fly out the next morning. One of my last memories was of a house high on a hill on Route 9, southwest of Calais. The American flag caught my eye at dusk. This scene was an appropriate ending to my American experience!

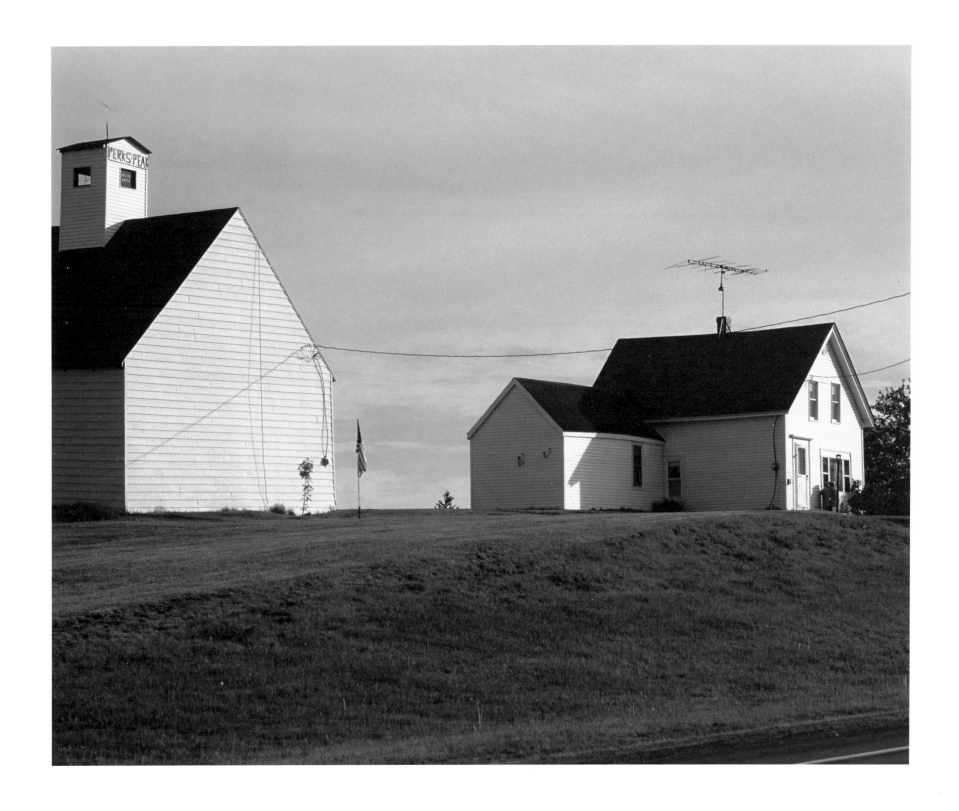

SOUTHWEST *to* NORTHEAST

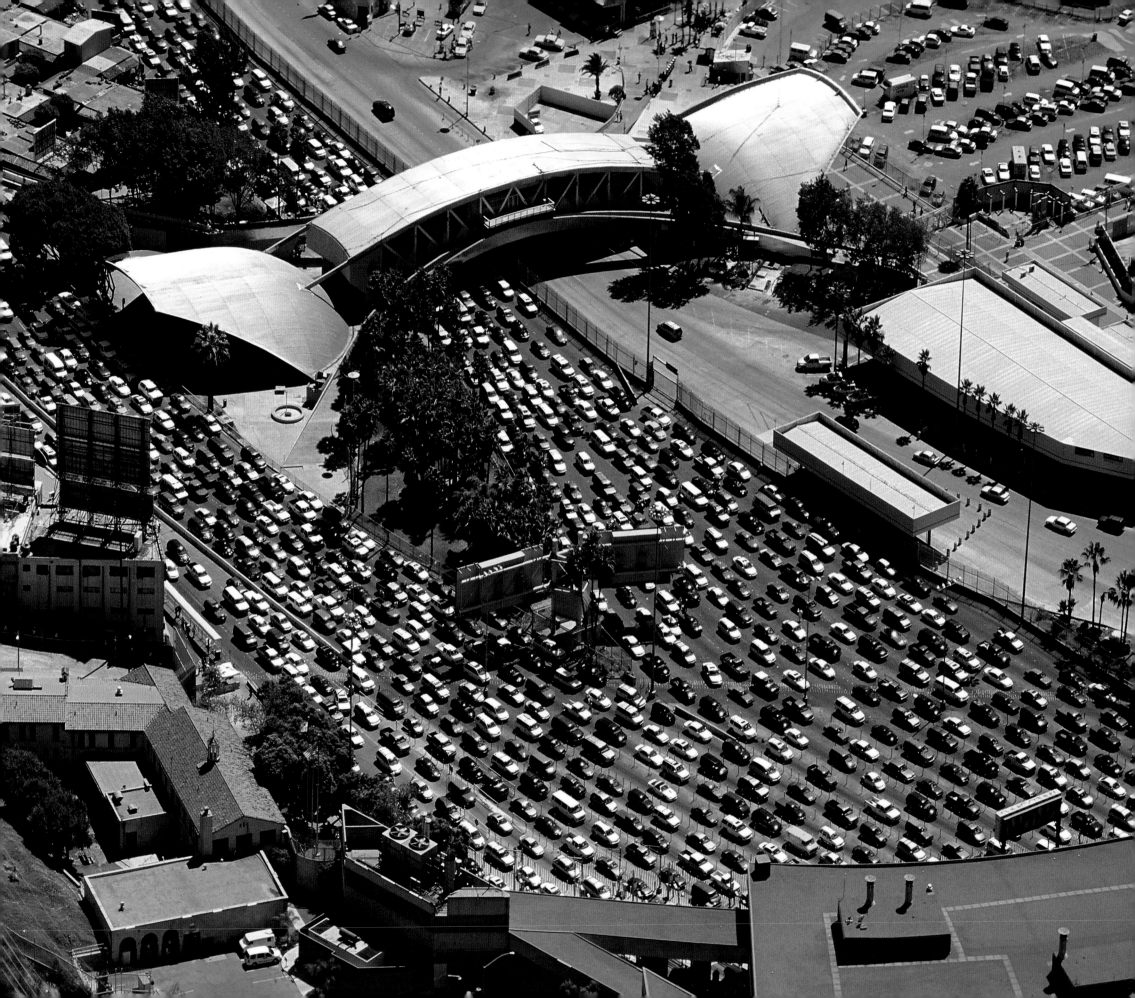

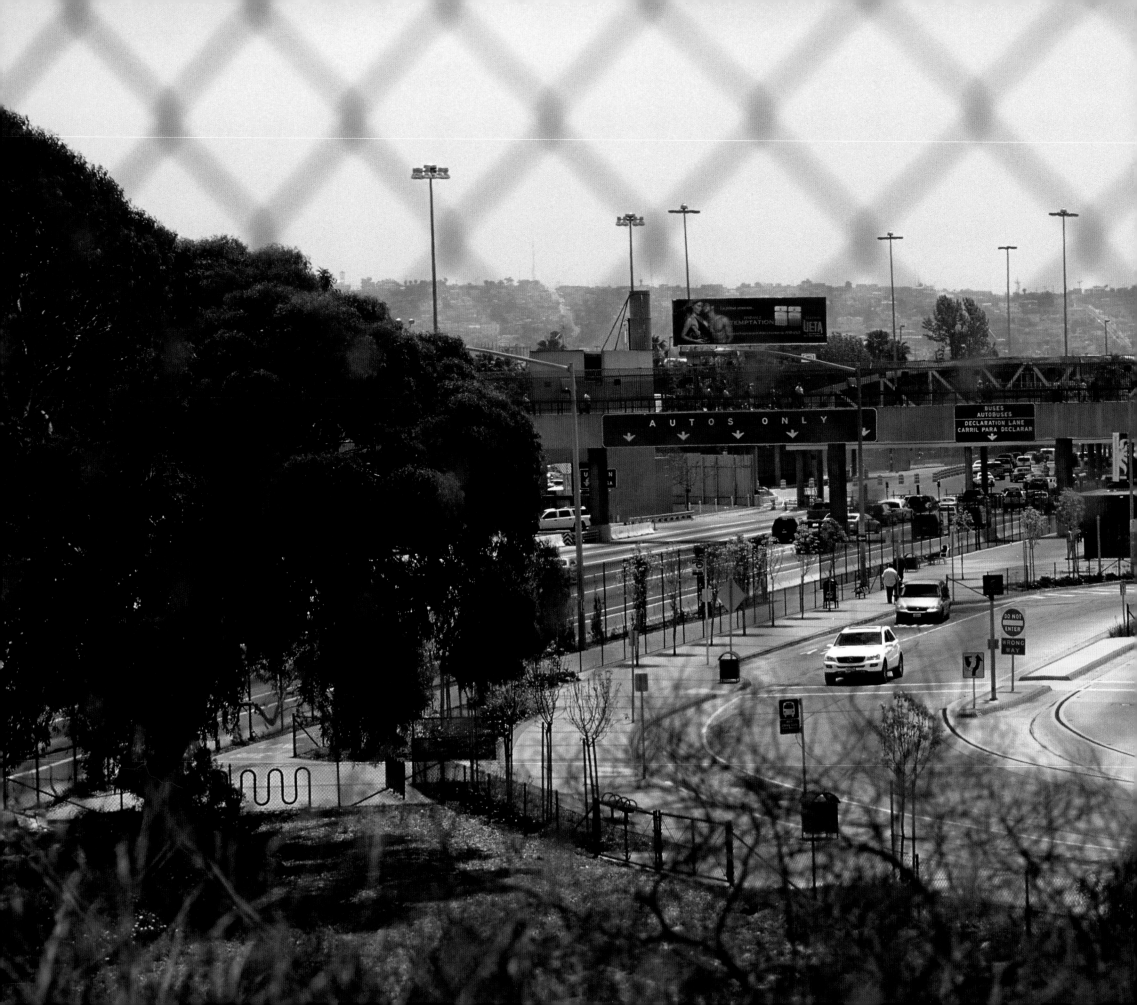

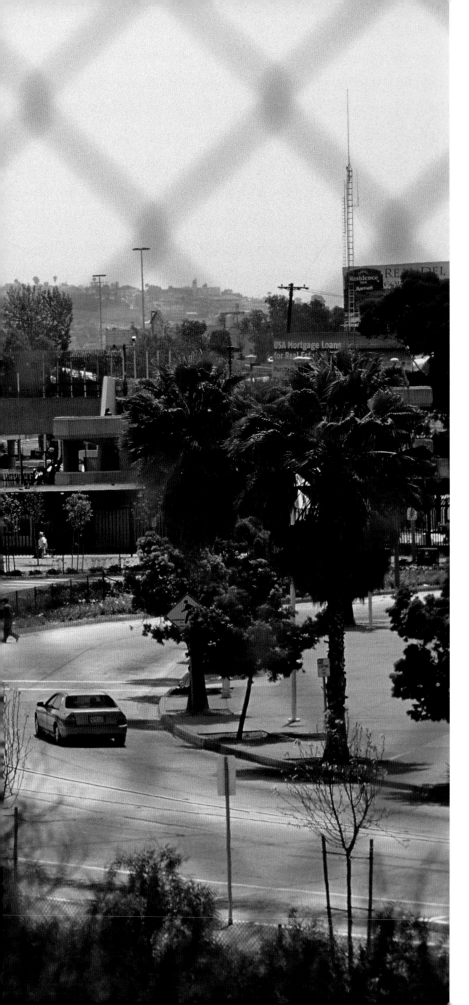

Preceding Page: Google Earth Waypoint # 32°32'40.66"N, 117°01'42.93"W San Ysidro, California. An aerial view facing southeast toward Tijuana, Mexico. The bottleneck at this border occurs daily as immigrants make their legal commute to work in the San Diego area. The number of inbound lanes entering the United States shows the volume of traffic that floods this fragile corridor.

Left: 32°32'38.40"N, 117°01'58.65"W Camino de La Plaza, San Ysidro, California, looking south toward Tijuana, Mexico, in the distance. Here, I'm pressing my nose against the chain-link fence and staring at the border of my birthplace country—a poignant beginning to my long journey. As I was about to embark across a "borderless" country with complete freedom, I felt the irony of the tables having been turned.

Overleaf: 32°46'59.50"N, 116°59'05.01"W Grossmont, California. This high school parking lot is a classic example of what I did *not* see from the road. Perhaps if I had looked carefully as I was riding east on I-8 past this San Diego suburb, I might have seen the school campus from afar. The aerial photograph reveals a group of talented young students creating art in their school parking lot.

Preceding Page: 32°50'31.57"N, 116°42'19.46"W; 32°50'26.40"N, 116°42'41.92"W Alpine, California. This is another example of what you can't see from the road. The large picture on the left shows what looks like a computer chip but that is in fact a maze of air-conditioning ductwork and piping on a roof. The aerial image on the right shows the same roof as it appears on top of the large, freestanding building at the left-center point of the photograph.

Above and Right: 33°08'24.52"N, 116°17'13.83"W Anza-Borrego Desert, east of Julian, California. Even though there is no visible water source for miles across this imposing landscape, this colorful, healthy Ocotillo plant oddly flourishes in these dry, desert climes. The only clue that this is not an aerial view of a martian landscape is the bright blue horizon and the delicately carved stretch of Highway 79 in the foreground.

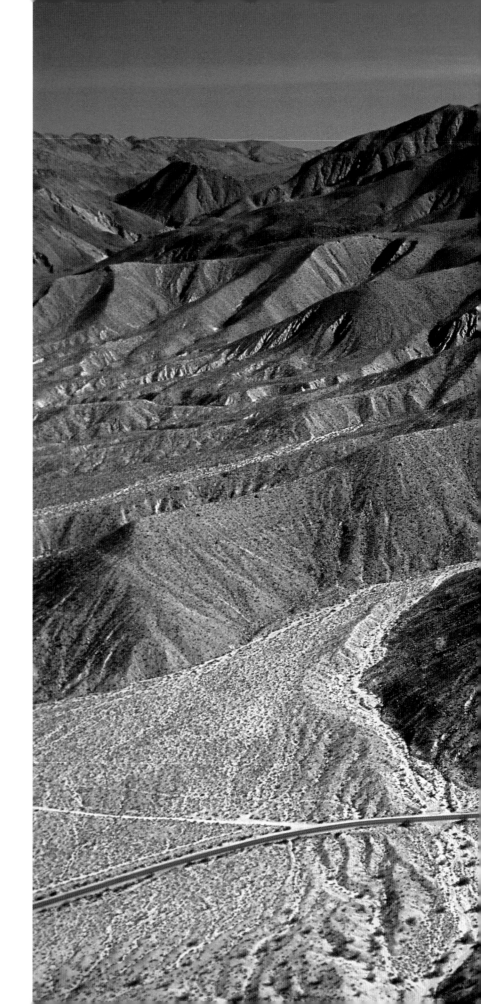

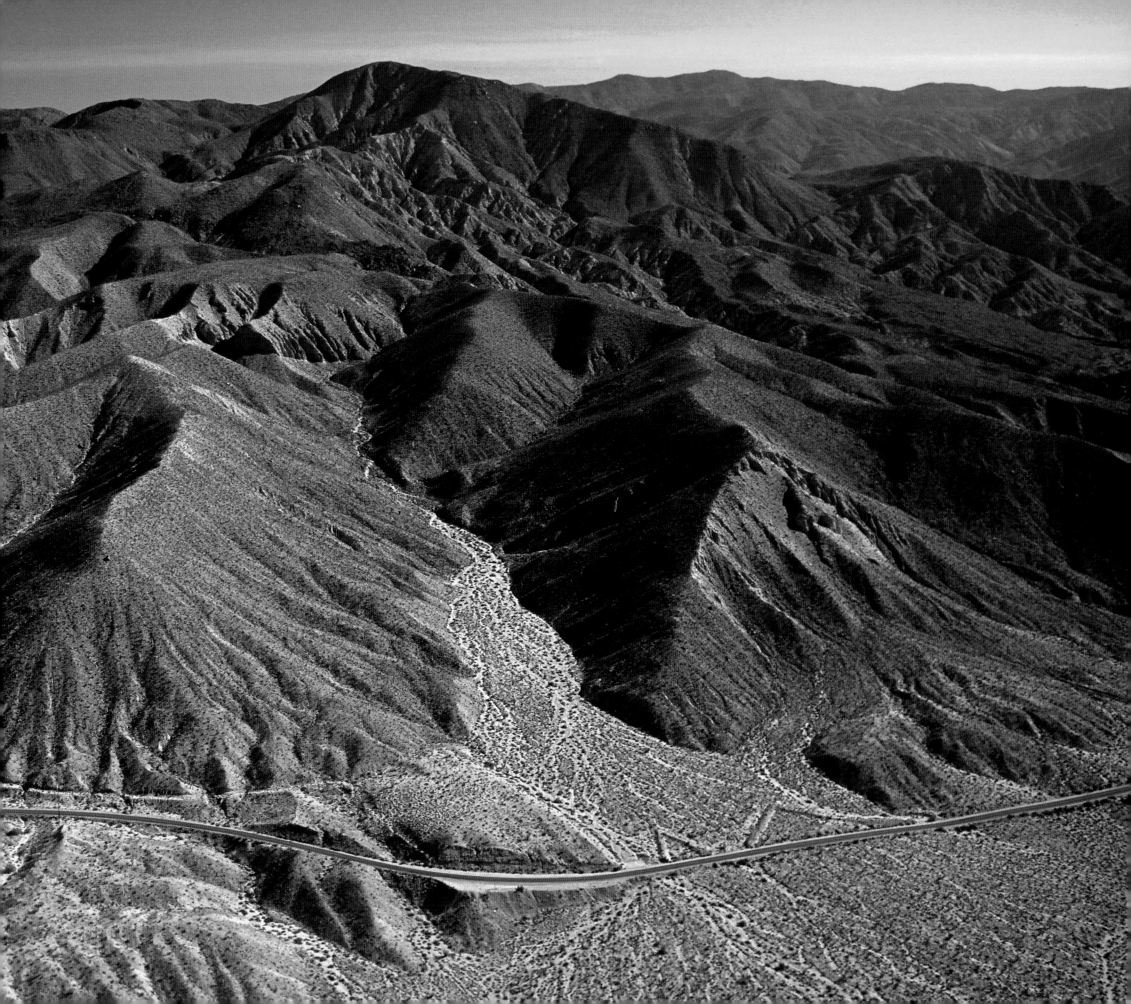

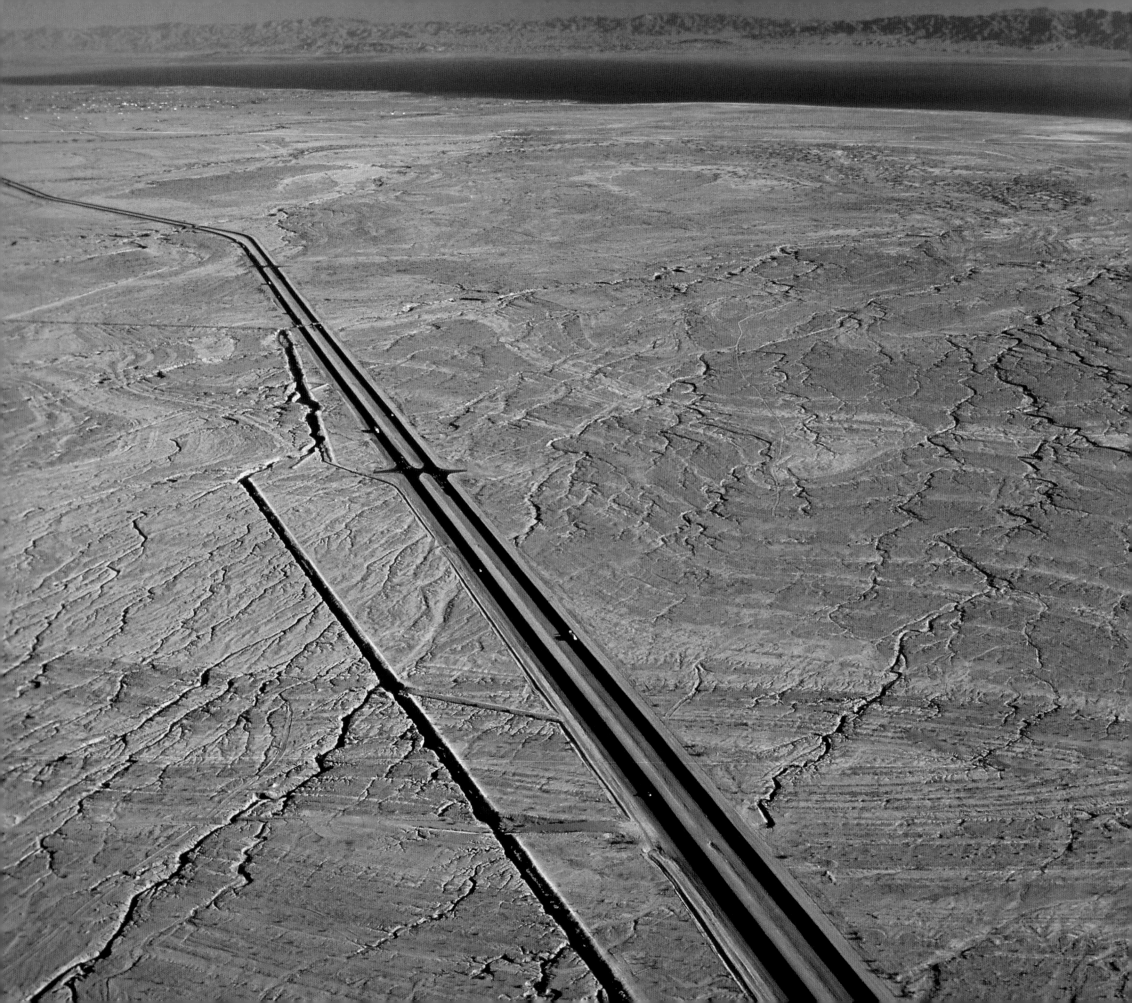

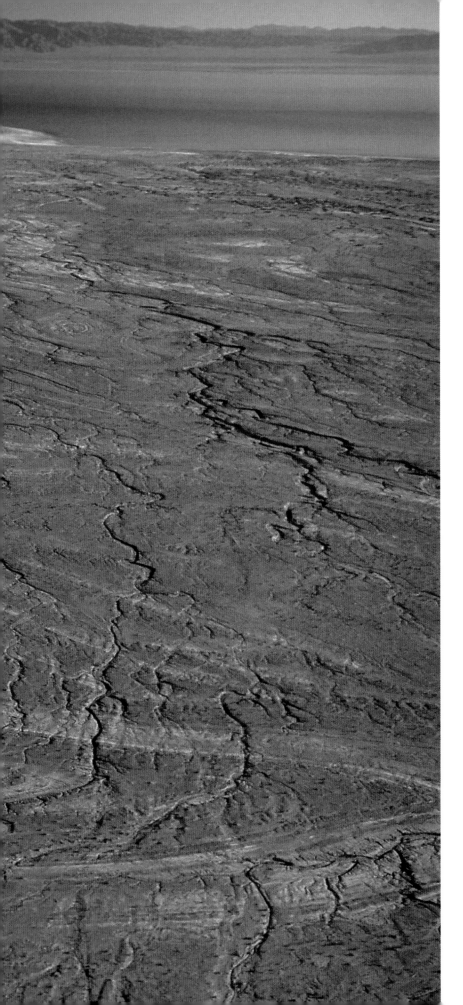

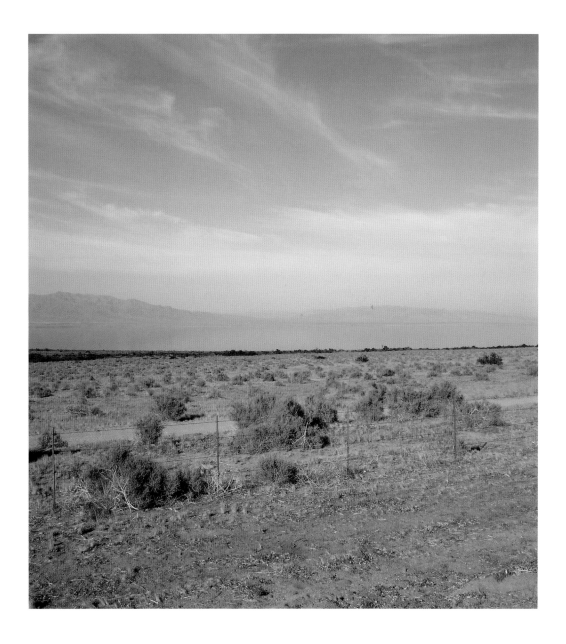

Left and Above: 33°11'06.40"N, 115°53'59.81"W A stretch of Highway 86 paralleling the Salton Sea, south of Salton City, California. Shockingly, the 105-degree temperature is typical of a spring day at the Salton Sea, which appears in the ground shot as a shimmering mirage across a lifeless desert, dotted with brush that is hard to distinguish in the aerial photograph.

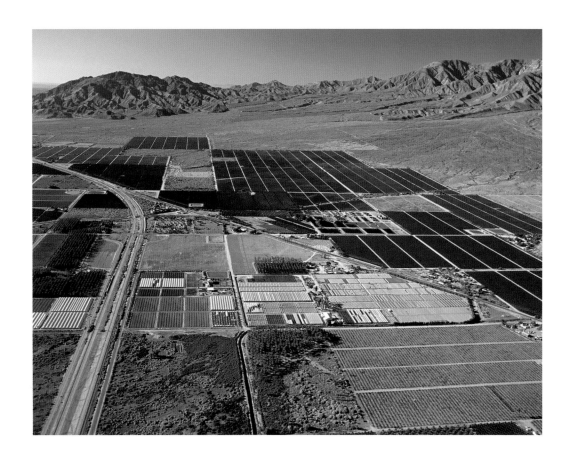

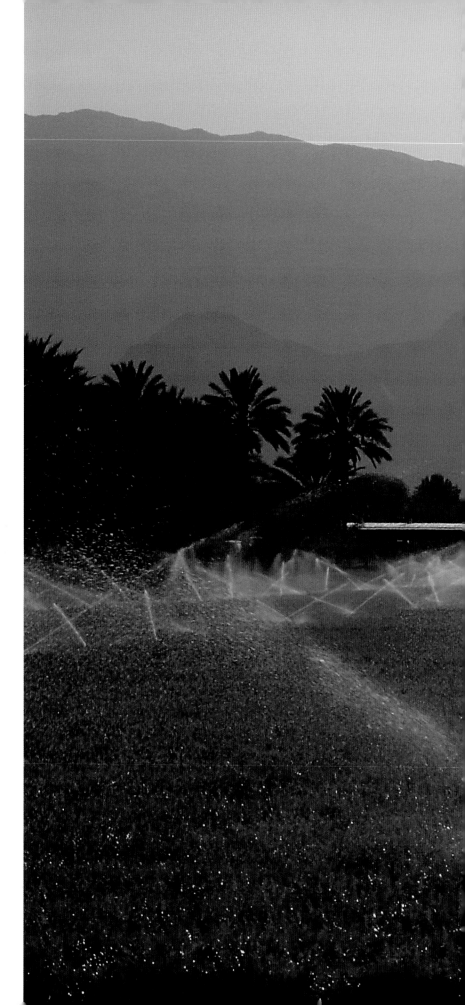

Above and Right: 33°37'00.53"N, 116°10'52.57"W South of Coachella, California. This is but one of many sprinklered fields in this rich oasis at the middle of the Mojave Desert. Dusk may be the only time when irrigation is practical in this perennially hot climate.

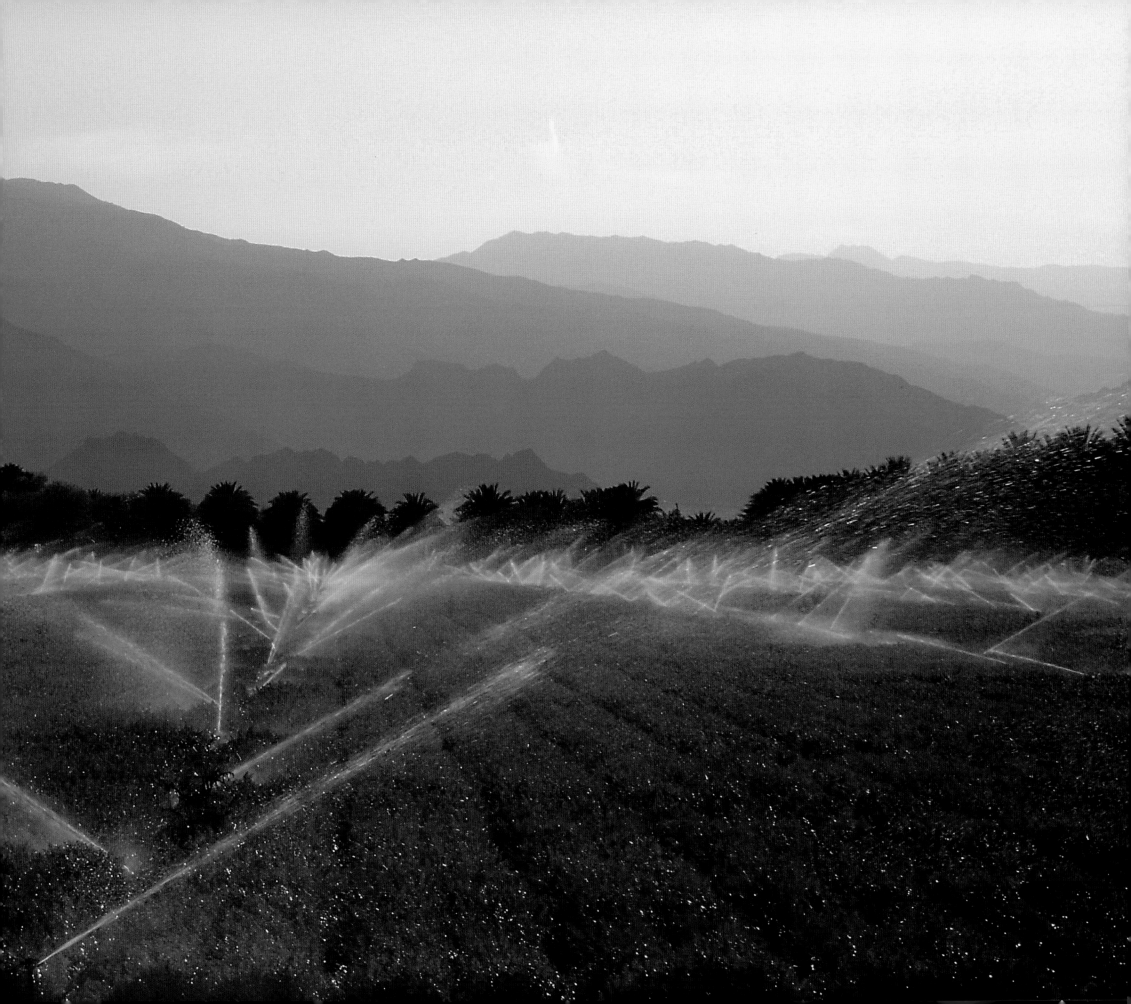

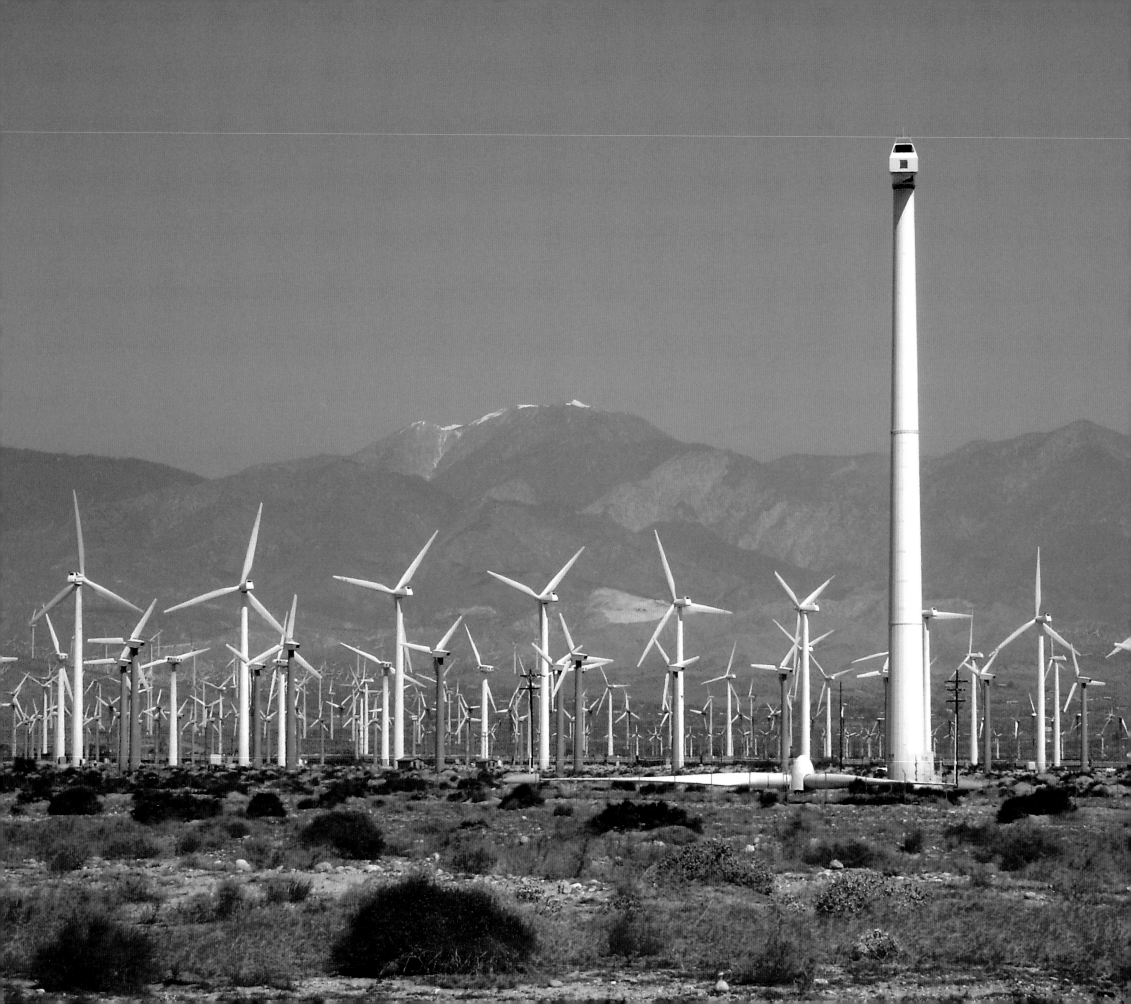

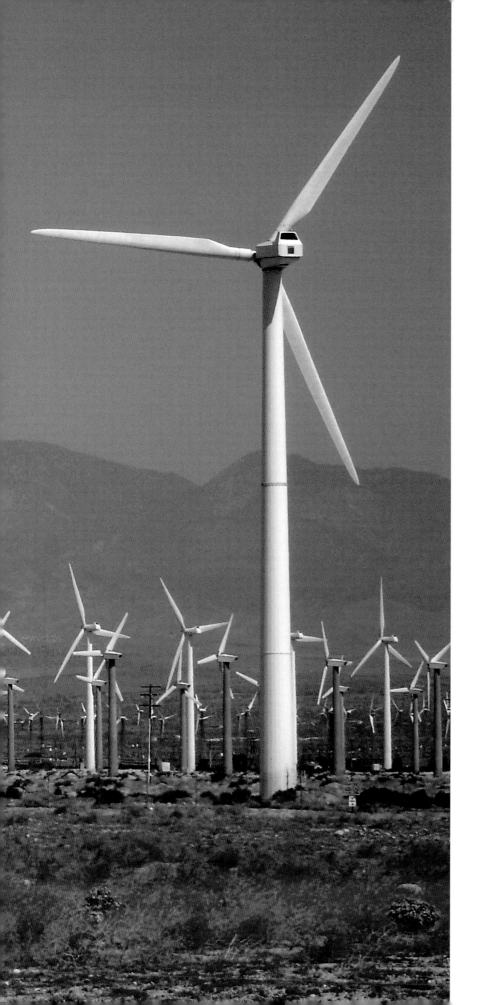

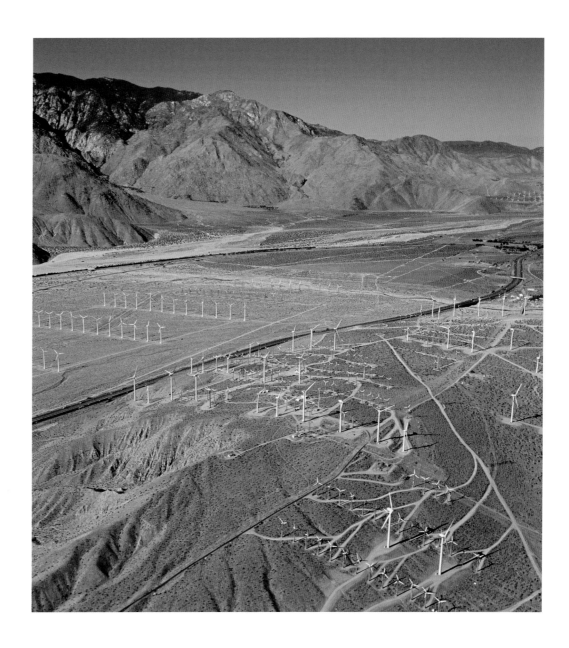

Left and Above: 33°53'28.76"N, 116°32'43.78"W A wind farm outside of Palm Springs, California. Being a pilot, I spotted these massive turbine propellers from a distance. The ground and aerial photographs underscore the significance of the word *farm* and opened my eyes to the scale of this "green" effort to harness energy.

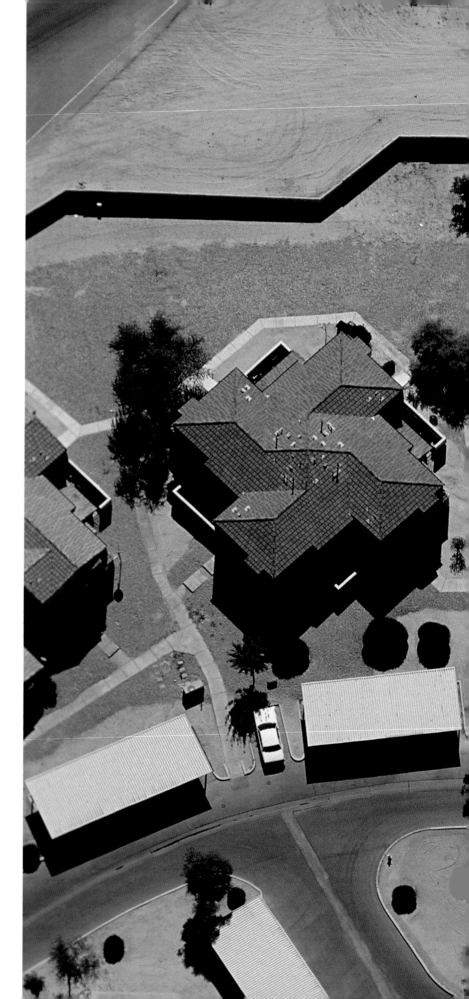

Above and Right: 34°07'43.23"N, 116°13'32.13"W; 34°08'41.70"N, 116°02'15.61"W Twentynine Palms, California. In this military town (home of the world's largest Marine base), these two communities—fewer than 11 miles apart—reveal a sharp contrast in desert living. The residents face a never-ending battle with creeping sand along their properties, like the unrelenting flow of lava down a mountainside.

Overleaf: 34°06'33.72"N, 114°41'14.13"W A railroad crossing at Highway 62, southwest of Vidal Junction, California. This was the first of my many encounters with freight trains. Amazingly, I reached this intersection just minutes before the westbound train surged across my path. In the aerial photograph, the train was headed along the straight line from the bottom of the picture to the top. My motorcycle was parked at the point in the junction where the long, curved road crisscrosses the railroad track.

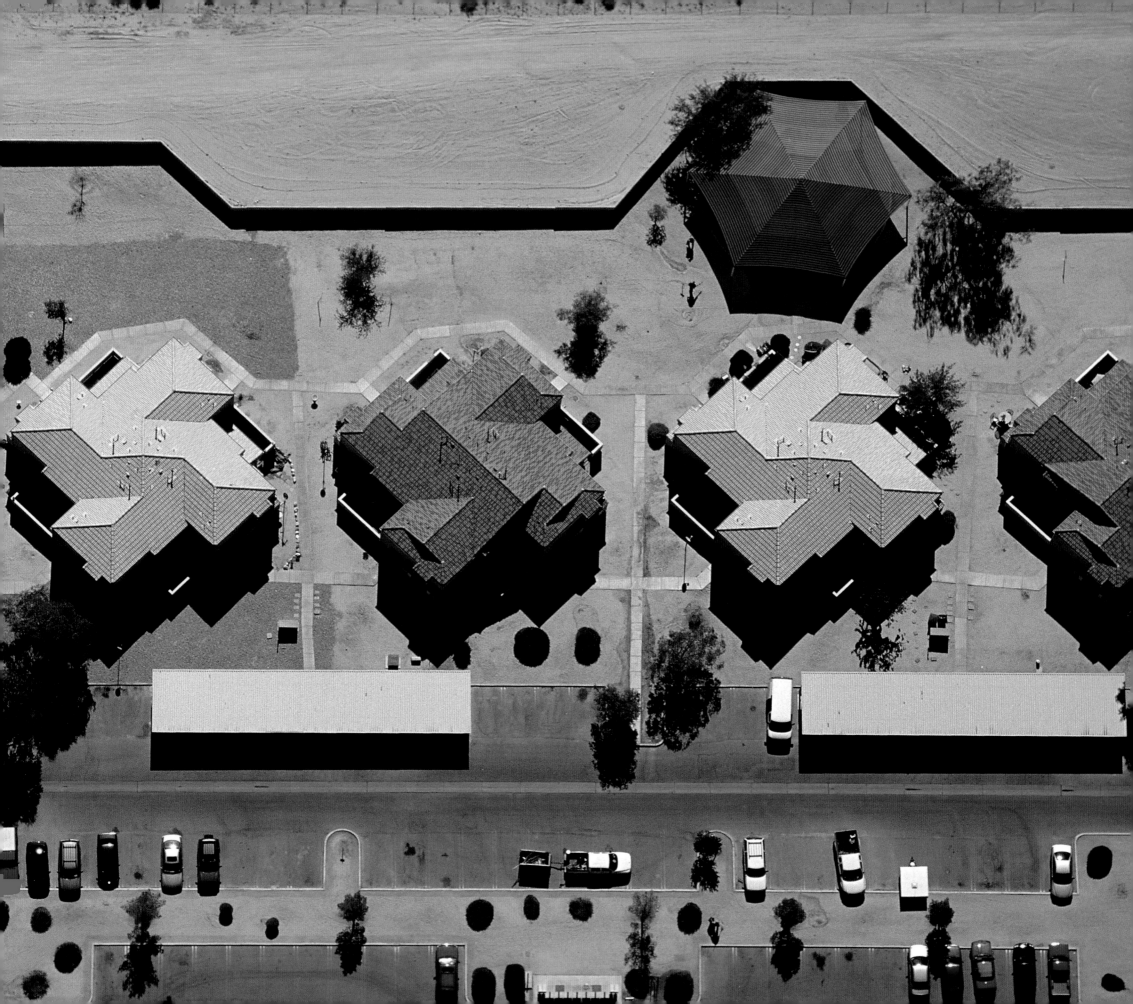

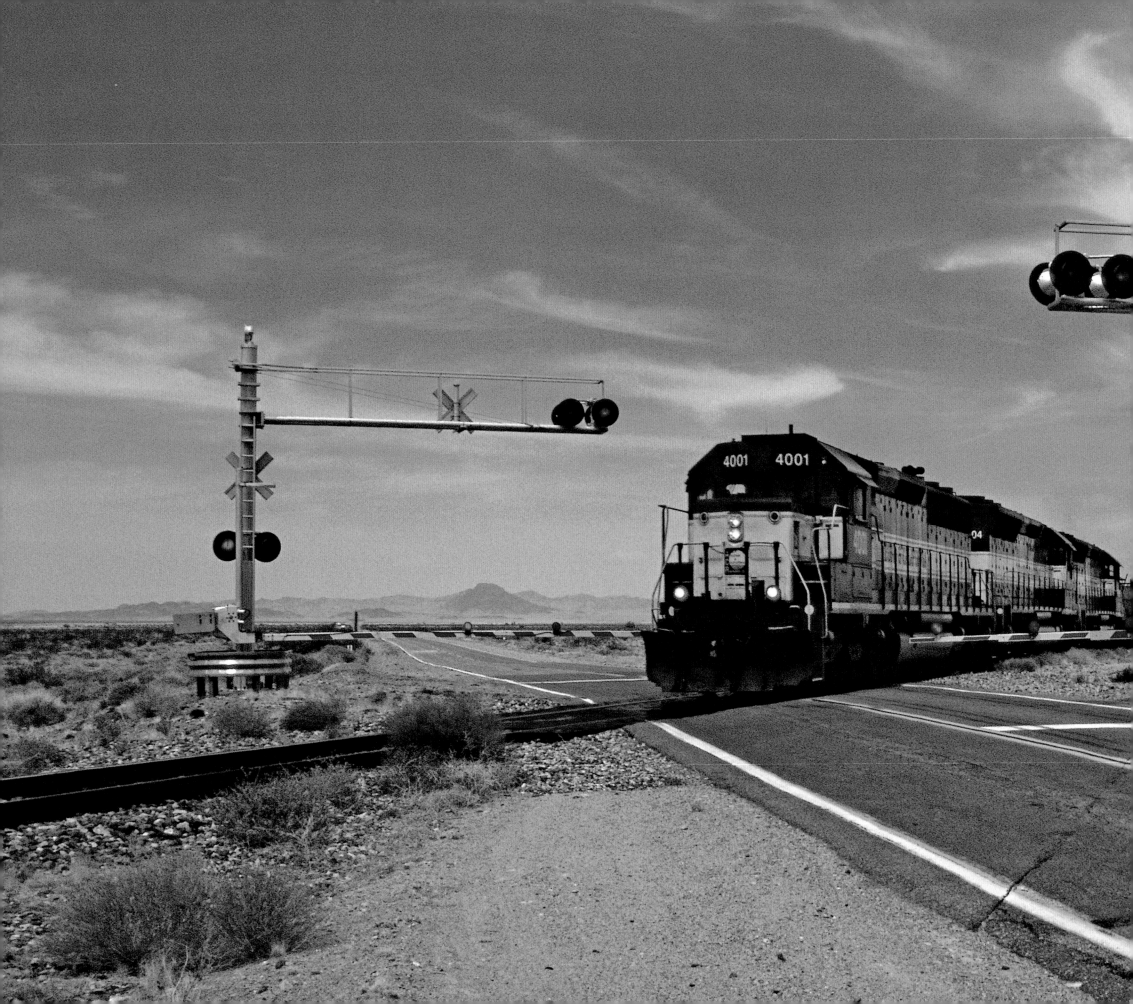

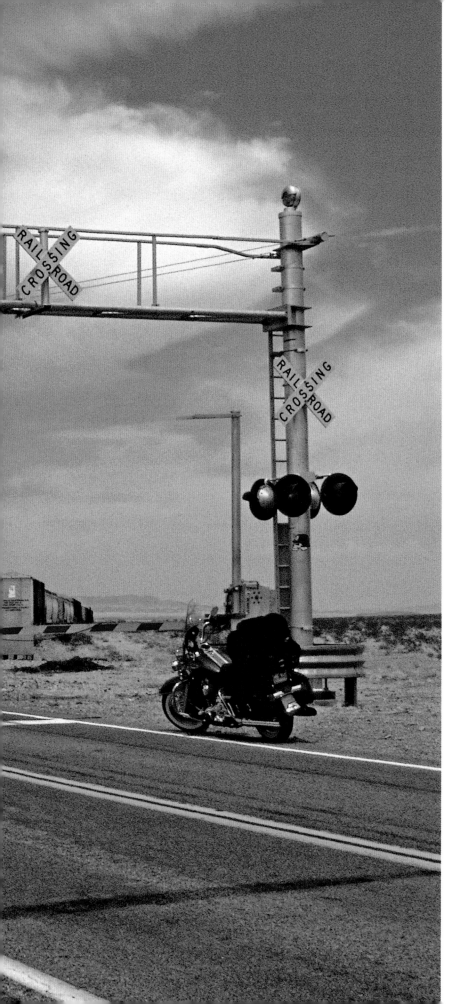

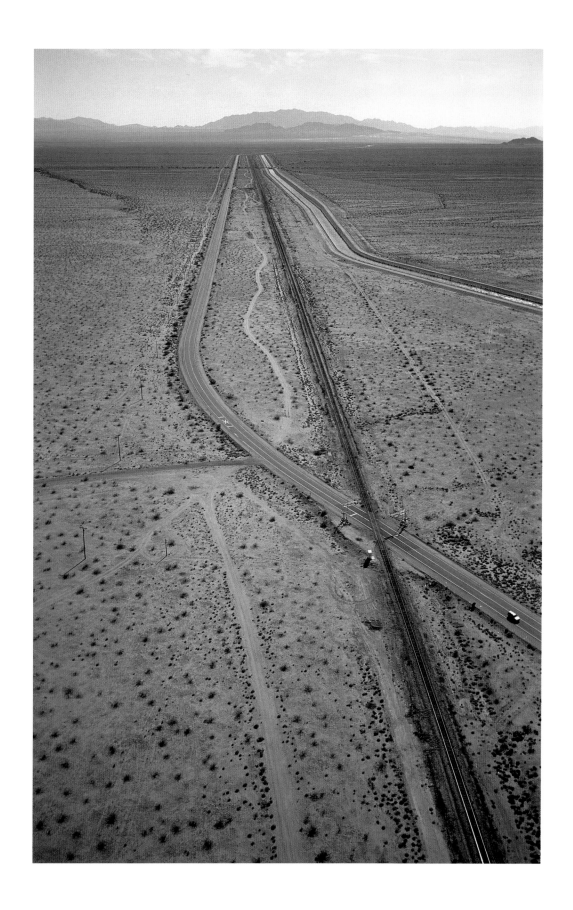

Above and Right: 35°11'18.97"N, 114°03'16.31"W East Andy Devine Avenue, Kingman, Arizona. The shuttered building at right was once a Harley-Davidson store. During its heyday, it was visited by waves of customers that included Harley fans of every ilk, including Hollywood celebrities, on their excursions along Route 66—also known as "the Mother Road." The murals, such as the one above and on the building at right, were painted by local artists. They depict real-life scenes from the vintage years, dating from the early 1900s, of this century-old company—an American icon.

Overleaf: 35°22'26.51"N, 113°43'19.85"W Hackberry, Arizona. This iconic Route 66 curiosity shop looks like it's been a favorite hangout for tourists over the years. The old-fashioned gas pumps and soda-pop dispensers evoke simpler times when road trips were a vacationer's dream. It was a thrill to peer inside these vending machines, make a choice, insert a dime or a quarter, and reach for a cold, frosted, glass bottle.

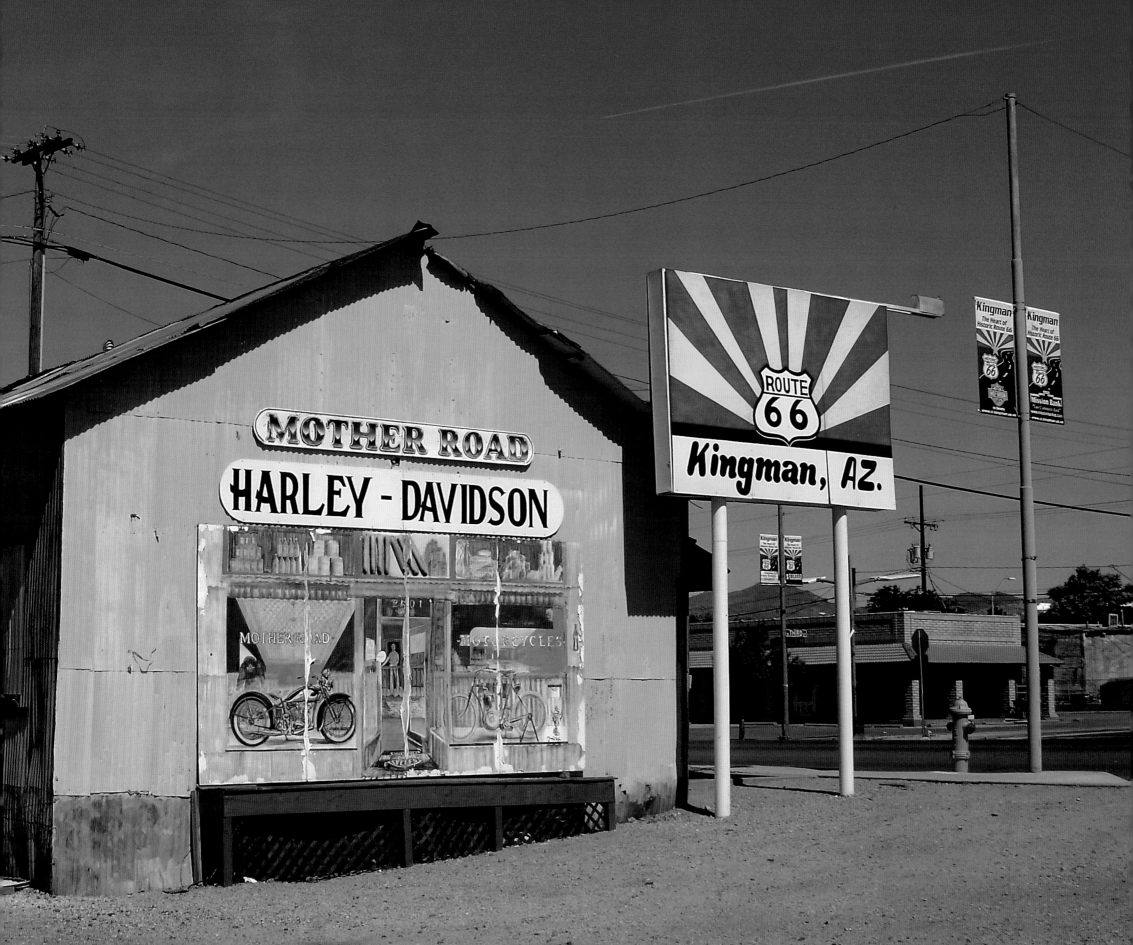

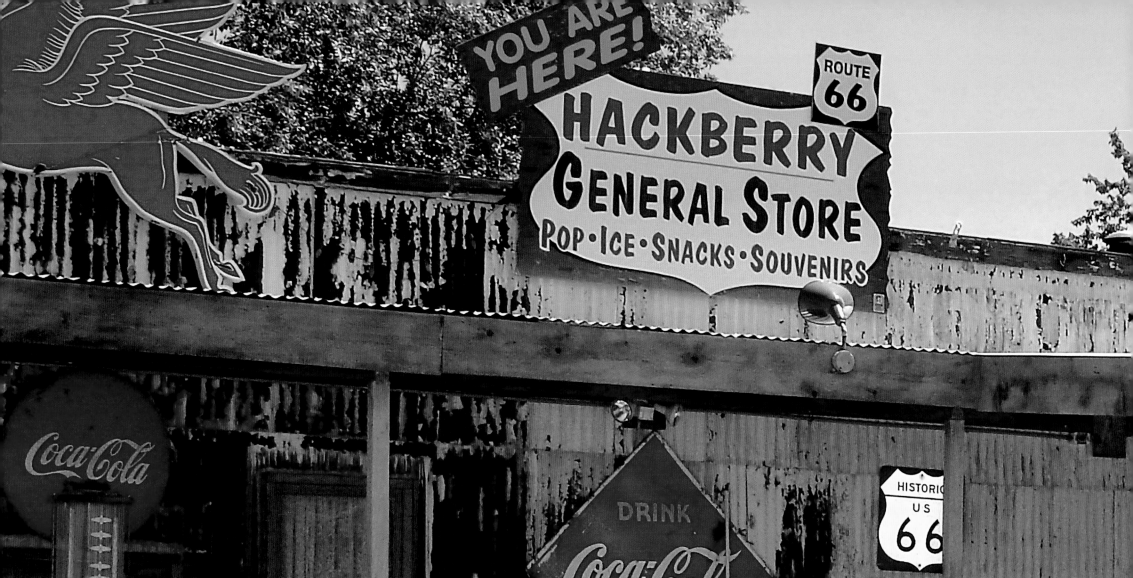
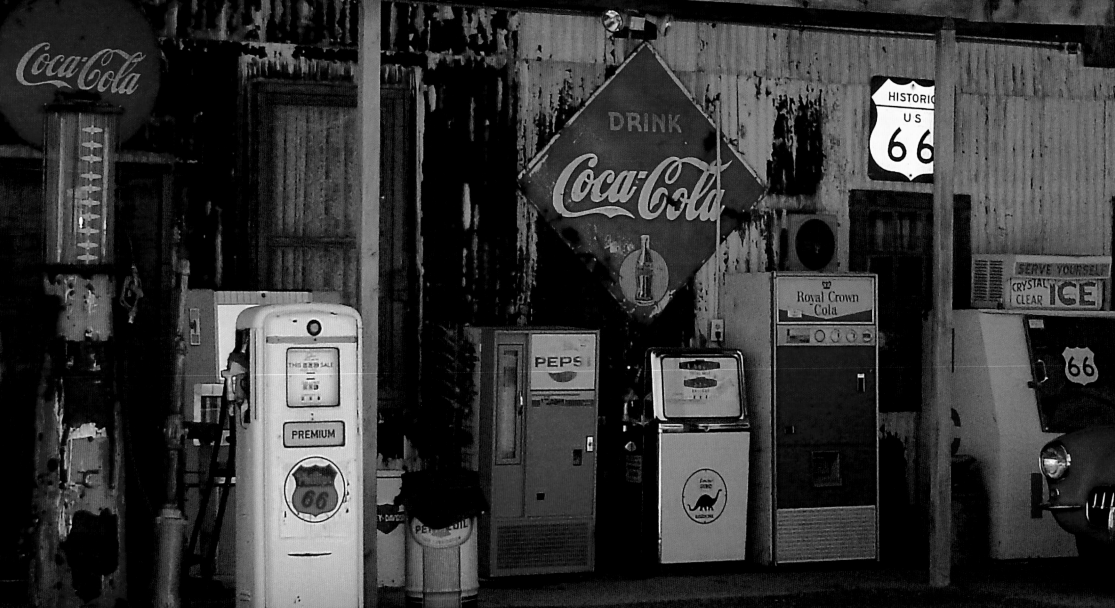

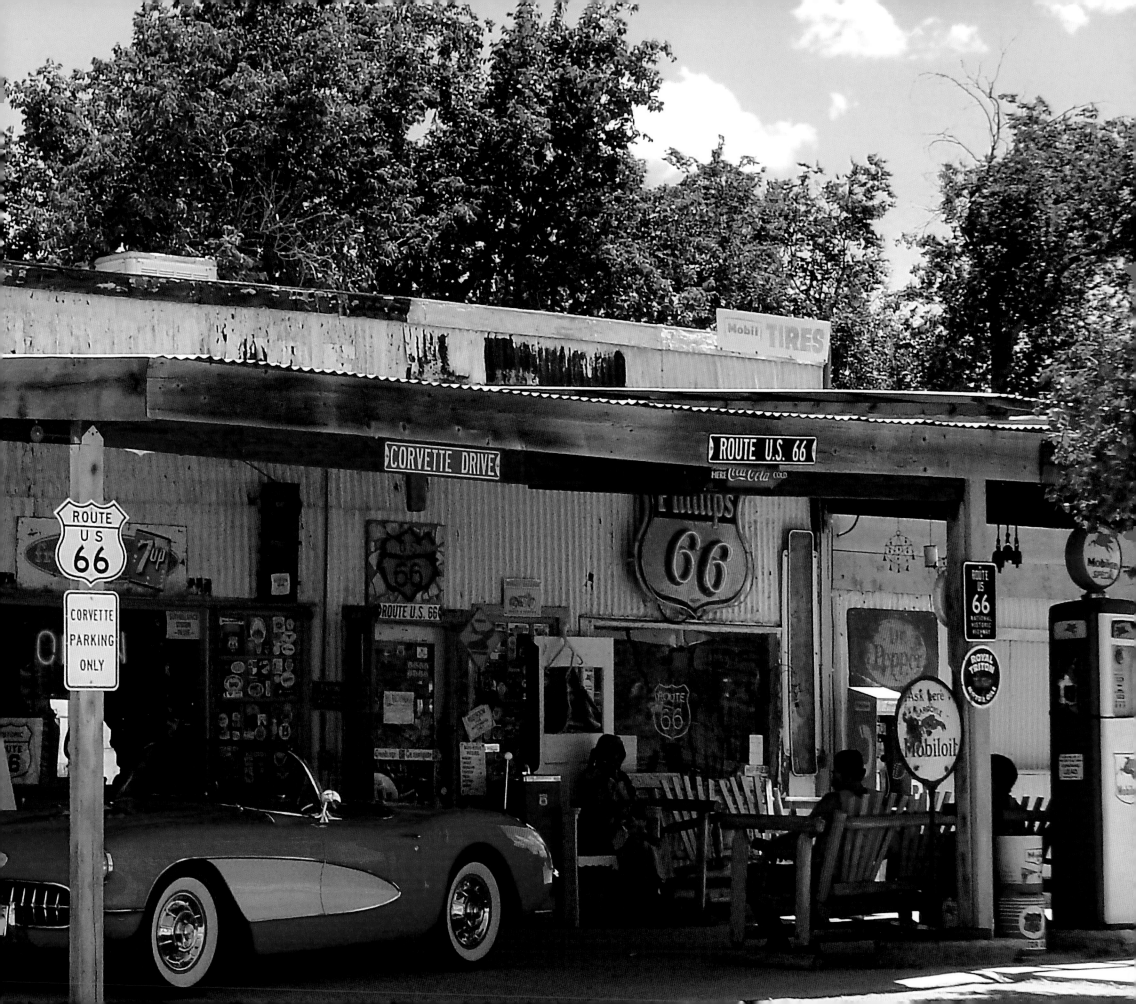

Above and Right: 34°44'58.54"N, 112°06'51.94"W Jerome, Arizona. The aerial picture above captures the uniqueness of this mile-high town known as "America's Most Vertical City," with its "J" carved into the side of the mountain. Built on the side of Mingus Mountain in 1876, Jerome flourished as a copper-mining town until the early 1950s when demand for copper decreased. Surprisingly, Jerome covers less than a square mile of meandering streets, such as in the photograph on the right.

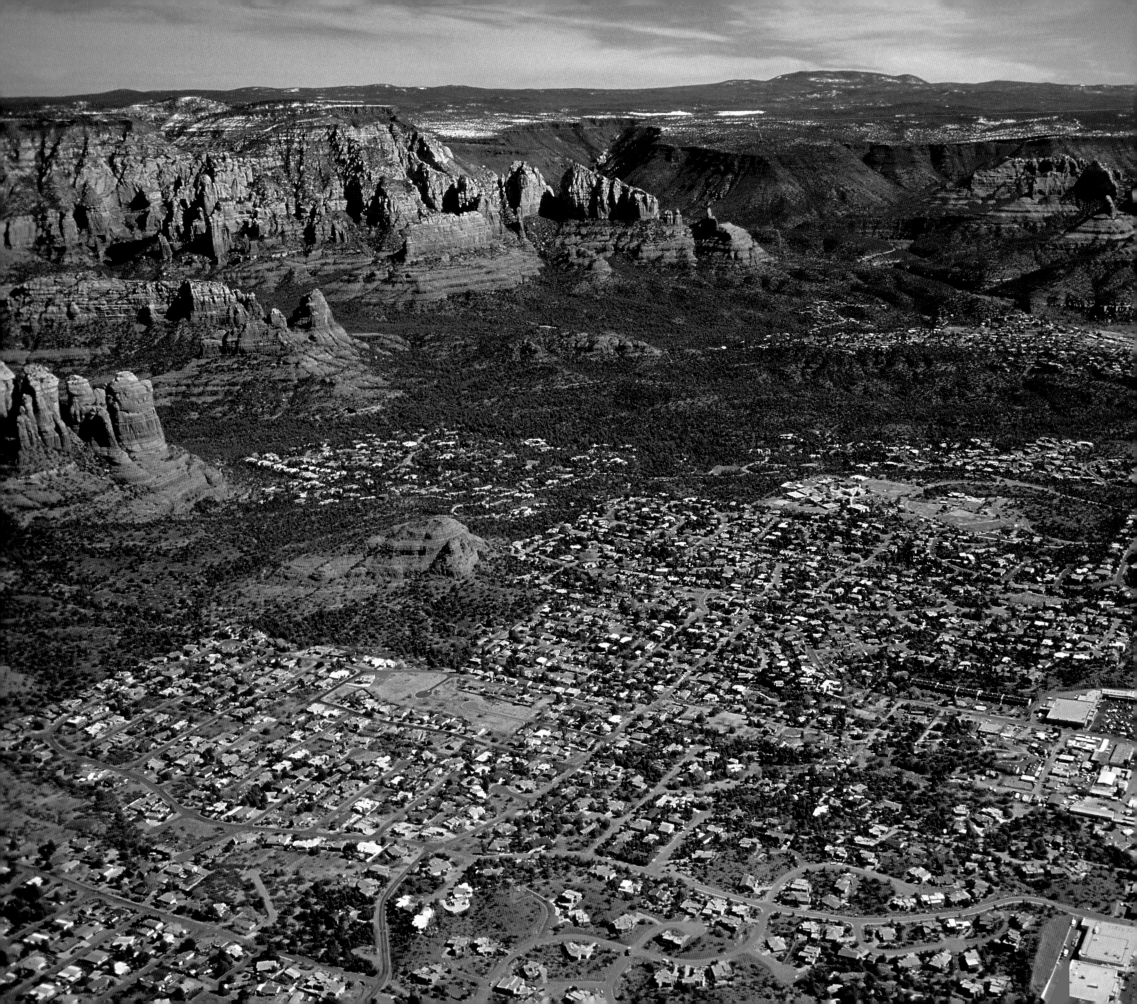

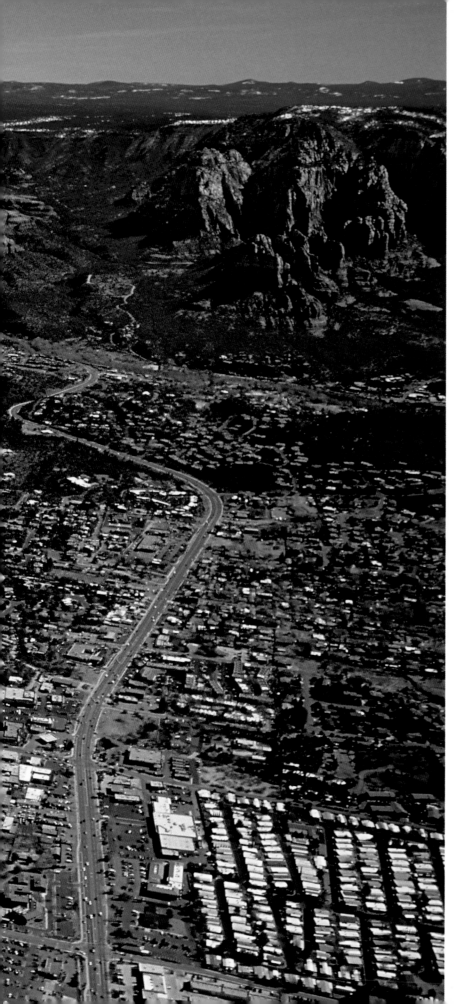

34°51'56.96"N, 111°48'00.87"W Sedona, Arizona. Known for its spectacular Red Rock Country vistas, Sedona is a popular destination resort and year-round community for those who enjoy clean air, outdoor activities, and breathtaking views. Highway 89 snakes through Sedona on its way north toward Flagstaff, Arizona.

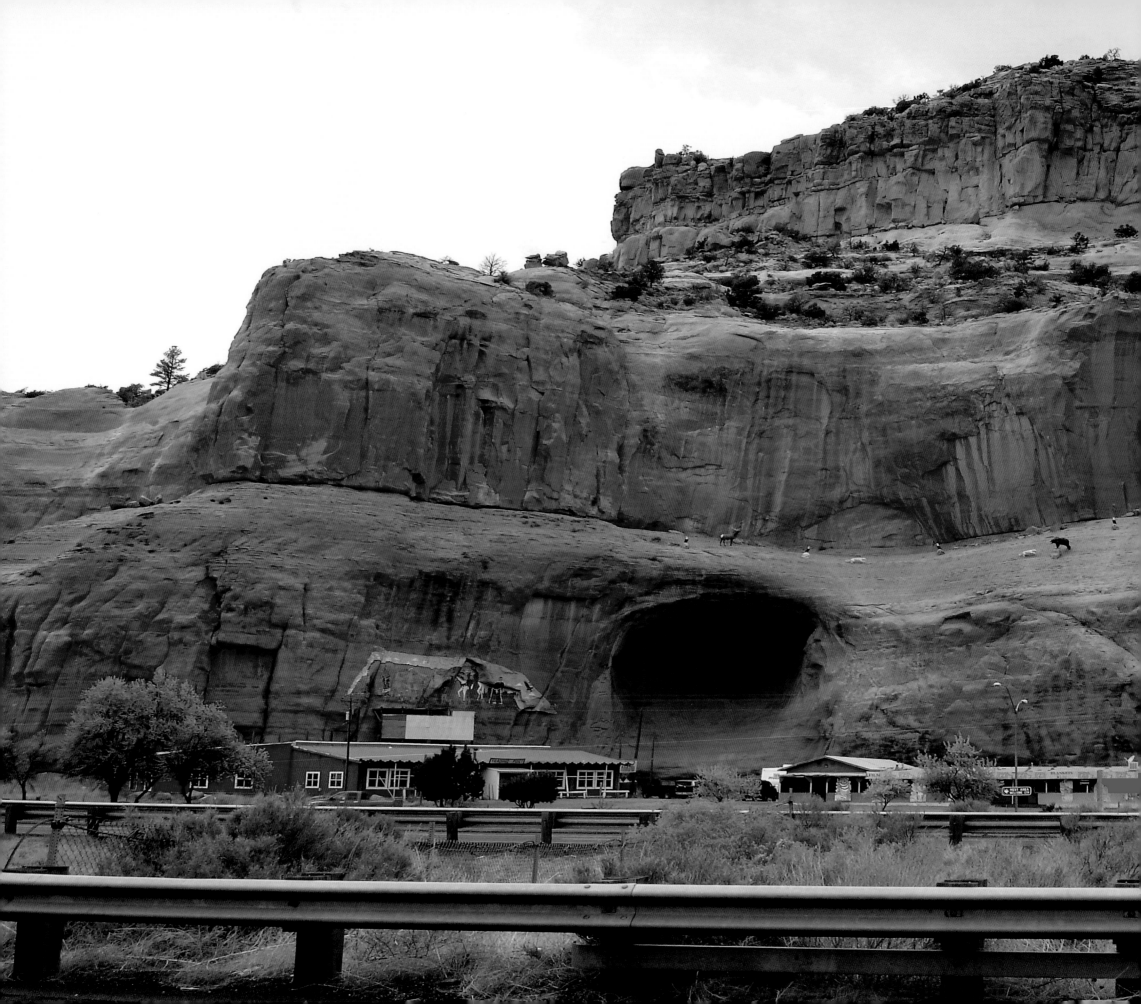

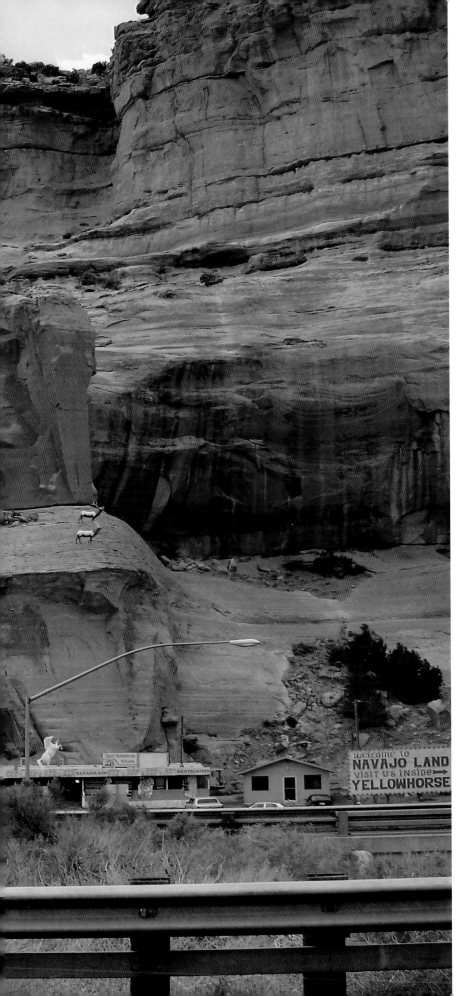

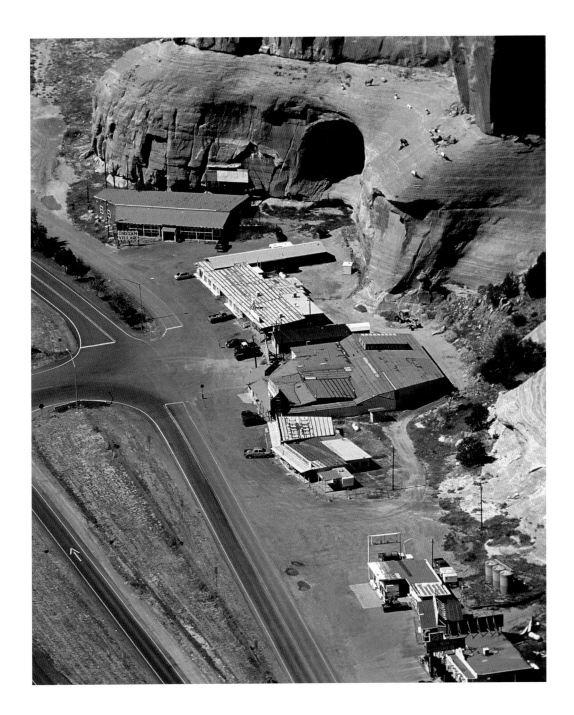

Above and Right: 35°21'28.28"N, 109°03'04.34"W Lupton, Arizona, on Interstate 40. This American Indian trading post sits only a few paces from the New Mexico state line. I had to laugh at the toy animals perched on the stone cliffs above the colorfully painted stores in the middle of the picture at left. I am not sure that they are for sale, but you wouldn't want to climb up to check their price tags.

35°22'16.06"N, 109°02'24.58"W West of Gallup, New Mexico. One of my many pleasurable encounters with a seemingly endless number of cheerfully colored trains on this southwest-to-northeast journey. This track sits on the Navajo Nation Indian Reservation, which comprises 26,000 square miles and spans vast sections of Utah, Arizona, and New Mexico.

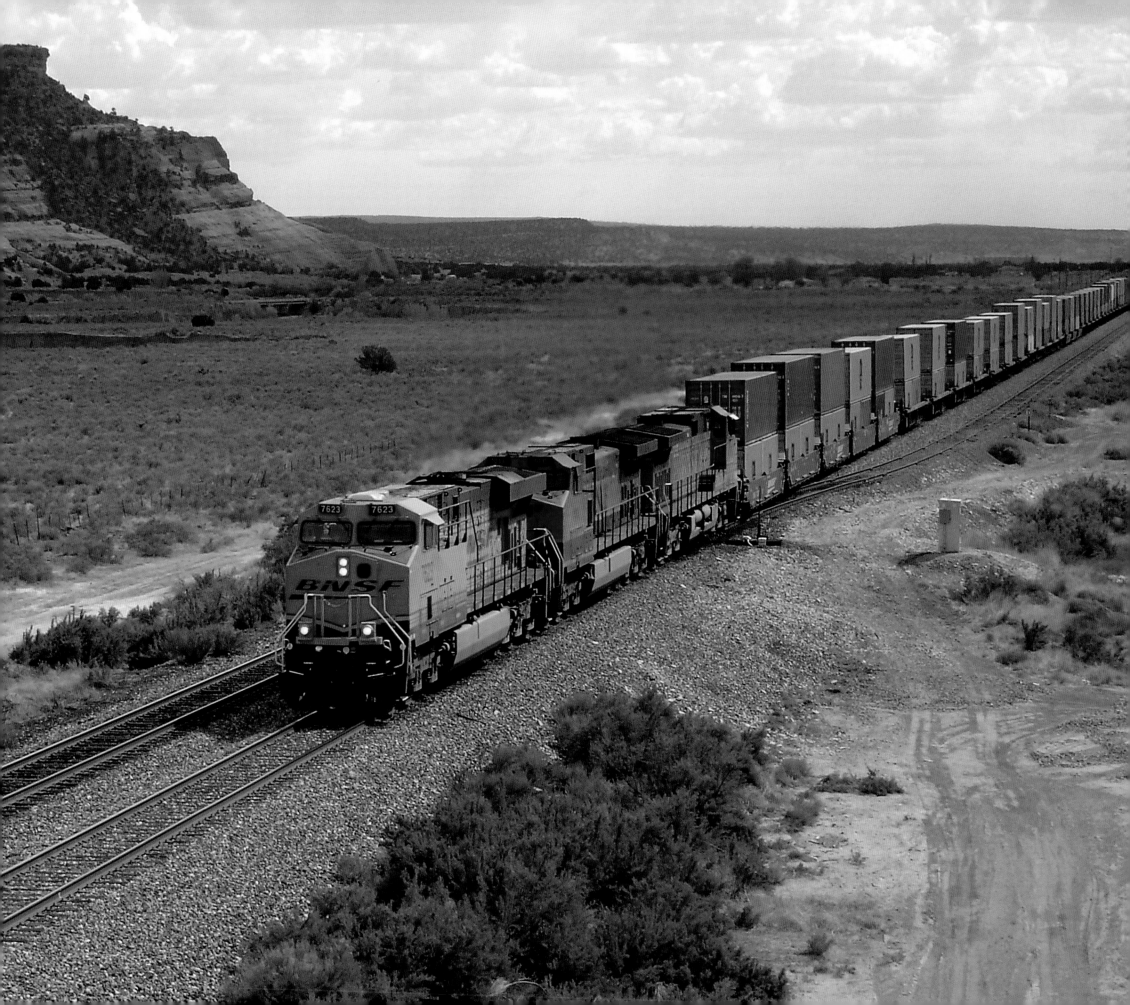

Left: 35°06'18.61"N, 106°38'15.73"W Albuquerque, New Mexico. This city of nearly a half-million people sits at the junction of two major transportation arteries, Interstates 40 and 25. This explains the ribbonlike maze of reinforced concrete and asphalt in the aerial shot facing east on I-40. Even though I was at the end of a long day's ride, I managed, luckily, to negotiate this intimidating intersection without event.

Overleaf: 35°20'04.96N, 106°31'15.86"W; 35°20'13.10"N, 106°31'09.51"W South of Bernalillo, New Mexico. I took both photographs while riding at the speed limit on my way to Santa Fe, 40 miles to the northeast. As they say, "Please do not try this at home." The shadow of the Harley best summarizes my solitary, yet peaceful quest.

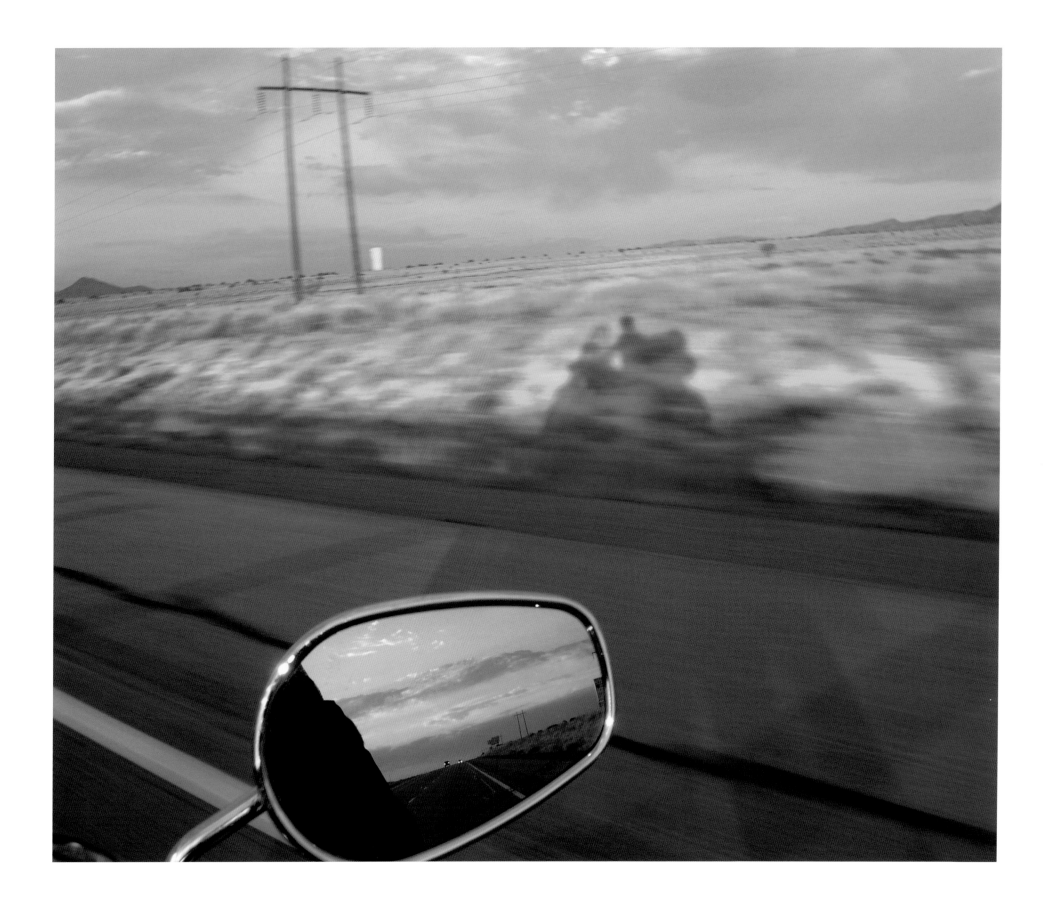

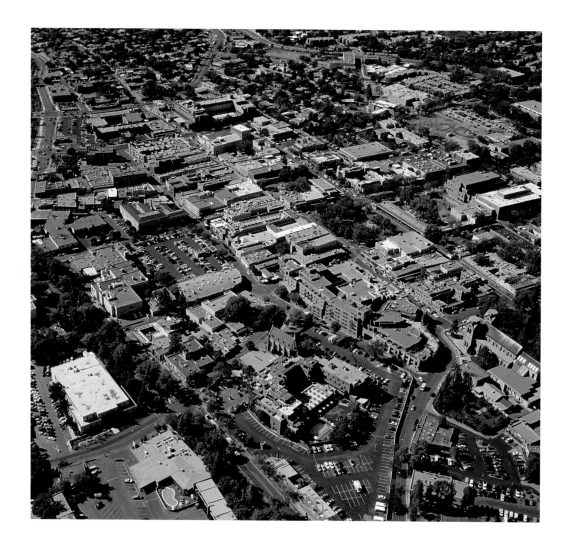

Above and Right: 35°41'02.80"N, 105°56'08.44"W Santa Fe, New Mexico. This state capital is located at 7,199 feet above sea level and was designed in accordance with 16th-century Spanish ordinances requiring that a central plaza prominently include a church. The latter can be seen on the lower-right edge of the aerial photograph above. I was fortunate to enjoy one of many acts of kindness at the restaurant shown in the photograph on the right. It was an inviting place from which to enjoy the sounds and views of this quaint, historic town.

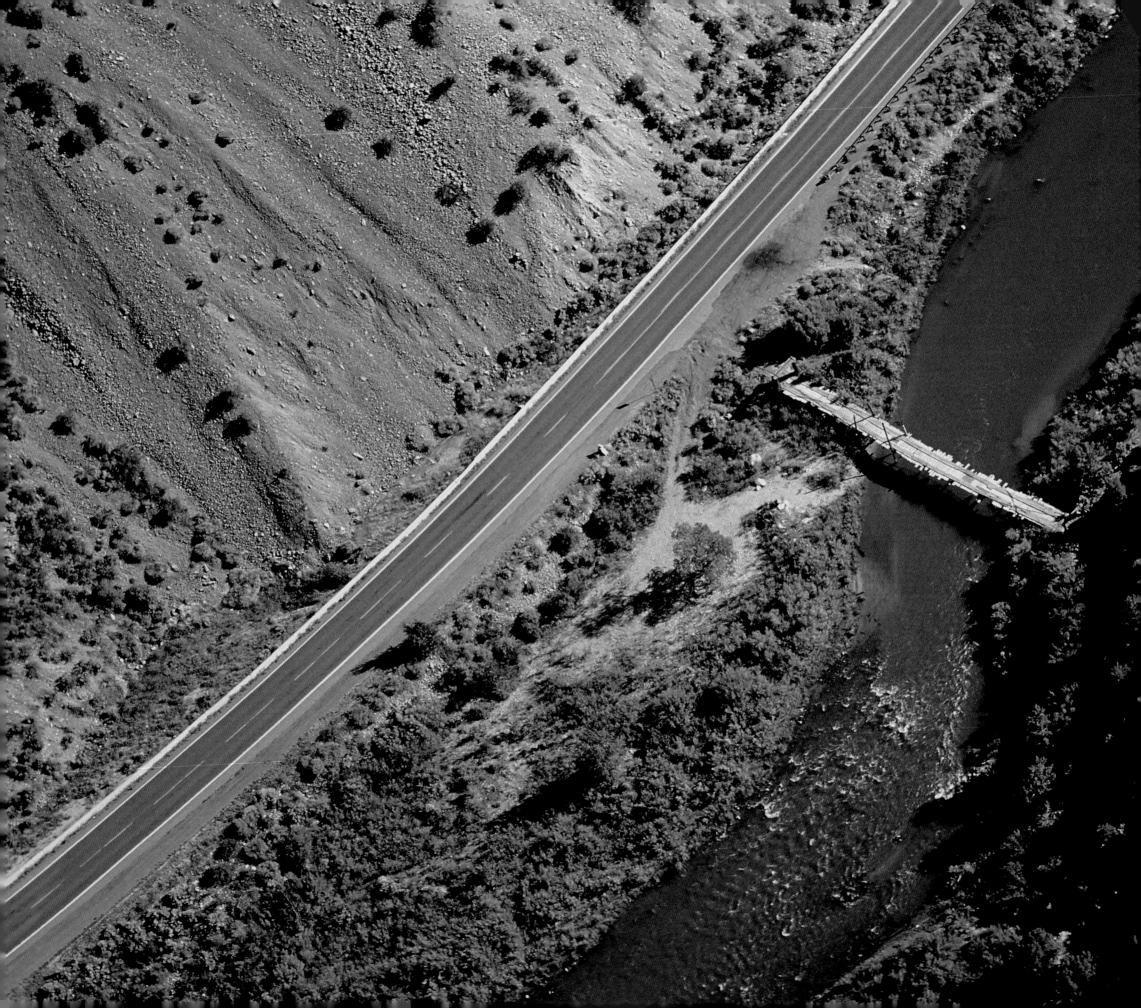

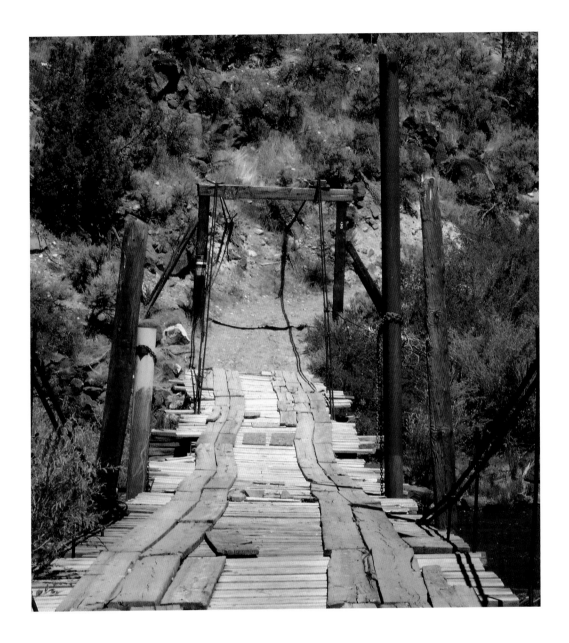

Left and Above: 36°14'48.91"N, 105°49'30.97"W South of Pilar, New Mexico. This bridge spans the Rio Grande River, at left, and is similar in design to San Francisco's Golden Gate Bridge, while obviously smaller and made of wood. In the picture above, notice the four cables anchored into the rock at the far end of the bridge. See how they suspend the cobbled planks of wood that form the bridge's foundation. This plank system creates a solid base for the larger planks used by automobiles.

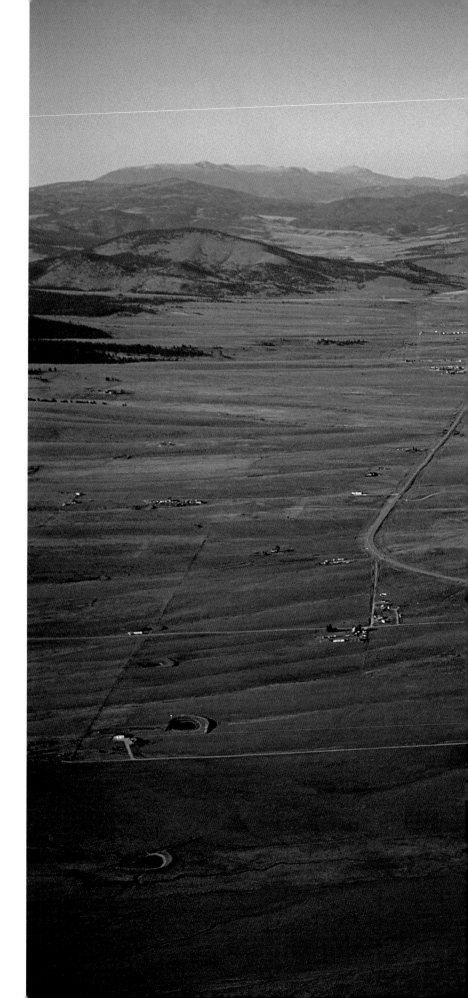

Above and Right: 36°33'01.43"N, 105°16'25.24"W Eagle Nest, New Mexico. The base elevation of this community is 8,258 feet. It is located at the north end of the Moreno Valley and is dwarfed by the imposing Sangre de Cristo Mountains, the highest peaks in New Mexico, at over 13,000 feet high. This 15 x 3-mile-wide valley is unlike most alpine locations in America, since it offers all the majestic features but condensed into a vastly smaller area.

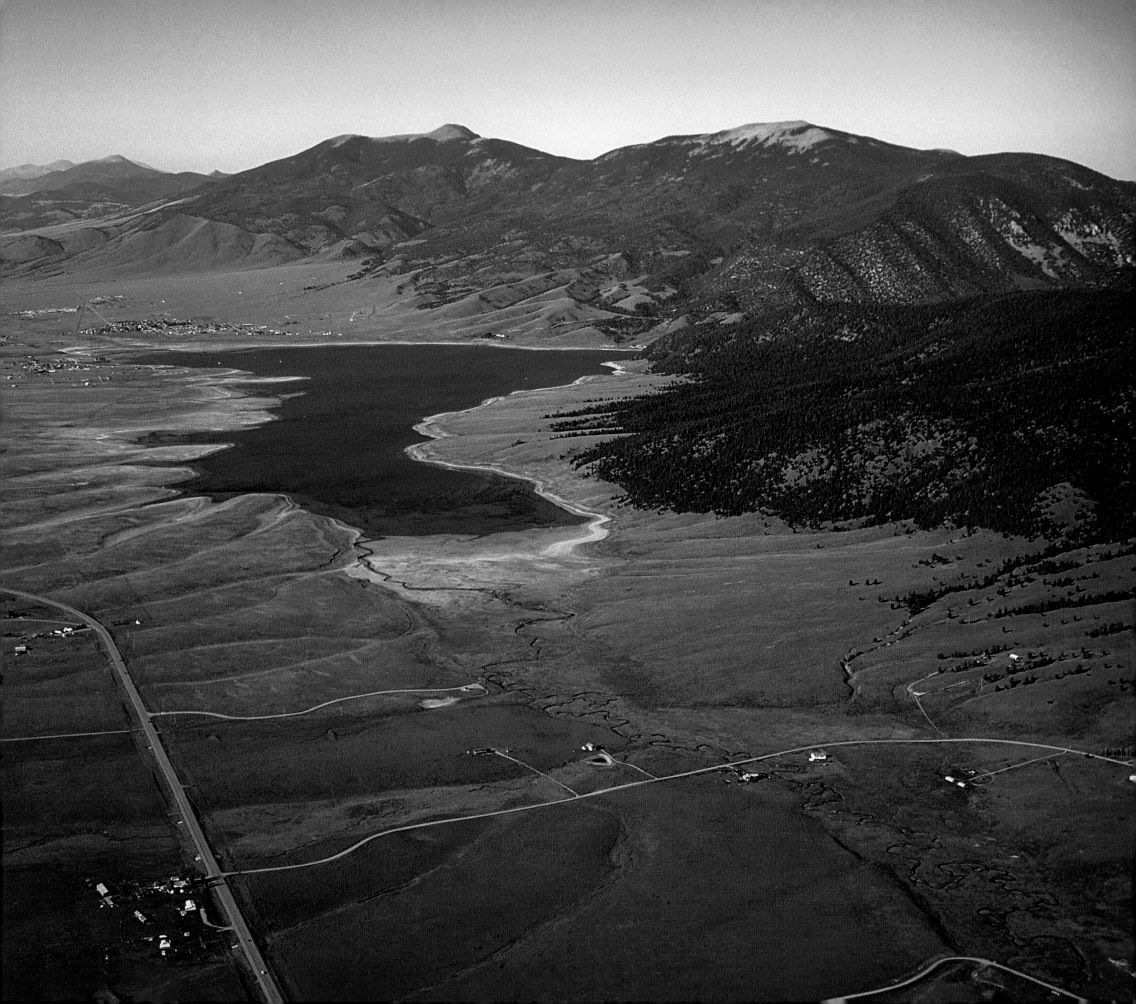

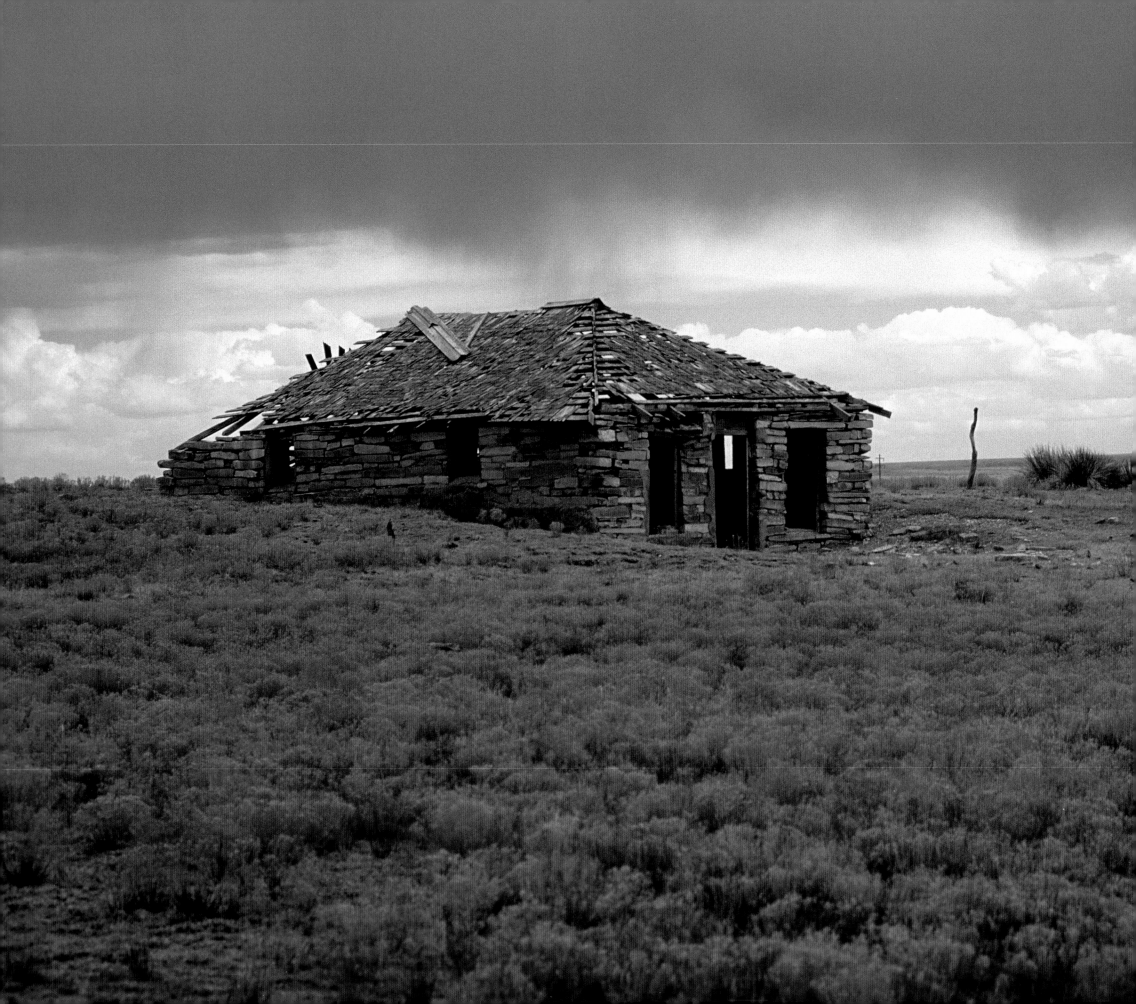

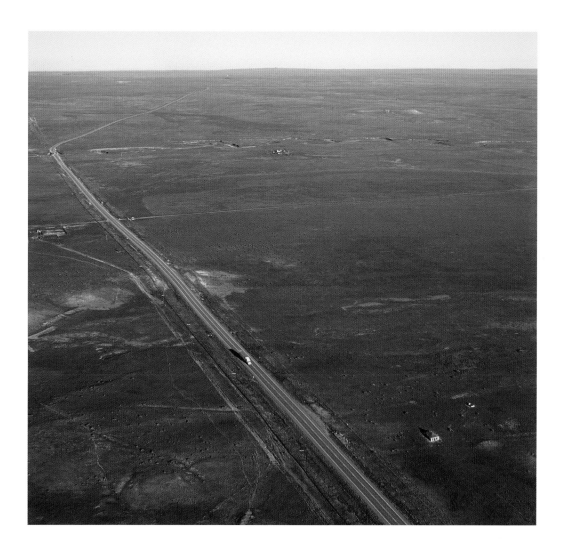

Left and Above: 36°19'12.41"N, 104°26'43.80"W Southeast of Springer, New Mexico. An abandoned stone farmhouse, at left, valiantly defends itself against the ravages of time and nature. As I rode past, I imagined what life must have been like for those who occupied this magnificent abode. And why was it cast aside? The ominous skies and the spring, virga showers are not uncommon in these desolate parts of eastern New Mexico. The aerial view makes clear the house's isolation on the right-hand side of the highway.

Overleaf: 36°18'17.03"N, 103°50'53.57"W Southwest of Clayton, New Mexico. The symmetry of the power lines and the wooden structures that support them struck my eye on this quiet stretch of highway leading to the Texas state line. They resemble stickmen holding sets of wires from their dangling arms. The aerial photograph captures the setting sun's rays bathing the same power lines as the latter veer diagonally upward, away from the highway.

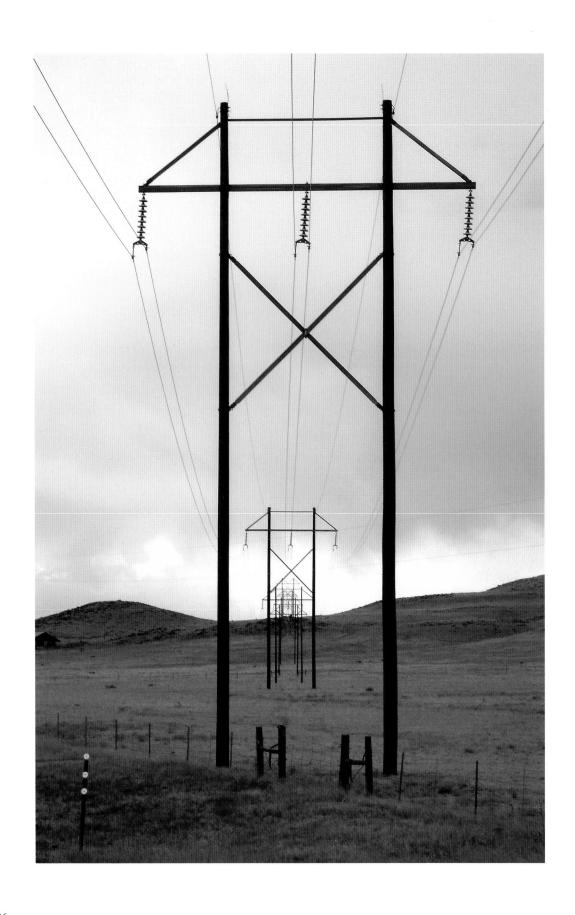

196

Above and Right: 36°27'08.98"N, 103°11'05.25"W Clayton, New Mexico. At right, one of many Main Street scenes that form the rich and diverse fabric of America. The aerial shot above looks south across Main Street and down Highway 87, which ultimately leads to the Texas state line, 15 miles away. Clayton was my last sanctuary for gas and food (see the gas station in the lower, left-center edge of the aerial photograph) before encountering a treacherous dust storm on the way to Dalhart, Texas.

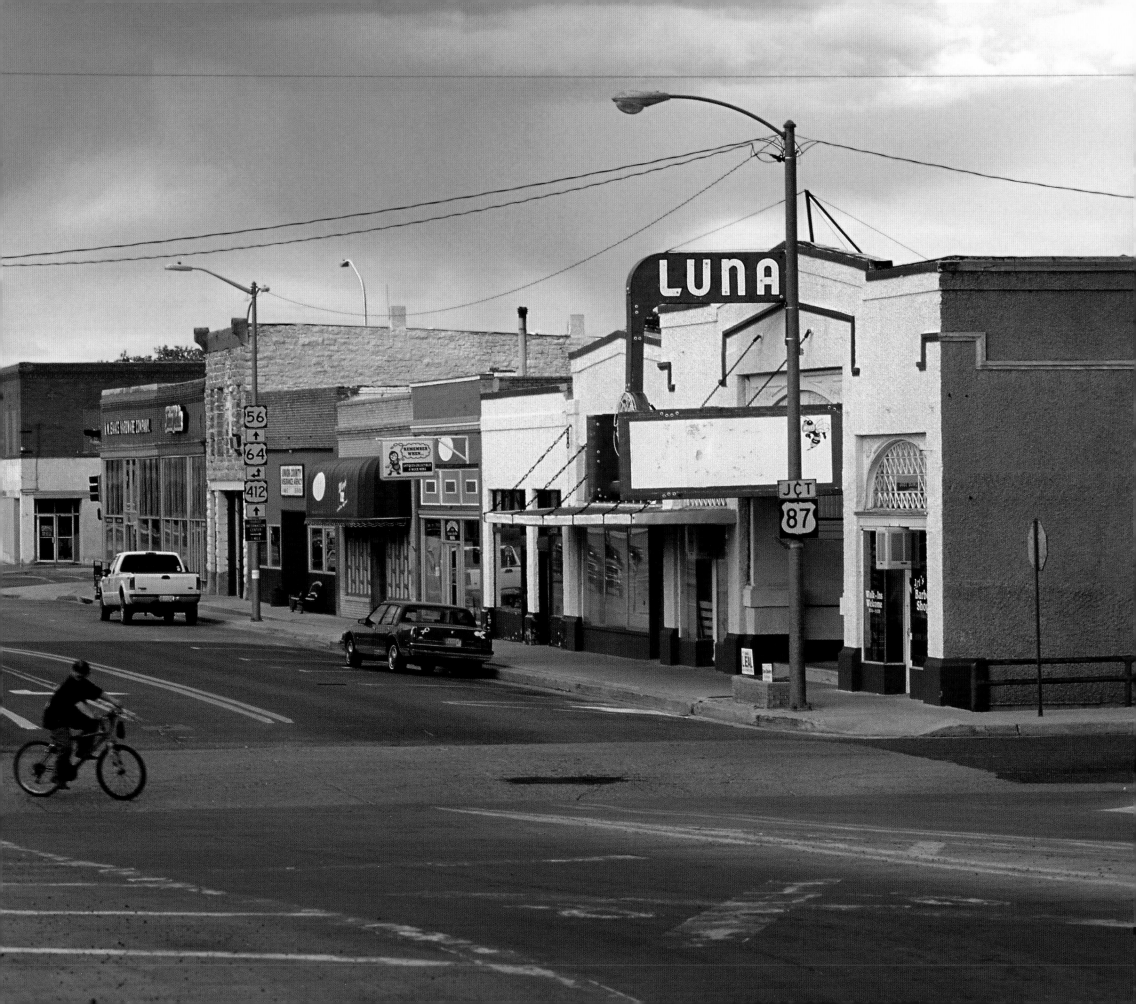

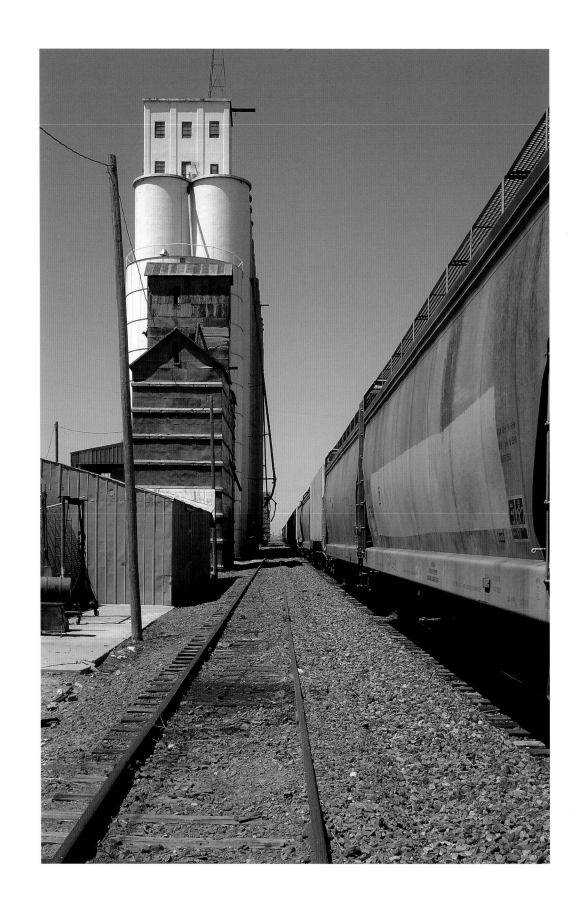

This Page and Opposite: 36°14'03.76"N, 102°14'23.27"W Conlen, Texas. These clusters of grain elevators and storage silos, lined side-by-side along a railroad track and major highway, are a common sight as you travel across Texas—further evidence of an agrarian community that depends heavily on these transportation arteries.

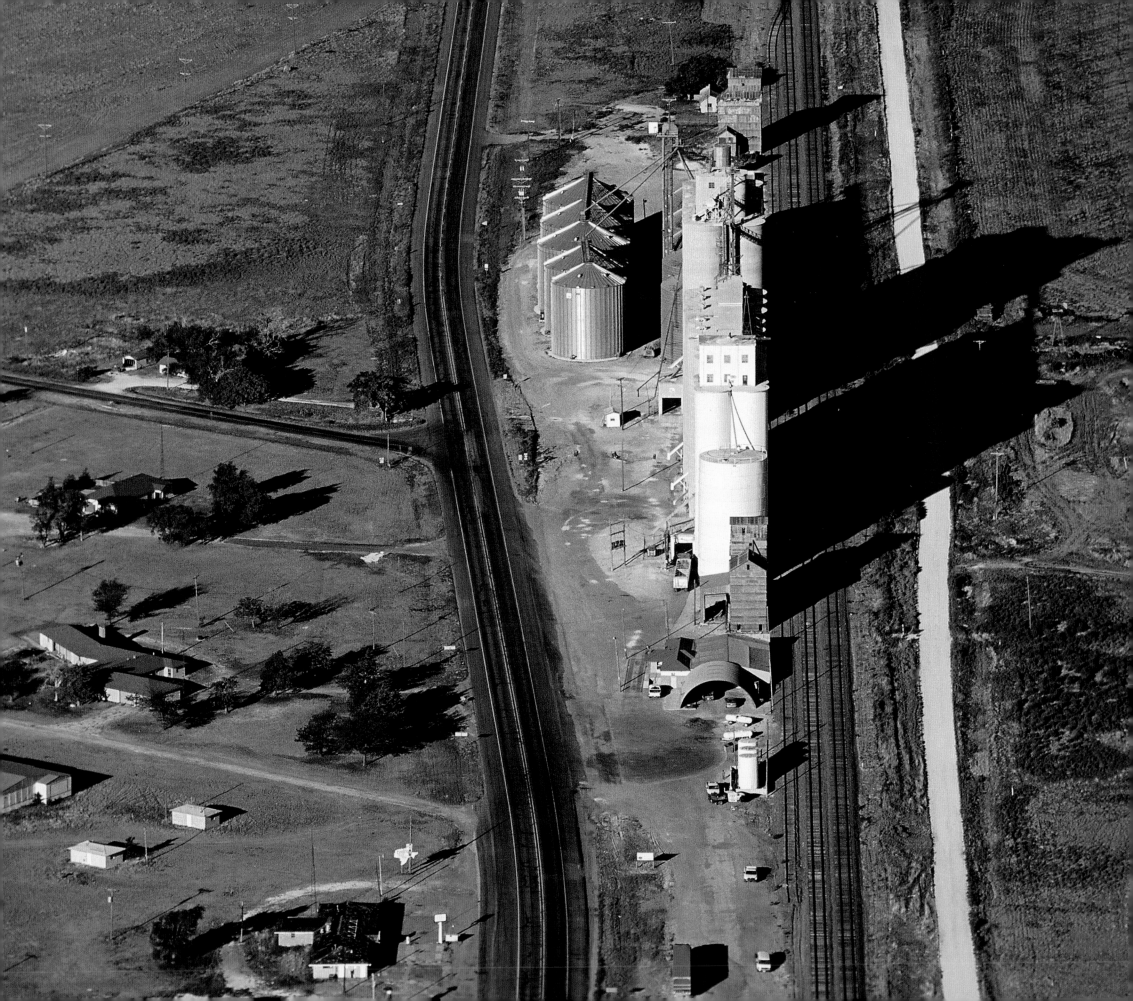

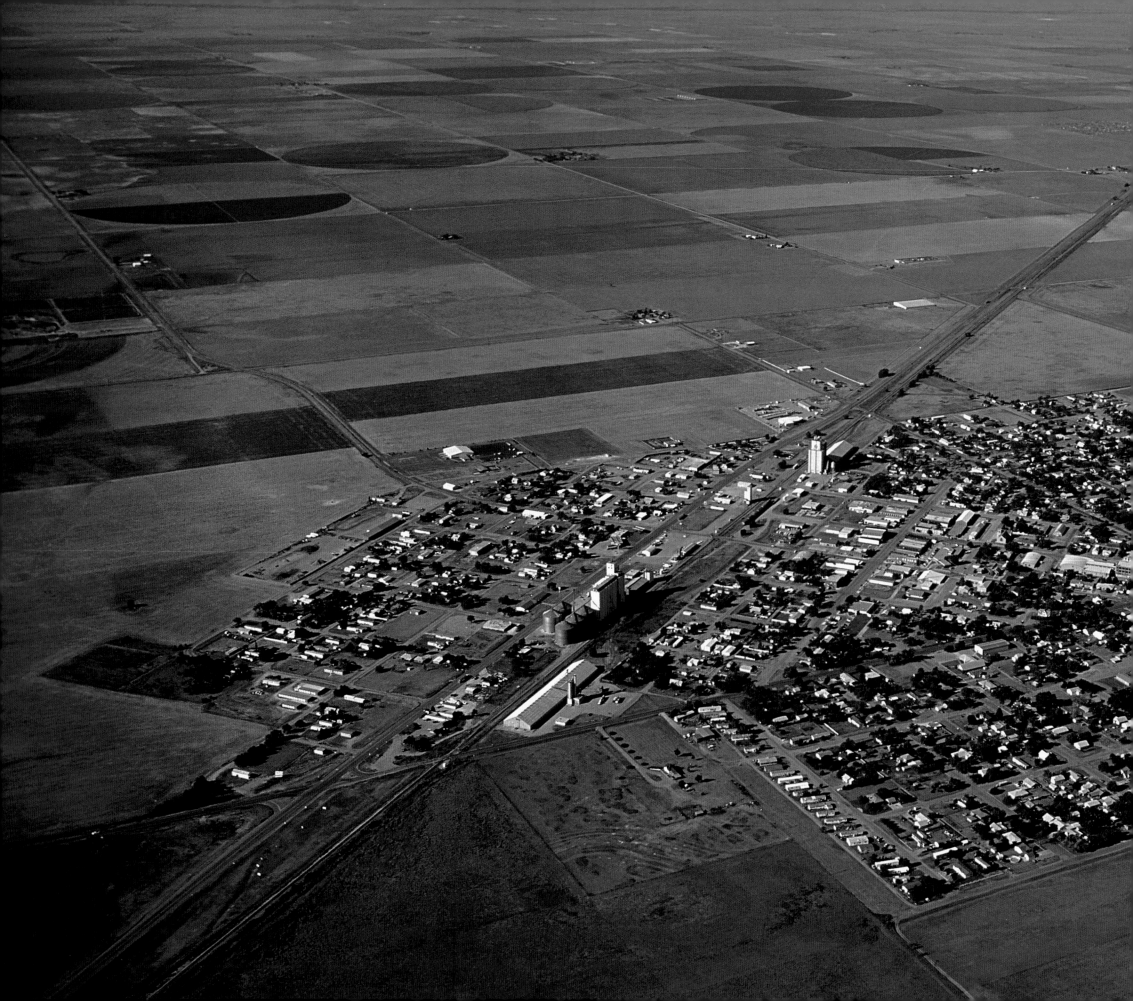

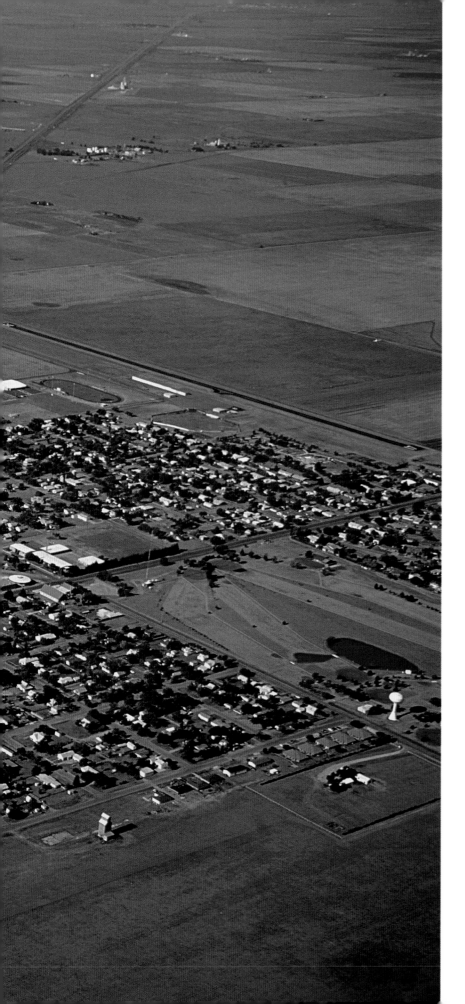

Left and Above: 36°51'26.91"N, 101°12'41.88"W Hooker, Oklahoma. This is a bird's-eye view of one of our country's few panhandle towns. In the aerial image, notice that Highway 54 cuts across the terrain from the lower left to the upper right of the photograph. Highways and railroad lines underscore the meaning of the word *lifeblood*. The road sign above applauds the proud American Legion baseball team.

37°45'09.21"N, 98°34'26.85"W Southwest of Hutchinson, Kansas. This is Dorothy's Kansas, if you've seen *The Wizard of Oz*: wide-open plains interrupted by railroad crossings and trails of dirt roads. Many motorists consider this route through the middle of Kansas on Highway 61 to be one of the most scenic in the country.

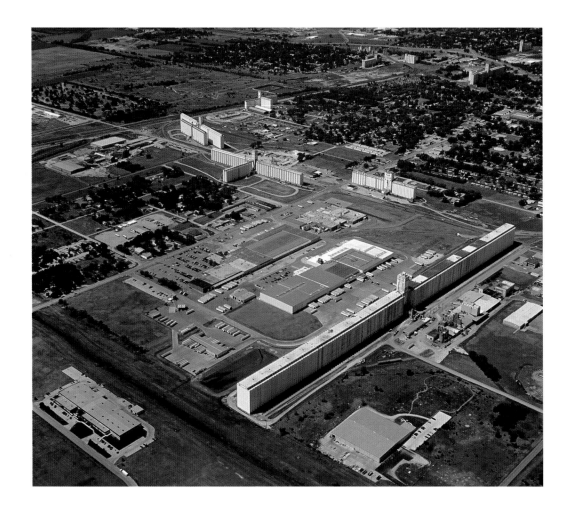

Above and Right: 38°03'58.20"N, 97°52'22.14"W Hutchinson, Kansas. Once known as "The Salt City," Hutchinson was the site of the first salt-processing plants west of the Mississippi. Today, farming is king. The grain elevators above—nearly half a mile long—are among the largest in the world. The ground shot looks down Halstead Street at what appears to be sterile, white monoliths. In fact, these elevators are situated perpendicularly to the largest of the elevators in the aerial view.

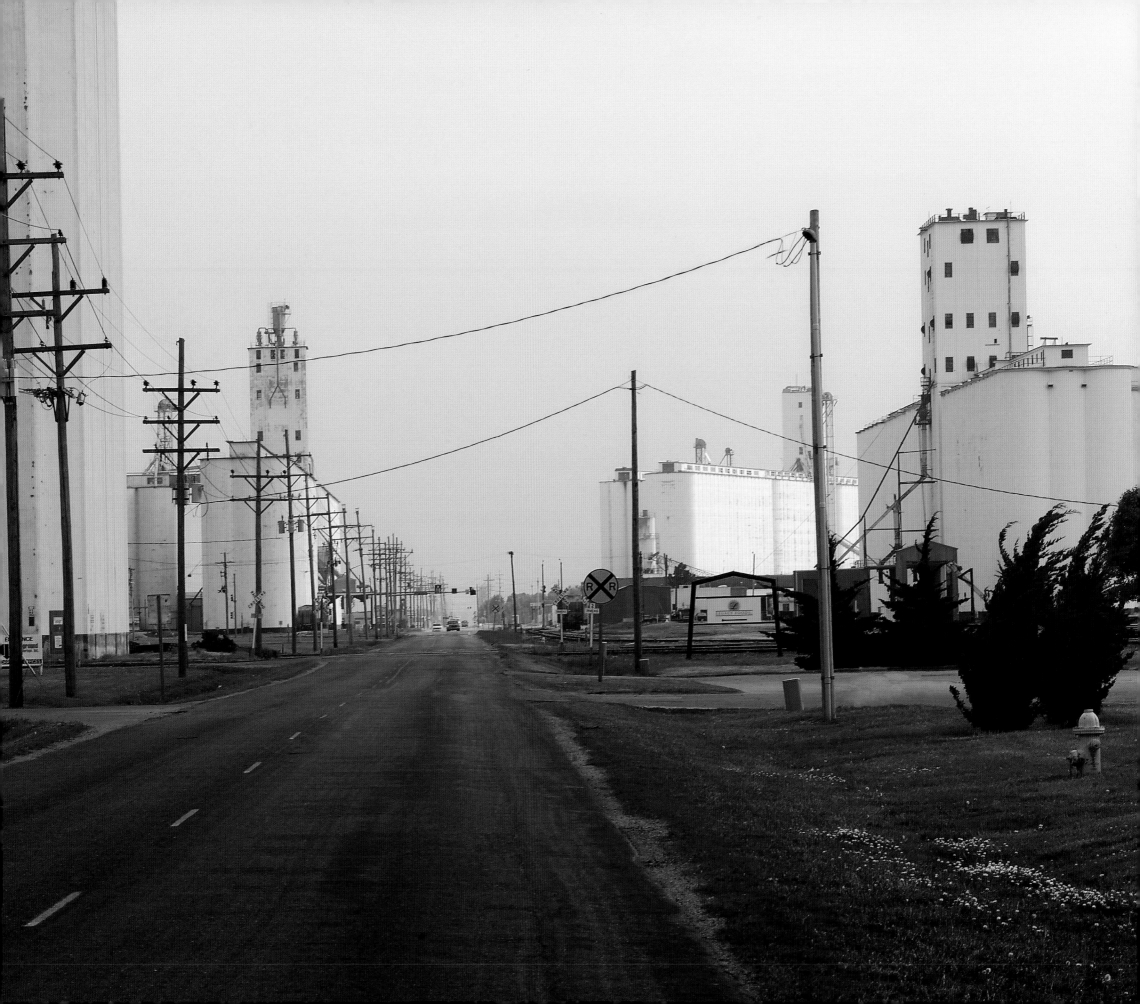

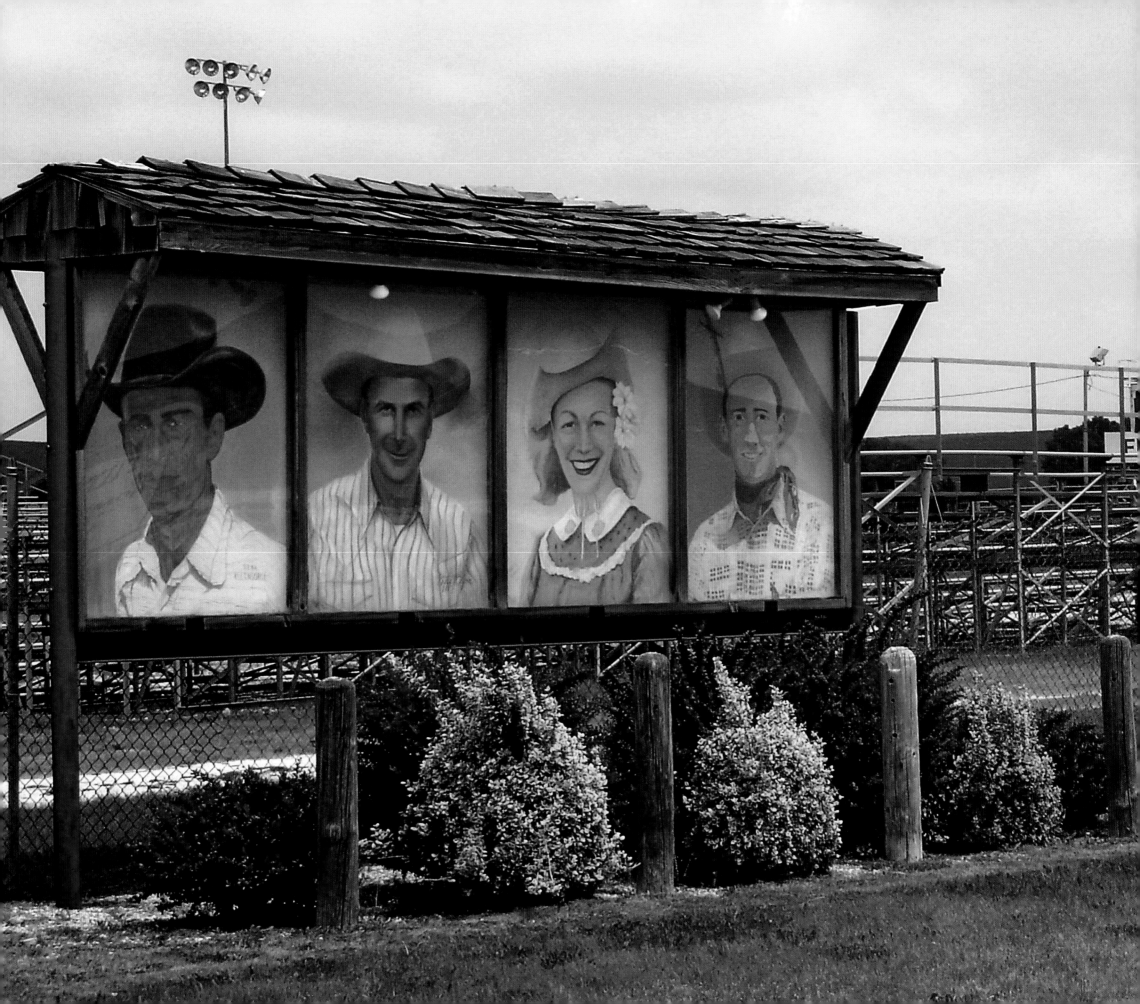

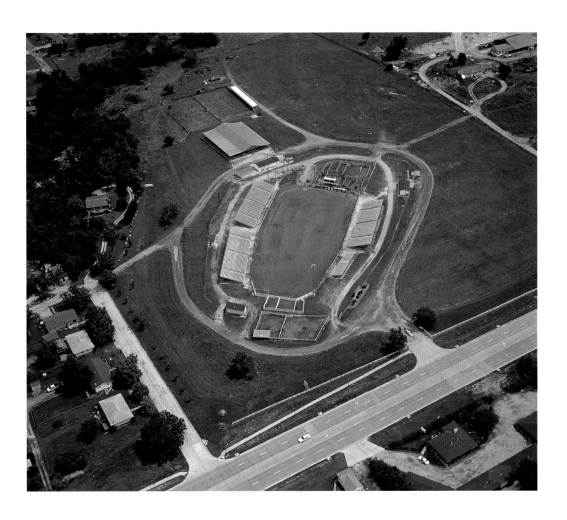

38°24'01.36"N, 96°32'11.49"W North of Strong City, Kansas. The Flint Hills Rodeo is a welcome reminder of Americana that I caught by luck as I was traveling toward Kansas City, Missouri. It sits on Highway 50 and welcomes fans to Kansas's oldest annual rodeo.

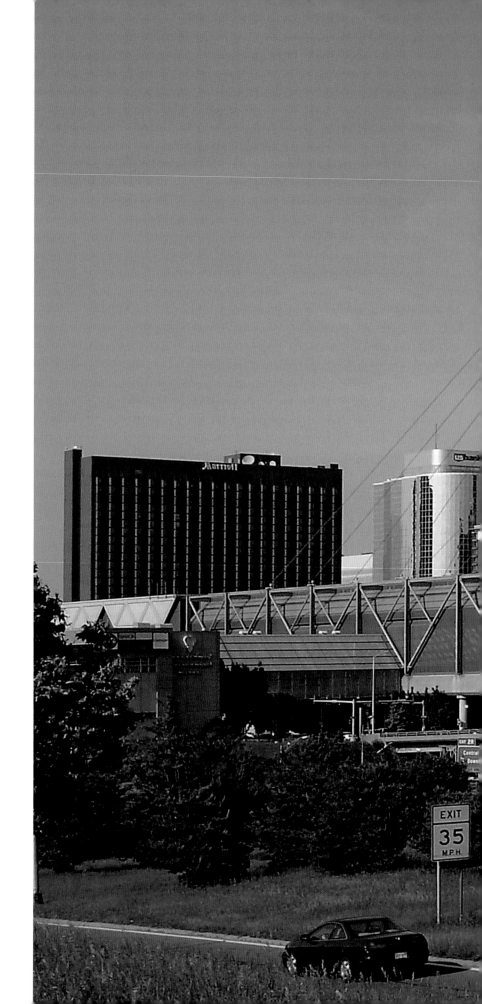

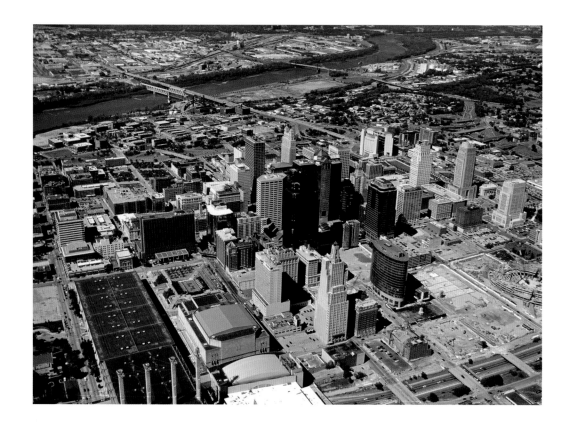

Above and Right: 39°05'44.29"N, 94°35'17.47"W Kansas City, Missouri. After San Diego, California, this was the largest city I had encountered on the 2006 leg of the trip. The aerial view reveals a dense city, with its long, dark-colored convention center, at the bottom of which you see four celebrated Art Deco pylons that look like toothpicks. In the image on the right, you can see that these pylons are actually massive, anchored by cables running diagonally to the rooftop.

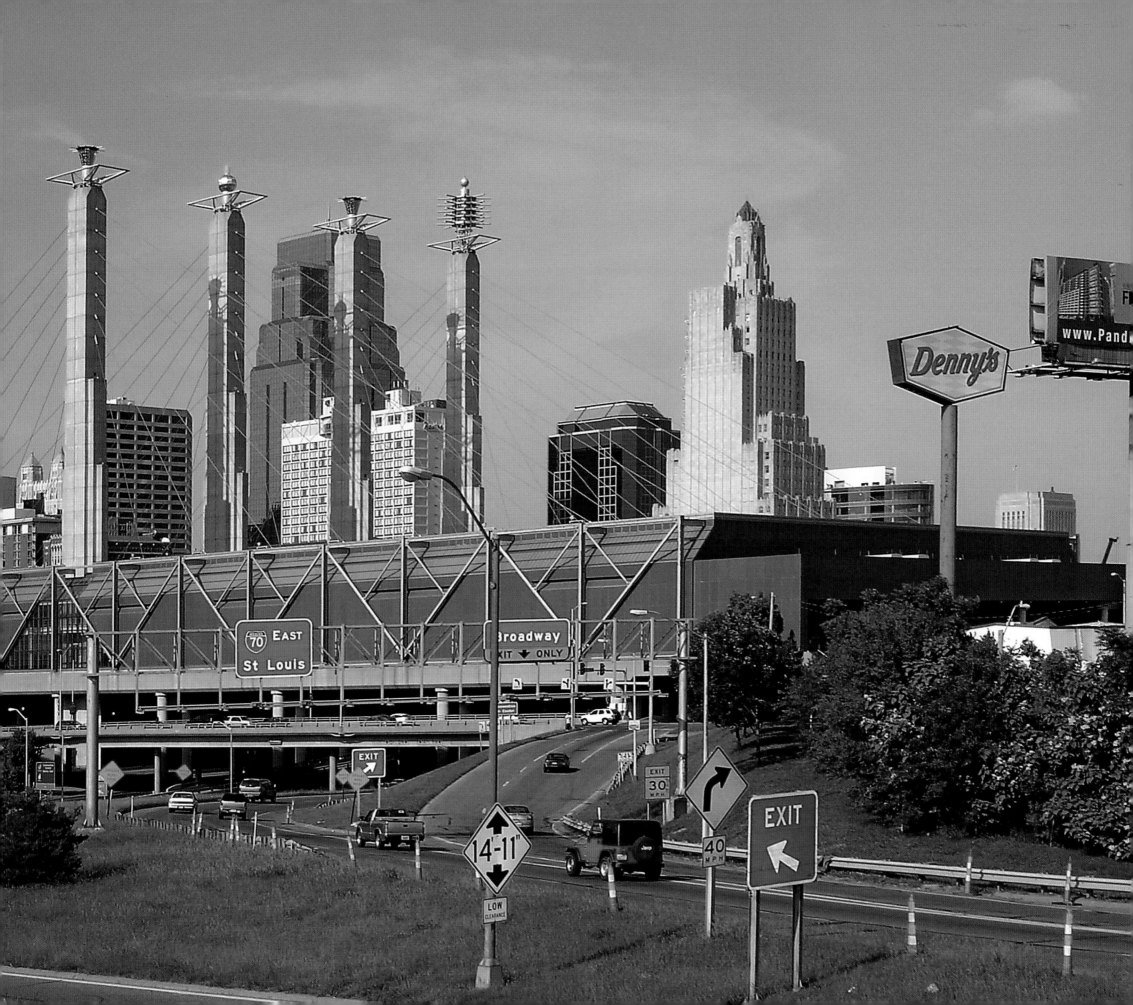

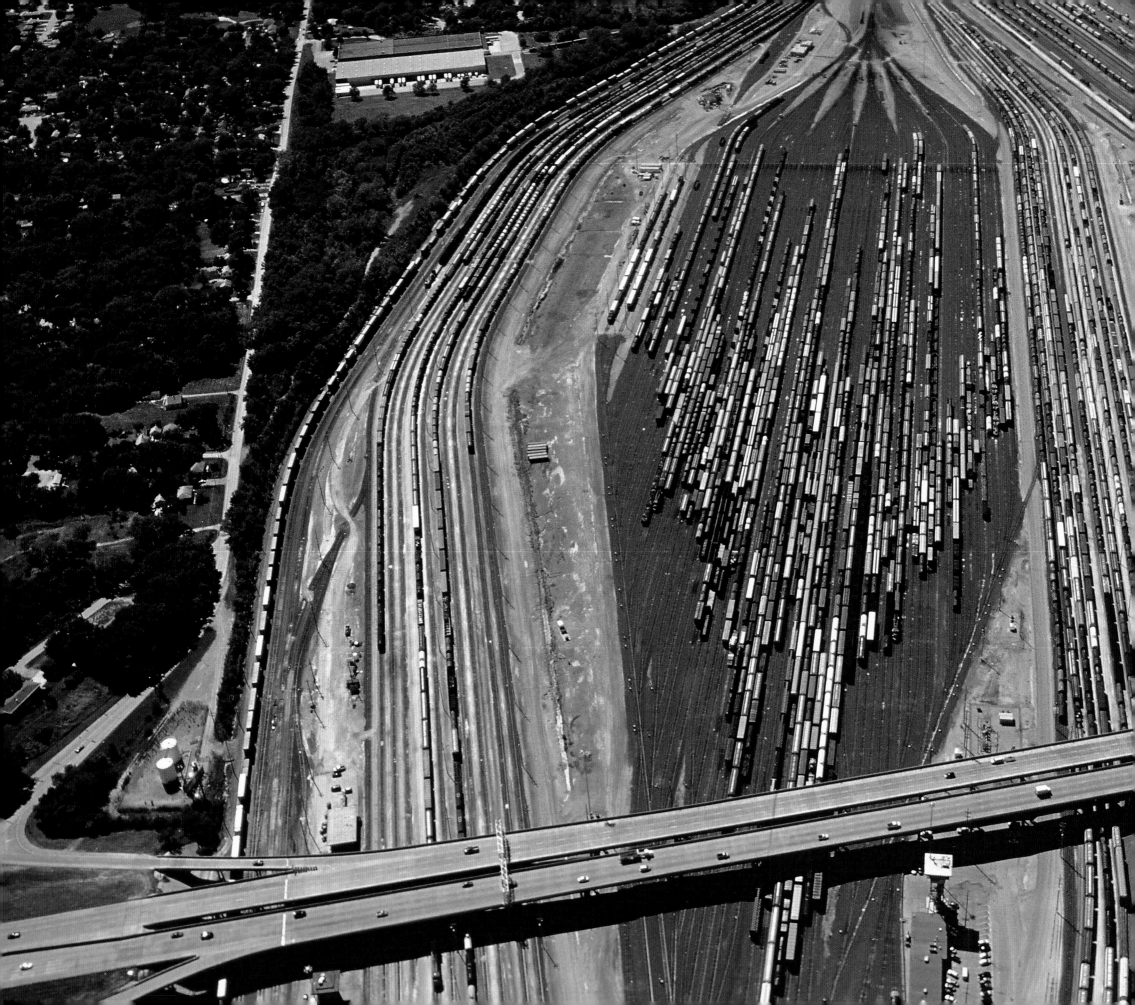

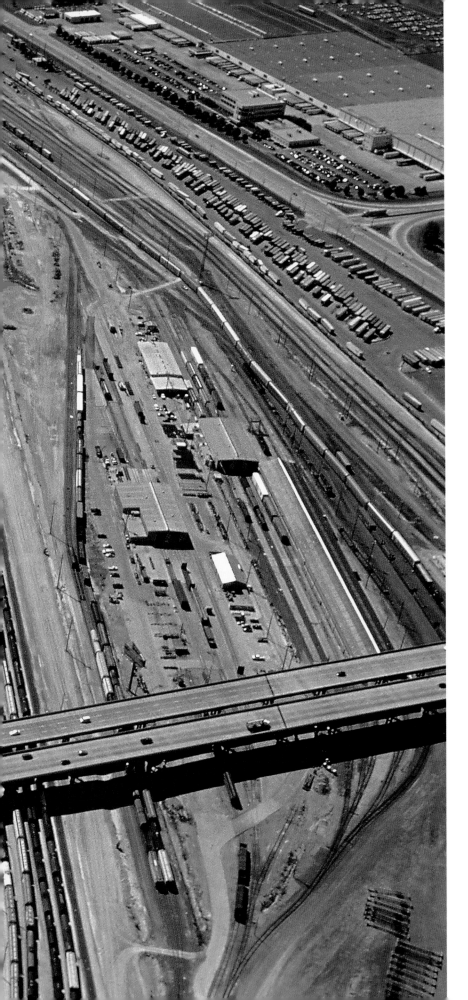

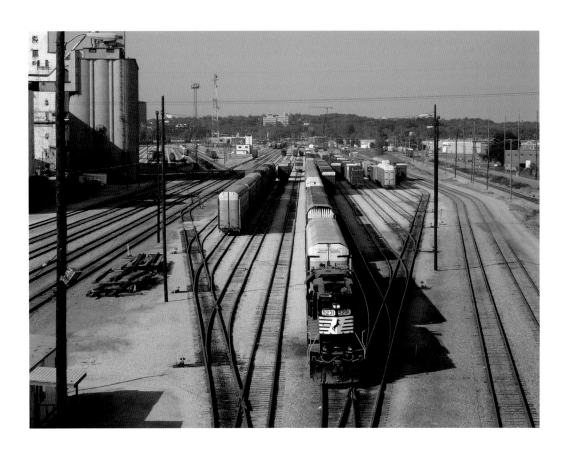

Left and Above: 39°04'59.92"N, 94°40'38.21"W; 39°07'53.85"N, 94°34'04.19"W Kansas City (Kansas and Missouri). Rail yards such as these can be found throughout these two river cities. More rail tonnage flows through these centrally located cities than anywhere else in the United States.

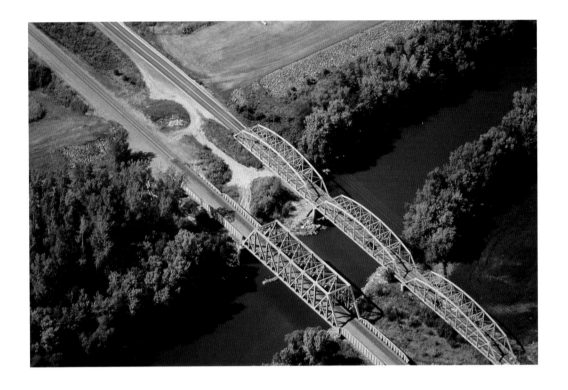

Above and Right: 39°16'25.80"N, 94°49'36.94"W Farley, Missouri. The aerial view above shows a railroad bridge on the left and a highway bridge on the right that cross the Platte River. Highway 45 follows part of the legendary Lewis and Clark Trail through this section of Missouri. I felt like a toreador dodging vehicles as they flew by me on this narrow and heavily trafficked bridge.

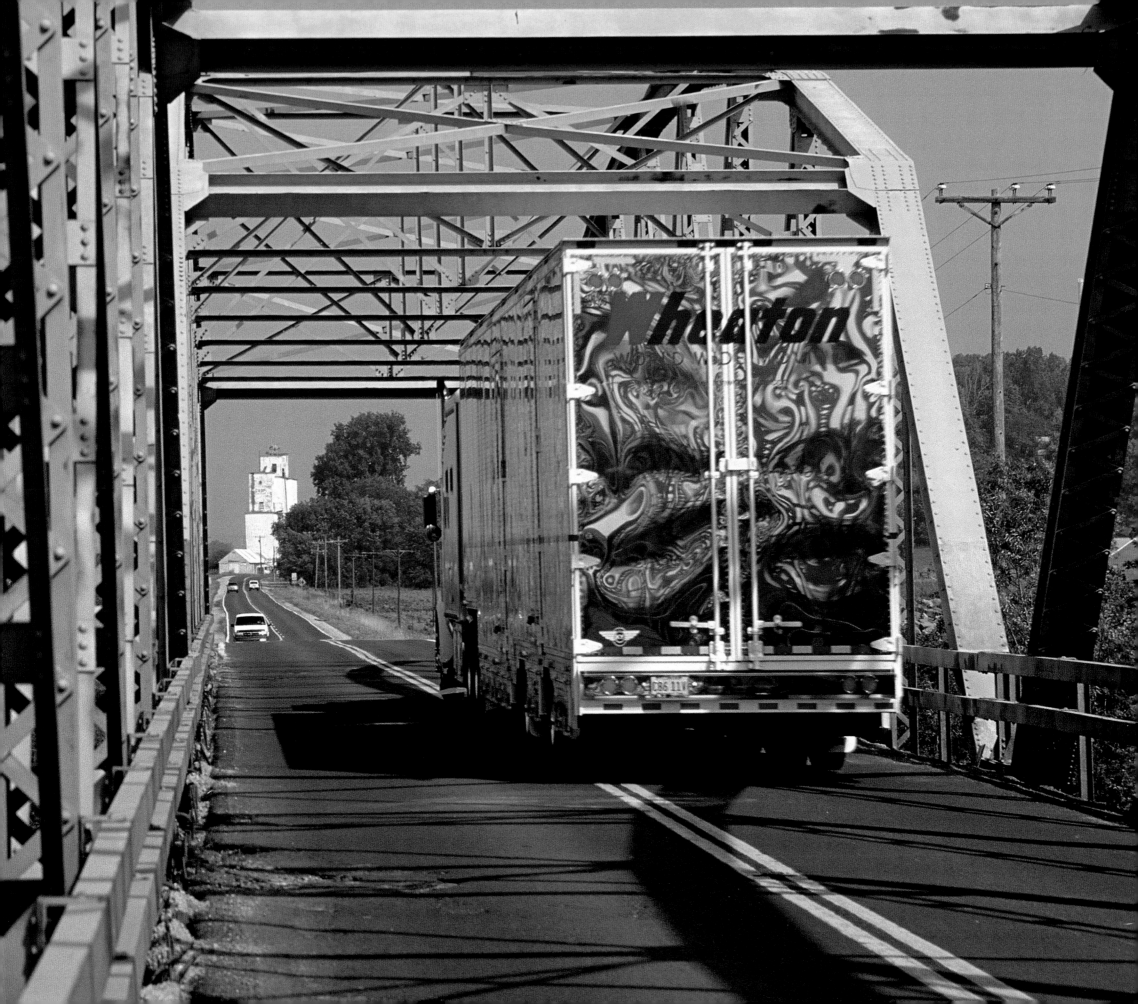

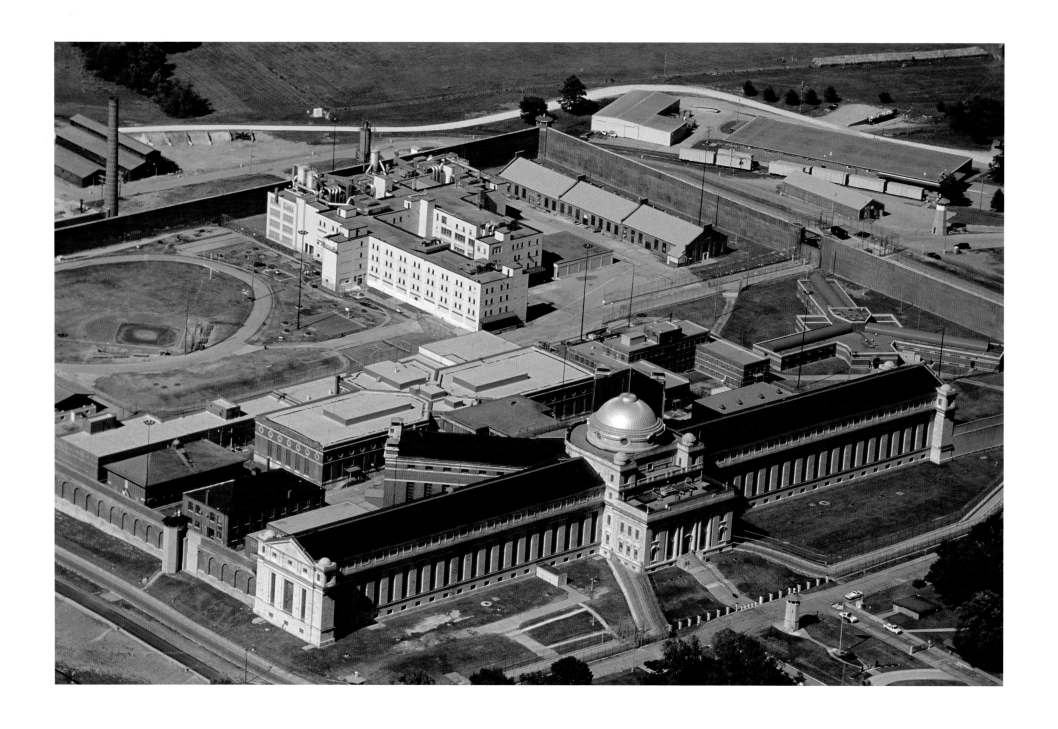

Above and Right: 39°19'39.89"N, 94°56'10.33"W United States Penitentiary, Leavenworth, Kansas. Even though I included the Leavenworth prison on my itinerary, I felt awkward and intrusive after stopping there to take pictures. This federal penitentiary was built in the late 1800s, houses 1,700 prisoners, and is one of the largest maximum-security prisons in the country.

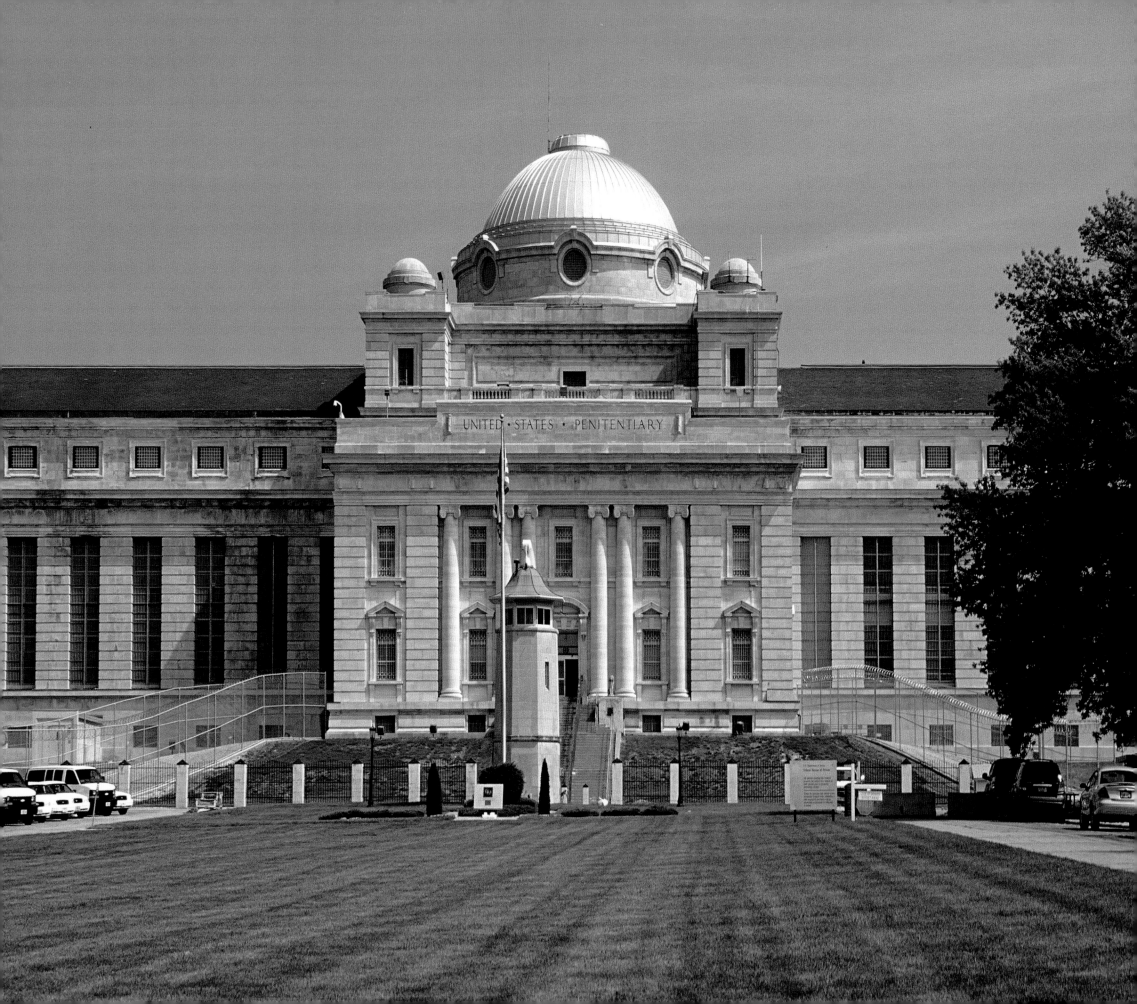

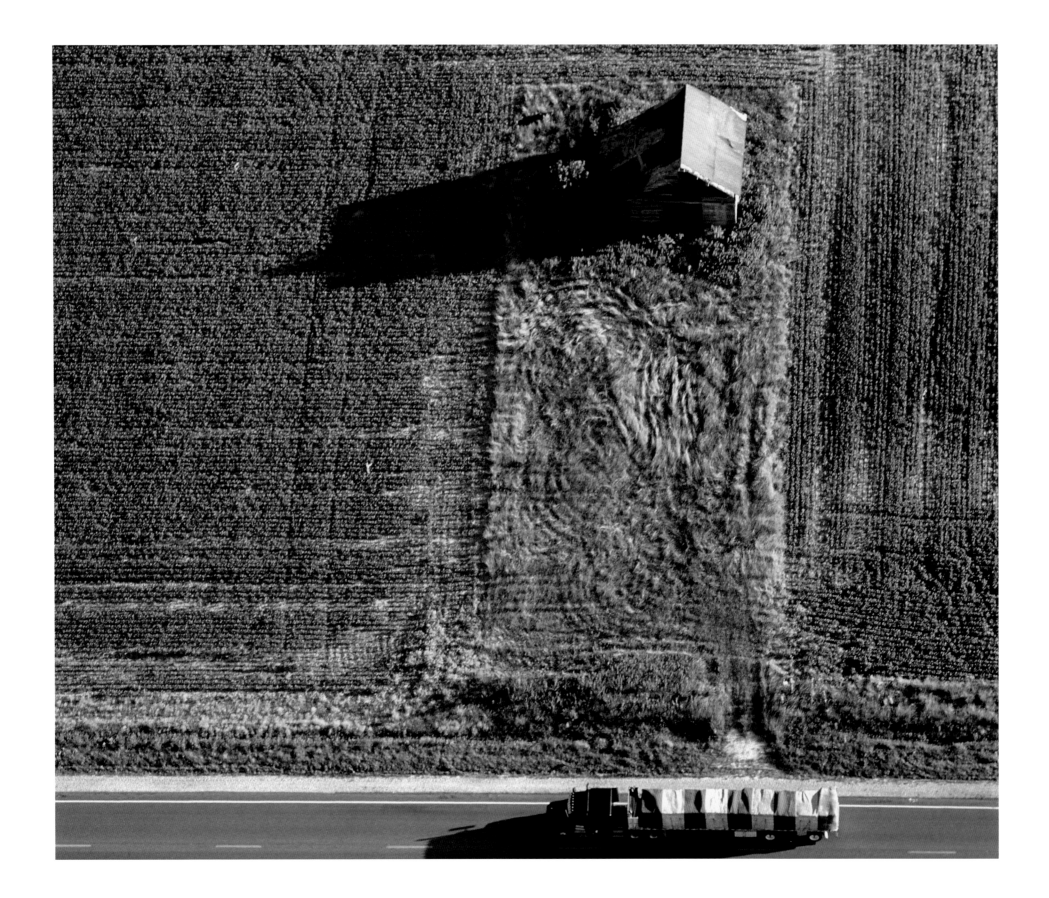

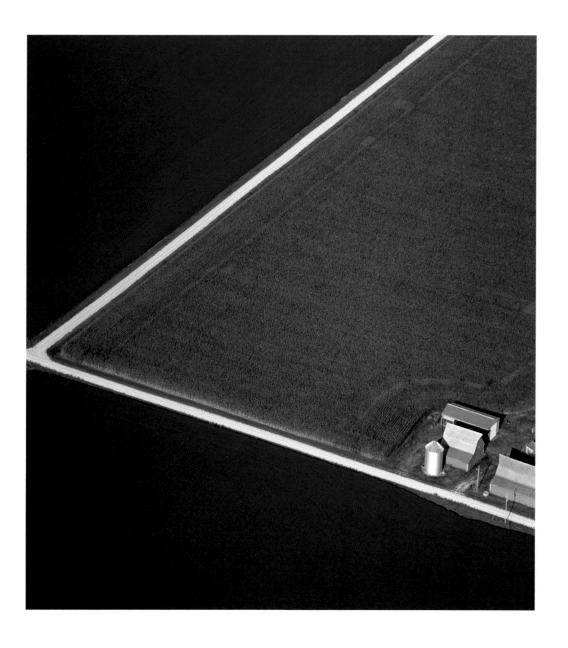

Preceding Page: 39°45'01.49"N, 92°20'27.76"W West of Anabel, Missouri. In its day, this shed obviously served a vital purpose, and even now appears reluctant to collapse. Sights like this are prevalent along these lengthy stretches of Midwest farmlands. My view from the ground was probably the same as that of the driver in the tractor-trailer with the candy-striped colorful canvas tarp.

Above and Right: 39°42'25.73"N, 92°06'02.03"W Northwest of Shelbina, Missouri. Have you ever been tempted (as I was, and did) to stroll through a field of six-foot-tall growing corn? I have the highest regard for the people who dedicate their lives to toiling the fields and growing the produce and food that sustain us.

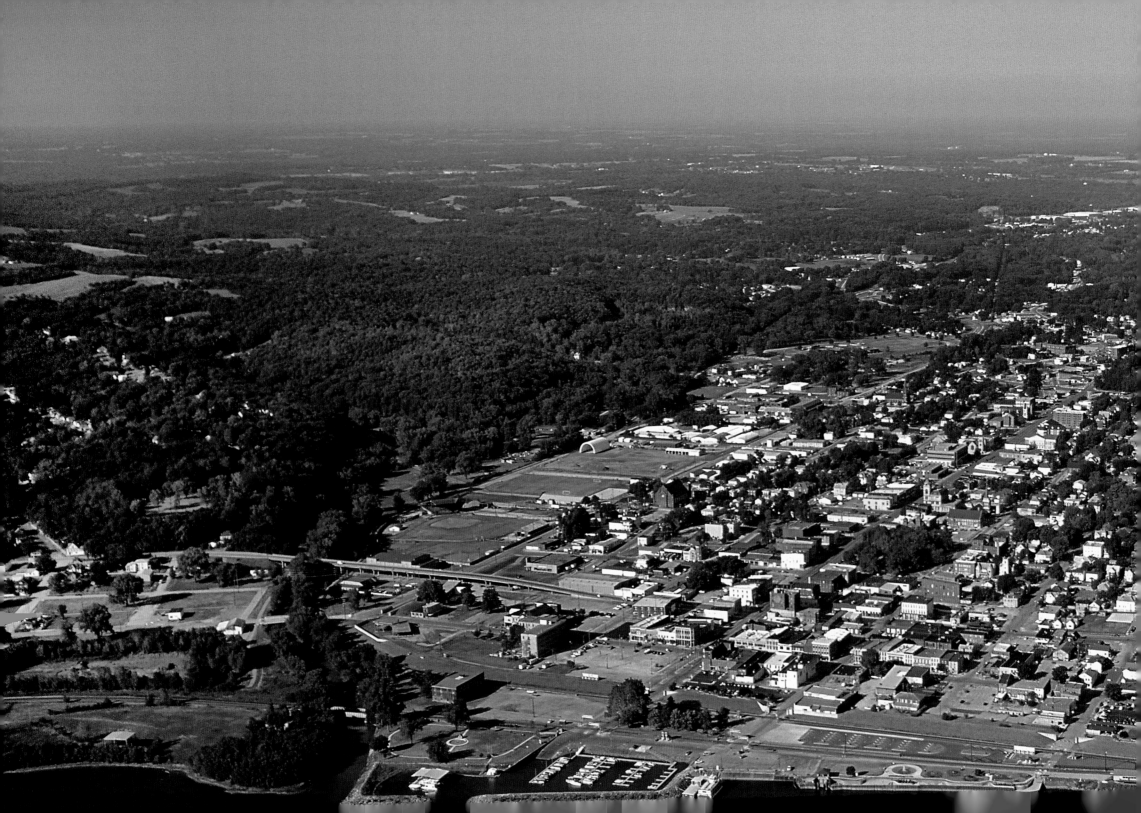

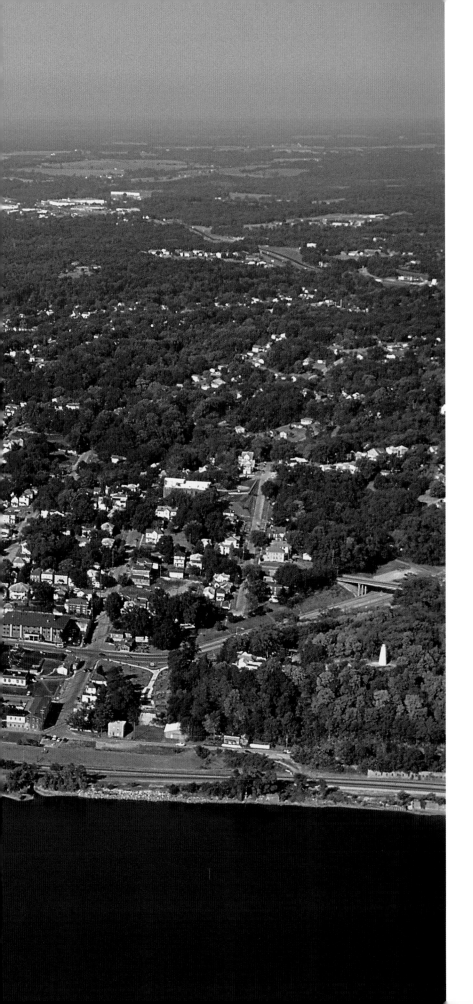

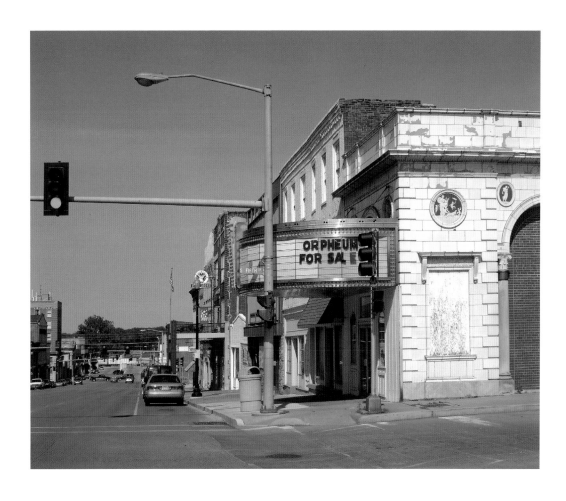

Left and Above: 39°42'29.27"N, 91°21'33.05"W Hannibal, Missouri. The aerial photograph on the left captures "America's Home Town," the birthplace of author Mark Twain and the setting for many of his books. It sits on the banks of the mighty Mississippi River (in the foreground). In the image above, the marquis of the Orpheum Theater sadly announces its fate. Located on the corner of 5th Street and Broadway, it must have hosted many a rip-roaring show in its heyday.

223

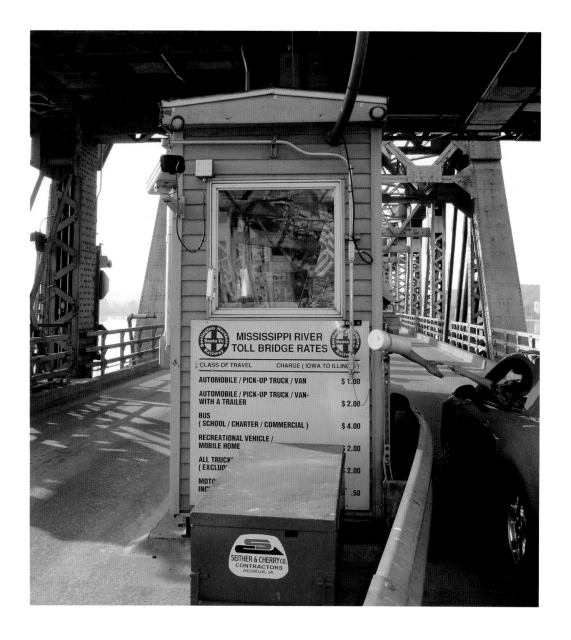

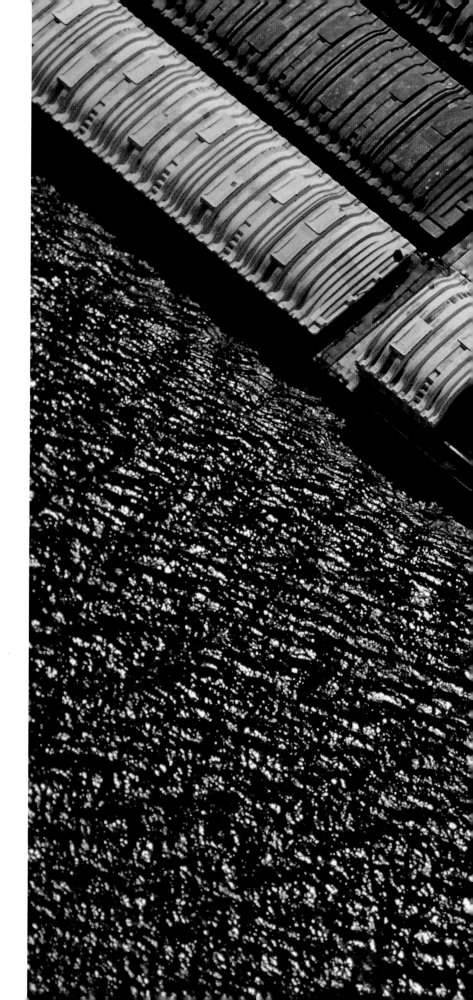

Above and Right: 40°37'40.39"N, 91°17'48.22"W Fort Madison, Iowa. The tollbooth above sits at the entrance to the Fort Madison Bridge, also known as the Santa Fe Swing Span Bridge. This bridge spans the Mississippi River and is one of the longest, double-deck (for cars above and trains below) truss bridges of its kind. An advantage that motorcycles have over cars is the toll is 50 cents cheaper (note the fees on the placard at the base of the booth). The aerial photograph, at right, singles out a few barges, making their way down the river near Fort Madison in shimmering light.

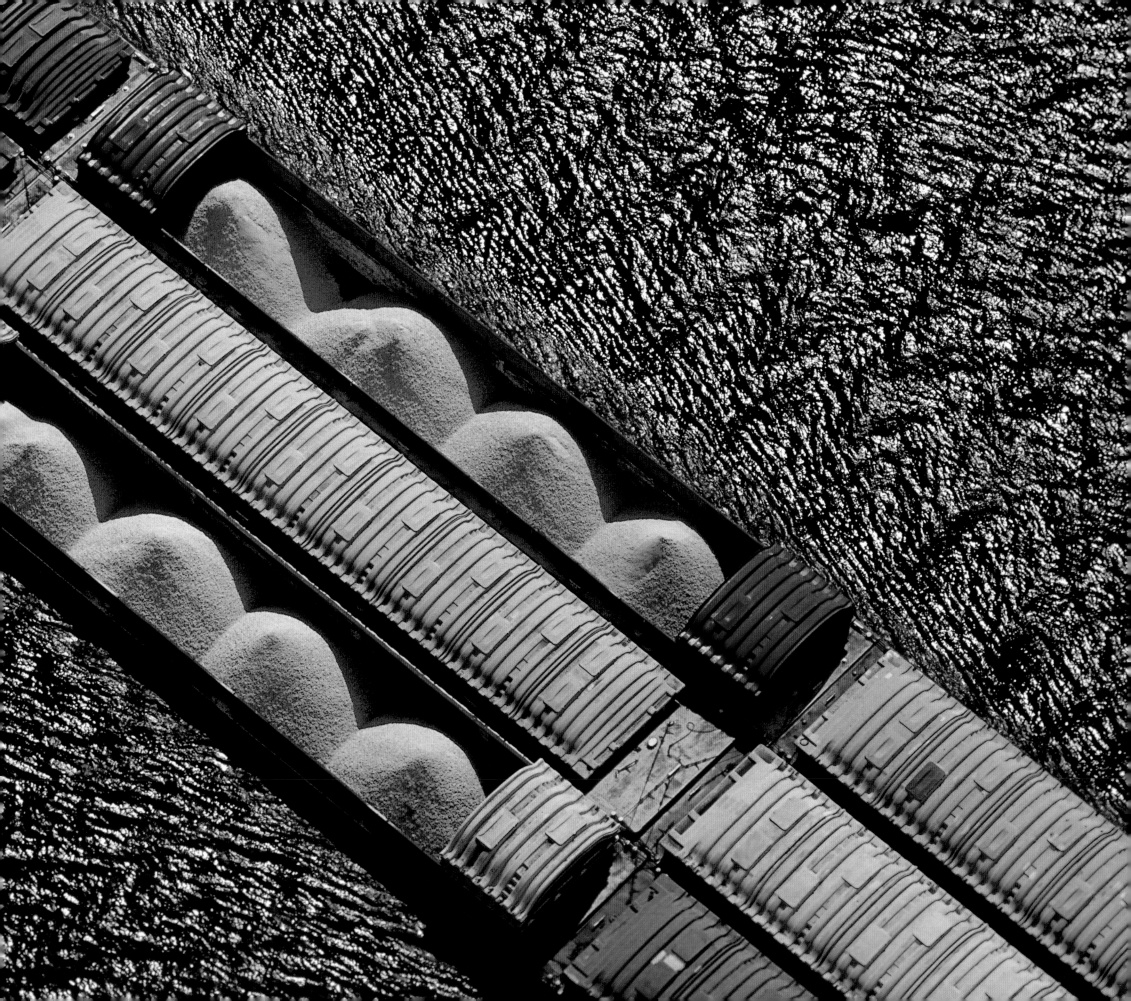

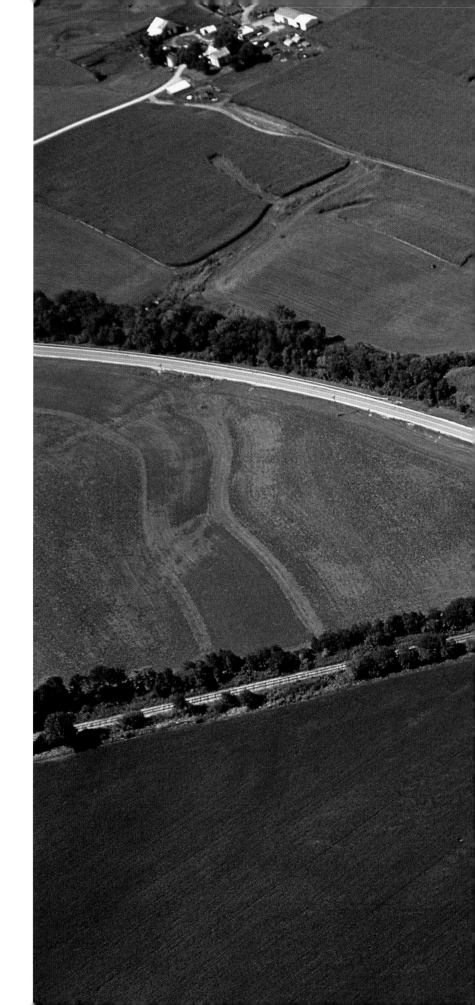

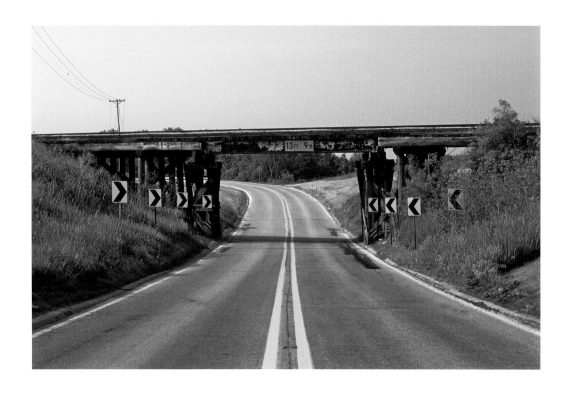

40°34'42.60"N, 90°55'40.57"W East of La Harpe, Illinois. I enjoyed this early-morning view of yellow directional signs against the backdrop of an aging railroad bridge. What a wonderful ride I had in the open air, along the gentle curves (as seen in the aerial photograph), and through this rich and colorful farming region of our heartland.

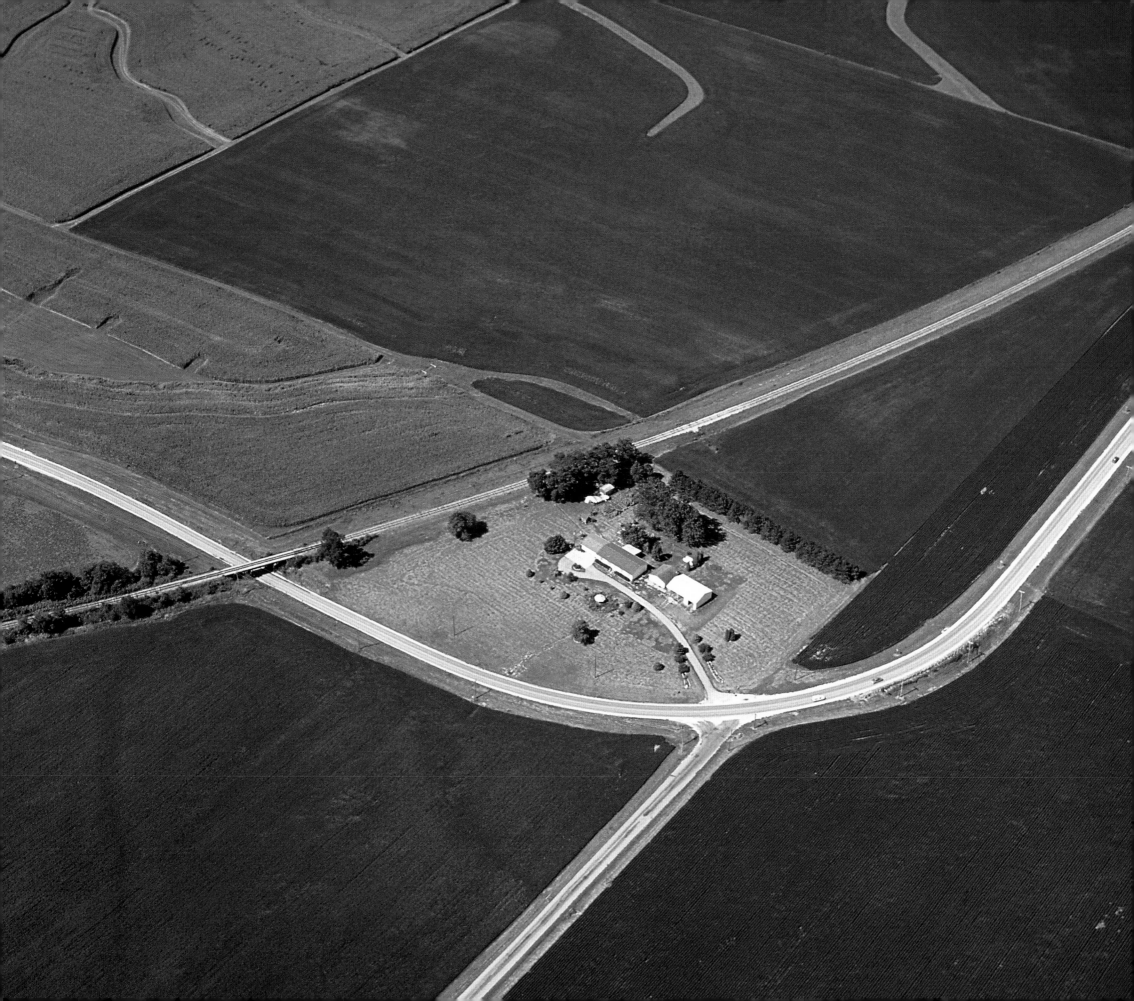

Left and Above: 40°38'00.42"N, 89°39'06.14"W Bartonville, Illinois. This abandoned feed mill was the first large industrial structure I had seen so close to the road since beginning my journey in San Diego. The mill was the largest in the world when it was built in the 1920s. This scene would begin to repeat itself as I moved farther into the industrial heartland of America. These abandoned structures are historical markers, telling the tale of a long-gone way of life.

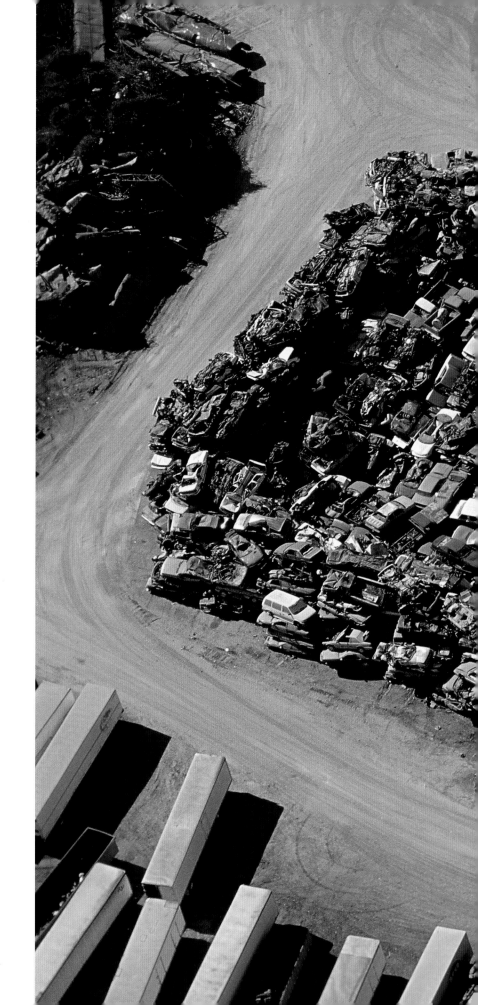

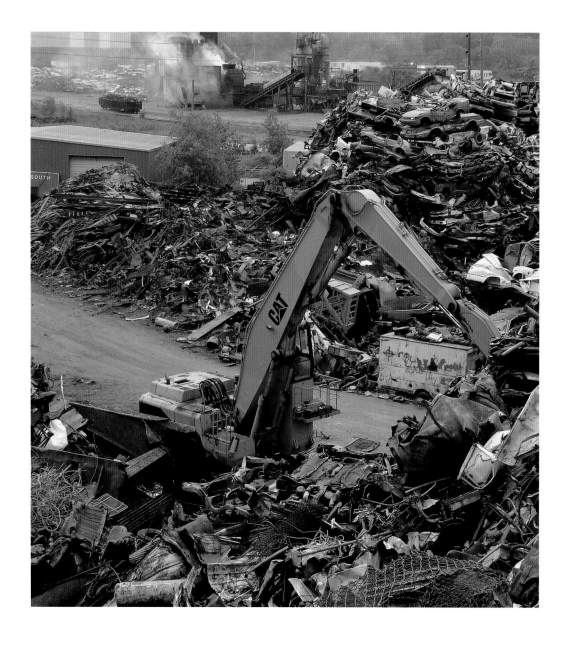

Above and Right: 40°39'32.10"N, 89°38'21.00"W Peoria, Illinois. The image above shows one of many junk and scrap metal yards that dot the southern entrance to the city. The sights and sounds of this busy spot are a sobering reminder of our consumer society. "Newer," "faster," and "better" trump "the older," which ends up here in these yards. Modern technology allows us to convert this waste into new metal products. The aerial photograph at right evokes the transformation of disorder into a kind of order.

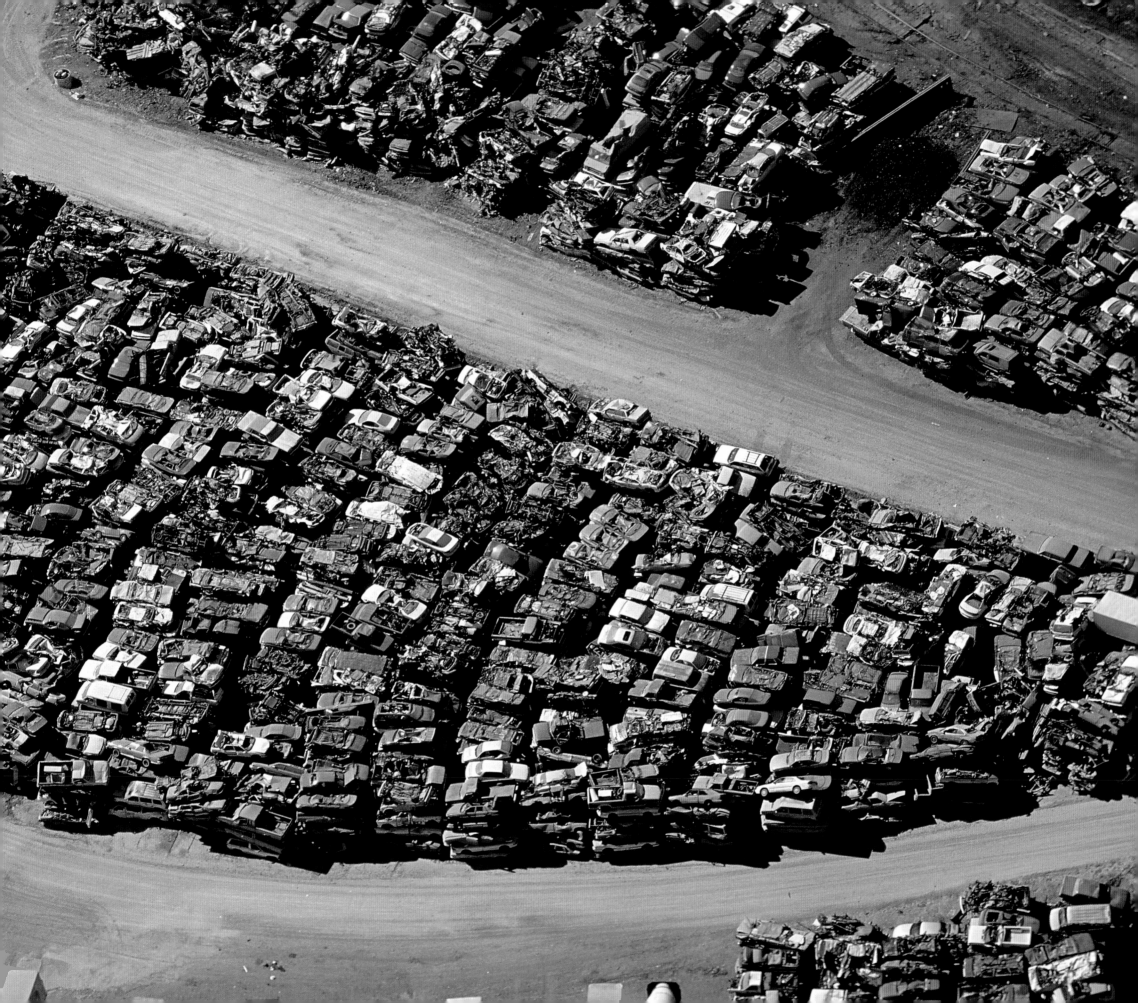

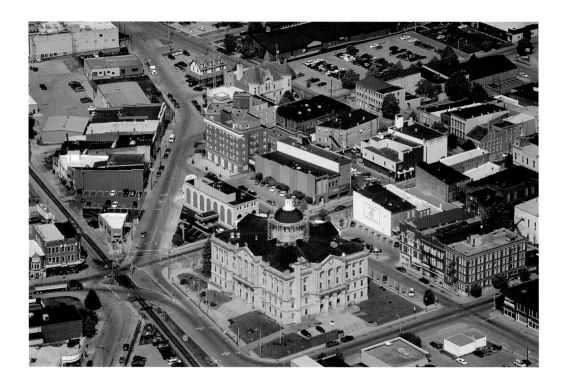

Above and Right: 40°52'49.75"N, 85°29'36.26" Downtown Huntington, Indiana. The aerial photograph shows the courthouse and county office building in this Midwest community. As with most cities in America, Huntington was built along a major rail line, which can be seen traversing in front of the courthouse from the center-left edge to the bottom edge of the picture. As luck would have it, a freight train passed along the railroad crossing, in the photograph at right, just as it seemed to do each time I approached a crossing on my journey.

Overleaf: 41°01'48.01"N, 82°31'05.43"W Greenwich, Ohio. Both photographs look east down Main Street. The triangular building at the corner of Main and South Railroad Streets must have been the most prominent address in this one-and-a-half-square-mile village. The aerial view shows the intersection (lower-left quadrant) of the railroad tracks and Main Street, also called Highway 224, an east-west artery across the northern part of the state. Greenwich is one of the many dots on the map, like a string of beads, along this stretch of highway.

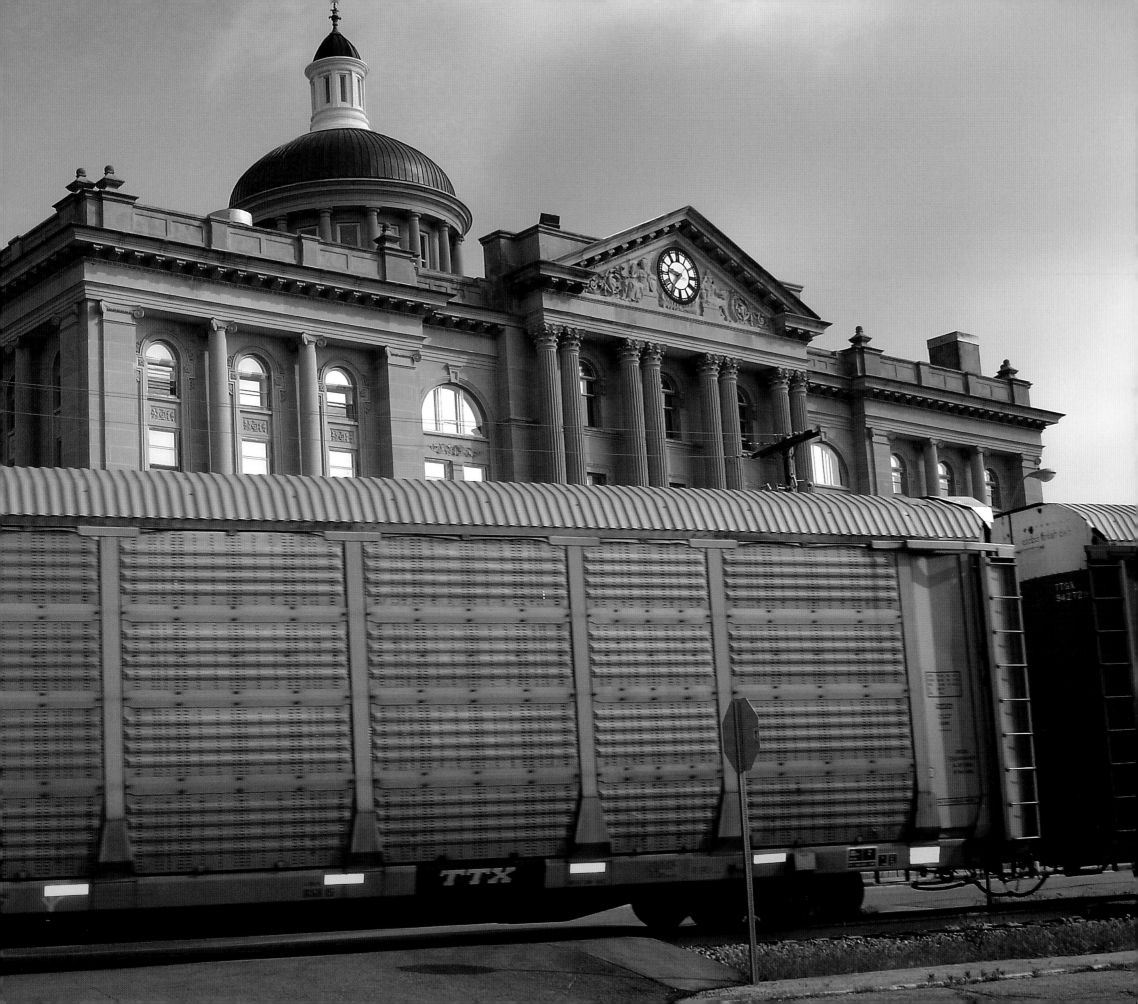

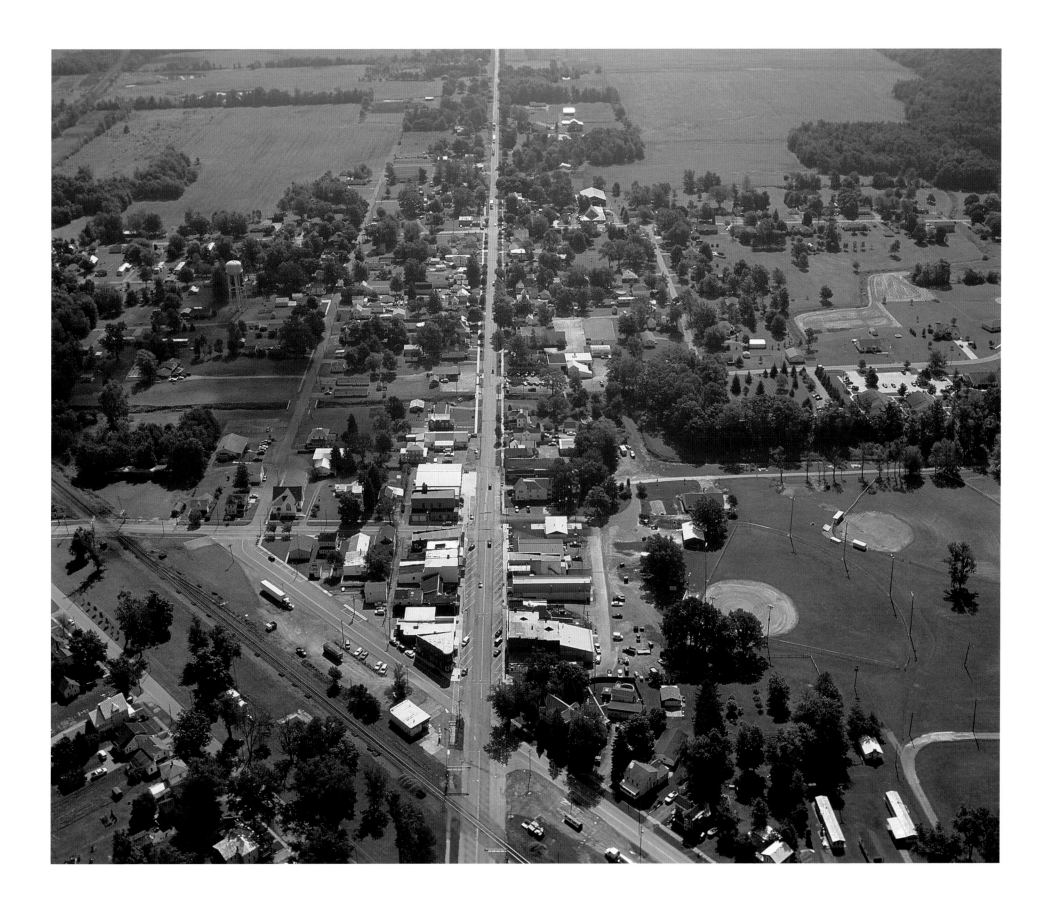

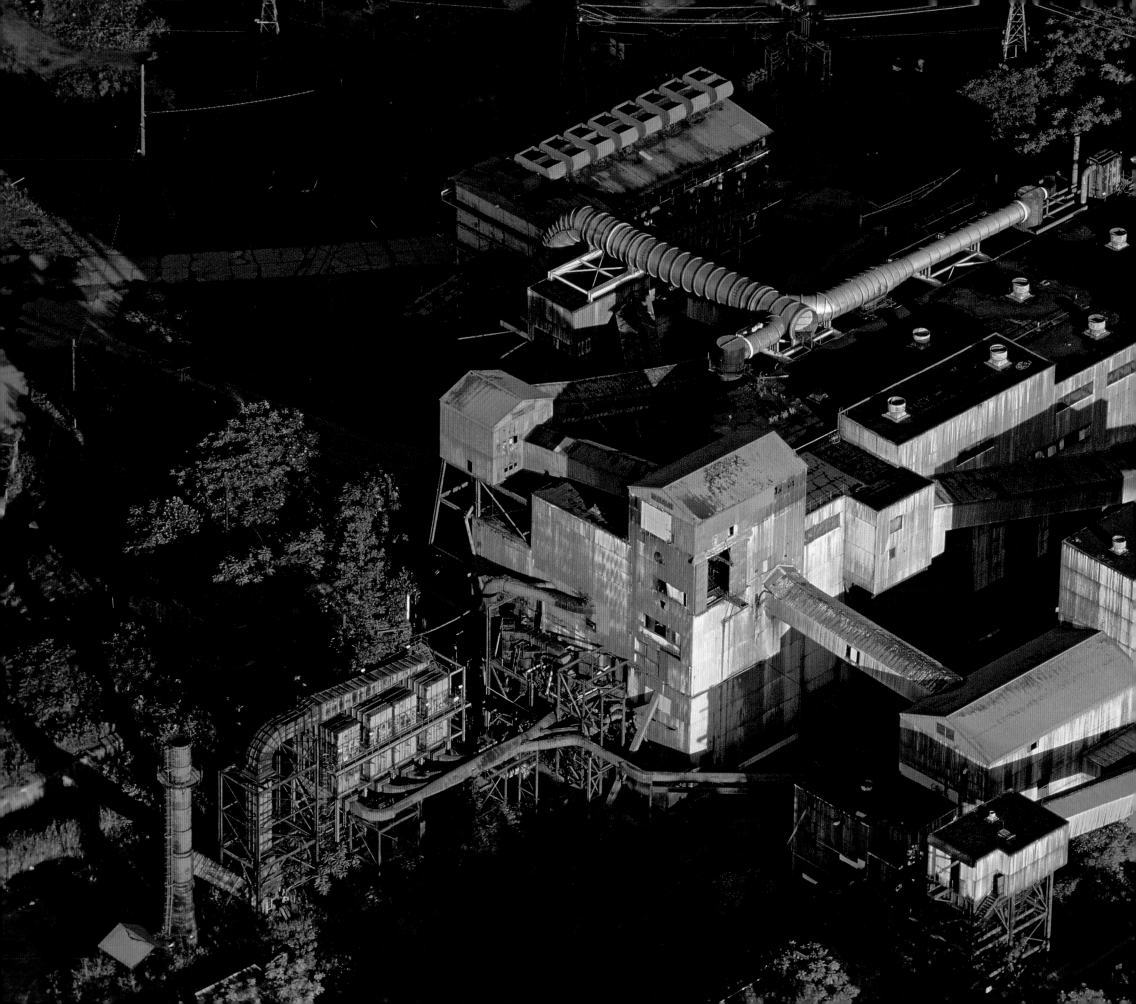

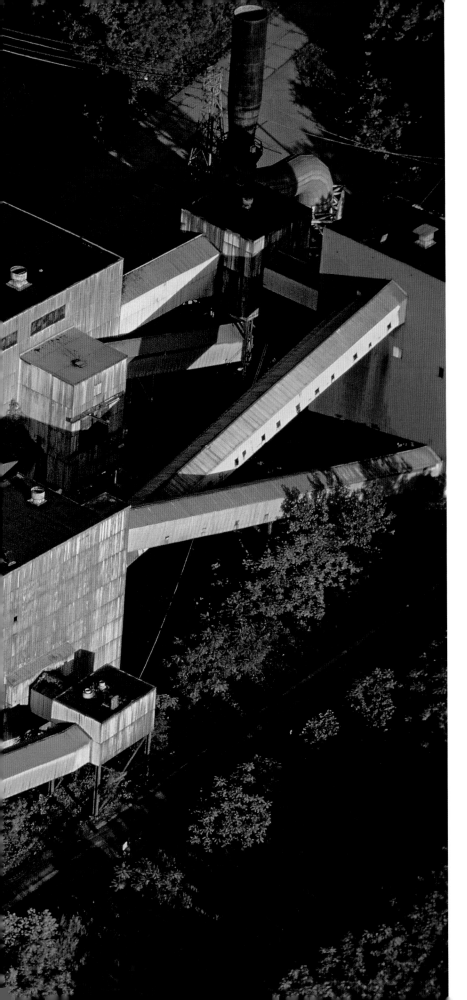

Left and Above: 41°07'16.54"N, 80°41'13.40"W Youngstown, Ohio. Big Steel and Youngstown are synonymous, so it was not hard to see the connection between the road sign, above, and the rusty structure in the background. The aerial shot of the abandoned steel mill, at left, pays respect, in the (ironically) setting sun, to a dying industry whose prominence in our economy and corporate history has temporarily been overshadowed by foreign competition.

Overleaf: 42°18'43.62"N, 77°51'04.39"W West of Karrdale, New York. One of the few stops I made on the coldest, wettest day of my crisscross. Despite the inclement weather, I got a taste of the marvelous vistas along New York's thruways. This particular road, the Southern Tier Expressway, is the old New York State Route 17 that is being upgraded to Interstate 86. It is the longest highway in New York State, stretching almost 400 miles.

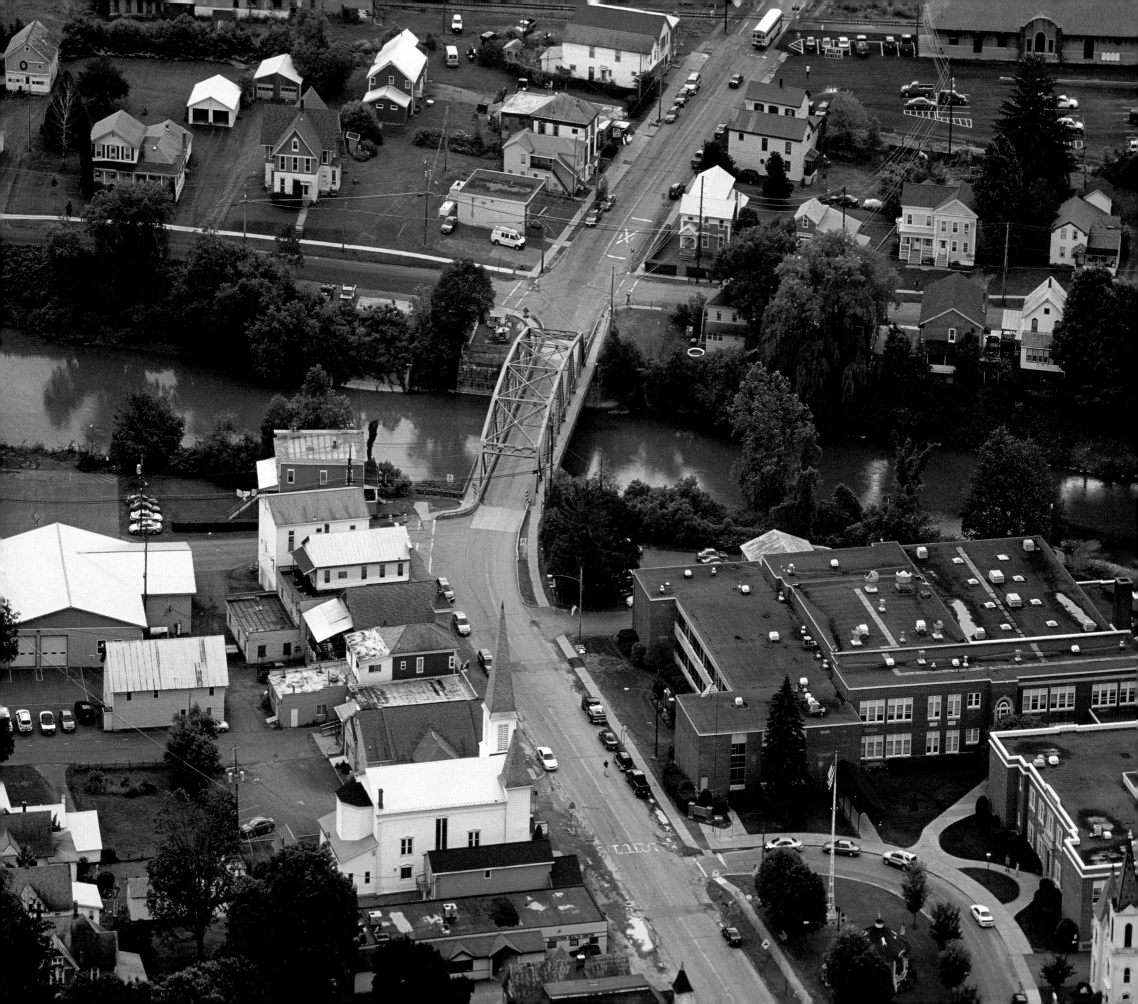

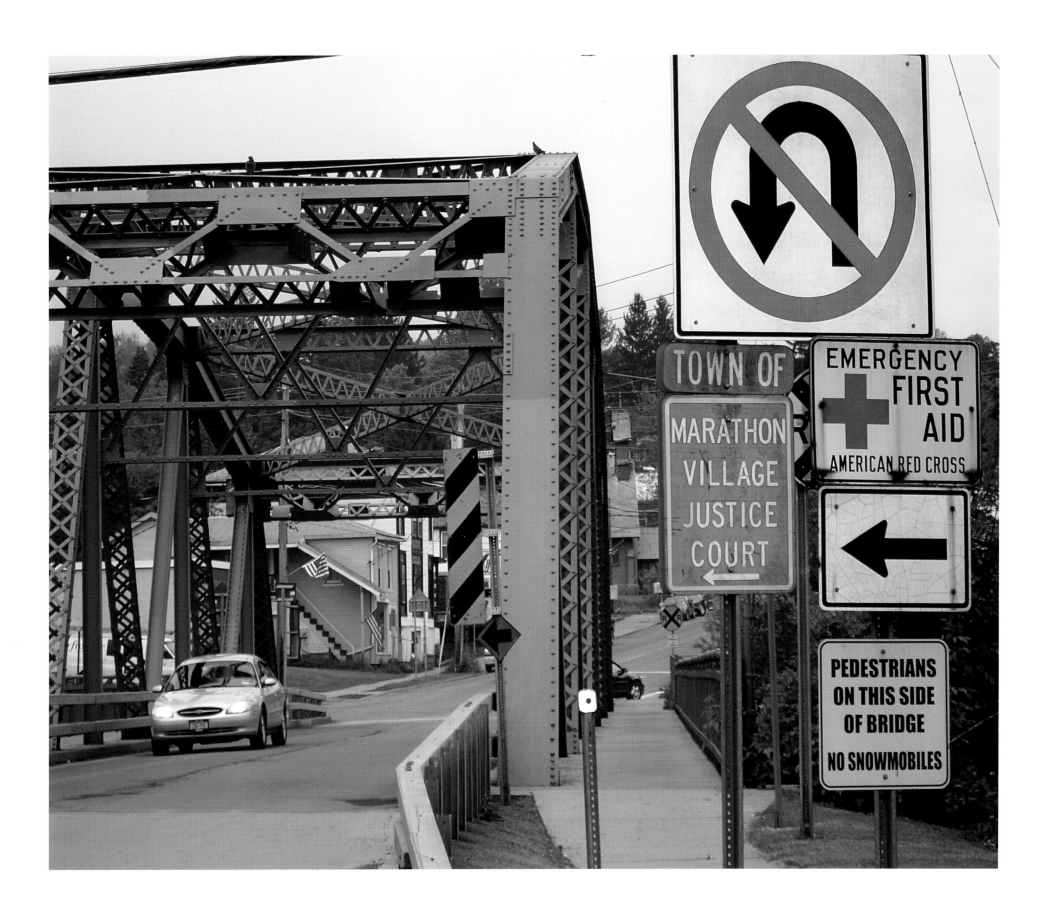

241

Preceding Page: 42°26'25.44"N, 76°02'06.16"W Marathon, Cortland County, New York. My crisscrossing of America was a quest of discovery and here I discovered my mother's birthplace in this town that I'd heard about as a young boy. Marathon sits along the banks of the Tioughnioga River in a lush, pastoral setting. An entry in the *Gazetteer* of Cortland County for the year 1869 mentions that an iron bridge was being erected in Marathon across the river for $14,000. As we see in the aerial photograph, the bridge connects the two halves of the town.

Above and Right: 42°07'34.73"N, 80°05'18.97"W; 43°05'38.50"N, 75°12'50.67"W The aerial pictures of these churches in Erie, Pennsylvania (above), and Utica, New York (at right), underscore the importance of religious institutions in our communities. In the Utica photo, the rows of homes appear attached to the church, as ducklings remain close to their mother.

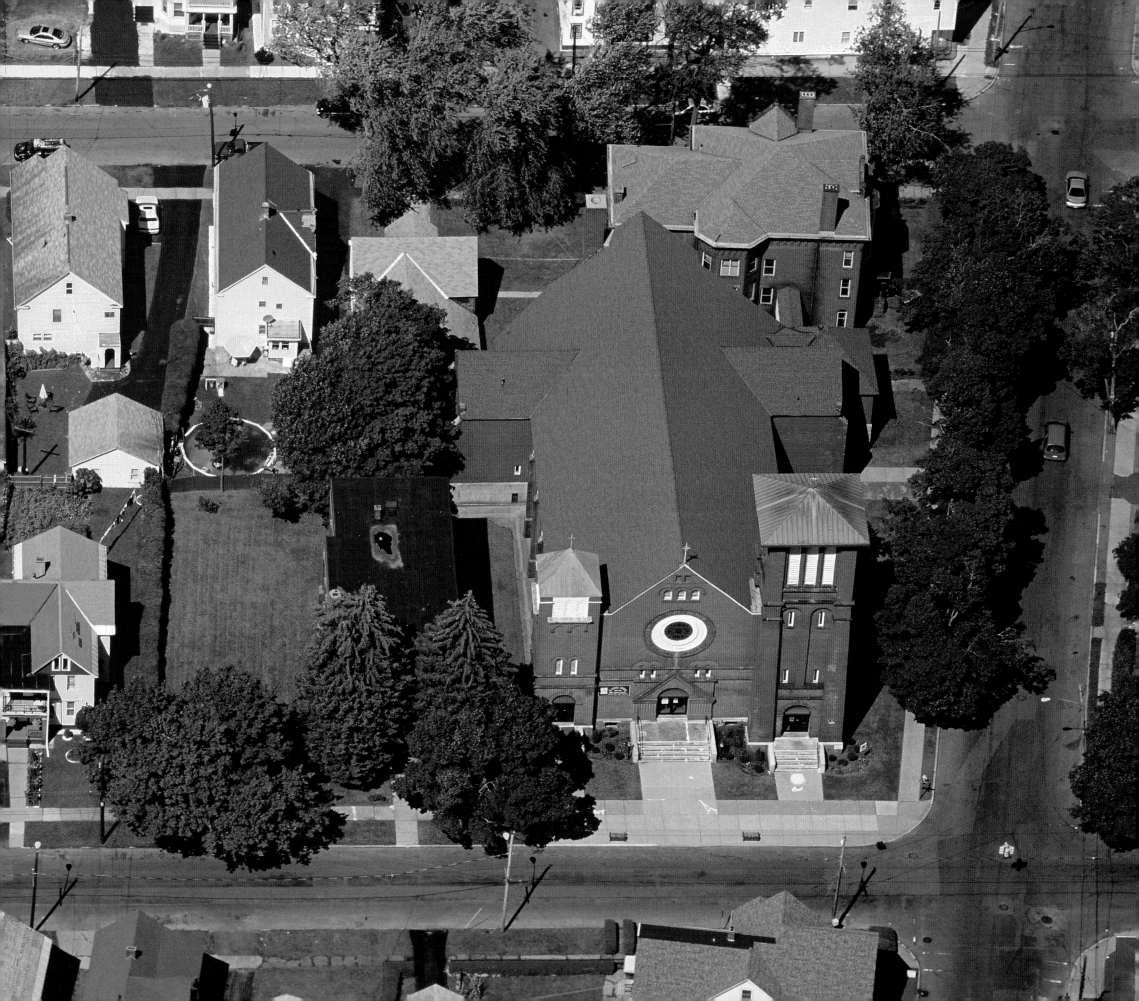

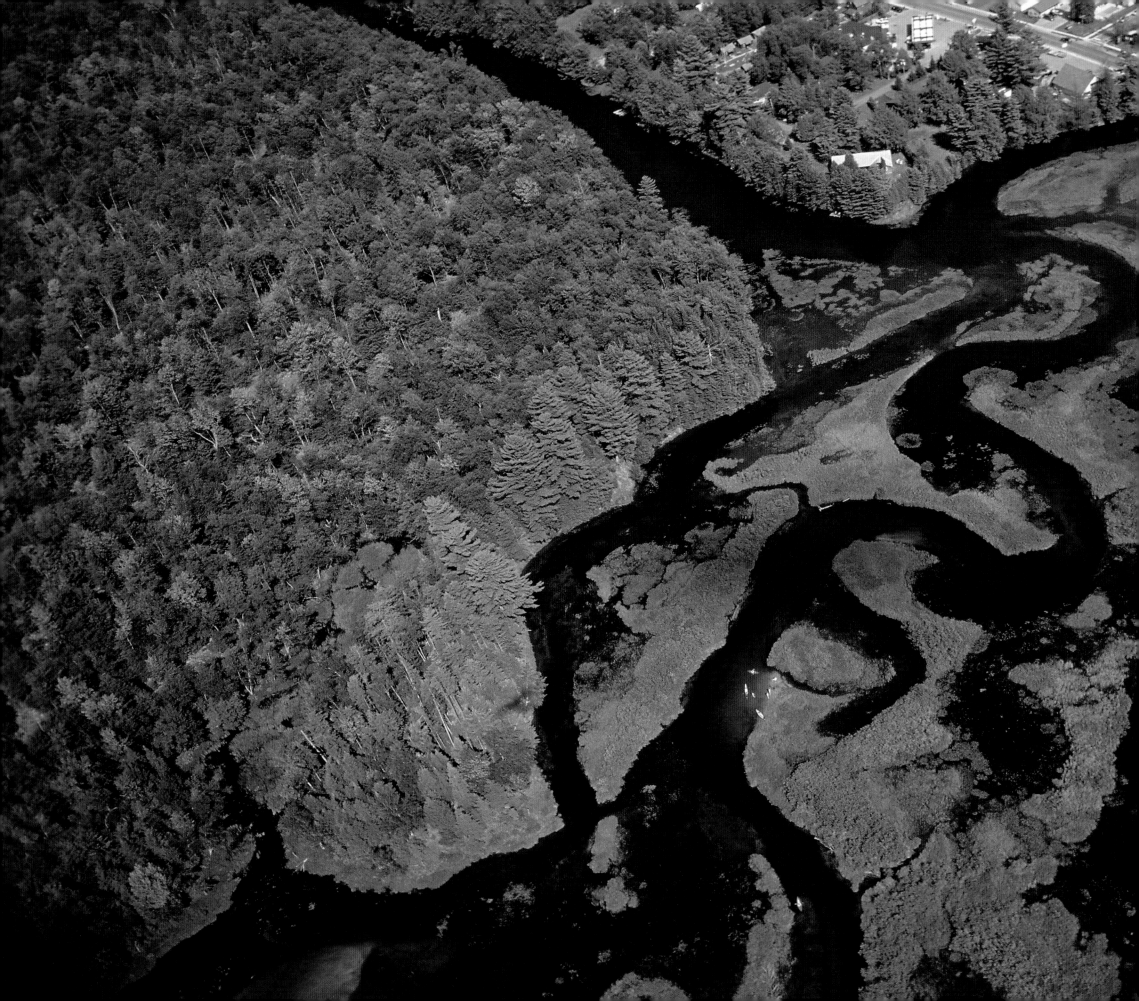

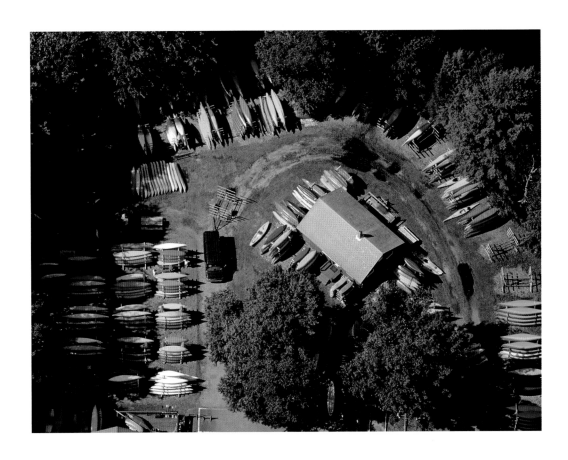

Left and Above: 43°42'21.55"N, 74°59'23.06"W; 43°42'11.95"N, 74°59'10.28"W Old Forge, New York. This Adirondack hamlet sits in the middle of the mountains. At 1,750 feet above sea level, Old Forge attracts many outdoor enthusiasts who seek to escape the heat of the coast or lower elevations. Canoeing and kayaking are popular sports in this region, as you can see in the meandering springs at left. The same canoe rental shop at the top right quadrant of the aerial picture, at left, can be seen in the photograph above, teeming with a panoply of colors for a daily paddle.

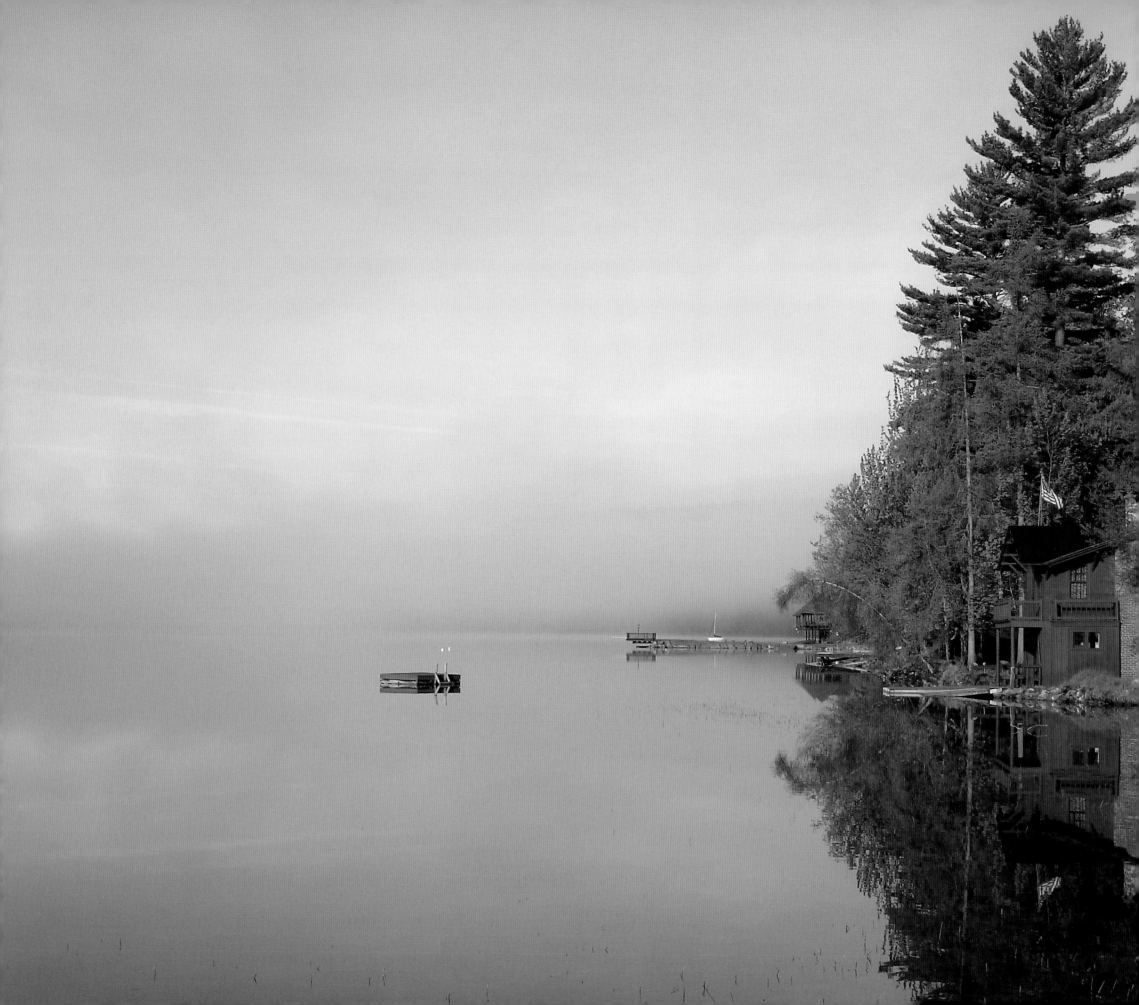

43°41'57.68"N, 74°55'17.21"W Little Moose Lake, Old Forge, New York. This early-morning scene reveals the serenity I felt in the Adirondack Park, the largest publicly protected area in the country. It occupies 6.1 million acres and contains the Adirondack Mountains.

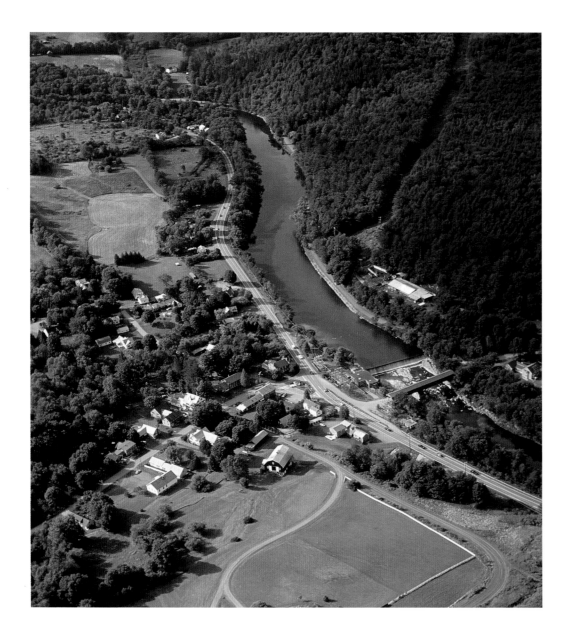

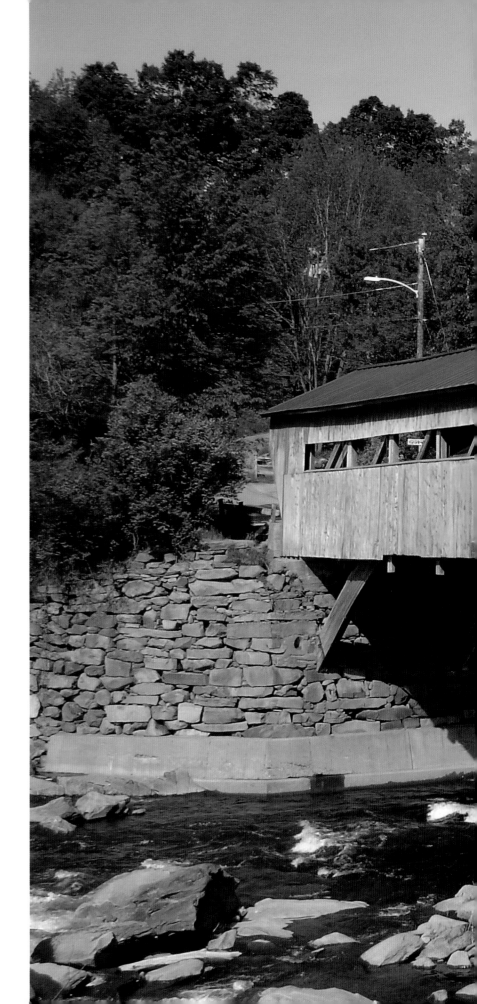

Above and Right: 43°37'50.92"N, 72°28'05.95"W Taftsville, Vermont. This is a classic example of an old-fashioned covered bridge. In the aerial photograph above, you see the same bridge, one of Vermont's oldest and longest, spanning the Ottauquechee River that flows through this scenic, postage stamp of a town.

Overleaf: 43°58'37.32"N, 71°47'04.51"W Northeast of Warren, New Hampshire. The famous White Mountains are located in New Hampshire's largest protected forest, covering more than 1,000 square miles. The gentle, weaving mountains are intoxicating.

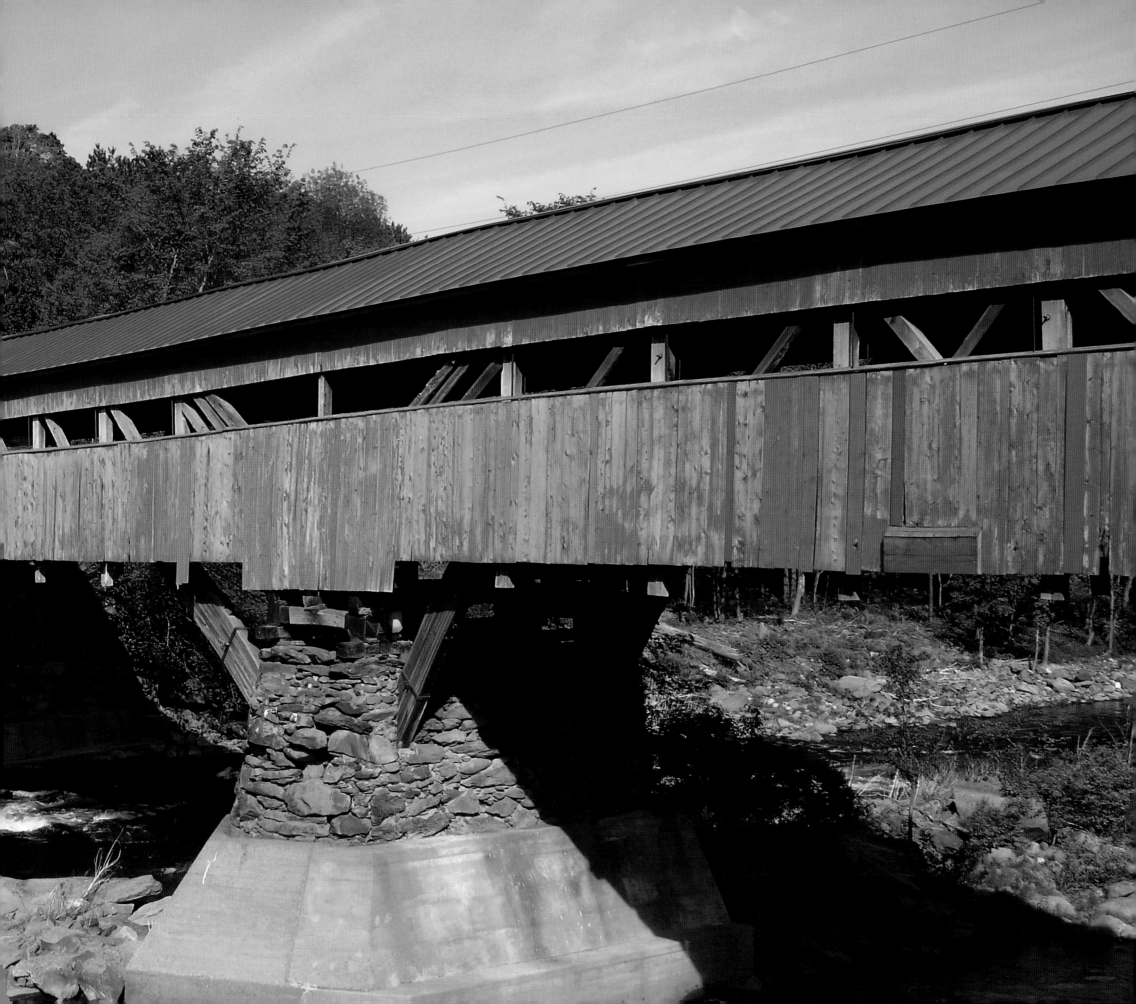

Above and Right: 44°01'42.63"N, 70°41'38.30"W Southeast of Bridgton, Maine. This old-fashioned drive-in theater is located off Highway 117/302. Talk about watching a movie on the *big* screen. I could almost smell the popcorn and hear the latecomers driving across the gravel and grass, pulling up to their window speakers. Notice in the photograph at right that there are two separate screens, each with its own parking area—a sign of expansion rather than extinction.

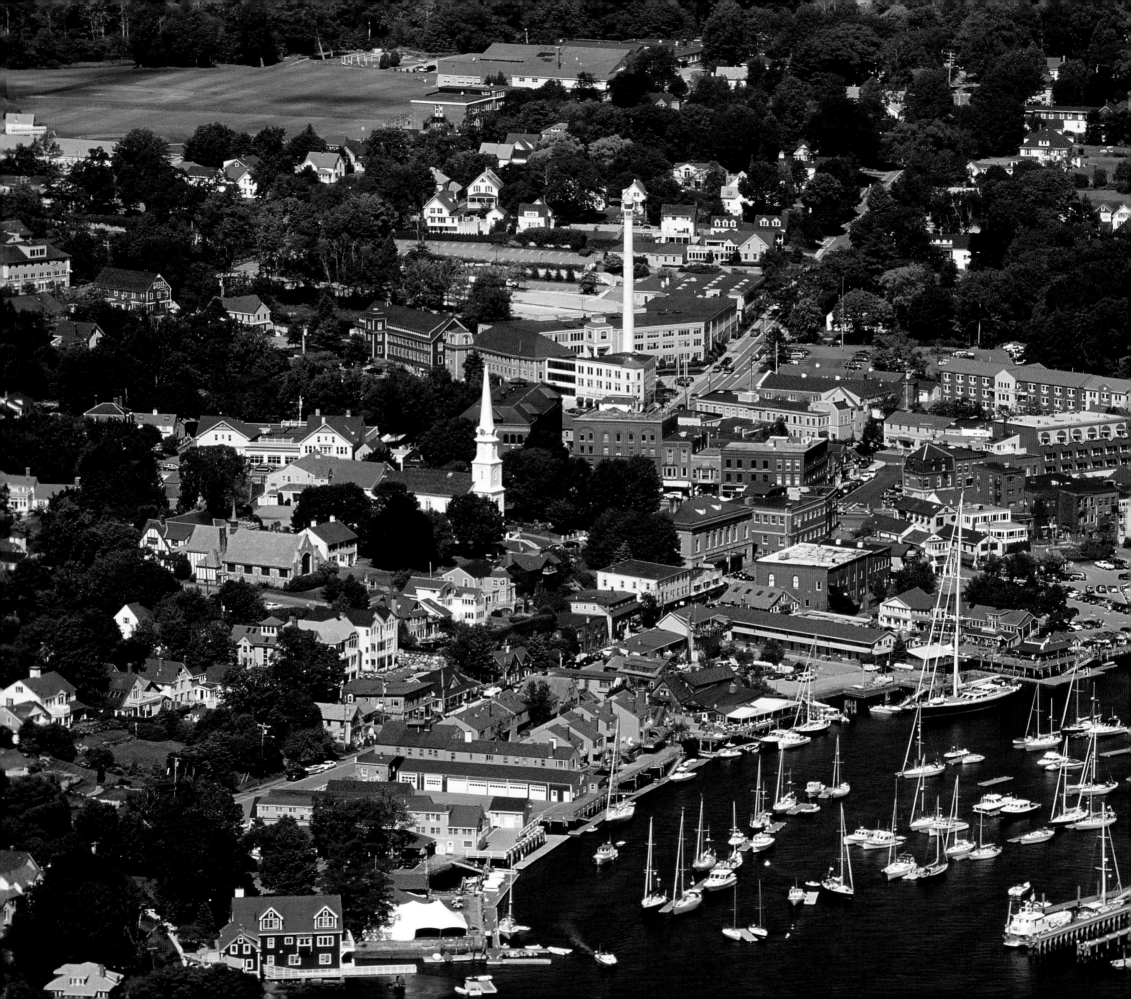

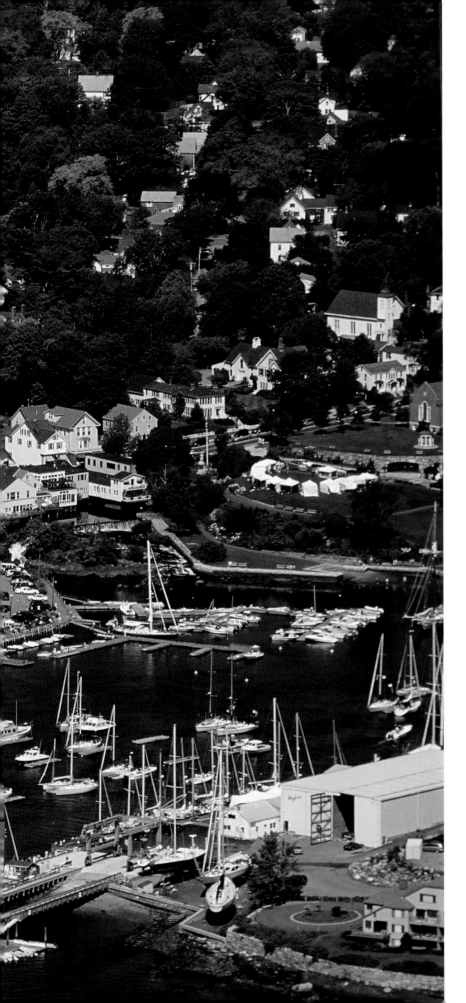

Left: 44°12'26.34"N, 69°03'32.69"W Camden, Maine. This is one of the most picturesque towns in New England. I could have spent a week enjoying the waterfront, with its many quaint shops and restaurants. Best lobsters in the world!

Overleaf: 44°33'40.88"N, 68°48'19.16"W Penobscot Narrows Bridge, south of Bucksport, Maine. This is a fine example of the new replacing the old. The Waldo-Hancock Bridge on the left in the ground shot had to be replaced because of extensive corrosion. The new bridge's support towers are constructed of granite blocks from a quarry in nearby Mount Waldo, the same origin of the blocks used in the Washington Monument. The new bridge, whose final span is being constructed and joined (as seen in the aerial photograph), boasts the tallest bridge observatory in the world at 437 feet above the Penobscot River.

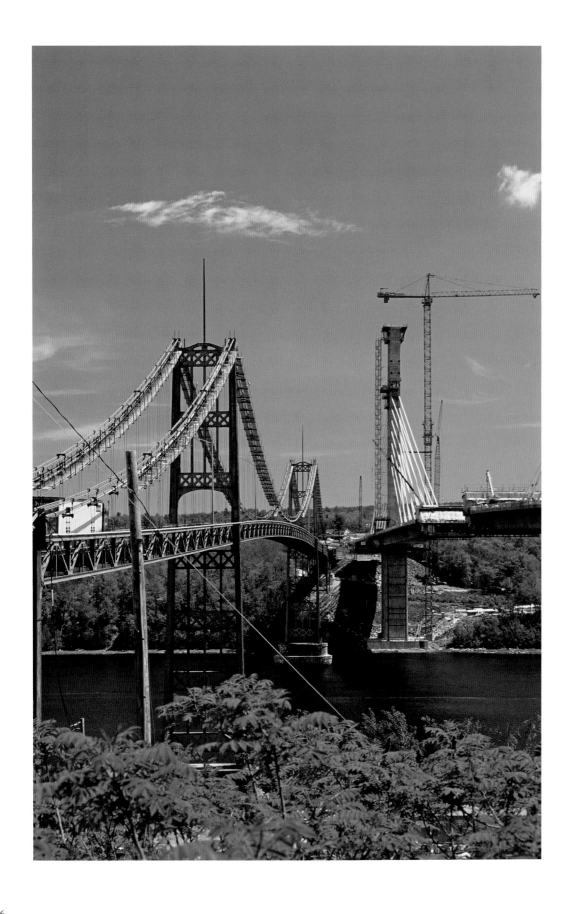

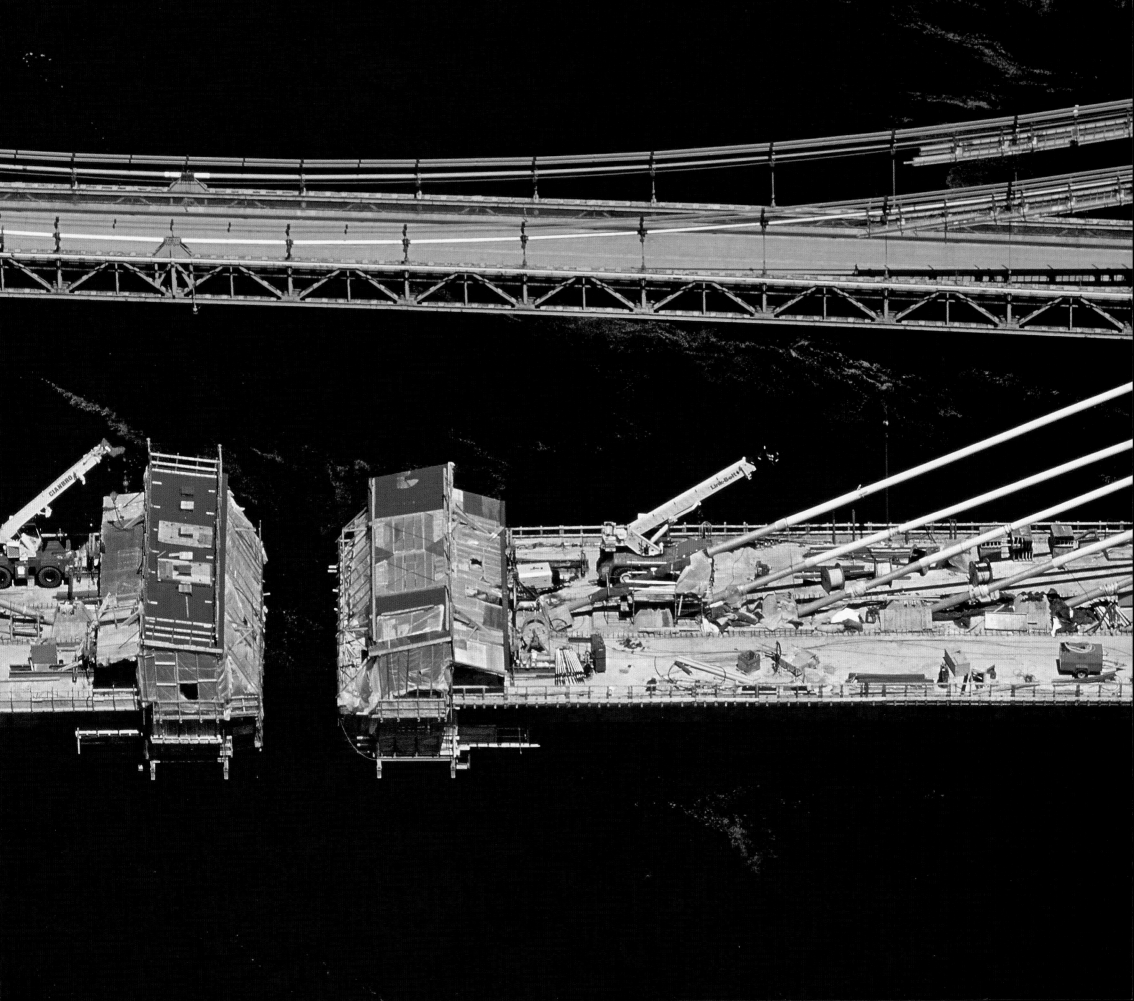

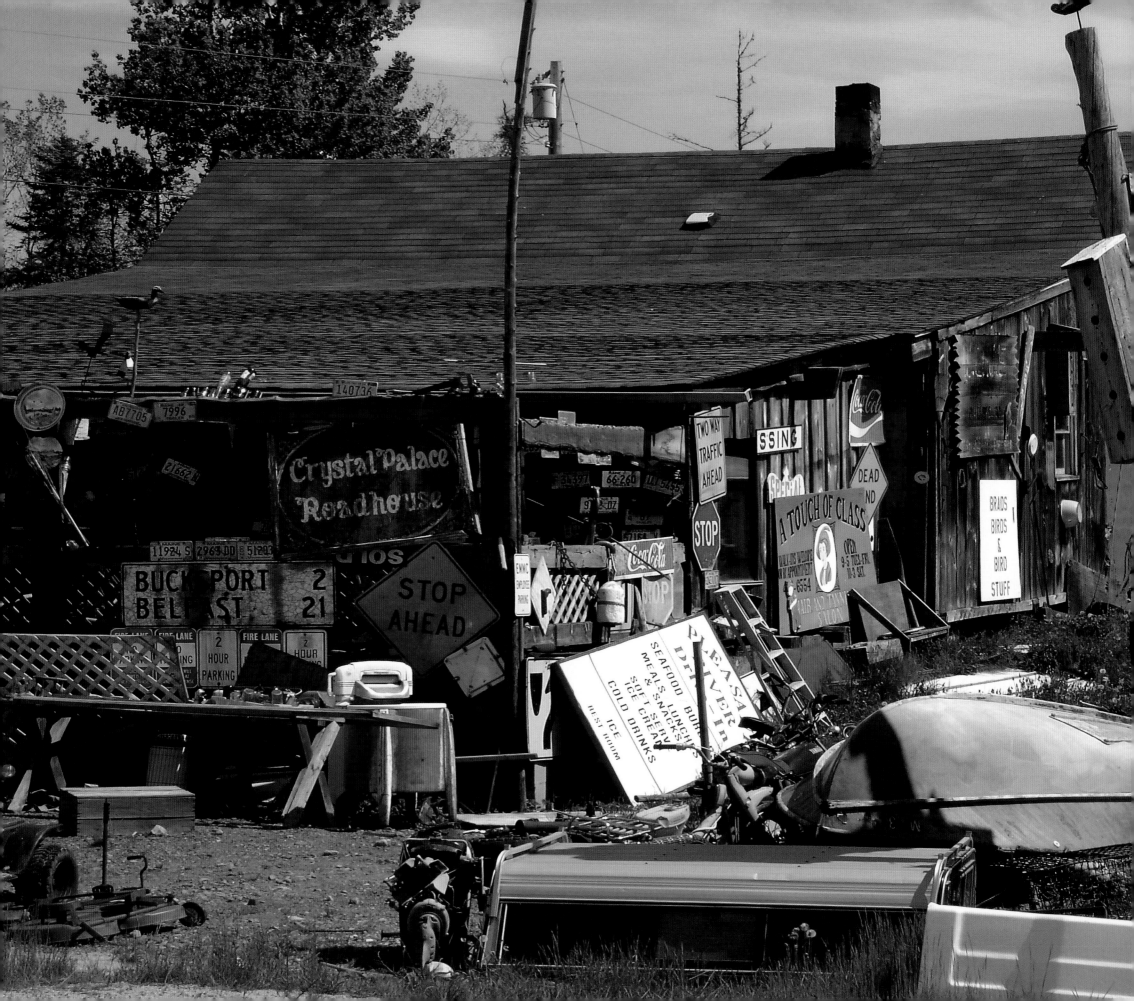

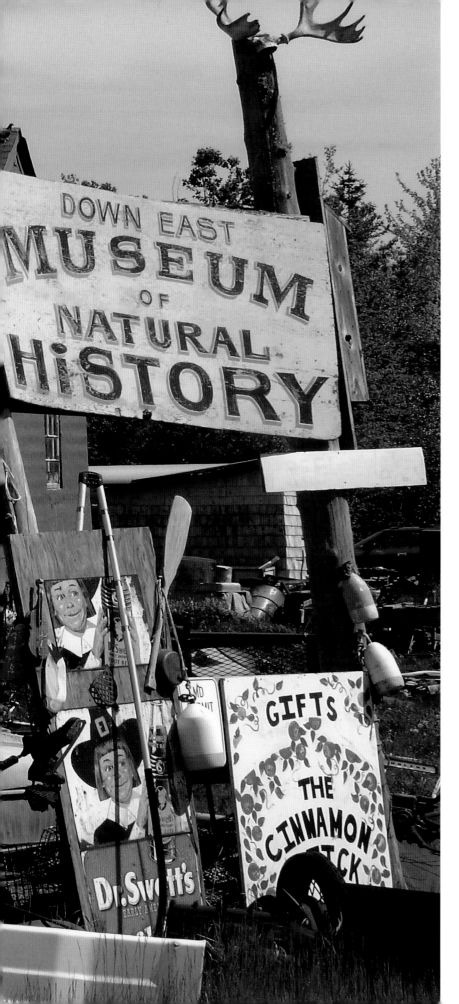

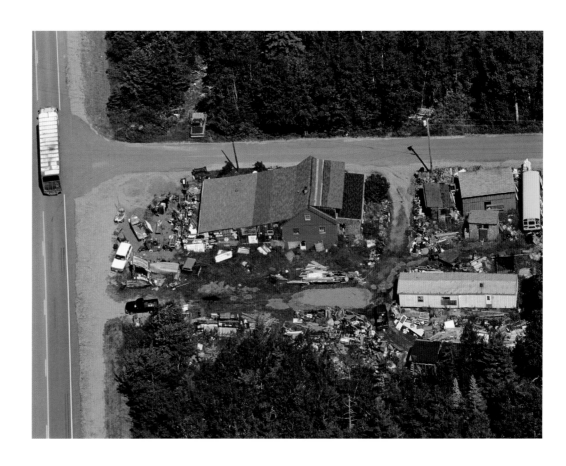

Left and Above: 44°36'42.76"N, 67°52'25.28"W West of Harrington, Maine on Highway 1. Even the world-famous Museum of Natural History in New York City would be hard-pressed to compete with this Down East counterpart and its vast collection of highway artifacts. Notice the myriad roof treatments on the main structure as seen from the air in the photograph above.

Overleaf: 44°56'46.49"N, 67°11'44.65"W West of Pembroke, Maine. Things looked pretty quiet at this roadside motel on a post-holiday weekend day. Nevertheless, the shoulder-wide motel rooms look appealing and comfortable, given the few choices in this most remote eastern part of Maine.

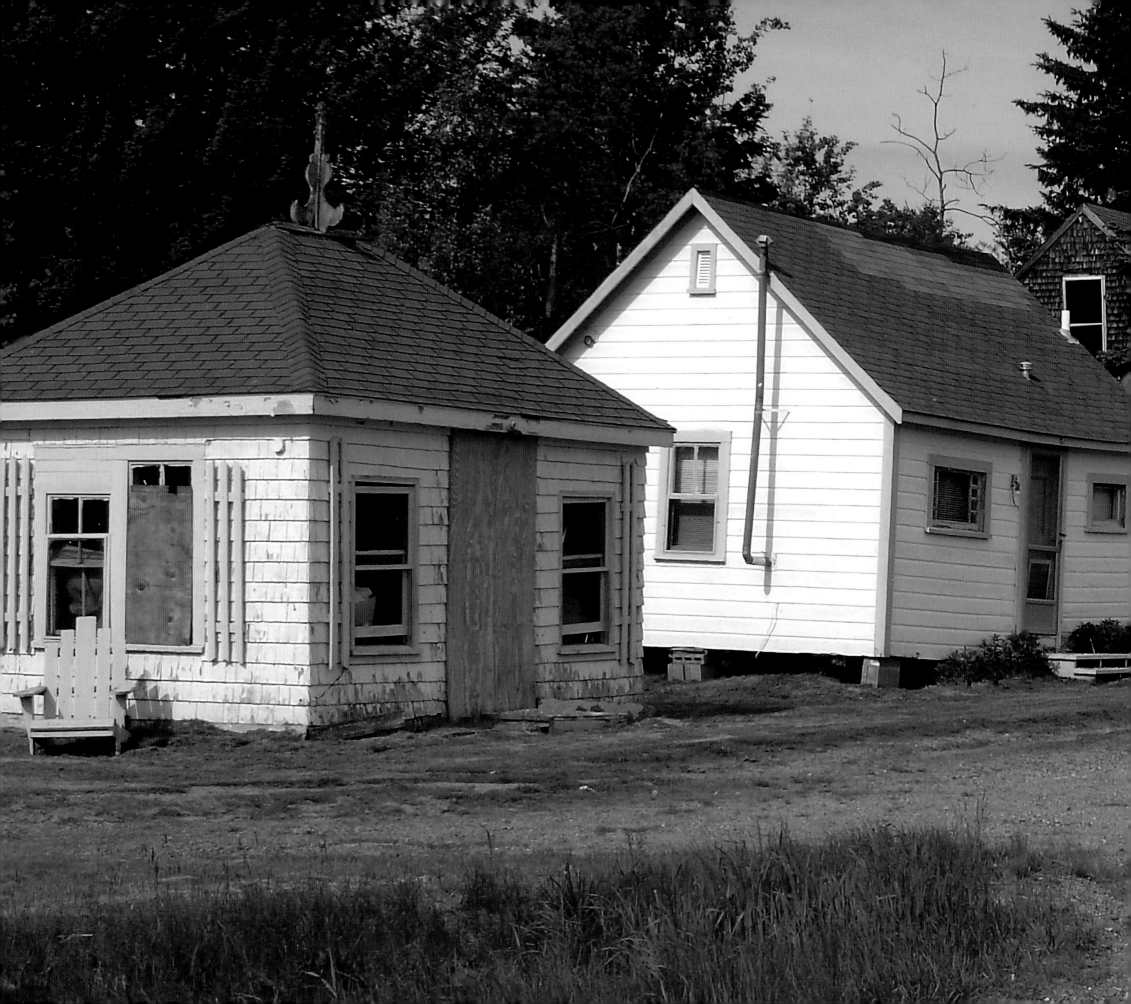

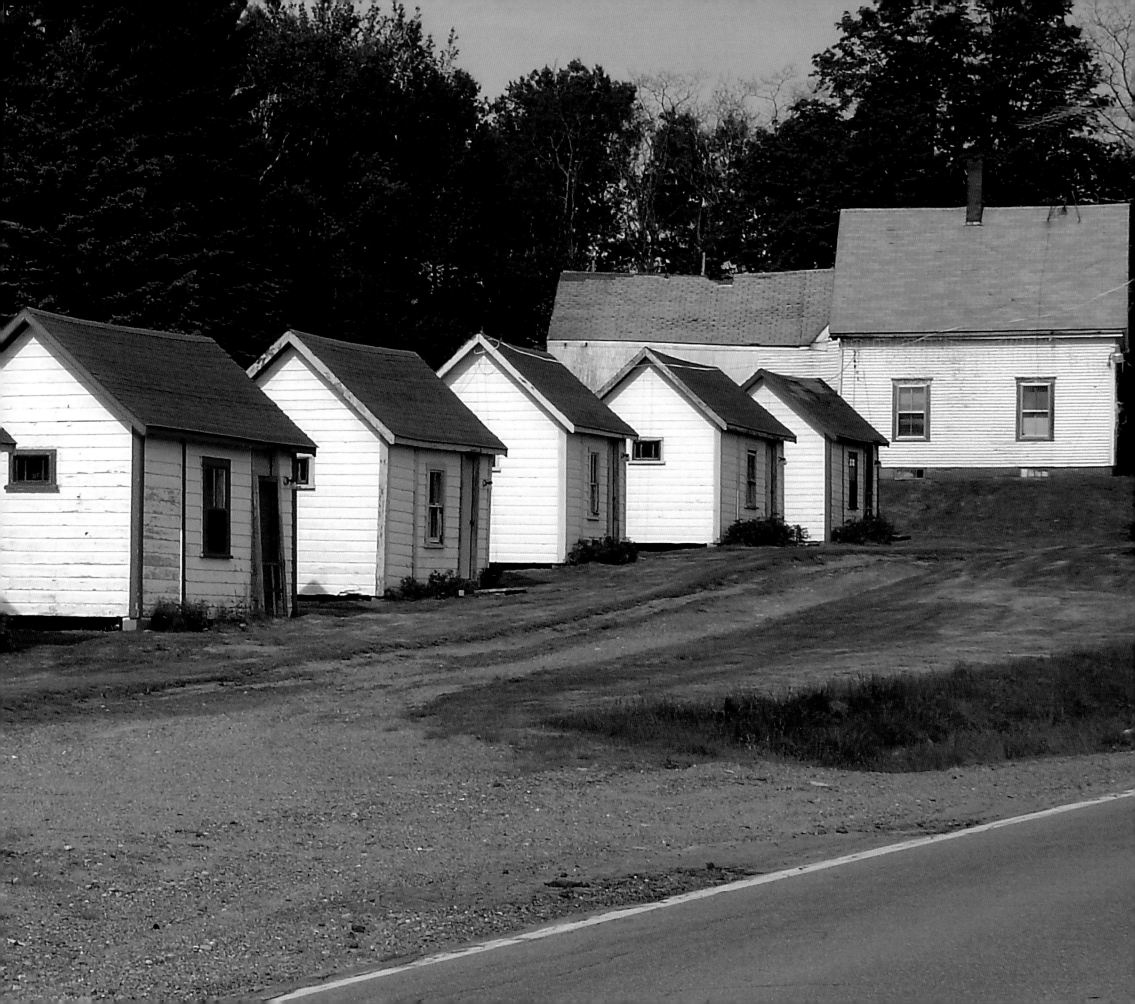

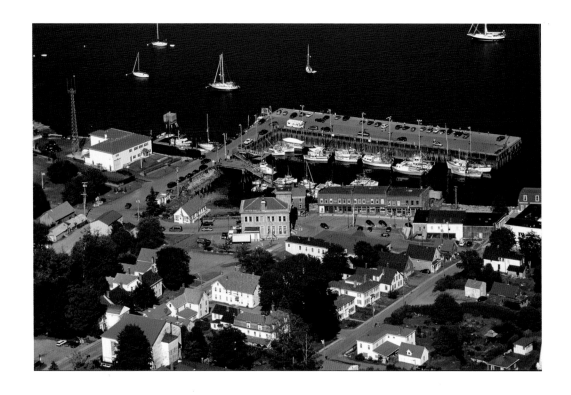

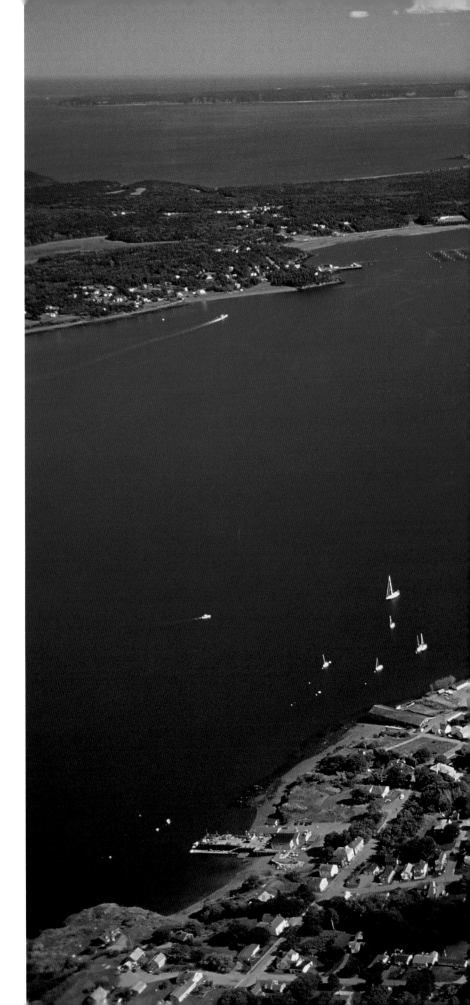

Above and Right: 44°54'19.49"N, 66°59'09.47"W; 44°54'30.83"N, 66°59'05.96"W Eastport, Maine, the end of my crisscross. As seen in the aerial picture, one could place an X in the center of the wharf (between the string of lobster boats and north side of the wharf) where I ended my two-year, two-leg journey. From the ground, I couldn't see the true beauty of this easternmost town in America. But I knew I could go no farther. I had completed my quest with great satisfaction and thankfully without injury or event—and knew that Jim Wark would catch anything I'd missed.

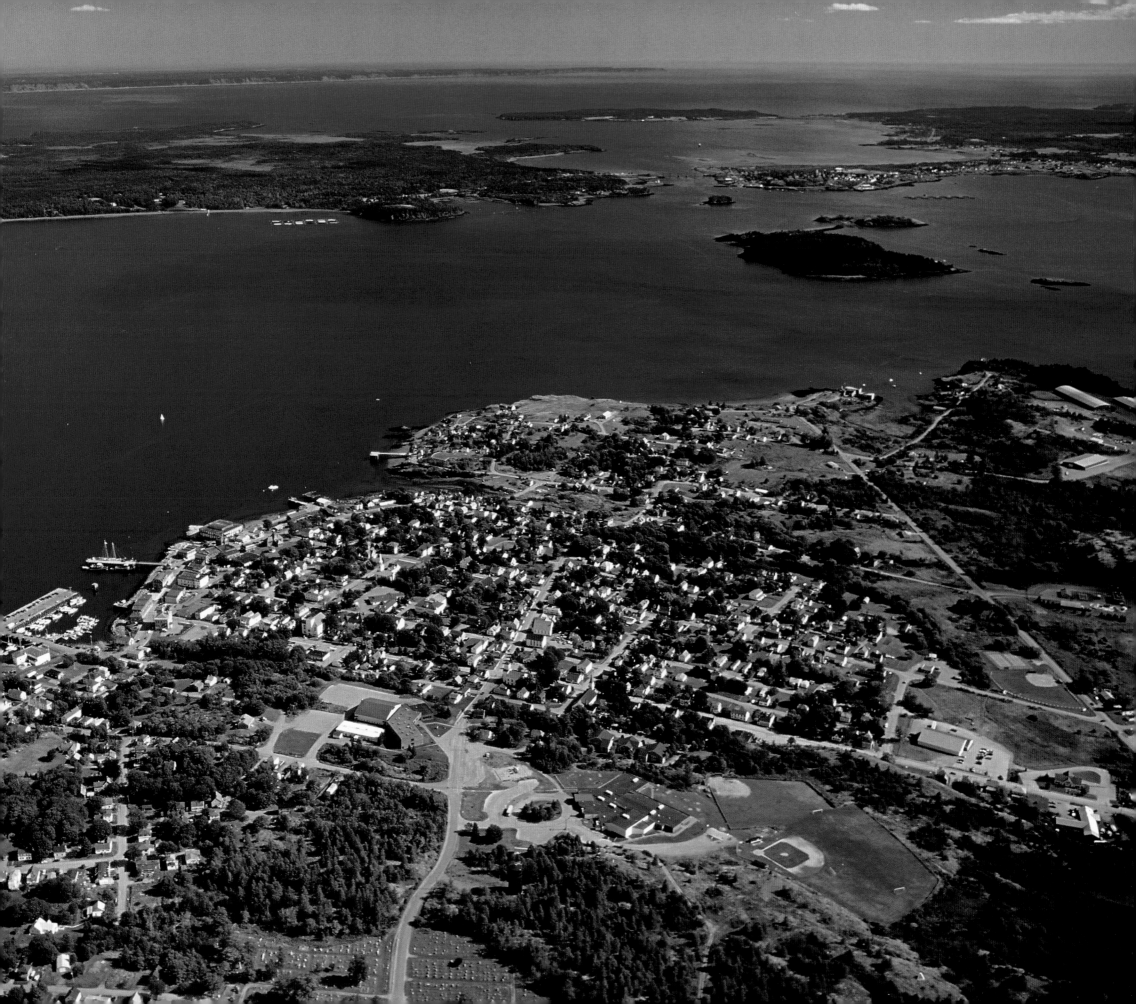

THEN AND NOW...

While my crisscrossing of America ended at dusk on May 30, 2006, the journey continues. Memories of the trip fill my mind, and to this day I continue to get questions from people who wonder if I feel differently now than I did before taking the trip. I want to share with you the most frequently asked questions I've received from family and friends as well as those I've received from total strangers. Their questions have nudged me to reach deeply inside to articulate the feelings and beliefs that I now have about this trip—and have also helped me bring closure to what seemed at the time an insurmountable goal.

As I mentioned in the Foreword of this book, I had intended to surprise my twin sister, Nini, with proofs of images from my trip that I hoped someday would be published. She died unexpectedly but her spirit lives on in our lives and in this book. Many of the questions below came from her as we spoke on the phone during my cross-country trek. Like me, she was deeply curious about the country she had never seen enough of since we had both grown up in Latin America. Her questions were always pointed and animated—and often I hadn't yet discovered the answers to them, so my responses may not have seemed well formed or thoughtful. They were merely gut reactions. Nonetheless, Nini took great pleasure in vicariously sharing my journey from her apartment in New York City.

Now that I have had some time since my trip, I have clearer answers to the questions that Nini and others have asked me. These answers have brought closure for both Nini's questions and my own, as well as for those who have wanted to know more about why I embarked on this trip and what I learned from the experience. I am eager to share them with you and hope they will shed light on issues that may have been puzzling you. No doubt you will have your own questions, which I would be thrilled to hear. Nini certainly had many more than those I have listed. Please visit me on the *Crisscrossing America* website www.crisscrossingamerica.org so that we can connect directly.

WHAT WERE YOUR TRIP'S HIGHLIGHTS?

While the log entries for the first day of both legs of *Crisscrossing America* reveal a sense of anxiety or caution on my part—a yearning, really, to start the journey—I hope they also reflect my exhilaration as well as the physical exhaustion of those first few days. These may seem like contrary feelings to have, but for someone such as myself who had never seen this country in any kind of fully mapped-out way, I wanted to cut the bonds of predictability and routine. I had become more than a little familiar with these two states of mind throughout my decades as a corporate executive and, quite frankly, I wanted to let loose and open up to whatever surprises awaited me at each shift of the handlebars and twist of the throttle.

While I took thousands of photographs from the ground, my favorites—which appear in this book and on our website—express the highlights of the America that I was discovering for the first time. On the other hand, Jim Wark's aerial photographs enhance the ground shots and provide a perspective that people traveling by rail and road would never be able to perceive. I had to maintain some discipline about stopping along the road to take pictures, since I couldn't help but linger in so many mystical, awe-inspiring locations, and since I only had two weeks for each leg of the trip. You can tell by the sheer volume of images that the Northwest and Southwest made the strongest impressions on me. Perhaps this was because I had spent more time, during my adult life, in the South and Northeast. What you don't always see in the pictures are the quirky details of each riding experience—biking along a curvy road in New Mexico after a light rainfall; stopping to double-check my itinerary; yelling with joy to an empty landscape about the sense of freedom I felt cruising through our country, and so forth. I had the great fortune to encounter not only breathtaking vistas, but I also had endless, spontaneous experiences with wonderfully generous fellow travelers and local residents.

WHAT WERE YOUR TRIP'S LOW POINTS?

If you set out as I did to discover America—or any other country—for the first time, you have to be prepared for setbacks. As luck would have it, none of the setbacks I experienced is worth mentioning, other than those I jotted down in my logs. Sure, I was disheartened that my bike was not waiting for me when I arrived in Seattle, Washington, in May 2005. When it finally arrived, I was forced to make a hasty departure in order to make up for lost time. However, if not for this delay I might not have enjoyed how fitting it was to begin my northwest-to-southeast trip in *Startup*, Washington. Did I dread the cold, wet day from Meadville, Pennsylvania, to Old Forge, New York, in 2006? You bet. The nasty weather prevented me from photographing some of our country's most scenic highways across southern New York State, not to mention the spectacular Adirondacks. On the other hand, the experience taught me about the rigors of biking in inclement weather—which many bikers don't think about until it's too late—and, thankfully, I would not otherwise have paused to look at the sky as the weather cleared miraculously on my approach to the rural, upstate town of Marathon, New York, my mother's birthplace.

DID THE TRIP HAVE A POSITIVE OR NEGATIVE IMPACT ON YOUR RELATIONSHIP WITH YOUR FAMILY AND FRIENDS?

Before beginning each leg of my trip, I informed my family and close friends that I wouldn't be responding to phone calls and e-mails as promptly as usual, even though I knew this lack of regular contact would be difficult. Truth is, I had no idea what lay ahead of me, and for all I knew, I could have found myself in vast tracts of land where phones or wireless Internet services were unavailable. Moreover, my goal was to focus on my journey. If I was going to do this, I was going to do it right. I knew I could find ways of calling my wife and immediate family from hotel rooms and road stops along the way, so my message to loved ones was more of a heads-up in case anyone wondered if I had strayed from the planet.

On those occasions when I did check in with my family and friends, I always received words of encouragement and support. Most of them happily lived through my experience vicariously. Some were envious of my ability to "check out" for two weeks to see such a wide expanse of the country, especially since few of them had seen what I was about to encounter. None of my family, friends included, could be considered biking aficionados, so the Harley experience was not one they understood. In fact, they were puzzled by my foray into the world of motorcycle cruising and probably wondered if I had lost my mind. Little did they know it would mushroom into a full-blown quest to crisscross the entire country. It would be a stretch to say that my unpredictable behavior endeared me to them. In fact, maybe the opposite was true. But I remain grateful that they gave me their emotional support and the go-ahead to pursue my dream. Like it or not, sometimes our family's approval is more important to us than we think it is.

DID YOUR TRIP CHANGE THE WAY YOU VIEW YOUR LIFE?

The two legs of my trip taught me that I had an insatiable thirst for learning more from hands-on experience than from books or business meetings or erudition passed on from other people. The act of *doing* and *feeling* for myself, divorced from any reactions that others might have, showed me that I was capable of taking risks—sometimes large ones, by my standards—and that I could emerge from them more enlightened. I have always felt empathy and an emotional connection with other people, but these sensations deepened broadly as I came to know more about others' often arduous lives. I have been asked when I thought I had come into my own as a man, and I've responded, "Soon after the start of this journey, or clearly by the end of its first leg." These trips were like jolts of electricity that triggered millions of synapses in my brain and awakened my native instincts. They reinvigorated my passion for life, which I continue to feel to this day.

IN WHAT WAYS DID YOUR TRIP CAUSE YOU TO REFLECT ON THE YEARS LEADING UP TO IT?

People can look back on earlier times in their life and say, "I wish I'd done things differently." Prior to my trip, I'd had the good fortune to carve out time for personal interests apart from my business life. I have a very supportive wife who has selflessly accepted me despite my stubborn, single-minded, Dutch-inherited personality that drives me to pursue goals, come what may. As I've found out, accomplishing these goals is easier said than done when seated at my desk in a plush office environment. The true test lay ahead for me: sitting on a Harley and navigating mountain passes, rainstorms, endless stretches of desert highway in 105-degree weather, and more. My one regret, after having seen my earlier life from the perspective of my post-trip eyes, is that I wish I had traveled more with my wife and son to faraway places that are now more difficult to enjoy than they might have been during pre-terrorism times. Other than this one lament, I ended my two-pronged journey happily—despite present moments of nostalgia for the open road—and I now have a greater resolve to let my newly found energy express itself in ways as yet unknown to me, especially when this includes my family.

WHICH CONVENIENCES OF YOUR HOME LIFE DID YOU MISS THE MOST WHILE YOU WERE ON THE ROAD?

Whenever people ask me this question, I always answer the same thing, "My bed!" As for my itinerary on the road, I purposely did not book hotel rooms in advance, since I never knew how far I'd be able to travel each day; therefore, I never knew how good the bed would be each night. Each evening, upon reaching my final destination, I would be as selective as possible in searching for comfortable accommodations. Getting a good night's sleep was crucial and a good bed located in a quiet room meant more to me than a hotel's fancy reputation.

I also missed sharing good meals with my family and maintaining a balanced diet. While I chose hotels located within walking distance to restaurants that served good, home-cooked food, I confess to having treated myself on more than one occasion to a root beer float or a Dairy Queen chocolate cone. (Shhhhh!)

DID MODERN TECHNOLOGY MAKE YOUR TRIP EASIER THAN IT MIGHT HAVE BEEN 20 YEARS AGO?

I planned my daily routine with the aid of a Michelin road atlas and depended on my handheld GPS to mark the waypoints for the photographs I took on the road, but not for directions. So it's fair to say that I did not rely on technology to plan or execute my two cross-country trips. Twenty years ago, a simple compass and a batch of state and county road maps would have been necessary. Back then, I could have taken all sorts of readings from the bike's odometer to pinpoint photo locations on a map. But the GPS was a godsend. And I could have just as easily made the trip without the use of a cell phone, which I rarely used. As a matter of fact, I actually preferred the idea of moving about the country without the intrusion of phones ringing, e-mail messages flooding my BlackBerry, and voicemail messages awaiting return phone calls. It was fine for me to use a good old-fashioned land line in order to make occasional telephone calls to my family or to arrange a rendezvous with friends on the road, as I did with the Snows in Oklahoma during my 2005 trip.

To be fair, the bike did offer some technological improvements that older Harleys would have lacked (e.g., electronic fuel injection, cruise control, etc.). I was fortunate that nothing broke down on my bike, save for a pesky, leaky piston valve. Perhaps a carburetor would have required a bit more patience and some choking on those cooler, early morning starts, or during some of the stifling hot portions of my trek across the desert or in high altitudes. There's no question that the cruise control provided some much-appreciated relief to my tired hands and arms during stretches where I was not taking photographs. One of my reasons for purchasing the Harley for this 8,000-plus-mile journey was the comfort of knowing that the bike could be serviced by almost any motorcycle mechanic or by any Harley-trained specialist from the vast network of dealerships that exists throughout the country.

Could I have successfully recorded the waypoints and logs each evening without the use of a laptop? Absolutely. I would simply have packed a notebook and kept written notes. The laughable thing, however, is that I might not have been able to read my abominable handwriting once I'd returned home to Florida, so thanks to technology I was spared the agony of deciphering my own penmanship. As for coordinating the aerial shots with Jim Wark, we would likely have set out together on the trip, had we done this 20 years earlier, and compared notes along the way. Weather permitting, Jim could have followed behind me at close range, and if he saw me come to a stop, he would have assumed that I was taking a photograph and would have immediately taken an aerial equivalent of the same shot.

Since most of America is rural, traversing the country would likely not have been much different in earlier decades, except for the improved road conditions—even though one could argue that our tax dollars have not found their way to many so-called road "improvements." The vast network of highways did, however, give me many alternatives that earlier travelers may not have had. But by the same token, today's traveler will likely find fewer motels that offer quarter-fed "magic-finger" massagers built into the bedsprings, or the quarter-fed black-and-white televisions, or the ubiquitous Coca-Cola and Orange Crush dispensers next to the front desk.

Most of the photographs in *Crisscrossing America* were taken with old-technology cameras and film. Jim Wark's airplane is a simple, fabric-covered, piston-driven airplane that harks back to the 1930s. Maybe one could characterize this undertaking as a low-tech endeavor by two fellows who are not the product of the technology generation. You be the judge of that.

DID YOUR TRIP HELP YOU GROW AS A PHOTOGRAPHER?

My passion for photography began as a hobby. I would agree with professionals and amateurs who claim that being "on the scene"—whether it's in a studio, on a formal shoot, or in the wild—and being one with the subject is the most thrilling aspect of the work. When I've needed to learn more about the art and science of using the camera, my curiosity and simple trial-and-error experiences have led me to find solutions and gain new insights into this art.

Perhaps being a pilot helps me use my eyes in ways that other photographers do not. When I fly, my eyes are constantly scanning—left to right, up and down—and I process images quickly in my mind. As I traveled on my bike at more than 60 mph, I had no choice but to engage my mind in the same process but at an even faster rate than if I were in an airplane at altitude. Here's how it worked: I would capture a scene from the corner of my eye, then take a second or two to decide if the subject was worth photographing. If so, I would slow down my bike, check for traffic behind me, then circle back to the object I had spotted. I repeated this cycle hundreds and hundreds of times. Like most photographers, I missed out on some really great images because I didn't deem them important enough to stop for—and in retrospect I realize that this was a mistake. I'll bet many photographers feel this. From this standpoint, I suspect my skills as a photographer became sharper from 2005 to 2006. I made more stops and took more pictures during the second leg of my trip, and perhaps this indicates that my sensitivities have become somewhat more focused.

DO YOU FEEL A SENSE OF PRIDE FOR HAVING CHALLENGED YOURSELF WITH THIS TRIP?

Maybe I'm a fool, but when I say I'm going to do something, I do it. I learned a long time ago that this kind of single-mindedness can work for or against you. It makes you think carefully about any pronouncements you might make, and it reins you in against setting goals that may prove to be unachievable or that may distress your cohorts and loved ones. I did not undertake my crisscrossing journey in any frivolous way. In retrospect, I believe it caused little, if any, harm to my family, despite their constant worries about my safety and well-being. In fact, I felt a sense of accomplishment at the end of each leg and especially at the crisscross point of Mullinville, Kansas, on May 21, 2006, at 3:34:22 p.m. Compared to the challenges that many people face—terminal illnesses, natural disasters, etc.—I keep this small achievement very much in perspective and am grateful that I can share it with other people through this book. It would bring me great pleasure to learn one day that perhaps I have inspired other journeys of discovery, and I hope that those people will share them with me on my website, www.crisscrossingamerica.org, if they have achieved goals that have made them quietly proud.

WHAT DID YOU DISCOVER ABOUT PEOPLE THAT YOU HAD NEVER SEEN BEFORE?

Whenever I stopped to take photographs, I knew that most passersby had no way of guessing the purpose of my trip. Yet many pulled over because of their good nature or because they wanted to make sure I was okay. This sense of caring moved me profoundly as I crossed the country, and to my joy I experienced it everywhere, not merely in one town or state. I know that many of these passersby would perhaps consider my Harley Road King Classic a luxury, but I never felt self-conscious about traveling on it. True, this beautiful machine is elegant, but it is not garish or ostentatious. People stopped not because I was (or was not) wearing leathers, but because they were concerned about the safety of another human being. Harley die-hards would say that these experiences occurred because I rode a high-end Harley. Who knows? It's win-win either way you look at it. I found this reassuring, as I was clearly vulnerable in open country and away from civilization.

In Wyoming, a highway patrolman pulled up behind me as I was taking a picture of a freight train from an overpass. He pointed out that it was illegal to be standing there, but did not ask me to leave. His purpose for stopping was to protect me from oncoming traffic. This is the kind of gesture that always restores my faith in human beings—and once you become sensitized to other people's generosities, you see signs of this everywhere. The chance meeting with the riders from the Iron Souls Motorcycle Club on May 21, 2005, probably left the greatest impression on me. Their kindness toward me revealed the compassion that people can have for strangers. Did they have an ulterior motive for inviting me to dinner? No. They knew nothing about me, except that I had been friendly with them and showed interest in their lives. Was the dinner conversation guarded? Not at all. Was their farewell embrace superficial? No. I felt welcomed into their group and, strangely, befriended into the larger crowd of Harley devotees.

In the same vein, when a couple in Santa Fe invited me to join them at an outdoor bar and restaurant, they surprised me with their thoughtfulness toward a stranger who had a week's growth of beard on his face and whom they did not know. These gestures underscore the uniquely American brand of hospitality. These friendly people did not treat me differently because of my background, race, education, or appearance. They did so, I suspect, because they saw someone alone who perhaps needed companionship and conversation. In each case, I made an effort to repay their kindnesses in my own ways, often by paying for a drink or dinner, but in other ways as well. When someone gives to you, there's an almost genetic desire to give back. That's what I felt toward the countless Good Samaritans who crossed my path regularly during both my 2005 and 2006 trips.

HOW DO YOU FEEL ABOUT HAVING DONE THIS TRIP ALONE, INDEPENDENT OF YOUR FAMILY AND FRIENDS?

When my plan for crisscrossing America first took shape, I shared the idea with friends, especially those who had cruised on motorcycles. I got lots of advice. All expressed concern for my safety, knowing that I lacked riding experience, and some offered to accompany me on my trip just for moral support. I could have accepted their offer to join me, but if any of these friends had come along, it would have changed my quest from one of personal discovery to that of shared enjoyment. I knew in my heart that this needed to be a solitary search, for all the reasons expressed in my logs. I realized early on that I would have to travel light in order to make room for cameras and film. That would eliminate the possibility of traveling with a passenger on the bike. Frankly, I was more concerned about the imposition I would make on my friends, having to stop every few minutes, unannounced, to take a picture and record every shot on the handheld GPS, and having to cope with my daily routine, which would have left little time for deep conversation and welcomed spontaneity. Clearly, to me anyway, the trip had to be made alone.

DID THE IDEA OF SEEING THE COUNTRY IN A "CRISSCROSSING" WAY PROVE ULTIMATELY SUCCESSFUL, OR DO YOU REGRET NOT USING A DIFFERENT KIND OF ITINERARY?

Since my goal was to learn as much as possible about America in a short but intimate way, I'm not sure that there is any other way of doing this than the crisscrossing approach I chose. Traveling along the diagonal from the Northwest to the Southeast, and from the Southwest to the Northeast, encompasses the most geography possible. This was done with precision and design. Had I ridden from west to east along I-40, I

would have touched only nine states. Heading from north to south from the Dakotas to Texas would add six states, yet this pattern of crisscross would have embraced only 15 states, with Oklahoma being crossed twice. My diagonal approach to crisscrossing the country covered 27 states, with only two of them (Oklahoma and Kansas) being crossed twice.

I think that integrating Jim Wark's aerial photography into my groundwork made the itinerary even more appealing. If you try standing on the roof of your car to get a better view of something in the distance, you will probably only be able to see nearby events such as a little league baseball game. This method would not help you much in the Mojave Desert if you wanted to catch the distant mountains or irrigation canals. Likewise, imagine seeing something new and glorious from the window of a commercial airliner. Unless you are looking at something close to the airport environs, you'll likely be cruising at 34,000 feet, from which point it is hard to see much detail. But if you could float down to 1,000 or 1,500 feet above the ground (Jim's preferred altitude for shooting) and have the luxury of scanning the horizon or picking out an especially intriguing subject—bingo! That's the ideal perspective.

I gained so much by having Jim Wark's backup pictures from the air, since they enlightened my perspective of events on the ground. In fact, you may remember that I said in the Foreword of this book that *Crisscrossing America* is as much about what I did not see as it is about what I saw. On the other hand, Jim would not have been able to see what I saw on the ground: shadows, patterns, and the topography's scale and depth. I could see movement (flowing rivers, crowds of people), color details, and structures in 3-D (versus a flatter, two-dimensional view from the air). From the ground, I experienced the sounds and smells of newly harvested fields, spring's call and attendant sounds, and the cleansing smell of a passing shower. Clearly we shared certain characteristics of the journey, but the differences meshed beautifully into a more complete picture of the country. I hope you agree.

WOULD YOU RECOMMEND THIS KIND OF TRIP TO OTHERS?

I planned my crisscrossing of America deliberately as a two-leg, two-week trip, so that others could carve a reasonable time away from work or family obligations to follow all or part of the route across our country— from Washington State to California; from Florida to Kansas; from California to Florida; and so on. If you can put your eyes where my camera took each photograph, then my recommendation would be less about how you got to that vantage point or spot on the ground, and more about having you share what I saw for the first time. I chose the motorcycle as an intimate means to cover this vast territory, which proved to be a much better method for experiencing the trip than if I had been in a car or other vehicle. So, yes, I would encourage motorcyclists to retrace the parts of my route that they would find challenging, rewarding, and fun—and I would say to all motorists that they step out of their car or truck for a view and a deep breath.

If, for example, I looked down at America from outer space on a clear, cloudless night, I'd see easily that our population is concentrated in big cities and the suburbs that surround these cities. The city lights would sparkle like jewels against a black velvet background, much as a galaxy of stars does in the heavens on a cool, crisp night. The smaller cities would be indistinguishable by their size and luster (given their fewer lights), and the rural communities would be pitch-black, as would most bodies of water, including the oceans that define the east and west coasts of our country. If one has the time and resources, I would try to discover the areas in black that I couldn't see from space, since these locations must contain gems that are not immediately visible from the air or from the ground. I would recommend using the same crisscrossing method that I employed in order to see the United States, since one can follow any segment of my trip and make deviations as one pleases (see my itinerary on pages 269–270). The route is defined and the trip can be easily achieved. Some people may prefer to follow the coastline (Pacific or Atlantic) or to travel across the southern or northern borders of the country. For me, the great joys lie in the discovery of people and places that I can't see in their full color on maps or in atlases.

DID YOUR TRIP HELP YOU GROW SPIRITUALLY?

While my faith is personal and something I hold close to the chest, I was ever mindful of God's presence and handiwork on my two-leg odyssey. I hope my photographs do justice to the beauty that abounds in America and serve as another testimonial to this supreme Architect. I know Jim Wark's photographs provide a second testimonial to what must be God's daily view. On both crossings, I could not help but celebrate His creation. God's reach went beyond what I could ever capture on film. As the recipient of a number of Good Samaritan acts in every quadrant of the country, I couldn't help but be reminded of His presence as I witnessed His radiance in others. These acts inspire me to this day to give back and try, in my own way, to help others who may be in need or require a lift. So to answer the question above, I would simply point to this book and its charitable purpose as one example of a journey that was restorative and seminal in my spiritual growth.

Each of us must decide for ourselves how God's presence affects (or does not affect) our lives. My beloved twin sister Nini was alive during both legs of my journey, but she took wings before I was able to publish this book. Yet I feel her presence every day. I had the good fortune (a coincidence?) to make both crossings without incident or physical injury of any kind—and, I might add, I was spared the jarring experience of witnessing road fatalities or accidents, even though I photographed locations where others had unfortunately lost their lives. I would like to believe that I had a guardian angel on the back of my bike for the duration of each trip and that the prayers of my family and friends were indeed heard.

DO YOU FEEL THAT YOU KNOW YOUR COUNTRY BETTER NOW?

Have you ever fast-forwarded a DVD movie? You lose the dialogue but can still grasp the essence of a plot in a fraction of the time it would take you to sit through the whole movie at regular speed. If you followed my route across America by plane instead of by motorcycle, much like fast-forwarding a movie, it would take a few hours—not weeks—to get a sense of the country's unique vastness and beauty. What you would miss, however, is the experience of feeling the differences between regions and seeing how human interaction—for good or for bad—has left its mark on our country's landscape. And you'd miss the lasting value of every experience, that ability to linger in every moment, or soak up every sight or encounter.

After completing my two trips, I had a more complete sense of our nation's character: our neighborliness, freedom of access to travel (no visible borders or checkpoints between states), a courtesy from most motorists toward motorcyclists, the embracing of strangers by good folk, and the quiet pride in what we own or have built with our own sweat and tears. For the most part we have reliable, safe highways, clean restaurants, affordable lodging, and dependable transportation, even though there are exceptions to all of these. A serious problem, however, is that our infrastructure is not as modern as that of Europe or Japan, whose economies were rebuilt after World War II. Our roads, tunnels, and bridges are aging and many are beyond repair. Work goes on daily to replace the old with the new. I caught

only a glimpse of the construction and other physical changes that must be occurring in every community throughout the country at considerable expense and dislocation to the local residents, not to mention the loss of buildings and artifacts that have historic importance.

The one sociological, if not economical, change that I witnessed firsthand and that has destroyed—or, at least, threatened—what we Americans hold dear to our hearts is the demise of our sense of community. To me, the idea of "Main Street" used to represent what was good about America. Now we are left with many cheerless, faceless strip malls, with block after block of undistinguished buildings that have little architectural beauty or merit. Main Street was once the glue for most communities. It boasted movie theaters, barbershops, small clothing stores, beauty salons, police stations, and family-owned grocery stores. Children could play in the town square and cajole the candy store clerk for a sweet or the soda jerk for a free malt, while their parents spent their Saturday mornings running errands. By and large, I discovered on my journey that Main Street has been forsaken for the "mall," with its multiplex cinemas, car palaces, and mega clothing retailers.

A phenomenon that clearly has contributed to Main Street's early demise is the construction of bypasses around small cities. Disguised as a way of easing traffic, the result has been disastrous to the commerce of these towns—and we can thank overzealous developers, national retail chains, and fast-food restaurants for this. Dothan, Alabama, a victim of this sort of civic dismantling, has tried to restore its downtown historic district, but the results are uneven. The cultural consequence of this inner-city blight and the dependence on mall life is that our towns have lost a vital thread that wove together the American family. Our grandparents, maybe more so than our parents, were responsible for instilling the great values that define us as Americans. These values were formed and shaped from Main Street experiences through good and bad times. So where's Main Street?

I confronted this issue and asked this question as I reached the town of Greenville, Mississippi, at dusk on May 27, 2005. I had always been fascinated by Mark Twain's "Big Muddy" folklore, and Greenville was my first crossing of the great Mississippi River. When I reached the outskirts of the town on the eastern bank of the river, I came to a busy intersection of a major east-west artery. This couldn't possibly be a Main Street that Twain would have recognized, since it was littered with fast-food restaurants, gas stations, and architecturally sterile, one-story buildings that lacked the ornate details you see in "old-fashioned" construction. I pulled my bike onto the shoulder of the road and asked a young couple for directions to Main Street—or, at least, to the old part of town (which I hoped still existed). The puzzled man replied, "I don't know."

As an aside, I returned to Greenville in May 2008 and, ironically, found Main Street only two blocks from where I had stopped to get directions three years earlier. It bisects the road I was on, State Highway 82. And, yes, I did find the old part of town, but to this day I remain stumped by the man's unfamiliarity. I wonder if Main Street is simply an anachronism in the hearts of most modern Americans, a place they once read about and forgot or simply never discovered. What a loss.

Call it nostalgia, but you may now understand why, of all the pictures I took during my trip, I was almost always mesmerized by abandoned factories and old mills that you could see from the roads leading into the larger, industrial cities, especially in the Midwest and Northeast. Technological innovation and global competition have created orphans of our once-leading industries: steel, textiles, shoes, automobiles, etc. So while these industrial ruins may litter our land, they remain a vestige of our golden past and are important historical markers. We need not dwell on what once was or should have been. As Americans, we should rely on our resiliency and optimism, and adapt to a new world order that will see us through these painfully difficult times we now face. Maybe if we experiment with bringing back the old values of "Main Street," if not Main Street itself, we will rediscover the American character that made us a great nation.

DO YOU FEEL MORE AMERICAN NOW THAN YOU DID BEFORE THIS TRIP?

I have always been proud of my American nationality. Even though I was born abroad, I have never felt like anything other than an American. The fact that I lived in so many countries while I was growing up made it impossible for me to feel assimilated into any culture except that of my American parents.

At this stage in my life, having crisscrossed America, I now have a deeper understanding of our country than I possessed prior to my trip. I could certainly never have gleaned these insights into American culture from the foreign countries where I grew up. Our country's cultural diversity, beauty, and spirit of freedom have given me great admiration for it. Despite our flaws, Americans are a generous and caring people. I witnessed during my trip people who toiled the earth that feeds us, local merchants and truck drivers who form the infrastructure of our vast economy, and a labyrinth of every imaginable kind of person, craft, trade, skill, and activity that collectively form the greatness of this country.

Even though we respect the American flag and what it stands for, I was dismayed, during the Memorial Day weekends when I was out on the road, by the lethargy and apparent lack of patriotism that I witnessed. Some flags were not at half-staff, which flag etiquette requires for this holiday. And some towns were devoid of any signs of planned festivities. Perhaps I saw these places at the wrong times, but no one seemed to be celebrating the great sacrifices that our forefathers and mothers had made for this great country. I add this detail in order to capture as realistic a picture of our country as possible, since I believe that as Americans we often take for granted the freedoms and good fortune that are tragically lacking in other countries. My crisscrossing of America helped me appreciate being an American more than I might ever have imagined.

This gratitude leads me to think about our flag, on which each star represents a different state. I can claim 27 stars as part of my American experience on an American bike during the two years of my trip. Symbolically, the red on our flag stands for valor and hardiness; the white represents innocence and purity; and the blue represents justice, vigilance, and perseverance. Based on my own experiences, I would substitute courage for valor, wisdom for innocence, and compassion for vigilance. This would help us describe more fully the origins of this great nation and what sustains it to this day.

Yes, I am proud to be an American and am grateful that my journey allowed me to appreciate the words of a poem written in 1893 by the young Katharine Lee Bates. Her poem, "America the Beautiful," was put to music in 1910 and has become the second-most popular patriotic song after our national anthem: "Oh beautiful, for spacious skies, for amber waves of grain, for purple mountain majesties, above the fruited plain!" From sea to shining sea, you and I are the "America the Beautiful" that she so joyously celebrates.

ITINERARY

Note: There are many inconsistencies between editions of road atlases in their use of road nomenclature and symbols, primarily with state highways and routes. Thus, we've used highway to describe most roads, except where local signage states otherwise.

LEG 1

Northwest to Southeast, May 16–30, 2005
[4,119 Miles]

Monday, May 16, 2005—Tukwila, WA, to Mt. Vernon, WA
[80.1 Miles]

Downtown Harley-Davidson in Tukwila, WA, to 48th Avenue South; Interurban Avenue South to Interstate 5 (Exit 156); I-5 to Mt. Vernon, WA (Exit 226); Freeway Drive north to Tulip Inn.

Tuesday, May 17, 2005—Mt. Vernon, WA, to Wenatchee, WA
[168.5 Miles]

Freeway Drive to Interstate 5 (Exit 227); I-5 south to Everett, WA, (Exit 194); Route 2 to Startup, WA; then over Stevens Pass and through Wenatchee National Forest to Leavenworth, WA; Route 2/97 and 285 to Wenatchee, WA; Wenatchee Avenue to Red Lion Inn.

Wednesday, May 18, 2005—Wenatchee, WA, to Lewiston, ID
[253.5 Miles]

Route 285 to Chelan Avenue, south to Peachy Street, east to Mission Street, and south to Stevens Street; Hwy 28 toward Quincy, WA; south on 281 to I-90 (Exit 151); east to Moses Lake, WA; south on Hwy 17 to Othello; east on Hwy 26 to Colfax; south on Hwy 195 to Hwy 95/12 to 21st Street, Lewiston, ID, to Comfort Inn.

Thursday, May 19, 2005—Lewiston, ID, to Boise, ID
[300.9 Miles]

21st Street to Hwy 12; Hwy 12/95 east to Hwy 95 and south to Culdesac, ID, through Nez Perce Indian Reservation; pass Cottonwood, Grangeville, and Riggins to New Meadows, ID; Hwy 55 east to Payette Lake and McCall, ID, and south to Donnelly, Lake Cascade, and Eagle, ID; Hwy 44 to Hwy 55 and then Hwy 20/26 east into Boise, ID; West Myrtle and South Capitol streets to Anniversary Inn.

Friday, May 20, 2005—Boise, ID, to Logan, UT
[310.3 Miles]

South Vista Avenue to Hwy 84 East (Exit 53 junction); Hwy 84 east to Hwy 93/79 south (Exit 173) to Twin Falls, ID; Blue Lakes Blvd (Hwy 93) to Kimberly Road (Hwy 30) south to Hansen, ID; north on G3 connector to Hwy 50; junction I-84 East (Exit 182) past Burley, ID, and south into Utah to Tremonton, UT; I-15 north to Hwy 30 East (Exit 335) to Logan, UT; left on North Main Street; Hwy 89/91 to Best Western Inn.

Saturday, May 21, 2005—Logan, UT, to Laramie, WY
[408 Miles]

North Main Street to Hwy 89 east to Garden City, UT, and Beaver Lake; Hwy 30 east through Sage and Kemmerer to Granger Junction, WY. Merge onto I-80 at Exit 66. I-80 to Laramie, WY (Exit 316); Grand Avenue to Comfort Inn.

Sunday, May 22, 2005—Laramie, WY, to Castle Rock, CO
[194.2 Miles]

Grand Avenue to South 3rd Street; left on South 3rd to Hwy 287; south on Hwy 287 past Tie Siding, WY, and Virginia Dale, CO, to Hwy 287/14 at Ft. Collins, CO; east to North College Avenue, then east on Mulberry Street (Hwy 14) to junction with I-25 (Exit 269A); south on I-25 South to Denver, CO; brief stop off Exit 199 and East Belleview Avenue; back on I-25 to Castle Rock, CO (Exit 187).

Monday, May 23, 2005—Castle Rock, CO, to Lamar, CO
[227.6 Miles]

I-25 south past Colorado Springs, CO, to Pueblo, CO. Exit 99A to 6th Street, North Santa Fe Avenue to East 4th Street to Hwy 50 past Fowler, CO, Hwy 287/50 to North Main Street, Lamar, CO, and Best Western Inn.

Tuesday, May 24, 2005—Lamar, CO, to Wichita, KS
[341.9 Miles]

North Main Street to East Olive Street; east to Hwy 385/50 to Granada, CO; Hwy 50/400 east through Dodge City, KS; right on North 2nd Avenue (Hwy 283/56) to Hwy 400 East/Southeast to Mullinville, KS, to the junction of Hwy 54 and Hwy 400; Hwy 54/400 east to South Mid-Continent Road, Wichita, KS, and Hilton-Wichita Airport.

Wednesday, May 25, 2005—Wichita, KS, to Bixby, OK
[224.1 Miles]

South Mid-Continent Road to Hwy 54/400 east; Hwy 54/400 to I-135 south (Exit 3A); Hwy 15 South past Udall, KS, to Hwy 77; south on Hwy 77 through Winfield, KS, to Ponca City, OK; east through Osage Indian Reservation on Hwy 60, past Burbank, OK; Hwy 60/11 to Pawhuska, OK; Hwy 11/99 to Pershing, OK; Hwy 11 east to Skiatook, OK; East 146th Street north to Hwy 75; Hwy 75 south to Hwy 75/64 and Tulsa, OK (Exit 4B); Riverside Pkwy to South Delaware Avenue; 121st Street east to Mingo Road, Bixby, OK.

Thursday, May 26, 2005—Bixby, OK, to Hot Springs, AR
[284.1 Miles]

Mingo Road south to 121st Street; right on 121st Street and left on South Memorial Drive to Bixby Road; east on Ferguson, then Skelly Road to Hwy 64 south of Haskell, OK; Hwy 64 past Jamesville, OK, to Hwy 62 past Boynton, OK, then Hwy 72 past Council Hill, OK; Hwy 266 east to Checotah, OK; continue on Hwy 266 east to junction with Hwy 2; Hwy 266 north to Hwy 64 junction at Warner, OK; east on Hwy 64 through Webbers Falls, OK (Arkansas River and state line) past Gore, AR, then Hwy 10 South to I-40 (Exit 291); east on I-40 to Moffet, AR (Exit 325); continue on Hwy 64 to Hwy 71B, then Hwy 71 south to Y City, AR; connect with Hwy 270 east to Hot Springs, AR; right on Central Avenue to Comfort Inn.

Friday, May 27, 2005—Hot Springs, AR, to Jackson, MS
[353 Miles]

Central Avenue to East Grand Avenue to Malvern Avenue (Hwy 270 East) through Malvern, AR; Hwy 270 to I-530 (Hwy 63) bypass at Pine Bluff, AR (Exit 46); Hwy 425/65 to Hwy 65 south past Dumas, AR; Hwy 65/165 to McGehee, AR, then Hwy 65/278 past Fairview, AR; Hwy 82/278 into Greenville, MS; continue past Leland, MS, on Hwy 82 east to Indianola, MS; south on Hwy 49W to Yazoo, MS; Hwy 49 to Jackson, MS; I-220 to Hwy 80 East to Days Inn.

Saturday, May 28, 2005—Jackson, MS, to Dothan, AL
[365.6 Miles]

Hwy 80 east to Ellis Avenue to junction of I-20/55 south; continue on I-20 to Meridian, MS (Exit 154A); Hwy 19 to Alabama State Line; Hwy 10 past Sweet Water, Camden, Pine Apple, and Greenville, to Rutledge, AL; Hwy 29/231 to Luverne, AL; Hwy 29 to Troy, AL; Hwy 231 to Dothan, AL; Hwy 210/231 bypass to Holiday Inn Express.

Sunday, May 29, 2005—Dothan, AL, to Gainesville, FL
[268 Miles]

Hwy 210/23 bypass to Route 84 east to Downtown Dothan (North St. Andrews Street and Main Street); continue on Hwy 84 to Hwy 27/84 loop to south Bainbridge, GA; south on Hwy 27 through Tallahassee, FL, to Adams Street; east/southeast on Apalachee Pkwy (Hwy 27) to Capps, FL; Hwy 19/27 through Perry, Mayo, and Branford to High Springs, FL; Hwy 441 east to I-75 (Exit 399) to Gainesville, FL; I-75 south to Exit 387; east on Hwy 26 (University Avenue) to the University of Florida and to the Holiday Inn Gainesville-University Center.

Monday, May 30, 2005—Memorial Day—Gainesville, FL, to Naples, FL
[339.3 Miles]

University Avenue (Hwy 26) west to I-75 (Exit 387); I-75 south past Ocala, FL, to Bradenton, FL (Exit 220B); Hwy 64 west to Hwy 301/41 and north to Palmetto, FL, for a short rest; Hwy 301/41 south to Manatee Avenue West; south on 75th Street West to 53rd Avenue; east to I-75 (Exit 217); I-75 south to Golden Gate (Exit 107); Pine Ridge Road to Hwy 41 (Tamiami Trail) and south to Naples home.

LEG 2

Southwest to Northeast, May 15–31, 2006
[4,437.5 Miles]

Monday, May 15, 2006—National City, CA, to Palm Springs, CA
[214.4 Miles]

Sweetwater Harley-Davidson, National City, CA, Hoover Avenue to West 33rd Street; Hwy 54 to Interstate 5 (Exit 8B); I-5 to Camino De La Plaza and East San Ysidro Blvd. (Exit 1A); I-5/805; Exit 1A to I-805 to Hwy 94, to Hwy 125 to Interstate 8; I-8 to Exit 40; Hwy 79 North, past Descanso, CA, and Cuyamaca Rancho State Park to Julian, CA; Hwy 78 through Anza-Borrego Desert State Park to Salton Sea; north on Hwy 86 to Coachella, CA; Grapefruit Avenue/Hwy 111 N through Indio, Palm Desert, Rancho Mirage to Palm Springs; S. Indian Canyon Drive and Las Brisas Best Western.

Tuesday, May 16, 2006—Palm Springs, CA, to Kingman, AZ
[271.2 Miles]

South to North Indian Canyon Drive to Indian Avenue to Hwy 62; east on Hwy 62 through Yucca Valley to Twentynine Palms, CA. Continue on Hwy 62 to Vidal Jct., CA; Hwy 95 to Exit 144; join I-40; I-40 West to Exit 139, Needles Hwy; Needles Hwy to River Road (along Colorado River) north to Laughlin, NV. Right on Hwy 163 to Downtown Laughlin, NV, and South Casino Drive, back onto Hwy 163 to Hwy 68 East; Hwy 93 South into Kingman, AZ; East Andy Devine Drive (Route 66) to Best Western-Kings Inn & Suites.

Wednesday, May 17, 2006—Kingman, AZ, to Sedona, AZ
[230.7 Miles]

Route 66 to Detroit Avenue east; Harrison Street north to Beverly Street east and Harley-Davidson Mother Road; Beverly Street to Route 66 through Seligman, AZ, to Interstate 40 (Exit 139); I-40 east to Ash Fork, AZ, (Exit 146); Hwy 89 south to north Prescott, AZ; Alternate Hwy 89 to Jerome, AZ, and then to Sedona, AZ, to Best Western-Arroyo Roble.

Thursday, May 18, 2006—Sedona, AZ, to Santa Fe, NM
[438 Miles]

Alternate Hwy 89 north to Interstate 17 (Exit 337); I-17 north into Flagstaff, AZ; South Milton Road to Santa Fe Avenue and back to South Milton Road to Interstate 40 (Exit 340A); I-40 east to Albuquerque, NM, past Winslow, AZ, and Gallup, NM; Exit 157A to Rio Grande Blvd. NW to Central Avenue NW; back to I-40 (Exit 157A); east to I-25 junction; I-25 north to Santa Fe, NM (Exit 282), and St. Francis Drive; north to Cerrillos Road; Galisteo Street to West San Francisco Street and La Fonda Hotel.

Friday, May 19, 2006—No travel

Historic Santa Fe, Canyon Road Art District, and environs.

Saturday, May 20, 2006—Santa Fe, NM, to Dalhart, TX
[310 Miles]

San Francisco Street to Cathedral Place to East Alameda; North Guadalupe to North St. Francis Dr./Hwy 84/285 to Riverside, NM; Hwy 68 to Taos, NM; Don Fernando Street, then Kit Carson Road to Hwy 64 to Eagle Nest and Cimarron, NM; Hwy 21 south past Miami Lake and Miami, NM, to Springer, NM; Hwy 412/56 east to Clayton, NM; Hwy 87 to Dalhart, TX; Liberal Street/Hwy 54 to Holiday Inn Express.

Sunday, May 21, 2006—Dalhart, TX, to Hutchinson, KS
[327.7 Miles]

Hwy 54 through Stratford, TX, Texhoma, OK, Liberal, KS, to Plains, Kansas; Hwy 54/160 to Meade, then Hwy 54 to Bucklin, KS, to join Hwy 54/400 8 miles west of Greensburg, KS (intersection of *Crisscrossing America*); Hwy 54/400 through Greensburg, KS, to Pratt, KS; Hwy 61 north to Hutchinson, KS, to East 17th Avenue and Holiday Inn Express.

Monday, May 22, 2006—Hutchinson, KS, to Kansas City, MO
[320.6 Miles]

17th Street to Downtown Hutchinson, KS; Main Street south to East F Avenue; North Main then South Main Street to Hwy 50, east to Newton, KS; I-135 to Hwy 50 (Exit 33) to Strong City, KS; Hwy 177 north through Council Grove to I-70 (Exit 313) to Hwy 75 and 24 for detour; east on I-70 past Topeka, KS, for second detour on I-70/670 onto I-35 (Exit 2T); back on I-35/29 to Gladstone, MO; return to Kansa City, MO, on I-35/29 to Broadway Street (Exit 1B), to East 43rd Street to Main Street and Best Western Hotel.

Tuesday, May 23, 2006—Kansas City, MO, to Ft. Madison, IA
[365.6 Miles]

Main Street to Westport Road to Broadway Street to I-35/29 north (Exit 1B); I-29 north to Exit 1C, North Oak Street to Worth Harley-Davidson; North Oak Street to 152 West; NW Jones Myer Road to Hwy 45; north on Hwy 45 to Hwy 45 Spur to Hwy 92 across Missouri River to Leavenworth, KS; Metropolitan Avenue to Leavenworth Penitentiary; back on Hwy 92 to Platte City, MO; north on Hwy 92, then Hwy 273 to I-29/Hwy71 (Exit 20) to St. Joseph, MO; Exit 46A to Hwy 36 to Hannibal, MO, and Exit 157 on Hwy 36/I-72 to Mark Twain Avenue to Broadway. Back to Mark Twain Avenue/Hwy 61; North on Hwy 61/24 to Taylor, MO; Hwy 61 then Hwy 136/61 to Keokuk, IA, and Hwy 61/218 then Hwy 61 to Ft. Madison, IA, and Kingsley Inn.

Wednesday, May 24, 2006—Ft. Madison, IA, to Huntington, IN
[353.7 Miles]

Hwy 61 to Hwy 2; Illinois Toll Booth, Mississippi River bridge; Hwy 9 to Hwy 9/96 to Dallas City, IL; Hwy 9/94 to La Harpe, IL, Hwy 9 to Banner, IL; Hwy 24 through Peoria, IL; 24 East past Watseka, IL, Monticello, IN, Hwy 224 to Huntington, IN, and Holiday Inn Express.

Thursday, May 25, 2006—Huntington, IN, to Meadville, PA
[377.2 Miles]

Hwy 224 (North Jefferson Street) to downtown Huntington, IN; Cherry Street to West State Street to South Jefferson Street; continue on Hwy 224 to Decatur, IN; Hwy 224/27 to Hwy 224 west of Van Wert, OH; Hwy 224/30, then Hwy 30 to Hwy 235 north to I-75 (Exit 145); I-75 to Findlay,

OH (Exit 159); Hwy 224 east through Greenwich, OH, to Interstate 76 through Akron, OH; I-76 to Exit 38A to Hwy 44/5, then Hwy 5 to Warren, OH; Hwy 5/82 to Hwy 11 south; Hwy 711 to I-680 south to Belle Vista Avenue (Exit 3B) to Mahoning Avenue, to downtown Youngstown, OH; West Rayen Avenue to Wick Avenue to I-680 (Exit 6A); I-680 north to Hwy 711 north (Exit 3A) and I-80 east to Hwy 60 (Exit 4B), then Hwy 18 through Hermitage to Greenville, PA; Hwy 18/358 to Hwy 18/58, then Hwy 18 to Hartstown, PA; Hwy 18/322 to Conneaut Lake, PA; Hwy 322 to Meadville, PA, and Park Avenue to Holiday Inn Express.

Friday, May 26, 2006—Meadville, PA, to Old Forge, NY
[507 Miles]

Park Avenue to Hwy 19/322 to Interstate 79 (Exit 147B); north to downtown Erie, PA, to West Bayfront Parkway to Niagara Pier Road at Presque Isle Bay; return to I-79 and Exit 182 to West 26th Street (Hwy 20) to Harley-Davidson of Erie; back on Exit 182 and I-79 to I-90 (Exit 178A); north to I-86/Hwy17 (Exit 37) to Horseheads, NY (Exit 54); Hwy 13 through Ithaca, NY, to Dryden, NY; Hwy 38 to Harford, NY; Hwy 221 to Main Street, Marathon, NY; Main Street to I-81 (Exit 9); I-81 north to I-481, Syracuse, NY; I-90 to Utica, NY; U-turn on I-90 south of Little Falls, NY; I-90 westbound to Utica and exit to Hwy 12/28; north on Hwy 12/28 to Alder Creek, NY; Hwy 28 to Old Forge, NY; Main Street to Shore Road and to the home of friends.

Saturday, May 27, 2006—No travel

Old Forge, NY, and environs.

Sunday, May 28, 2006—Old Forge, NY, to Hanover, NH
[261.1 Miles]

Shore Road to Hwy 28 to Inlet, NY, then to Blue Mountain Lake, NY; Hwy 28/30 east to Indian Lake, NY; Hwy 28 to Warrensburg, NY; Hwy 9 to I-87 (Exit 23); I-87 south to Exit 15, Saratoga Springs, NY; Hwy 50/9 to Broadway; Hwy 29 (Lake Avenue) east to Schuylerville, NY; Hwy 4/32 to Northumberland, NY; Hwy 4 to Whitehall, NY, to Rutland, then Woodstock, VT, and to I-89 (Exit 1); I-89 south to I-90 (Exit 10N); I-90 north to Hanover, NH, (Exit 13); Hwy 10A to South Main Street and Hanover Inn.

Monday, May 29, 2006—Memorial Day—Hanover, NH, to East Boothbay, ME
[266.7 Miles]

South Main Street to East Wheelock Street; Hwy 10 north to Orford, NH; Hwy 25A to Wentworth, NH; Hwy 25/118 to Warren, NH, and Hwy 118 to west of North Woodstock, NH; Hwy 112 (Kancamagus Hwy) to Conway, NH; Hwy 113, then Hwy 302 through Fryeburg to Bridgton, then Naples, ME; then Hwy 11 to Mechanic Falls, ME; Hwy 121 and Hwy 202 to Lewiston, ME; Hwy 136 to Durham, ME; Hwy 9 to Lisbon Falls, ME, to Hwy 196 then Hwy 1 junction; northeast to Bath through Wiscasset, ME, to Hwy 27; Hwy 27 south to Boothbay Harbor; Hwy 96 to East Boothbay, ME, and the home of friends.

Tuesday, May 30, 2006—East Boothbay, ME, to Eastport, ME
[233.5 Miles]

Hwy 96 north to Hwy 27, then Hwy 1; northeast through Rockland, Camden, Belfast, Searsport, Bucksport, Ellsworth, and Milbridge to south of Perry, ME; Hwy 190 south to Eastport, ME, and Water Street to city wharf.

ACKNOWLEDGMENTS

If you ever embark on a long journey, you take months of planning to ensure that all goes well. Invariably you forget something, which may or may not affect the outcome of the trip. For a solitary journey such as Crisscrossing America, it was no different, but I am pleased to report that I made the trip safely and without any regrets.

Can I say the same for this publishing journey that I have chosen to tackle? It has taken me down unfamiliar and sometimes baffling roads, and like most unpublished authors, I had no idea how to proceed. The only common denominator has been perseverance, faith, and the encouragement and unconditional support from family, friends, and my new colleagues at Rizzoli International Publications, Inc.

My twin sister, the late Jean C. "Nini" Gussenhoven, was in touch with me daily throughout my journeys during 2005 and 2006, but died suddenly in October 2006 before I had found a home for the book. I know, however, that she has been at my side and in my heart during every moment of the book's creation. Almost effortlessly and with miraculous grace, she had set, during her life, an exceedingly high bar for herself. Through our heartache over her loss, we have strived to reach for that high bar in producing this book.

How can I not thank and embrace my extraordinary wife, Harriette, who has been so supportive and self-effacing throughout not only my crazy motorcycle trips but also during the months it has taken to fulfill this literary pursuit. I now see, looking back over the past few years, that she has been more than patient with my long absences and has quietly endured the rollercoaster of my getting this book published with nary a complaint or protest. God bless you, Harriette, and may I repay you in some way that I have not yet thought of.

My beloved son, Jordan, has watched his Dad from a distance, but little does he know how much I needed his blessings and cheers in order to pursue my trip and finish the book—which, for all you unpublished writers, has actually been as challenging as the cross-country journey itself!

My older brother, James, has made a fascinating life for himself through travel, learning, and doing. His philosophy set the standard for my own approach to life (i.e., learning from doing) even if I began doing this, regrettably, later in life than he did. I love and admire James deeply for his unassuming character, astonishing intellect, and great inner strength. Thank you, James, for staying close and for guiding me through this facet of your younger brother's life.

Never would I have dreamed of being able to interest an agent to represent me on my book project. To me, in the illustrated book world there is one agent who stands above all others and that is John Campbell. I could write several pages to describe this incomparable human being, but as a published author himself, he could perhaps do a better job of articulating my feelings. Almost divinely, John embraced Nini and her life from the first time we met and, thankfully, has kept her in his thoughts and actions throughout every phase of our book project, delivering only what he believes she would have wanted for me. I pay this martial artist the highest compliment by calling him a warrior, whose sense of duty and compassion are visible as proven, tested swords on his sash. He has been a source of inspiration, a steady but firm hand in guiding me through a literary labyrinth that would intimidate even the fearless Minotaur in Greek mythology. As busy and consumed as he was with his other clients, John took on the added role of editing the book, for which I am most grateful. His deft hand and immensely artistic and creative mind are like bright threads woven throughout the entire book, from the written word to the selection and positioning of images. Our friendship survives this effort, which may be the greatest blessing of all, and Nini has gained another friend. Bless you, John.

My deepest thanks go to Jim Wark, the acclaimed aerial photographer whose stunning images grace the pages of *Crisscrossing America*. To him and his lovely wife, Judy, I will be forever grateful for their friendship and steady support. I am awed by his brilliant insights and never-ending focus on the work at hand.

The apple does not fall far from the tree. Jim's son, John Wark, is also a supremely gifted photographer. While Jim was in the air taking the aerial photographs, John was in his studio developing and digitizing the thousands of images that Jim and I had taken on Fuji Velvia film. John has been a can-do mentor since the beginning of our project in 2004. We will joyously continue to work on future projects and I thank you, John, for your immense help, moral support, and uniquely discerning judgment.

Crisscrossing America is in the reader's hands thanks to Jim Muschett, an Associate Publisher at Rizzoli who immediately grasped my story and had the confidence in our team to inspire everyone's finest work. In addition to being a consummate team leader and friend, Jim obviously has a secret career in the diplomatic corps. He moves projects forward with seamless dexterity and to great effect, regardless of obstacles or setbacks.

Rizzoli is fortunate to have at its helm Charles Miers, a publisher whose astounding good taste and fine eye have enhanced this tome enormously. Rizzoli's wonderfully wise chief financial officer, Alan Rutsky, contributed much-appreciated feedback as we moved through the various phases of this project.

Melissa Veronesi shepherded a fine team of copy editors through some especially tricky straits—all of whom deserve applause for their shrewd remarks and brilliant editing. In the end, it was Melissa who gave the project its much-needed refinement.

As you scan through the pages of the book, you'll see the powerful work of a startlingly gifted designer, Aldo Sampieri. He laid out the book and stirred the broth as a number of cooks, including me, looked over his shoulder, throwing in a number of unexpected ingredients into the pot. Aldo always responded with ease and great humor, but never veered from the vision he had in mind when he took on the project. He, too, has become a friend to all of us and can proudly take the stage to receive a much-deserved bravo!

I am blessed to have Joe Platt in my life. I have cherished him for more than 34 years as my business partner and treasured confidante. Over the decades, we have followed each other's families and activities like a closely read book. My excursions and gypsylike movements have never eluded Joe's sharp acumen. He has always been my greatest ally and booster. How many of us can count on one hand the friendships that survive time and innumerable tests? I am lucky to be one.

Joe introduced me to my first bonafide publisher, Jed Lyons, of Rowman & Littlefield. Alas, Jed does not publish illustrated books, but he indirectly led me to my agent, John Campbell. Joe also paved the way for meetings with WQED-TV, one of the country's celebrated public television stations. Its chairman, George Miles, and his brilliant leaders—Darryl Ford Williams and Patty Walker—were the first audience to hear about my book concept. Both Jed and the people at WQED were exceedingly generous with their time and encouragement of my project.

There are so many friends who have taken an interest in the book and have provided the enthusiasm that helped me press on to the finish line. I thank them for their kindness and empathy, especially since I felt guilty about neglecting these very friends during the completion of my book.

I salute my co-pilot and friend, Garrett Snow, who was at my side not only at 41,000 feet but also on the ground at three main points during the crisscross—in Seattle, San Diego, and at the finish in Maine. In each case, his presence relieved much of my uncertainty.

I have a special thanks for those people who introduced me to the Harley experience and launched me safely on my crisscrossing odyssey. Bob Milliken taught the motorcycle safety course sponsored by Harley-Davidson called Rider's Edge. Bob showed me how to never compromise on safety while at the same time savoring every moment in the saddle. The folks at Harley-Davidson of Naples, Florida, were most accommodating and professional from the day I first took possession of my bike: Don Huttlin and Jim Maddox were the tops! Their parts manager, the diminutive Sara Zivich, made sure my bike was properly outfitted for the 8,000-plus-mile journey. It moved me greatly that Sara lent me her cross to wear around my neck for the second leg of the trip. I did so with great comfort and peace of mind. Thank you, Sara, for your kindness.

I owe huge kudos to the many superb Harley dealers who extended a hand as I made my way across America. They are legions, but some of the standouts include Steve Miller and Tony Screws of Downtown Harley-Davidson in Tukwila, Washington; the folks at Wenatchee Harley-Davison in Washington and at Shumate Harley-Davidson in Lewiston, Idaho; Cycle Nuts & Bolts Harley-Davidson in Boise, Idaho; Snake Harley-Davidson in Twin Falls, Idaho; Saddleback Harley-Davidson in Logan, Utah; Laramie Harley-Davidson in Laramie, Wyoming; Thunder Mountain Harley-Davidson in Loveland, Colorado; Dodge City Harley-Davidson in Dodge City, Kansas; Mid-Continent Harley-Davidson in Wichita, Kansas; Jones Harley-Davidson in Hot Springs, Arkansas; Harley-Davidson of Jackson, Mississippi; Harley-Davidson of Dothan, Alabama; Paul Garibay of Sweetwater Harley-Davidson in National City, California; Palm Springs Harley-Davidson in California; Lyn Moss of Mother Road Harley-Davidson in Kingman, Arizona; the Santa Fe Harley-Davidson in New Mexico; Bruce Brink and Rick Tisdel of Worth Harley-Davidson in Gladstone, Missouri; Debbie McCauley of Harley-Davidson of Erie, Pennsylvania; Ithaca Harley-Davidson in Cayuta, New York; and Clint Parsons of Central Maine Harley-Davidson in Hermon, Maine.

As you read through my journals in *Crisscrossing America*, you will see me describe the many acts of kindness I experienced. Since the journals in the book are excerpts from the logs I maintained at the end of each day's ride, you may not read about everyone who touched my soul in one form or another. Many gestures of goodwill came from passersby, whose names I missed. The Good Samaritans with whom I had more contact included Steve Miller, Ward Tree Rountree, Richard "Gil" Gilbert, and Bennie Kirtman of the Iron Souls Motorcycle Club; Don Holmes, Lino Ambriz, Marcia and Carl Snow, Sara Zivich, Paul Garibay, Lyn Moss, the Wyoming Highway Patrol, Heather, Lisa Stuckey, Zeb, Rebecca, Bruce Brink, Tom Berry, Rebeca and Fayek Andrawes, Gary, Ron Cotton, Fred and Dinny Genung, and Kathy and Chet Evans.

My heartfelt thanks to my attorney Erik Kahn, Esq., at Bryan Cave LLP, in New York City for his legal advice and trademark assistance. Thanks also to Patricia Werner, Sam Fleishman, and Chuck Campbell for their help along this publishing highway and to my publicist, Sally McCartin, whose endearing spirit, effervescence, and supreme talents contributed immeasurably to our success in reaching a broad audience of readers and adventure enthusiasts.

And to all the other people who have helped me squire this book through its gestation and publication, Nini and I thank you.